American Photogr

Oxford History of Art

WITHDRAWN

Miles Orvell is Director of American Studies, and Professor of English and American Studies at Temple University, Philadelphia. He is the author of *The Real Thing: Imitation and Authenticity in American Culture, 1880 to 1940* (Chapel Hill: University of North Carolina Press, 1989), co-winner of the American Studies Association's Franklin Prize; and of *After the Machine: Visual Arts and the Erasing of Cultural Boundaries* (Jackson, MS: University Press of Mississippi, 1995). He has written widely on literature, photography, and the arts, and is the Senior Editor of the *Encyclopedia of American Studies* (four volumes, New York: Grolier, 2001).

Oxford History of Art

Titles in the Oxford History of Art series are up-to-date, fully illustrated introductions to a wide variety of subjects written by leading experts in their field. They will appear regularly, building into an interlocking and comprehensive series. In the list below, published titles appear in bold.

Oxford History of Art

American Photography

Miles Orvell

OXFORD

UNIVERSITY PRESS

OXFORD
UNIVERSITY PRESS

Great Clarendon Street, Oxford OX2 6DP

Oxford New York

Auckland Bangkok Buenos Aires Cape Town
Chennai Dar es Salaam Delhi Hong Kong Istanbul Karachi
Kolkata Kuala Lumpur Madrid Melbourne Mexico City Mumbai
Nairobi São Paulo Shanghai Taipei Tokyo Toronto

and associated companies in Berlin Ibadan

Oxford is a registered trade mark of Oxford University Press
in the UK and in certain other countries

0-19-284271-4

10 9 8 7 6 5 4 3 2 1

British Library Cataloguing in Publication Data
Data available

Library of Congress Cataloguing in Publication Data
Data available

ISBN 0-19-284271-4

Picture research by Charlotte Morris and Elisabeth Agate
Copy-editing, typesetting, and production management by
The Running Head Limited, Cambridge, www.therunninghead.com
Printed in Hong Kong on acid-free paper by C&C Offset Printing Co. Ltd

To Ariana and Dylan

Contents

Preface

Although there are good grounds for viewing photography from a global perspective—aesthetic and stylistic trends do tend to jump national boundaries—the grounds for a national history of photography are even stronger, for the particular conditions governing the production and reception of photographic images are best seen within a specific culture. Long-standing arguments against the 'exceptional' nature of American culture have certainly alerted any Americanist to the dangers of viewing American history—or any national history—in isolation; but nevertheless national—and regional—cultures have developed qualities that reflect the unique circumstances and ingredients of their construction. Hence the 'Americanness' of American photography will be a recurrent (though by no means obsessional) theme in this volume. It will be necessary both to relate American practices to global trends and to offer some discussion of their American inflection. Does the American landscape, for example, afford opportunities or limitations that are peculiar to American photography, combined with the intellectual construction of 'nature' in the American tradition? Do attitudes towards social change, along with the history of poverty, immigration, and urban development in the United States, create an environment for documentary photography that is reflective of national conditions, political, and social habits? Does the American obsession with advertising and the media shape the production of contemporary modes of image-photography? These are some of the ways the 'Americanness' of American photography will be highlighted in this history.

In the last twenty years, serious scholarship and criticism on photography, along with ever-increasing numbers of photographic exhibitions, have established a solid base for the study of photography today. Starting from this foundation, the opportunity to write a history of American photography can thus be the occasion for synthesizing recent work and for constructing a narrative that provides the reader with a sense of order and structure not currently available in the more broadly conceived histories of photography.[1] What this volume attempts to offer is a sense of American photography as a comprehensible whole, with each chapter encompassing certain tendencies that

are distinct and identifiable, based upon the various functions and purposes of photographic practice.

Any history such as this faces essentially the same problem: how to translate into a linear narrative the complex history of a medium in which things are in fact happening simultaneously. In the present case, I have attempted to sustain a sense of historical movement by beginning with chapters (on portrait and landscape) that dominate the nineteenth century, while the later chapters—for example, on memory or on fictional photography—primarily feature aspects of twentieth-century photography. But each chapter will move forward and backward depending on how best to present a sense of the continuities from one century to another. Traditional genres and modes are not 'used up': rather, they are adapted and transformed. Conversely, new modes often draw upon past models for inspiration. This history will thus attempt to satisfy one of Andy Grundberg's complaints, in *After Art: Rethinking 150 Years of Photography*, that there are 'precious few' narratives or photographic collections that are 'capable of shedding light on the crucial transition between photography's historical traditions and its contemporary practices'.[2] Told with a sense of the historical dimension, the history of photography in America thus becomes a narrative of successive paradigms, rather than a string of masterpieces.

At the same time, a history of American photography should also aim to question assumptions that govern contemporary thinking about the medium. For example, how does photographic art relate to the rest of the art world? How has the mechanical nature of the medium been exploited (or resisted) by photographers? Where do we draw the line between documentary representation and the manipulation (or direction) of the picture? How can a culture assimilate the shock of photographic representation—and at what point does photography inure us to shock? How far can the photographer go in exploiting his or her subjects? What are the cultural effects of photographic misrepresentation, made widely possible now with digital photography?

Given the centrality of photography to American culture, and especially to contemporary America, thinking about it critically is, we might say, an essential cultural act, and the aim of this volume is to frame the subject historically and conceptually.

A word about the illustrations. Given the intentions of the Oxford History of Art Series—to provide readers with a freshly conceived yet broadly authoritative history on a given subject—I have tried to choose illustrations for this volume that are both well known and perhaps little known. First, there will be familiar images, the classic and representative photographs that will immediately connect the reader with the subject. Second, there will be relatively unfamiliar work, allowing readers with a grounding in the subject to discover

images and photographers perhaps for the first time. The greatest frustration in making any selection for a volume like this, with such a broad coverage, is simply the extraordinary number of great images one must exclude, so that the final choice inevitably has a certain arbitrary quality. Why this? Why not this?

My particular thanks go to numerous individuals who over many years have shaped my views about photography through their writings and through their conversation and friendship. Among them are Richard Chalfen, James Curtis, Judith Davidov, Mick Gidley, Peter Bacon Hales, David Nye, Mary Panzer, David Peeler, Steve Perloff, Jay Ruby, Maren Stange, Sally Stein, and Alan Trachtenberg.

Thanks also to my students, both undergraduate and graduate, in courses I have taught on the history of photography and on literature and photography. Their questions, and their responses, have also informed the writing of this book. My thanks to Temple University for providing a study leave during which I was able to spend part of my time getting started on this project.

Any author would be delighted to have the expert and imaginative support of the Oxford University Press staff, and I thank particularly Simon Mason for his early editorial inspiration and Katharine Reeve for seeing it through. To Charlotte Morris, Elisabeth Agate, and David Williams, who aided greatly in producing the manuscript, my special thanks.

To Gabriella, Ariana, and Dylan, I express my familiar gratitude; they have, yet again, tolerated my long hours in the study on occasions when I might much better have been taking family snapshots.

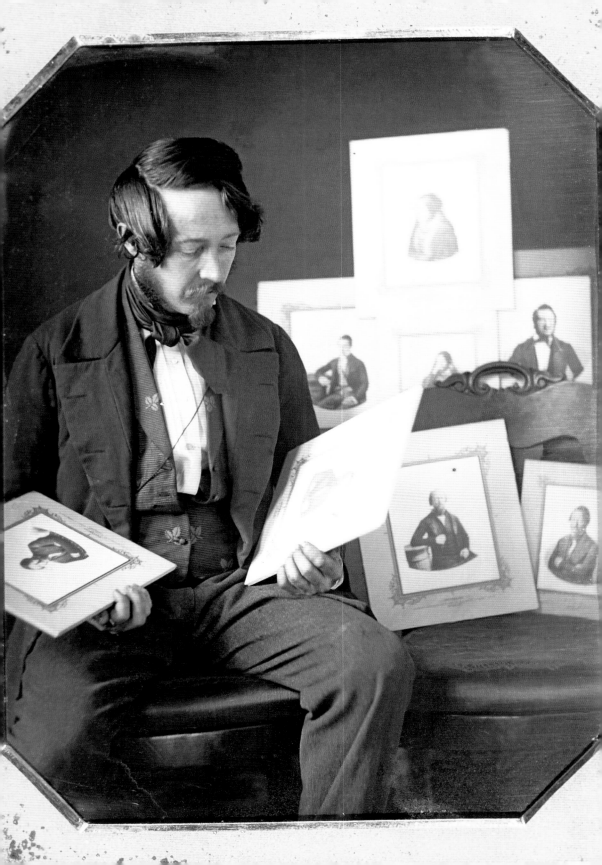

Introduction

1

'There is no more important event than seeing or being seen.' Ray Carney[1]

Few inventions have so completely changed the course of civilization, let alone our whole way of knowing the world, as photography. And this has been especially true in the United States, where photography quickly became a part of American culture at every level—from the practical and scientific, to the industrial, to the aesthetic, not to mention the whole world of amusement and entertainment that opened up with the advent of the camera. 'It is arguable that America's photography', historian Sean Wilentz has written, 'has been this country's greatest single contribution to the visual arts. Photography is the jazz of the visual arts. In no other art form has American work loomed so large.'[2] This is indeed a large claim, but it reflects our sense, at the outset of the twenty-first century, that photography has moved to the centre of American intellectual and aesthetic discourse and that we must, to understand its impact fully, look backward to its beginnings in the mid-nineteenth century.

Why was this new art so appealing to Americans? Firstly, the very fact that photography was a mechanical process harmonized with a growing enthusiasm for technology, part of a national mentality that accepted change as a fact of life. Along with the steam engine, railroads, and later on electricity, photography would revolutionize the idea of modern life. And just as these technologies were making the world smaller by enhancing the means of communication and travel, so did photography too, bringing the wonders and sights of the world into the parlour with an immediacy that was breathtaking.

Secondly, the camera has been the prime instrument for self-representation, capable of fashioning an image for public consumption in a democratic republic where personal identity and national identity were always to be invented and reinvented. And thirdly, as an instrument for creating and sustaining a sense of self and family, the camera has also been hugely important, a means of endowing the family with a history of its own, even if a somewhat idealized one.[3] And finally, as Wilentz observes, the photograph's inherent realism was in harmony aesthetically with a tendency towards realism and the representation of

1 William and Frederick Langenheim

Frederick Langenheim Looking at Talbotypes of Himself, 1849

The Langenheim brothers, immigrants from Germany, settled in Philadelphia and soon became expert at producing daguerreotype portraits. In 1849 they invested $6,000 in purchasing from Henry Fox Talbot the exclusive American licence to the Talbotype process (which used a paper negative), but the process could not compete with the far more detailed results of the daguerreotype; nor could it compete with the glass negative, which was just then also coming into use. Here, Frederick stares forlornly, one might suppose, at examples of the Talbotype process, his own and his brother's portraits. It is an unusual daguerreotype in being self-referential, and in capturing the fascination that the portrait held for the first generation of photographers.

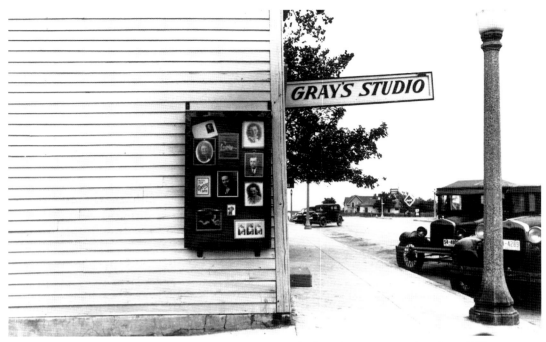

2 John Vachon

Photographer's Studio, Sisseton, South Dakota, 1939

Vachon was working for the Farm Security Administration when he took this picture, on assignment in South Dakota. It shows how visible in the fabric of small town life was the photography studio, with the samples of photos in the display case outside. The photos attest to their being at least some people in this place, which otherwise looks quite deserted. Still, the photo studio held its place as a recorder of rituals and public functions, along with its private uses. Vachon was lucky to find a studio with this particular name—Gray's studio—suggesting the tonality of the photographic image, at a time when the full potential of grey tones was just being discovered by photographers like Ansel Adams.

everyday realities that we find in American artists from Whitman to Eakins.

Any photograph is a way of calling attention to something, a picture of what a photographer wants us to look at; and every picture is implicitly saying, *This you should see!* The fact that the picture is an image made by a machine (as opposed to, say, a drawing) adds a unique characteristic: photographs are records of events, of people, of things; records—at the very least—of what was in front of the camera, and as such the photograph embodies a certain objectivity. And yet, as the product of a particular individual *taking* the photograph, the image also carries with it an inescapable element of a point of view, a subjectivity.

Our awareness of an image is at once an awareness of its subject and of the approach the photographer has taken to it, and photography has this ambiguous quality: it is both objective and subjective at the same time, a window into 'reality' and a constructed language. Put another way (and borrowing the semiotic terminology of Roland Barthes), a photograph is coded in both a denotative and a connotative way. Its denotative meaning is what the image shows us, the subject; its connotative meaning is how the subject is shown, the various cultural and aesthetic codes that tell us more fully what it means. In fact, as has been argued, these seemingly opposing qualities are better seen as complementary, even overlapping, if not simultaneously present in our perception of a given photograph.[4]

We may look at a photograph and think—because we recognize the subject, let's say—that we know what the photograph *means*:

consequently photography has been hailed since its beginnings as a 'universal language'. But photographic meaning is rather more complex than that. There are few things standing before us—whether a person, a thing, or an event—that speak their own meaning; and few images are presented to us without some frame of information that leads us to an interpretation—whether it is a caption in a newspaper, or a layout on a magazine page, or its placement on a gallery wall, or in the pages of a book. If we want to understand a photograph historically, then we need to pay special attention to its purpose and function within a given cultural matrix: Why did the photographer make the image? How did people first see it? And, to complicate matters further, the same image might be shown in several different contexts, and its meaning (connotative) would accordingly be different for each one.

In fact, we might say that a given image does not have a single meaning but, rather, multiple meanings, depending on the particular context and its purpose. To know what the image means, we need to know something about why the image is there. To understand a photograph is therefore to recognize that any image is produced at an *intersection* of cultural determinants. These determinants include:

- the photographer's personal history, encompassing biographical and motivational factors
- the social or commercial matrix in which the image was produced, encompassing the relations between photographer and client
- the semiotic context, which includes the codes of meaning governing the subject's gestures and dress (or with a non-human subject, material construction)
- the aesthetic composition of the photograph, ranging from balanced to deliberately disorganized; focus and lighting can also be coded (e.g. blurred focus and/or chiaroscuro equals 'romantic')
- interpretive codes, whereby an image can be seen as 'symbolic' or simply 'literal' in its meaning
- the presentational format (gallery, family album, newspaper, book), including the caption
- and the history of the photograph's reception.[5]

Not all of these parameters can be invoked for every discussion of a photograph, but the confluence of these angles of consideration argues strongly for an interdisciplinary approach to photography, beginning with the assumption that the photograph is a site of tension and ambiguity, an event whose construction is multiplex.

As Abigail Solomon-Godeau puts it, the history of photography is 'the history of photographic uses'.[6] We might distinguish among the uses of photography in several different ways: we can talk about public uses (photographs made for public consumption) and about private

uses (e.g. images made for the family album). Or we might talk about the distinction between images made to please us aesthetically, and those made in the documentary mode to supply information. But again, these functions can overlap, and a consideration of any photograph or movement within the history of photography might take any one of several approaches. Still, faced with the necessity of dividing this book into chapters, I have taken the photographer's underlying *purpose* to be the most important determinant of the work's historical meaning or at least the place to begin. Any photographic image—from news, medicine, or science, or any family picture—can easily migrate from one context to another, in the same way as, for example, W. Eugene Smith's *Life* magazine photographs have been transformed into art objects when brought to the museum. Nevertheless, one must begin to understand a work by developing a historical sense of its original purpose. Most photographs, given the nature of camera imaging, contain both information and the interpretive organization of that information (denotative and connotative meaning, in Barthes's terms), but we may still see one function and purpose, rather than another, as dominant at a given time.

Consequently, the chapters in this book will each emphasize a coherent mode of photographic practice: the portrait; landscape photography; the documentary mode; artistic photography; social observation; autobiographical photography; photographic fictions; photography and the image world; and digital photography, which threatens the traditional 'truth-telling' characteristic of the photograph.

It seems fitting—given the multiple contexts in which we find photography, from the newspaper to the gallery—that photography should originate in both the high arts and the popular arts. On the one hand, the process was simply an extension of an often used artist's tool, the camera obscura, a box that provided a framed, and helpfully contained, view of the landscape as light entered through a small hole in one side. Making that image permanent was the challenge, and it was successfully met in England in 1839 by Henry Fox Talbot, a scientist with broad intellectual interests, working at his country estate, Lacock Abbey. But simultaneously, in France, photography developed out of the popular arts, in the hands of Louis-Jacques-Mandé Daguerre, a scenic artist and designer of dioramas, a theatrical entertainment that featured changing scenes manipulated by lighting effects. And the medium has continued, to our day, to reflect this fascinating and puzzling dual parentage, as both an art form and a medium of popular entertainment and mass communication.

One such puzzle is the relationship of photography to painting. Aaron Scharf's *Art and Photography* and Van Deren Coke's *The Painter and the Photograph*[7] have shown that painters relied on the camera as an aid to composition, but the degree of dependency may have been

underestimated, as a Thomas Eakins show at the Philadelphia Museum of Art demonstrated in 2001. For several of his famous works, the exhibition revealed, Eakins seems to have traced a projected photographic image on to his canvas. Meanwhile, painter David Hockney, in *Secret Knowledge: Rediscovering the Lost Techniques of the Old Masters*,[8] extravagantly and meticulously documented his claim that optical devices like the camera obscura and the camera lucida have for centuries been aiding painters in the achievement of realistic effects.

If the camera's importance to the artist was kept secret for a long time, it is now, for the contemporary artist, anything but a secret. For the last several decades, beginning with Andy Warhol's exploitation of the photograph in individual paintings, silk screens, and multiples, artists have been incorporating photographs into their work in a variety of ways. Robert Rauschenberg's paintings brought them in as part of an overall historical collage of images. Chuck Close's painted portraits took the photograph itself as their subject, enlarging the scale of the image to make us acutely and uncomfortably aware of the camera's verisimilitude and its distortions. Photo-realist painters took a different approach, mimicking in their painting the glossy sheen of colour photography and its peculiar way of capturing the urban subject. In short, photographic vision (if we can call it that) has come to seem not at odds with painting in the history of art, but the indispensable adjunct to painting, integral to our notions of representation in the West even before the invention of the camera.

Coming after decades of significant work in the history of photography, and at a time when photography has come to occupy a vital and indispensable place in the American culture of simulation, the present volume aims to take stock of this complex social, educational, and artistic force, viewing it in terms of its own inner history and in relation to the larger cultural history of America.

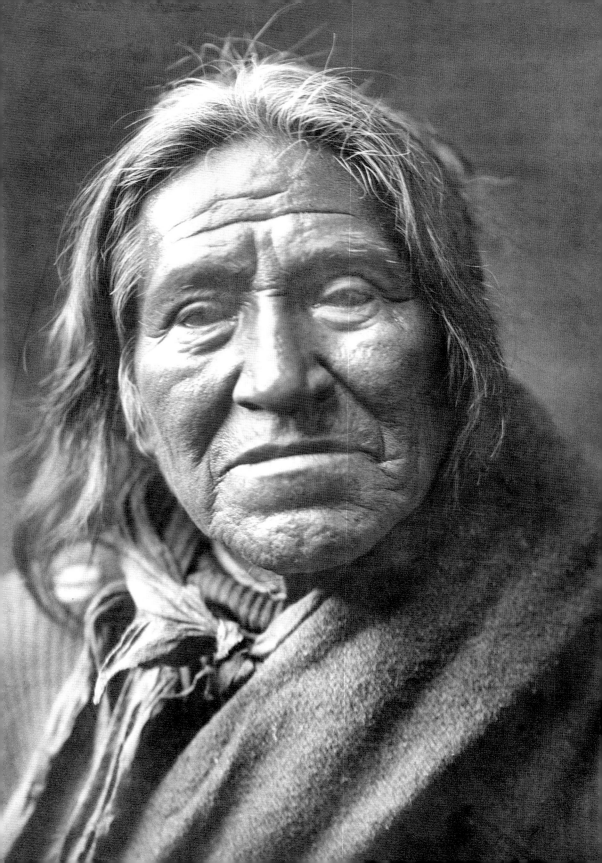

Presenting the Self

2

At the heart of the enthusiasm for the new process of photography was the simple astonishment and pleasure at seeing an image of external reality reproduced with such fidelity. 'Perhaps', wrote Edgar Allan Poe in 1840, 'if we imagine the distinctness with which an object is reflected in a positively perfect mirror, we come as near the reality as by any other means. For, in truth, the daguerreotyped plate is infinitely (we use the term advisedly) is *infinitely* more accurate in its representation than any painting by human hands.'[1] And Poe delighted in looking with a magnifying glass at the image, which revealed not the diffuseness of a painting when scrutinized, but 'a more perfect identity of aspect with the thing represented'. Initially, given the long exposure time required to take an image, the subject had to be immobilized, and so buildings and other stationary objects proved to be most cooperative; but as the chemistry and techniques improved (and American inventors were soon winning prizes for innovative techniques at world expositions, establishing the United States as a leader in the growing field), it became possible to make images of the human subject.

From its beginnings in 1839 the photograph has been in the public eye, a part of the rapidly expanding visual culture of the nineteenth century, which was turning the city into a vast urban spectacle, including such popular entertainment as art exhibitions and trade expositions, unrolling panoramas, dioramas, illustrated newspapers, large-scale paintings, illustrated advertisements and stereographic cards.[2] In the safe precinct of an urban household, one could view the pyramids of Egypt, the Yosemite Valley, the artworks of the finest European museums, and so on. Oliver Wendell Holmes, in his 1859 article, 'The Stereoscope and the Stereograph', put the case in terms of the difference between an artist's rendering and the mechanical image of the camera: 'The very things which an artist would leave out, or render imperfectly, the photograph takes infinite care with, and so makes its illusions perfect. What is the picture of a drum without the marks on its head where the beating of the sticks has darkened the parchment?'[3]

Above all, it was the photographic portrait that captured the enthusiasm of the general public and, from the earliest daguerreotypes to the

3 Edward Curtis

A Yuma Type, early twentieth century

Curtis straddled the worlds of art and anthropology, as Theodore Roosevelt noted in his Foreword to the former's twenty-volume *The North American Indian*: 'In Mr. Curtis we have both an artist and a trained observer, whose pictures are pictures, not merely photographs.' Curtis was consciously preserving the Indian, whose civilizations were passing away, in a kind of time capsule, and his portraits often evoke a melancholy nostalgia for times gone by, along with a typification of the subject, as here.

present, the portrait has remained the most popular of photographic genres. The pre-eminent master of the nineteenth-century portrait from the 1840s through to the Civil War was Mathew Brady, a peerless maker of symbolic images, who both understood the immediate value of the photograph in the currency of political discourse and worked with a highly developed sense of its historical and artistic functions.[4] Brady's galleries—in New York and in Washington—regularly photographed the celebrated statesmen, military heroes, literary, and theatrical figures of the day (the leading categories of celebrity at the time), adroitly straddling the political parties. Brady was using the camera to achieve a record that could serve not only the artists of his own day in their construction of fashionable historical paintings, but also the future historian—visual and verbal—who would draw on this bank of imagery. Through the 1850s and 1860s, Brady's galleries and publications promoted the idea of the portrait as the embodiment of national history and the model of citizenship.

Brady was a new kind of historian. But he was also a new kind of businessman, running elaborately decorated galleries that needed to bring in the trade on Broadway and in the fledgeling capital in order to survive. Working in a fiercely competitive atmosphere, Brady produced images of prize-winning quality that emphasized a simple background (it grew progressively more elaborate with the passing of time), lighting that brought out the sculptural qualities of the face, and a pose and facial expression that emphasized the dignity and drama and—at its best—the individuality of the sitter. At the same time, Brady was providing images—at a price—to the printed media, and his work appears in book illustrations (copied by engravers), in newspapers and magazines and posters. When the war came, Brady struggled to balance the ideal of the heroic generals with the terrible journalistic reality of war's sufferings, which was so shocking to his contemporaries that they hardly dared look at the pictures of mutilations and death.

There are more than a few anomalies in Brady's career: immersed entirely in a visual world, Brady's eyesight was troubled from early on by inflammation and diminished vision. (Almost uniquely among his contemporaries, Brady is always portrayed wearing spectacles.) After winning medals during his early years as a daguerreotypist, Brady seems to have ceased to operate the camera, instead training others to execute the work of photography while he handled the business side— and, with important clients at least, the posing and lighting. The authenticating stamp of 'Photograph by Brady' meant only that the studio had produced the work, not Mathew Brady himself. Yet so intent was he on being the auteur that he refused to credit any of those able assistants who worked for him. A consummate artist, a friend of artists from early on, late in his life he was yet dismissed as merely

competent by a younger generation. Sadly, Brady died in debt, though recognized as a national figure.

Brady's major work was in creating portraits that served the nation as models of character. But expanding our view of the photographic portrait in the nineteenth century, we can distinguish three major social contexts for its production: *the private*, *the public*, and what we might call *the scientific*.

The private portrait

Consider first the private realm, where the image (whether daguerreo-type or one of the later processes) would remain essentially within a circle of family and friends. At a time when the painted portrait was a luxury very few could afford, the daguerreotype arrived suddenly with the promise of letting virtually everyone establish a visible self-image, even if it might be little bigger than a large postage stamp. For a nation premised upon a belief in the value—and rights—of the individual, the photographic portrait was, by its very nature and affordability, the emblem of a democracy. The working-class daguerreotype portrait studios, at 50 cents an image, were charging the equivalent of half a day's labour; not cheap, certainly, but far less expensive than a painted portrait. Looking at one's image as an object to contemplate, or offering

The daguerreotype and other early processes

Although two quite different forms of fixing an image were simultaneously discovered, it was the daguerreotype process—invented by the Frenchman Daguerre in 1839 and made freely available to the world—that dominated the American market for nearly twenty years. With its elaborate chemistry, which resulted in a unique metallic image (unlike the Talbotype, which produced multiple paper copies), the daguerreotype had certain drawbacks; but the technique spread quickly in America, following its introduction by the painter (and inventor) Samuel French Morse shortly after its announcement. By 1853, at the height of the daguerreotype era, there were 86 studios in New York City alone, of which 37 were on Broadway.

The daguerreotype is a unique image (non-reproducible except by re-photographing it) made on a polished copper sheet, plated with silver and suspended over iodine. Its surface is reflective when held at a certain angle, creating a mirror-effect and reversing the white/dark values. Lasting until the early 1860s, the daguerreotype was succeeded by the collodion process, invented in 1851 in England, which required the coating of a glass plate with a sticky substance which had to be immediately exposed and then fixed. From this negative any number of paper positives could be made. The wet collodion was replaced by the dry-collodion process in the 1870s, which allowed the photographer to prepare the plate in advance, but it was slow work; it was replaced by the gelatin silver process, which was faster and more reliable. Gelatin was initially placed on a glass surface, but it was ultimately possible to create a gelatin-coated flexible film, which led to the roll film put on the market in 1888 by George Eastman.

4 Anonymous

'Spurzheim's Phrenological Head', frontispiece from J. G. Spurzheim, *Phrenology, or the Doctrine of Mental Phenomena*, 1832
Building on Lavater's theories of physiognomy, Franz Joseph Gall and Johan Gaspar Spurzheim conducted empirical experiments that led them to construct a physical map of the brain's capacities and functions. This widely popular (though scientifically fallacious) system underlay the belief that one could read a portrait as an index of the sitter's mental characteristics, with different areas of the head corresponding to various faculties and capacities.

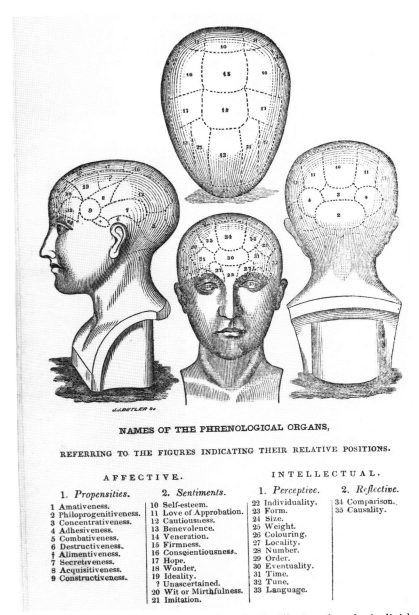

J.J.BUTLER SC

NAMES OF THE PHRENOLOGICAL ORGANS,

REFERRING TO THE FIGURES INDICATING THEIR RELATIVE POSITIONS.

AFFECTIVE.		INTELLECTUAL.	
1. Propensities.	*2. Sentiments.*	*1. Perceptive.*	*2. Reflective.*
1 Amativeness.	10 Self-esteem.	22 Individuality.	34 Comparison.
2 Philoprogenitiveness.	11 Love of Approbation.	23 Form.	35 Causality.
3 Concentrativeness.	12 Cautiousness.	24 Size.	
4 Adhesiveness.	13 Benevolence.	25 Weight.	
5 Combativeness.	14 Veneration.	26 Colouring.	
6 Destructiveness.	15 Firmness.	27 Locality.	
† Alimentiveness.	16 Conscientiousness.	28 Number.	
7 Secretiveness.	17 Hope.	29 Order.	
8 Acquisitiveness.	18 Wonder.	30 Eventuality.	
9 Constructiveness.	19 Ideality.	31 Time.	
	? Unascertained.	32 Tune.	
	20 Wit or Mirthfulness.	33 Language.	
	21 Imitation.		

it for others to view, one might easily gain the illusion that the individual was indeed a coherent entity, for what one saw was taken not simply as a record of appearance but as a symbol of the inner self. As one of the leading daguerreotypists, Robert Southworth, put it, 'The artist is conscious of something besides the mere physical, in every object in nature ... It is the life, the feeling, the mind, the soul of the subject itself.'[5]

Underlying this belief that external appearance mirrored the subject's personality and character was the 'science' of physiognomy, the reading of facial characteristics according to a scheme of interpretation

5 Anonymous

The Daguerreotypist, 1849
Throughout the nineteenth century cartoonists satirized the rigours and seeming absurdities of photography. In this cartoon from *Godey's Lady's Book* (1849), the dignity of the subject is compromised by the posing apparatus, which was standard equipment in the photographer's studio. The rigidity of facial expressions and bodily posture is often the result of such constraints in early portraiture, which required at least several seconds of exposure time.

that was elaborated by its major exponent, Johann Kaspar Lavater, in *Essays on Physiognomy* (1789). Lavater's followers in the United States adapted the principles of physiognomy to the higher 'science' of phrenology, through which the adept reader could discern, in the bumps on the head, the various faculties and characteristics that compose the self [4]. Phrenological parlours were popular places to have one's head examined, and a good reading was worth advertising as a sign of one's promise—as a very promising Walt Whitman did.[6]

Not all daguerreotype portraits, however, were successful. They generally required the subject to pose without moving for anywhere from five or ten seconds (at best) to several minutes. Speed improved as the chemical processes were refined and studios were designed to maximize lighting conditions. Not surprisingly, given the discomfort of having your head fitted into the jaws of an iron posing apparatus, the results were sometimes startling—semi-comatose stony stares, wild-eyed glares, eyes frightened by the monstrous staring lens of the

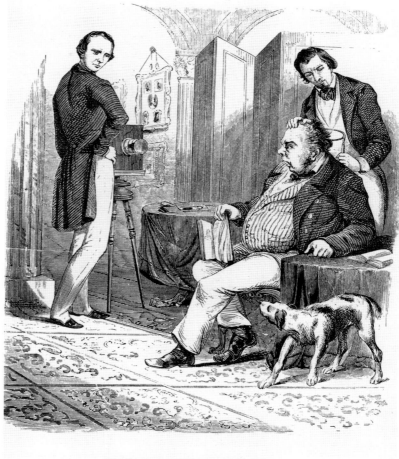

THE DAGUERREOTYPIST.

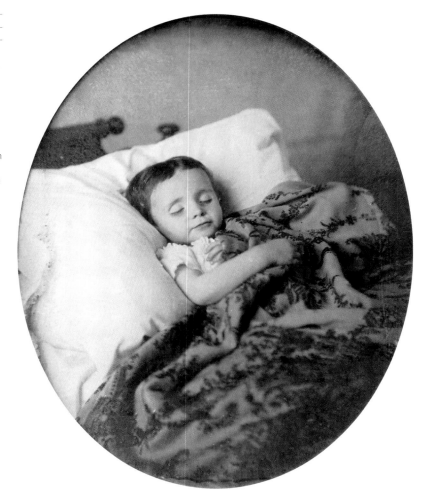

camera. Were these portraits true 'likenesses'? The question was much debated: 'I was in Boston the other day', Ralph Waldo Emerson wrote to his English friend, Thomas Carlyle, '& went to the best reputed Daguerreotypist, but though I brought home three transcripts of my face, the housemates voted them rueful, supremely ridiculous.'[7]

Yet a lesson might be drawn from even the most unflattering of portraits, which could be viewed as a gain for some abstract principle of truth: in fact, photography was establishing a new standard for visual representation and posing questions for the future of painting that would be answered only later in the century by the Impressionists, and later still by the Cubists, who would abandon the canons of realism, yielding to the superior capacities of the camera. As a writer in *Littell's Living Age* observed in 1846, '[The daguerreotype] is slowly accomplishing a great revolution in the morals of portrait painting. The flattery of countenance delineators, is notorious . . . Everybody who pays, must look handsome, intellectual, or interesting at least—on

canvas. These abuses of the brush the photographic art is happily designed to correct.'[8]

It was precisely this literal characteristic of the photograph, whether flattering or not, that gave the portrait its most treasured quality: as an exactly corresponding record of what had at one moment existed in front of the lens (what semioticians would call its 'indexical' quality), the image served, within the private realm, as a memento of the absent loved one. All photographs embody a paradoxical temporal quality: freezing a living moment, they are at the same time records of morbidity, for by the time we view the image, the instant is already past. And during a time when painted portraits were rare and expensive, a photographic image of a deceased loved one would be especially treasured. And if the deceased had not been photographed in life? It was the common practice, in nineteenth-century America, for photographers to be hired following the death of a loved one—especially in the case of children—in order to create what might be the only portrait of the subject [6]. These pictures of the dead would very often be made with the body posed to suggest a sleeping subject, in line with the Victorian sentiment that softened the absoluteness of death with this solace to the bereaved.[9]

Although the main goal of the studio portrait, throughout the nineteenth century, was to present the subject in a favourable light and with respect for the individual's character and personality, the conventions of portraiture changed considerably from the 1840s to the end of the century. The earliest daguerreotypes bear some resemblance to established traditions of the painted portrait: subjects are seated, often with an arm resting on a cloth-covered or carpeted table; the gaze is straight ahead into the camera; sometimes a book, or cane, eyeglasses, or even another framed daguerreotype might be held in one hand. Or the subject is treated in a close-up, as in Brady's copy-portrait of Daniel Webster (original by Southworth and Hawes), which emulates the character studies of the painted portrait [7]. And though many

Photographic formats

A variety of formats succeeded one another throughout the nineteenth century. The daguerreotype, mounted in a plastic case, was joined in the 1850s by the ambrotype, a glass-backed image, also encased, that is often confused with the daguerreotype because of its reflective qualities. Tintypes, popular from the 1850s up until the early twentieth century, consisted of a wet collodion process on a sheet of blackened iron; valued for their durability, they could be sent through the mail during the Civil War or mounted on tombstones, or simply put into albums. Another widely popular form, the *carte de visite* size (about 4½″ × 2½″) was a portrait glued to a card, with the individual's name printed on the back, like a visiting card. During the 1870s the larger cabinet cards were introduced (6¼″ × 4¼″), allowing for more detailed portraits on more durable cardboard backing. Both the *cartes de visite* and the cabinet photographs were collected widely in albums.

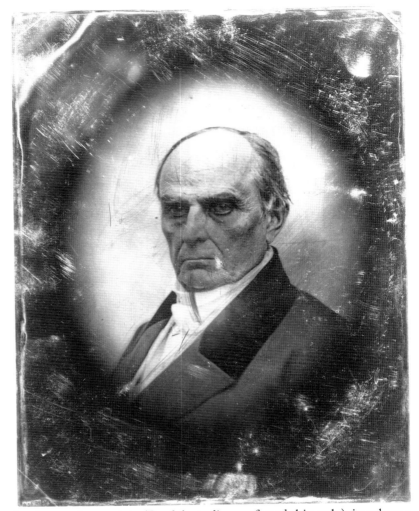

backgrounds are plain (Brady's studios preferred this style), in others a painted landscape is used, in imitation of easel painting. One variation, however, in the daguerreotype era is the 'occupational portrait', in which the male subject is featured with objects that relate to his work: actors in costume, a surveyor with his instrument, a fireman in his hat, a clock maker with his clock [**8**]. (Female subjects might occasionally be pictured with musical instruments, denoting leisure.) Where a particular place of business is involved, the building itself—a bank, a factory—might form the background, with figures in the foreground.

With the progression in the 1860s to wet plate processes and paper prints (*cartes de visite*, cabinet size), the portrait became far more commonplace and its connection with a growing consumer society became more evident: instead of portraits of individuals associated with their work, we see the subject in a setting that suggests consumption of the luxuries of middle-class life—ornate chairs, drapes, columns, books.

8 Anonymous

*Toleware Maker, c.*1850

'Occupational portraits'
featured the sitter surrounded
by the tools of his trade,
reflecting a period in American
culture when production
(rather than consumption) was
central to economic and social
identity, when the craft of the
maker was a reason to be
proud. Because portraits
before photography were so
expensive, the 'occupational'
was a new kind of self-imaging,
open to the working class. Tole
was tinware or other metal,
fashioned into such objects as
boxes, trays, and lamps, and
painted in various colours.

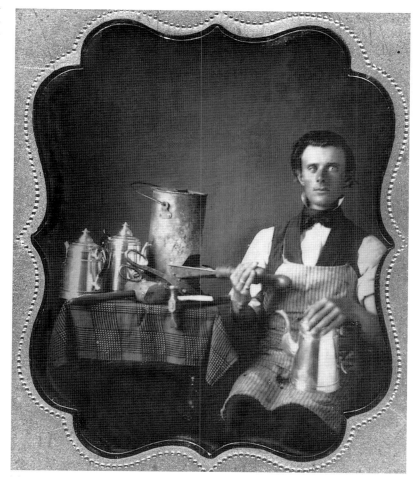

The photograph begins to function during this era—from around 1860 through to the early twentieth century—as a key element in the project of modernity in a society where the self could be constructed as a public object in order to achieve upward mobility.[10]

The public portrait

The institution of photography in the nineteenth century was not simply a matter of a camera and a subject: interposed between the two was the professional photographer, known variously as the operator, the artist, the professor. The image could be moved to a private sphere, but it originated in a public one—the gallery, which encompassed the studio where the picture was taken and the workrooms where it was finished and mounted. It is this social context for photography that we examine next. While many daguerreotypists travelled the countryside with their cumbersome apparatus (large wooden cameras, tripods, chemical set), making pictures for a rural population, most images

were made in the many galleries that sprang up in the urban centres of the United States. With their rows upon rows of portraits, these galleries initiated Americans into the pleasures of looking; unencumbered by social restraint, the viewer could transgress the boundaries of propriety and gaze intimately (as if through a one-way mirror) at the subject. 'There is always, to us, a strange fascination, in portraits', Walt Whitman wrote after visiting Plumbe's Gallery in 1846:

We love to dwell long upon them—to infer many things, from the text they preach—to pursue the current of thoughts running riot about them. It is singular what a peculiar influence is possessed by the *eye* of a well-painted miniature or portrait . . . For the strange fascination of looking at the eyes of a portrait, sometimes goes beyond what comes from the real orbs themselves.[11]

We might date the beginnings of what would become our obsessively voyeuristic society in the twenty-first century—with 'real' TV shows covering the everyday lives of 'real' people—from these galleries, with their privileged act of looking at the other.

In effect, the public daguerreotype galleries were introducing to Americans the beginnings of a culture of celebrity, for these images—often enlarged and hand-coloured—would be admired and studied for the signs of greatness and character that the individuals stood for.[12] The galleries were also places to be seen, where the outward signs of worldly success could be exhibited and where an aspiring middle class could enjoy, in the lavish surroundings—walls hung with gold paper and mirrors—the vicarious pleasures of social class and taste [9]. A contemporary observer wrote: 'The floors are carpeted with superior velvet tapestry, highly colored . . . The ceiling frescoed, and in the center is suspended a six-light gilt and enameled chandelier. Suspended on the walls, we find Daguerreotypes of Presidents, Generals, Kings, Queens, Noblemen—and *more nobler men*—men and women of all nations and professions.'[13] If the gallery was a place for gaping at royalty, it was also—as the last quote affirms—a place where the democratic ethos was competing for equal time, and where local and national figures, politicians, statesmen, writers, and military leaders were on display.

The gallery concept was carried over, metaphorically, into print, with the publication in 1846–7 of John Plumbe's *The National Plumbeotype Gallery* and the *Plumbeian*, featuring engravings of various public figures; Brady followed suit in 1850 with his own set of twelve lithographs based on daguerreotypes (and including brief biographies), the *Gallery of Illustrious Americans*. Reflecting back on this venture, Brady said in later life that he was 'under obligation to my country to preserve the faces of its historical men and mothers'.[14] The goal was to elevate the American democracy by encouraging the emulation of its most worthy exponents, and in doing so Brady would claim, somewhat paradoxically perhaps, a certain *noblesse oblige*.

M. B. Brady's New Photographic Gallery, Corner of Broadway and Tenth Street, New York, 1861

Daguerreotype galleries were located typically on an upper floor in order to capture the strongest light, some adding skylights later on. At the back of the gallery was the 'operating room', where the picture itself was taken; other rooms were required to prepare the plate and, after exposure, finish and frame it. (Colour tinting was also available for an extra fee.) Brady might arrange the sitter on special occasions, but usually a 'photograph by Brady' was done by his assistants.

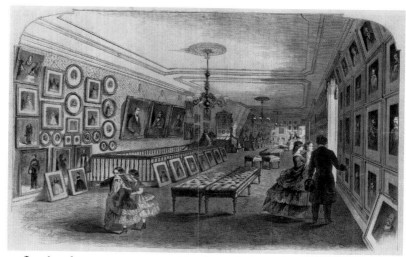

In the daguerreotype era, Brady and the others would offer the celebrity sitter a free copy of the image itself; in the post-Civil War era, when negatives and paper prints made multiple copies an easy matter of production, a fundamental change occurred: the gallery owner would now pay the subject for the privilege of displaying and selling the image. Thus would the commercial value of celebrity be recognized as a commodity with a value and therefore a price.

The greatest celebrity photographer in late nineteenth-century American studio portraiture, Napoleon Sarony, exploited the new photographic technologies that, by the early 1860s, were displacing the unique image of the daguerreotype in favour of the multiple paper positive images that could be made from the negative. Now the celebrity could be admired not only in the gallery; instead, a small and inexpensive replicated image, a so-called cabinet card (approximately 4″ × 6″) could be taken home and included in the family album (after the family pictures), or placed in a special collection of celebrity photos. Coincidentally, the basis of celebrity was shifting from the political figure to the theatrical performer, and Sarony—himself a flamboyant and self-dramatizing showman—capitalized on this change in taste by marketing the renowned actors of the day: Sarah Bernhardt, Lillie Langtry, Joseph Jefferson, and others [**10**]. Sarony's operating studio expanded, filled with exotic props of all descriptions—draperies, armour, mummies, tables, crystal balls—to accommodate the roles that would be re-enacted for his camera. With some cards going for as much as five dollars, Sarony's business was most profitable, but his stars also profited, Lillie Langtry being paid as much as $5,000 for a sitting. But Sarony—who posed his subjects, then retouched them to perfection—owned the copyright. Styling himself an 'artist', Sarony was one of the great creators of our popular culture, a manager of images for a broad public effect.

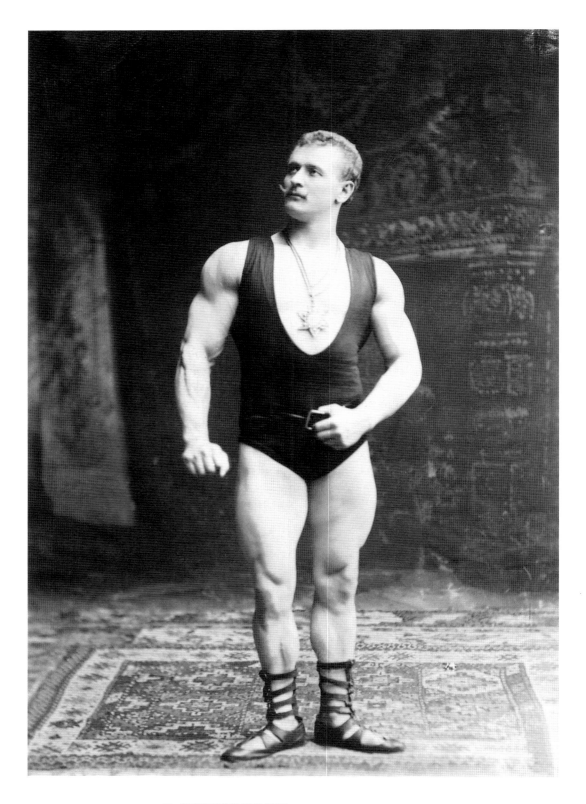

10 Napoleon Sarony

10 Napoleon Sarony

Eugene Sandow, 1893

Sarony, the leading theatrical photographer, carried souvenir photographs of all the leading performers of the day. Posing them in his studio, Sarony had elaborate props and settings, used to re-create the theatrical essence of the personality. Here, a vaudevillian strongman—calling himself 'The Perfect Man'—is pictured standing on a fashionable carpet, the epitome of masculinity for the late nineteenth century, when the industrial regimentation of the body made figures like Sandow the ideal of strength and autonomy.

The scientific portrait

Yet another social context for nineteenth-century portraiture, originating in the daguerreotype era and extending to our own day, is what we might call the scientific, or anthropological, portrait. The portrait in the private realm sought to convey the individuality of the subject; the portrait of the public personage created an image that resonated with the popular imagination; but in this 'scientific' mode the photographer was seeking to record 'objectively' a subject who must be made to conform to a social type. Looking at such 'scientific' portraits, one realizes that it was, after all, the ruling class that held the cameras, and their use of them, in picturing the 'primitive', the 'criminal', the 'insane', the 'poor'—all those on the margins of the social order—confirmed the fixed boundaries of the social world.

The phrenological premise supported an argument for mental superiority, but it just as well supplied the foundation for studies of mental disability; pictures of inmates of mental asylums and prisons would likewise serve the purposes of quasi-scientific theories of personality disorder.[15] One such early effort, Marmaduke Sampson's *Rationale of Crime & Its Appropriate Treatment: Being a Treatise on Criminal Jurisprudence Considered in Relation to Cerebral Organization* (1846), was illustrated with nineteen engravings by Brady of criminals on Blackwell's Island and the Long Island Farms. One would 'read' these heads in the same way that one read the character of the non-criminal—according to the phrenological correspondence of the head and the character. And the bureaucratic (and scientific) mentality extended its cataloguing throughout the nineteenth and twentieth centuries in images of criminals that would supply a massive gallery of rogues, evidence for twisted theories of criminality that associated anti-social behaviour with a certain slant of the forehead or tilt of the nose.

The same phrenological premise could be used in studies of racial characteristics. Louis Agassiz, one of the great evolutionary biologists of the nineteenth century, commissioned a photographer in 1850 to make images of Southern slaves in order to justify the theory of special creation, which held that the races were created at different moments of time, and were not therefore part of the same 'family'. J. T. Zealy's resulting images of slaves on a Columbia, South Carolina plantation, offered frontal and side views of each subject, stripped to the waist [11]. Yet despite the severe objectification and the dehumanizing treatment of the subject, some of these slaves possess a dignity that is startling and defiant.[16] Other photographic techniques involving the measurement of skulls for comparative purposes were also promoted during the late nineteenth century. But the pursuit of scientific objectivity reached a kind of *reductio ad absurdum* in the work of the English eugenicist, Sir Francis Galton and his American followers, who sought

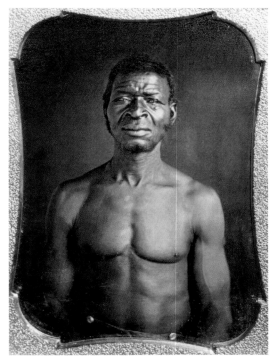

to create through photography the ideal type of the criminal, the banker, the Jew, the tubercular, and so on [12]. Merging individual photographs into a composite image that erased all differences in favour of a blended type, this technique demonstrated the authority of the camera to create what was literally fantastic, incorporating the subject into a discourse on race and identity that supposedly confirmed innate differences and made possible the prediction of behaviour.[17]

The Native American subject, when viewed by the photographer, presented a far more complex case.[18] Beginning with the stark and confrontational images of Thomas Easterly, in the mid-1840s, photographers in the Western territories recorded the Indian in the unromantic mix of native dress and borrowed clothing that was typical at that time [13]. Later expeditionary photographers—Timothy O'Sullivan, Alexander Gardner, John K. Hillers—sometimes placed their Indian subjects within their local habitats, and at other times treated them in the context of contemporary portrait conventions, thus erasing the individuality of the subject and recording the Indian as a generic type. In either case, essential to the depiction of the Native American were Indian dress and accoutrements, always featured prominently in the straightforward posing.

By the end of the century, with a growing realization that the native peoples of North America were fast disappearing (or rather had been made to disappear), several photographers began to take a more systematic approach to picturing the Indians. The most extensive such

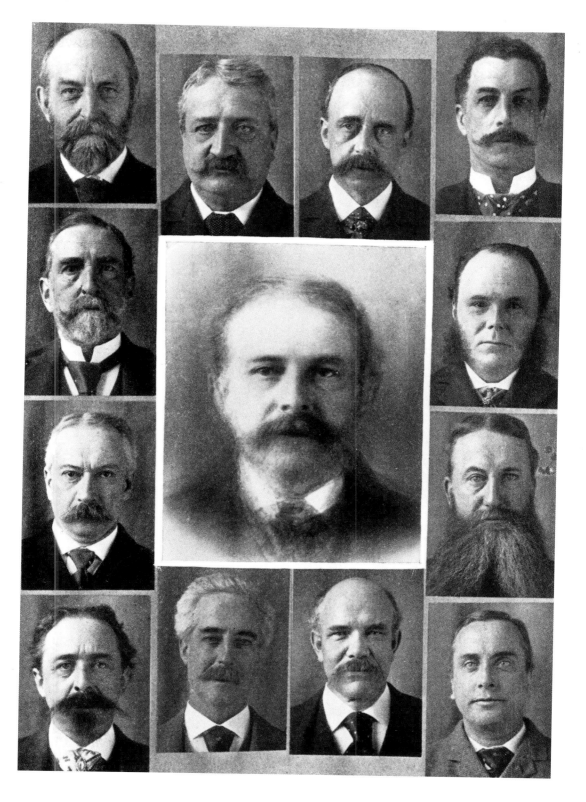

13 Thomas Easterly

Keokuk, Sauk Chief, 1847
Easterly, a Missouri
photographer, took many
pictures of the West and of the
Native American population,
of which this dignified portrait
is one of his best. The dramatic
effect derives from the chief's
straightforward and slightly
menacing stare, dramatically
lighted from one side,
combined with the fierce
headdress and bone necklace.

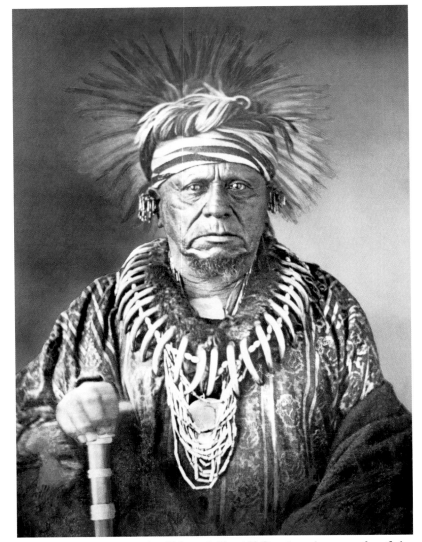

effort was undertaken by Edward Sheriff Curtis, whose study of the
North American Indian tribes lasted from the early 1900s until 1930.
Underwritten partially by J. P. Morgan, Curtis's twenty-volume
ethnography, *The North American Indian*, recorded legends and folk-
lore and featured 2,200 images of the approximately 40,000 that he
took. Though Curtis was deeply sympathetic towards the Indians, he
was preserving them in an imaginary time capsule, excluding non-
traditional garments and artefacts, emphasizing traditional tribal
costume and 'authentic' props, even when he had to supply them
himself from his travelling studio supply.[19] Sometimes identified by
individual name, Curtis's Indians are more often rounded off into
ethnographic types (e.g. Jicarilla Maiden, Typical Nez Percé), thus
fulfilling their representative function [**3**]. His romantic treatment—

pensively melancholy Indians staring into a vacant future or else re-enacting the heroic postures of the past—was enacted in a Pictorialist inflection (soft focus, twilight atmosphere) that has often evoked an ambivalent response from Native American viewers, who can see the distortions but at the same time can appreciate Curtis's motivation and his encyclopaedic effort to record what was rapidly disappearing.[20] Curtis claimed in his introduction to *The North American Indian* that, 'being directly from Nature, the accompanying pictures show what actually exists or has recently existed (for many of the subjects have already passed forever), not what the artist in his studio may presume the Indian and his surroundings to be'.[21] Yet Curtis clearly had a double aim: to give insight into his subjects' lives, but also to satisfy 'popular interest' in the Indians.[22] It remains questionable whether he could do both of these things at once.

The portrait in the twentieth century

In each of these three major contexts for photographic portraiture in the nineteenth century, the picture-making process required the subject to hold still for a certain length of time. These assumptions would change dramatically in the twentieth century, thanks to two major technological innovations: one was the high-speed camera, the other the mass-produced Kodak. What the high-speed camera made possible was the instantaneous portrait, allowing the photographer to capture the expression of the subject as it might appear in the flash of an instant, not just an 'average' or typical facial mask. Reading the image was then not a matter of the subject's physiognomy but of an expression that might embody some facet of his or her character. These new possibilities are dramatically visible in Edward Steichen's famous portrait of J. P. Morgan (1903), which captured the great man's irritation with the photographer and with the posing session in a way that seemed

Amateur photography

Making the leap from dry plates to gelatin roll film, Eastman issued the first easy-to-use, lightweight Kodak camera in 1888. Starting off at $25, and loaded with 100 frames, the Kodak was immediately popular. By 1900 the price was down to $5, and Eastman was also offering his efficient and hugely popular Brownie camera at $1. (In sixty years, what had been the price of a single daguerreotype was now the price of a camera.) Portraits of family members were no longer restricted to the half-dozen studio images of the earlier nineteenth century; now the self could be imaged in a variety of circumstances on a daily, or at least an annual basis. Expanding photography beyond the practice of the professional and the serious amateur, Eastman made it possible for the average person to accumulate an enormous harvest of personal photos, bulging shoe boxes filled with images, family albums overburdened with the photographic archive that we all now could carry around with us.

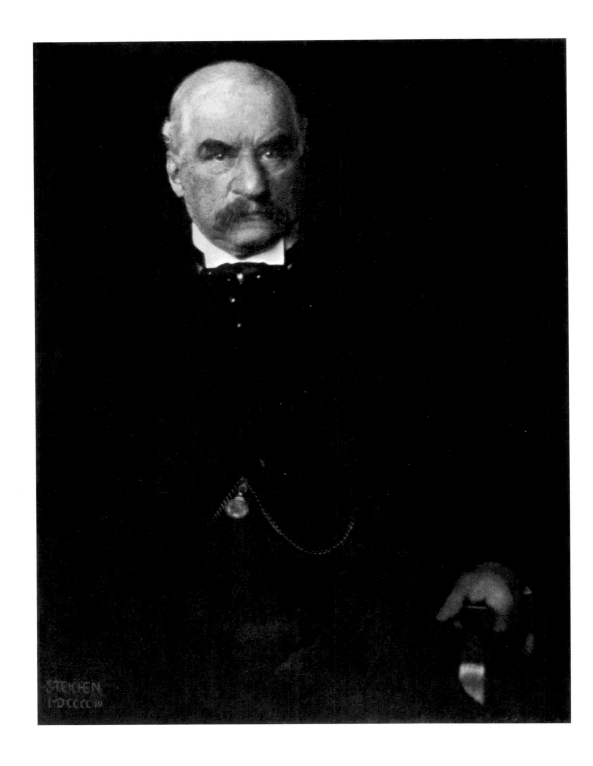

to personify his monumental determination and mythical predatory habits [**14**]. (The 'dagger' in his hand was actually the arm of the chair he was grasping, a happy accident that Steichen had not foreseen.)

The other technological innovation was George Eastman's Kodak, which put the camera into the hands of the ubiquitous amateur, who had only to push the button, and Kodak would do the rest. Kodak's inexpensive machine provided a visual documentation of the American family at the same time that it created a dream-image of the ideal that families could look at from time to time to define themselves in accordance with the prescribed models.

Adapting new technologies, the three broad functions of the portrait—the private, the public, and the scientific—originating in the nineteenth century, have continued into our own time. The studio portrait created for private consumption has been carried on by such mass market studios as the Olan Mills chain, whose posed portraits are meant to capture an average essence of the subject's character.[23] At the same time, the public portrait has been carried on from Brady to the high-end studios of Yousuf Karsh, whose more sophisticated poses portray the subject's essential public persona. Meanwhile, Sarony's theatrical portraits have mutated into the glamorized portraits of Hollywood stars in the 1930s and 1940s, and—in a key of grotesque parody—into the bizarre theatrical images of Joel-Peter Witkin in the 1980s and 1990s. As for scientific portraiture, it has survived intact in the contemporary police photos, the wanted posters, and the more benign forms of anthropological photography (the pages of *National Geographic* offering countless examples) throughout the last century that have sought to fix the identity of the cultural Other for the American visual consumer.[24]

Viewing the Landscape

3

Photography arrived, we sometimes forget, at the height of an international Romantic movement, when nature was viewed as a revelation of God's work and a repository of spiritual meaning. To some extent, the hierarchy of subjects in painting, which put landscape above the portrait, carried over to photography, as we can see in a pronouncement like the following by the Revd H. J. Morton in *The Philadelphia Photographer*: 'What is [portraiture] in comparison with representing and actually reproducing the etchings of the Almighty on the rocks, and His mouldings, and carvings, and textures in cliffs, and hillsides, and velvet mosses?'[1] Yet like the portrait, the landscape photograph relied initially on a long-established tradition in the fine arts, and many of the early photographs, inspired by paintings, feature a vista of land and water framed by trees, with a distant view of mountains, all brought into view from a foreground perspective.

In certain respects the photographer could not compete at all with the artistry of the painter: in 1871 photographer William Henry Jackson travelled with Thomas Moran, learning lessons in composition from the great painter and frankly acknowledging the superiority of Moran's medium in capturing the 'color and atmosphere of spectacular nature'.[2] Painters had at least three advantages over photographers: they could add or subtract imagery from the scene in front of them; they could paint in colours that imitated, even surpassed, nature's; and their huge canvases (measuring at least ten feet across and seven high) could create an overpowering effect on the viewer. Nineteenth-century photographers eventually had their 'mammoth' size prints, but they were miniscule by comparison (up to 20″ × 25″), though far larger than the earlier daguerreotype plates had been (a normal full plate was 6½″ × 8½″). And the black and white of the nineteenth-century photograph (even when clouds were added from another negative in a combination print) obviously lacked the colour and drama of the painting. Nevertheless, from the earliest daguerreotype to the wet collodion process, the landscape view made an impression that was uniquely its own: as daguerreotypist Robert Vance claimed, regarding his Views of California: 'These views are no exaggerated and high-coloured sketches, got up to produce effect, but are as every daguerreotype must

Landscape photography in America covers an enormous range of work that cannot easily be made part of a unitary discourse. Several analytic schemes have been proposed: Daniel Wolf, in *The American Space*, categorized nineteenth-century photographs according to their subject matter: Space, Rocks, Trees, Waterfalls, Light (all part of 'Nature'); and Indians, Man and Space, Trains, and Growth (part of 'Man and Nature').[4] Weston Naef, in *Era of Exploration*, devised a framework that encompassed subject matter (e.g. Yosemite, railroads) and function (government patronage for official surveys; scientific projects), all the while recognizing the aesthetic experimentation of these early landscape photographers.[5] Estelle Jussim and Elizabeth Lindquist-Cock, looking at the broader sweep of landscape photography from the beginnings to the late twentieth century, developed multiple categories (thematic and formal) for viewing the landscape: as Artistic Genre; as God; as Fact; as Symbol; as Pure Form; as Popular Culture; as Concept; as Politics and Propaganda.[6] And more recently, Merry Foresta has focused on the moral and aesthetic dimensions of contemporary landscape photography, encompassing 'the new environmentalism'.[7]

be, the stereotyped impression of the real thing itself.'[3] As with the portrait, the ability of the photographic image to offer a literal view of reality endowed it, in the nineteenth century, with the unique virtues, uncannily appealing, of literal mimesis.

Although America has been called 'Nature's Nation', there has been no nationally fixed idea of nature; rather, it has changed dramatically over the years, and photographs have inevitably reflected these changes. By the time photography was introduced in the United States, the wilderness had lost much of its earlier unholy resonance as a fearful place of savages. With the transformation of forests and arable land into farmlands, nature seemed hospitable to Americans' efforts to plant some form of civilization; and the destiny of America, its famously 'manifest destiny', seemed to lie in the ever-expanding frontier, moving westward as the push of peoples from the American East extended across the land. In 1869 the transcontinental railroad was completed, amid a fanfare of celebratory photographs. Nature, in this nineteenth-century context, was land to claim and defend in the name of the US government; it was a wild land to be exuberantly explored, mined, and mapped, with an eye to military occupation or industrial development. And it was spectacularly beautiful landscape—sweeping vistas of canyons, mountains, valleys—America's answer (making a virtue of necessity) to the European complaint that Americans were a rude people, lacking a culture. At the end of the century, when the closing of the frontier was officially pronounced by historian Frederick Jackson Turner in 1893, a mood of nostalgia took possession, and the landscape became a grandeur to be remembered, to be framed within the gentler boundaries of the picturesque. (It is in this mood that the movement to preserve the land in state and national parks begins.)

15 William and Frederick Langenheim

The Falls of Niagara, 1845
Possibly the first photographs of Niagara Falls, this daguerreotype panorama was modelled on the popular painted panoramas of the time, though far smaller (the whole was about 12" × 18") and comprising a more discontinuous survey. Eight sets were made and, promoting the new art, were presented to Daguerre, President Polk, and several European monarchs. Photography was of immense importance in developing the habits of tourism, with all its accompanying industries.

Moving into the twentieth century, the photographer continued to draw inspiration from the landscape, but now often the heady optimism of the nineteenth century seemed to have turned into the hangovers of the twentieth, as photographers felt viscerally some of the consequences of that earlier exuberance—the ravages of soil erosion, industrial pollution, overpopulation, and overbuilding.

There are many ways of thinking about landscape photography, but the aim here is to offer a simple yet comprehensive framework for approaching this complex genre, emphasizing three broad types of landscape, according to their respective purposes: the *view*, which renders the scene itself as a spectacle of wonder; the *aesthetic landscape*, where the photographer's artistic vision animates the image; and the *topographic photograph*, where the image is more descriptive and is part of a larger political or scientific discourse. These divisions are of course somewhat arbitrary, and a single photographer might produce work that bridges these categories; still, they may usefully serve to distinguish several broad purposes, in fairly distinct traditions that span the history of photography from its beginnings to our own day.

View photography

In the view tradition we stand in awe before the sublimity of nature, our attention focused on the scene before us. The view tradition begins in the daguerreotype era, when the Western territories were largely inaccessible and the most dramatic images the East could offer were

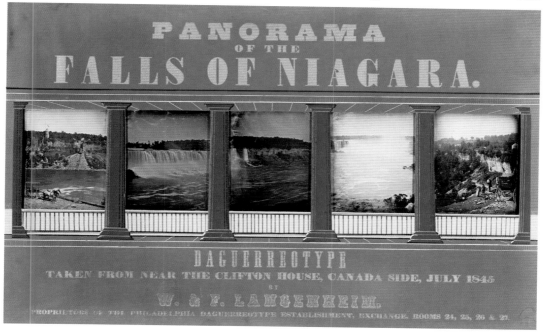

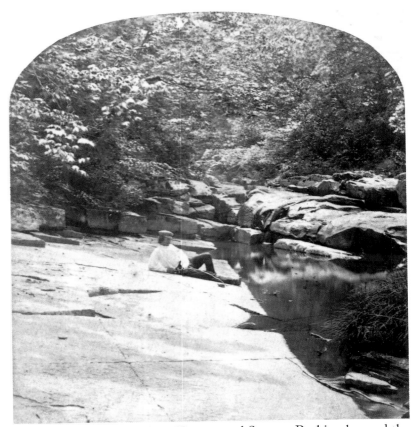

the great waterfalls, such as Niagara and Seneca. Pushing beyond the single plate, several daguerreotypists in the 1840s attempted to create panoramas (imitating the popular painted panoramas), mounting five, six, or seven small plates together in an elaborate frame to compose a wide view as, for example, in the Langenheim brothers' version of Niagara Falls, one of the most popular subjects for Eastern photographers [15].

The daguerreotype, limited to a single positive image (and limited in size) offered little incentive to the commercial photographer: his customer would pay for a portrait of himself but would be unlikely to afford a landscape image at the same price. All of this changed as photographic processes shifted to wet collodion, which produced negatives from which countless replicable images (single prints and stereographs) could be made and sold. Photography studios that were specializing in portraits could now branch out to include a line of landscapes from all over the country, produced by the major studios on the East and West coasts.[8] By the 1860s Eastern photographers were lugging their equipment through New Hampshire, New York, and Pennsylvania, aiming, as John Moran (the painter's brother) put it, to 'create imagery which calls forth ideas and sentiments of the beautiful' [16].[9]

17 Carleton Watkins

The Half Dome from Glacier Point, Yosemite. No. 101, c.1866

In this mammoth plate, about 18″ × 21″, Watkins looks out over the valley, placing the viewer in space, nearly free of the foreground on the lower right. The composition emphasizes the sublime majesty of the vista, evoking a religious sense of awe as our eye is drawn down the valley to the distant horizon. The half-dome mountain on the right was one of the most photographed sights in Yosemite. Watkins typically excluded the human figure from his views, giving us a sense of what nature might be like before mankind came on the scene.

The most powerful landscape images were being made in the West, by San Francisco photographers Carleton Watkins and Eadweard Muybridge, who gradually learned to go beyond the picturesque Romanticism of the East in presenting a nature that was sublimely unpeopled, with huge vistas under open skies. Where the picturesque featured trees and rivers, a scene one might walk into, the sublime invited the viewer to gape in awe at the vista, often seen from above, looking into a vast valley [17]. Although their equipment today seems impossibly bulky and heavy, photographers managed to climb to the tops of mountains, stretching the lens out to record a view that seemed taken from mid-air, the immediate ground rendered invisible by the camera's frame; the effect in the stereograph was even more dramatic, radically changing our sense of space, opening it up to the drama of nature in a way that would capture the attention of painters like Frederick Church, who used photography as an aid in his own grand-scale paintings.[10]

Watkins, who in the early 1860s pioneered the use of the mammoth-size camera, was awarded a medal at the 1868 Paris exposition, establishing the pre-eminence of his studio on the West Coast. But Eadweard Muybridge, who had migrated from England and, following an apprentice period, opened up a studio in San Francisco,

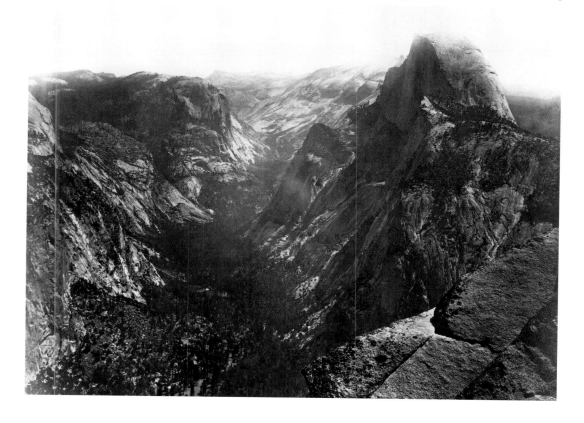

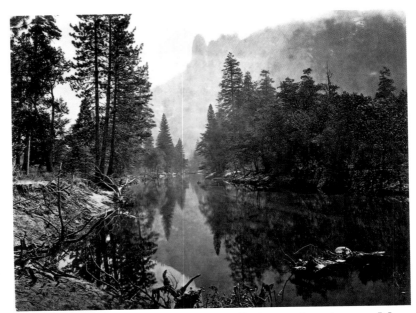

18 Eadweard Muybridge

Loya (The Sentinel), Valley of the Yosemite, No. 14, 1872

Muybridge catches the reflection of the trees in the water, and places a pair of symmetrical trees at the centre of the image; clouds are faintly visible in the sky above the looming Sentinel mountain. The composition of this photograph imitates the typical construction of landscape painting, with the use of deep perspective and three main sections of the view: the foreground, the middle, and the background. But Muybridge's camera includes the bare and twisted sticks, individualizing the scene. Such photographs, especially in the mammoth size here (18″ × 21″) were instrumental in furthering the idea of California as a natural paradise.

was soon producing his own technically innovative pictures. Muybridge's images show a responsiveness to shadows, reflections, mists, and perceived symmetries; they also show Muybridge's inventiveness, in creating composite photographs that included clouds, which would otherwise register as a bright blur on the slow plate required to capture the earth. Around 1869 Muybridge began shooting the clouds separately, printing them together with the landscape portion to create a composite. Above all, Muybridge's compositions demonstrate his love of contrast between foreground and background, between light and dark [**18**].

Ansel Adams

The direct descendant of this view tradition in the twentieth century is Ansel Adams, whose extraordinary technical skills resulted in the invention of what he called the Zone System. Adams, whose popularity in the mid-twentieth century helped bring photography in general to a wide audience, wedded a strong subjective impression of the pristine beauty of nature to a scientific obsession with the gradations of tone from pure black to pure white [**19**]. (The very American combination of Romanticism and science might account in part for Adams's strong appeal.) Working in some of the same areas of the Yosemite Valley as his nineteenth-century predecessors, Adams inspired his viewers with the feeling of God's presence in nature, harmonizing well with a growing national sentiment for the environment that would flower eventually in the lush colour photographs of Eliot Porter and the Sierra Club calendar. Though Adams influenced many, both

19 Ansel Adams

Monolith, the Face of Half Dome, Yosemite Valley, California, c.1927

Adams chooses to come in close up to Half Dome, revealing the steel grey surface of the rock face, with its delicate vertical lines. Here, geology is sublimated into an abstract composition of grey tonality, the white snow, and the black sky, edged by the white reflections off the top surface of the mountain. Adams's camera reveals a scene we would not see with the naked eye, rendering the details with a greater reality than we would ordinarily be conscious of.

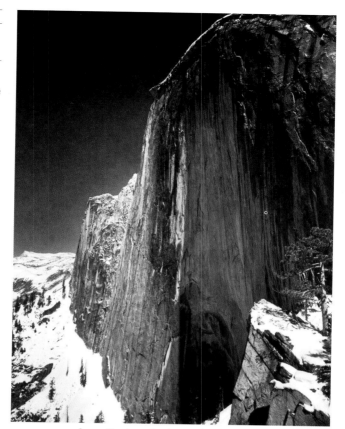

amateur and professional, through the dissemination of his technical system, the sheer virtuosity of an Adams print is unique: the subtle gradations of tone and contrast; the detail in surfaces of rocks, ice, trees; the atmospheric effects of clouds, snow, ice, all subsumed within a discourse of sublimity.[11]

If Adams was tapping into a feeling for nature in a century that would be dominated by the machine, one could see this same sentiment in many other places: in the growing national and state park systems, in the pursuit of nature through camping; in the land preservation and environmentalist movements. One could see it even earlier, in the mid-nineteenth century's rapidly expanding urban park movement, exemplified by Frederick Law Olmsted's Central Park, which raised landscape design to a fine art, supported by a social vision that would bring the different social classes together in the same recreational space, under the civilizing and ennobling influence of nature. Photography, by promoting the spiritually uplifting value of nature, contributed crucially to these cultural changes, creating symbols that crystallized and made tangible these feelings.

The aesthetic landscape

Given the wide availability of prints and stereographs—including thousands of landscape images—many enthusiastic amateurs were drawn into the mysteries of making images themselves, often in newly established camera clubs. More than thirty Philadelphians, for example, banded together in 1862 to establish the Photographic Society of Philadelphia, a harbinger of the growing amateur movement, where the focus was on sharing technical information and on exhibitions which promoted artistic standards in a variety of genres. The emphasis in landscape photography was on the medium's aesthetic potential, as adumbrated by Philadelphian Marcus Aurelius Root in *The Camera and the Pencil* (1864): 'sun painting is not a mere mechanical process . . . it is one of the fine arts'.[12] Another Philadelphian, John Moran, affirmed the primacy of the artist's impression

20 John Griscom Bullock

Untitled (Girl Reading under Tree), c.1898

One of America's leading amateurs, Bullock had the advantage of being a chemist. He helped organize the early photographic exhibitions on the East Coast and himself exhibited at international shows and with Stieglitz's Photo-Secession. Bullock's dark foreground subject contrasts with the lighter background scene, emphasizing the quiet and harmonious moment of the little girl, comfortably perched on a forest bench. The image captures an idealized moment of serenity in nature at a time when cities and factories were coming to dominate American life.

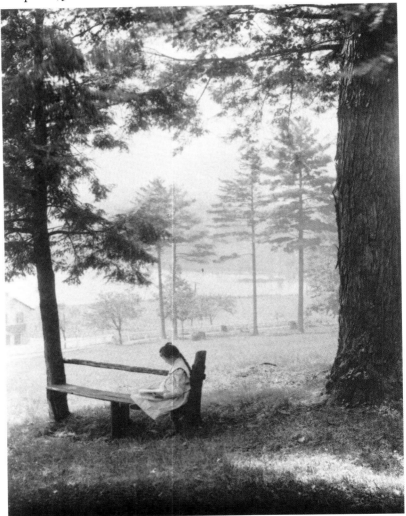

21 Anne Brigman

*The Dying Cedar, c.*1909

Using her own body, Brigman mimics the shape of the cedar, suggesting the union of woman and tree, of human life and natural life, and evoking the mythologies of pagan nature, of dryads and Pan figures. The freedom of the pose and its implicit sexuality marked the liberation of the New Woman from the constraints of Victorianism, a liberation echoed in the contemporaneous new dance of Isadora Duncan and the Bohemian spirit of the intellectual communities from California to Greenwich Village.

of nature and was especially attentive to atmospheric effects and the changes of light at sunset. As the Philadelphia club evolved (and we can take it as representative of similar clubs in Boston, New York, Chicago), its members went off on excursions to the surrounding countryside, coming back with visual trophies of a picturesque nature—peaceful streams, country roads, ponds, and woods—bucolic scenes that belied the growing industrialization of the cities and paralleled the local colour movement in literature. Often including a human figure contemplating the beauties of the scene before him, the naturalistic photography of the amateur camera enthusiasts (e.g. John Griscom Bullock, Robert S. Redfield, Henry Troth) was founded on

the aesthetic of the picturesque, far different from the wilder scenes—usually devoid of human presence—that characterized the sublime view photographers.[13]

This naturalistic photography became the foundation of a new landscape aesthetic that gradually replaced the older sublime with a softer, more delicately impressionistic work that would establish the landscape image within the context of the fine arts. Emerging out of the amateur circles, a group of photographers associated with Alfred Stieglitz opened up the aesthetics of landscape to even more subjective interpretation, moving away from the regional and the sentimental and towards a more allegorical treatment that transcended the particulars of a given place to achieve a more universal image of beauty, constructed under the inebriating influence of the Symbolist and Aesthetic movements in Europe. These more aesthetically fine-tuned photographers—Pictorialists—sought the moonlit landscape, the twilight atmosphere, the hazy mist of dawn, evoking a moodiness and dreaminess that was enhanced through techniques that in various ways manipulated the print: through gum bichromate coatings that could be brushed on the paper to achieve a softening effect; or through gauze placed over soft-focused lenses, creating a subdued tonal harmony that

stimulated the imagination. With nudes allegorically dressed as forces of Life and Nature, or else assuming the role of pastoral nymphs and Greek boy-gods, the American forests were peopled with mythological creatures, figures of the soul's aspirations beyond everyday life, perhaps also of the artist's alienation from everyday America.

Stieglitz, who supported such work by Photo-Secessionists like Alice Boughton, Anne Brigman [21], F. Holland Day, Gertrude Käsebier, Edward Steichen, and Clarence White, advocated a self-conscious aestheticism that would lift photography to the level of the other fine arts.[14] By the early decades of the twentieth century, a gulf had developed in the discourse of landscape, between Postcard America and the Aesthetic Landscape of Stieglitz's Photo-Secession. The postcards, inheritors of the nineteenth-century conventions, featured the mountains and waterfalls of the view tradition, and also the more local picturesque scenery of the naturalistic tradition;[15] the Photo-Secessionists, appealing to a far smaller segment of the art public, evoked the subtler moods of the soul. Stieglitz himself had evolved a notion of 'equivalents', that sought in natural symbols (clouds, especially) the emblems of the soul's condition [22]. In his photographs of trees and of the hills surrounding his Lake George house, one can see a more abstract treatment of landscape, emphasizing simple, formal elements, and corresponding to Stieglitz's sense of the suggestive power of nature's moods.

The topographic photograph

From the 1860s on, photographers had been called upon to survey in detail the features of a place or region, working usually under the auspices of an agency that required, for its own purposes, a photographic record. One of the great photographers in this mode was Timothy O'Sullivan who, following his work during the Civil War, was hired by geologist Clarence King in 1867 to record the geological features of the Southwest. O'Sullivan travelled throughout Nevada, Utah, Colorado, Idaho, and parts of California for several years, producing photographs that would survey the mountains, deserts, gorges, waterfalls, valleys, and rivers of the Western territories, furnishing images that could be read as supporting King's theories of the earth's eruptive changes [25].[16] O'Sullivan's images certainly are, on one level, literal and revealing pictures of earth formations, but they also have a powerful aesthetic dimension that compels us to construe some wilful intention on the photographer's part. At least once O'Sullivan remained at the same spot, high above a vista looking down into a valley at a huge rock face from morning till evening, taking images of the scene at different times of the day, thus revealing the scene under different lighting conditions—an effect that would lend clarity to geological observation but also one that suggests a sophisticated understanding of photography as

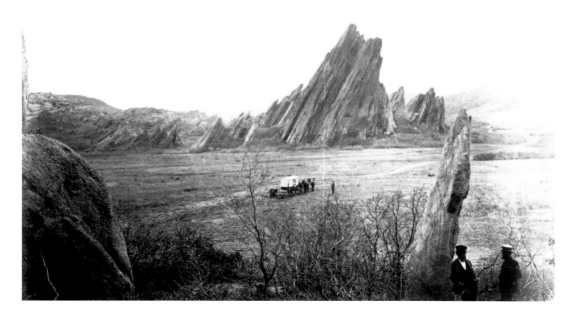

23 Timothy O'Sullivan

Desert Sand Hills near Sink of Carson [Nevada], 1868

23 Timothy O'Sullivan

Desert Sand Hills near Sink of Carson [Nevada], 1868

O'Sullivan was often travelling through extremely inhospitable territory—vacant of inhabitants, trees, water. He frequently posed a member of his party in the picture for scale, and possibly with a more suggestive intention; here, the footprints visible in the sand, leading to the camera's position, confirm a point of observation on an otherwise bleak scene. The wagon, carrying the elaborate equipment and chemicals needed to produce photographs at this time, has already been turned around and is heading back to wherever it had come from.

O'Sullivan and Jackson

In addition to the geological surveys, the major employers of topographic photographers in the nineteenth century were the new railroads. The images they commissioned, designed to record the triumphant progress of industrial civilization across the continent, embody the optimistic mood of the age more obviously than O'Sullivan's. One such photographer, whose long career stretched from the 1860s to the 1930s, is William Henry Jackson, who, like A. J. Russell and Charles Savage, was employed beginning in the late 1860s to make railroad pictures that would promote transcontinental travel to the West by showing the most attractive scenes—from a tourist angle—along the way.

Though O'Sullivan and Jackson were both working within the topographic tradition, two photographers could hardly be more different. Thus, Jackson photographed rocks in the shape of teapots, natural geysers, and the railroad train itself creeping miraculously along the edge of a huge rock face. Jackson's optimistic, forward-looking views of the West are summed up by the image of a wagon moving across a vast prairie framed by mountains [24]. The whole scene speaks of the easy progress of travel, echoing in the forward motion of its line the forces of nature. Compare this to O'Sullivan's characteristic image of a mule-drawn wagon in the desert: it moves into the middle space of the photograph, only to make a U-turn and appear to depart without having traversed the scene [23]. The opposition of nature to man's quest is obvious here, and it is framed ironically by the recorded footsteps of the photographer as he walked across the sand with his camera to a distant point where he could survey the travelling darkroom in all the futility of its movement, yet with an implied triumph—through the photograph itself—as well. O'Sullivan's seemingly more existential view of man in nature would appeal to the sensibility of the last twenty-five years, which could see in him at least the traces of a Symbolist.

24 William Henry Jackson

Rocks below Platte Cañon [Colorado], 1870

The unusual rocks, jutting forward out of the earth, would make this a noteworthy spot for Jackson to photograph; their forward thrust gives a feeling of forward movement to human progress across the canyon. Jackson frames the image to emphasize the diagonal movement from lower left to upper right. Images like this were designed to make travel through the Western territories look safe and leisurely, as well as entertaining, a conception that would be supported by the lounging travellers in the right foreground.

an essentially temporal medium. O'Sullivan's inclusion of human subjects (his assistants) in many of his photographs often takes on a strangely suggestive quality, as they lurk in the shadows of rocks, and other, man-made structures; although the human figure had a practical purpose in these images—to denote the scale of the view—it evokes a sense of the vulnerability and fragility of the human intrusion upon the Western landscape.[17]

With the settlement of the Western territories over the last quarter of the nineteenth century and the violent suppression of the Indian tribes, the frontier would become gradually mapped and surveyed, domesticated, settled, and eventually made safe for the tourist; by the turn of the century, Buffalo Bill would be playing himself on stage, re-enacting his exploits for a popular audience, and Edward Curtis would be posing his Indians in heroic aspects. If the mood of the nineteenth century was an essentially optimistic one, happy in its discovery and exploitation of the American continent, the twentieth century began gradually to wake up from that dream, look around, and see everywhere the destructiveness of the machines that had invaded the garden. For the twentieth century, the pastoral image could only be an ironic one. During the Depression of the 1930s, for example, the

25 Timothy O'Sullivan

Crab's Claw Peak, Western Nevada, 1869

O'Sullivan's photographs often seem to be literal renderings of the earth's surface, as in this image, where two plates come together and erupt upward at the point of contact. The earth was a record of past changes, according to Clarence King, the director of the geological survey, and in this eruption would be evidence of the abruptness of change in the earth's surface (an implicit refutation of Darwin's gradualism).

photographers of the Farm Security Administration, directed to provide pictures of the South and Midwest that would describe the ravages of the drought, produced images of farmlands turned to deserts, parched soil, ravaged crops, and eroded hillsides. Farmers, once proud of their lands and labour, were now forced to join the mass exodus to the supposedly greener pastures of California. Arthur Rothstein and Dorothea Lange photographed the forlorn houses of the farmers, deserted before the onslaught of the predatory tractors of the big agri-businesses, which took what they could, as efficiently as they could, from the land [**66**]. Anti-pastoral images like these would mark themselves upon the Depression psyche, reinforced by Pare Lorentz's epic documentary film, *The Plow that Broke the Plains*, and by John Ford's motion picture, *The Grapes of Wrath*.

New topographics

With the post-World War II growth of the suburbs in America and of the massive commercial corridors of megalopolis up and down the East Coast; with the urban sprawl of California and the decentring of once-flourishing urban locales into so-called 'edge cities'; with a pervasive sense of the fragility of our ecosystem, our whole attitude towards land use underwent a dramatic shift. Beginning in the 1970s, a growing

Dingus was part of the Rephotographic Survey Project, whose goal was to find the exact location where photographers like O'Sullivan and Jackson stood, and re-take the shot at the exact time of day (and season) as the original. In this case, the photograph reveals that O'Sullivan cropped his image and tilted the horizon on the camera in order to achieve a more dramatic effect of eruption. This sort of manipulation of the image, along with other, even more radical techniques, was not uncommon among nineteenth-century photographers, although the public was generally unaware.

body of work moved our relationship to nature to the centre of cultural consciousness, and photographers turned their attention to describing, often with a critical edge, the human presence in once pristine lands. Much of this topographic work, renewing our sense of place, was inspired by the nineteenth century. The most obvious link to the earlier work of Watkins, O'Sullivan, and Jackson, was the Rephotographic Survey Project (RSP), which attempted systematically to re-create the classic photographs taken by their predecessors a hundred years before [**26**].[18]

The act of seeing the landscape cannot, of course, be a purely 'objective' one, we realize. And that point was made even more explicitly the subject of photographs by a group of landscape photographers influenced by the conceptual art movement of the 1970s. This work took the investigations of the RSP into a more self-conscious field, moving us to contemplate the act of viewing itself. In Robbert Flick's work, for

27 Robbert Flick

*Near Live Oak 1, Joshua Tree
National Monument,
California*, 1981

The grid structure imposes an
artificial format upon the
landscape, forcing us to step
back and accept the
composite as a new thing,
apart from nature. Looking
closely, we discover that
adjacent images repeat the
subject from different
distances, angles, and lighting.
The result is a viewing that
moves the eye back and forth
from detail to whole. Flick's
use of multiples creates a
tension between the regular
grid structure and the irregular
shapes that populate each of
the squares.

example, a 'composite' image contains a square grid-like arrangement of dozens of smaller images, each of which is a photograph of a given field of vision [**27**]. Borrowing something from the panorama technique, Flick adds one image to another to create the larger whole; but Flick's images overlap in subject; or they will take the same subject—a boulder or rock formation—from two different points of view. The viewer cannot see the whole, really, in anything like a traditionally composed view, which mimics our perspective vision; instead, Flick's Cubistic rendering fragments the scene, forcing us to look closely at the parts and move back to the whole, then close-up again, as we gradually put together in our mind's eye a sense of what the whole means. Flick's work is thus about vision itself, and about representation— about the ways we see the landscape before us.[19]

Where Flick analyses the act of representation, leaving the subject alone, in John Pfahl's work, the site itself, the landscape being imaged, is altered *before* the image is taken. Pfahl might, for example, place some boulders around in a circle, but not complete the circle; instead, several rock places are 'saved' by an outline on the ground. In another, Pfahl chooses a large rock face that is jutting out at an acute angle from the earth; he places strings before the scene, with lines running at the same angle as the striations in the rock, thus 'matching' our human intervention and the natural. In these and other works, Pfahl examines the process by which the landscape is altered and seen, for each of these works depends on its particular angle of vision to make its point.[20] The reflexive, self-interrogating nature of all of this work takes us to a kind of ultimate theoretical point of postmodern self-consciousness in terms of viewing the landscape.

Landscape photography was not, however, swallowed up in self-consciousness in the late twentieth century. Instead, a number of photographers wanted to re-focus our attention on what must be seen. A landmark exhibition at George Eastman House in 1975 marked the importance of this new work. New Topographics, as it was called, focused on the 'man-altered landscape' in the work of ten photographers, including Robert Adams, Lewis Baltz, Joe Deal, Frank Gohlke, and Nicholas Nixon. It was the premise of these photographers that Americans have not been kind to their natural spaces: tyre tracks from recreational vehicles mar the deserts; telephone poles and wires block out once pristine vistas; gas stations, billboards, and roadside entertainments trek across the continent; forests have fallen victim to greed, and so on. Such sights have been the preoccupation, for example, of Robert Adams, who, drawing upon the view tradition of the nineteenth century, has ironically qualified the beauties of the landscape by showing, in often subtle ways, the tell-tale marks of a blighting human presence.[21]

Another figure of great importance in this mode is Lewis Baltz,

Baltz's deadpan view of the new desert real estate developments of the West shows us the vulnerability of even the bleakest of desert spaces to human intrusion. Here, the debris related to the construction of housing estates occupies the foreground, while in the background, a vista stretches out towards the horizon, imitating the expanse of space that is the signifier of the West. Baltz's irony cuts two ways: into the Western landscape tradition, reducing the scale of the mountains, and into the architectural efforts of man to make his mark on the landscape.

who, over the years, has created a body of work that critiques the effects of technology on the landscape, showing us our public places, our housing estates, our industrial parks—the new landscapes of the post-modern era [**28**]. It is not a pretty sight: the construction of housing in Park City reveals a sun-baked community of angular, modest homes, scattered in the midst of a vast, inhospitable, treeless space. Baltz's extended series, *Candlestick Point* (1989), offers close-ups of a nature that has been defiled by the random waste, the ramshackle chaos of speculative ambition. Standing behind Baltz, as Jonathan Green has observed, is Charles Sheeler's 1930s visualization of the industrial landscape, in paintings like *Classic Landscape* (1931), which offer a hard-edged, precisionist rendering of factories that have grown into the land, displacing whatever natural vistas might previously have been there.[22]

Aerial photographs originated in France, when Nadar (Gaspard-Félix Tournachon), aloft in a balloon, made spectacular views of Paris in 1858; meanwhile, the Boston photographer, James Wallace Black, captured views of Boston in 1860. Black proposed using aerial reconnaissance during the Civil War, but it was not until World War I that the military uses of photography were exploited. Oddly enough, it was Edward Steichen (serving at that time as the commander of the Army's photographic division) who pioneered its use. Entering the war as a pictorialist, Steichen emerged a modernist, following his discovery of the new world of scientific and precision photography.[23] Subsequently, there have been many different uses for aerial photography: surveying the earth for minerals and resources, assessing the condition of forests, locating archaeological remains, gathering military intelligence, and so forth.

The aesthetic dimensions of aerial photography have also been explored, in the late twentieth century, in the work of photographers like Terry Evans and Emmett Gowin.[24] Evans's images of the Mid-western prairie seem like purely aesthetic constructions—a revelation of the earth's patterns as seen from an airplane, showing natural features and areas of cultivation, yet from a distance that creates,

inevitably, an abstraction. Evans's intentions, however, go well beyond aesthetic construction. The altered landscape may reveal, as one title tells us, the *Smoky Hill Bombing Range Target, Tires* (1990), a bull's eye carrying the imminent possibility of violent destruction [**29**]. Even the agricultural landscapes as seen from the air may harbour a complexity not immediately apparent. Attracted first to the perfection of the prairie ecosystem, Evans found himself trying to picture 'the prairie in all its disturbed, cultivated, inhabited, ingratiated, militarized, raped, and beloved complexity'.[25]

More apocalyptic still is the work of Richard Misrach, whose *Violent Legacies: Three Cantos* (1992), is an examination of three places in Nevada and Utah, as the 'site map' frontispiece announces.[26] Misrach's spectacularly beautiful colour photographs have a descriptive and literal quality (the remains of bunkers, detonation craters, shrapnel, atomic bomb loading pits, and A-bomb assembly buildings) that places them on the border between visual archaeology and artwork. 'Project W-47' examines Wendover, Utah, a testing site for the atomic bomb late in World War II. Part II, 'The Pit', examines a dumping site for livestock that have died suddenly [**30**]. Misrach's close-up treatments of cattle in various states of decomposition likewise balance the nauseating corpses against the aesthetic beauty of the treatment. Seen

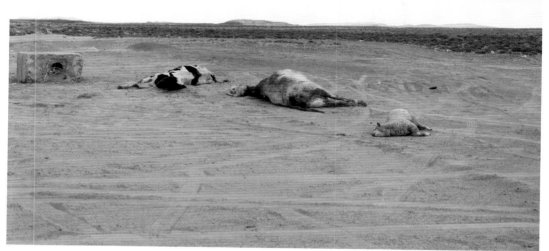

30 Richard Misrach

Dead Animals #324 The Pit, Nevada, 1987–9

In other pictures in this series (*Violent Legacies: Three Cantos*), Misrach offers distant views of the dumping site as well as close-up studies of the dead cattle and sheep. Here he takes the middle distance, placing the carcasses near a nondescript concrete block, with tyre tracks in the foreground, while the horizon beyond is clean, simple, vast, and clueless. The violence of death is everywhere present in this scene, despite the simplicity and elegance of the composition.

from a distance the dumping site is a region of crisscrossed dirt roads, concealing the surreal horror of the scene up close. Part III, 'The Playboys', shows the remains of a *Playboy* magazine that was used for target practice in a desert nuclear test site; the pages are riddled with bullet holes, suggesting the misogyny and dementia of the shooters and, as Misrach would have us see, the violence in American culture generally.

If Misrach's challenging, polemical images of destruction and sterility are at one extreme of contemporary landscape photography, the celebratory Sierra Club calendar images of a lushly beautiful nature stand at the other. Between the warning of the former and the promise of the latter, Americans are reminded of the discontents, raptures, and above all the responsibilities of civilization.

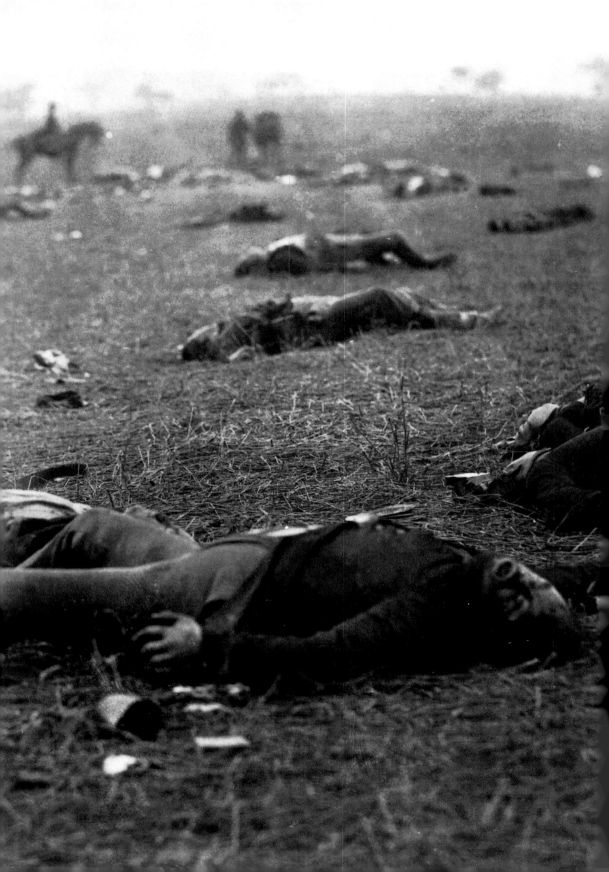

Seeing and
Believing

4

From the very beginning photographs were seen to carry a burden of truth that no other graphic medium possessed, and photographs of events had a particular superiority that newspapers were quick to capitalize on. The earliest daguerreotype images of the sort we would nowadays consider photojournalistic were (because of their slow speed) taken in the aftermath of some catastrophic or otherwise historically significant event: the wreck of a train, the burning of a building, the survivors of an Indian attack [31]. Such images were translated to the illustrated magazines through engravings and presented to the public with a claim of authenticity that ostentatiously derived from their being based upon photographs, as opposed to drawings from an artist's hand. Translations from photographs to engravings were not without their distortions, yet they carried an imprimatur based on the universally recognized authority of photography to deliver a 'true' picture of the world, and they added considerably to the appeal of the increasingly pictorial newspapers of the 1840s and 1850s. As *The New York Daily Graphic* put it in 1853, 'We propose to illustrate daily occurrences in such a way that the life of our times shall become photographic; and the illustration of events will be as accurate and pleasing and elegant as any word painting in the text.'[1] Artists' illustrations and engravings based on photographs increasingly competed for the same space in the press, until the photomechanical process displaced the artist finally in the early twentieth century.

The illustrated press was not alone in creating the beginnings of our contemporary 'society of the spectacle', as it has been called. The commercial lithography of the 1860s brought before the public eye engravings of contemporary figures and events, while pictures were brought even more directly into the home through the very popular stereograph cards, sold by such establishments as Edward Anthony's in New York. From the 1860s through to the turn of the century, these featured the widest possible range of visual subjects: scenes of the newly explored Arctic and Antarctic, conventions and jubilees, earthquakes, floods, fires, mining operations, occupations of all sorts, the refining of petroleum, the construction of transcontinental railroads, steamship wrecks, and so forth. Though there would inevitably be a

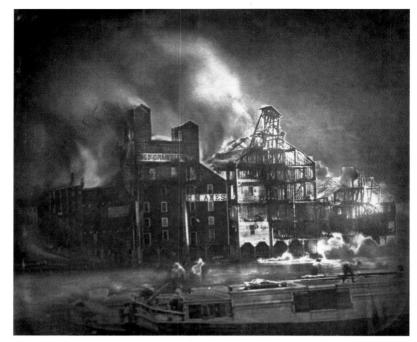

time-lag between event and publication, the nineteenth-century con-
sumer had available an extensive visual record of the main events of the
day, in a form, moreover, that created a powerfully effective illusion of
three-dimensional reality.

Photography in the Civil War

The most spectacular of subjects during the latter half of the nine-
teenth century, if also the most disheartening, was the Civil War,
covered extensively by the hundreds of photographers who eventually
were working on the field and behind the lines. The first photographer
to record the scene, and the creator of the most extensive record, was
Mathew Brady, though we cannot be sure that any of the thousands of
'Brady' photographs were in fact taken by him—like other studio
entrepreneurs, Brady's name covered the work of many photographers
in his employ. It was Brady's genius to imagine the possibility of
making a contemporary record of the war as it was happening and, at
his own expense, to see the enterprise through to the end.[2] Sending his
photographers into the field behind the action, Brady's men captured
scenes of camp life, officers, and—most affectingly—the slain on the
battlefields [**32**]. Oliver Wendell Holmes's reaction, looking at a series
of photographs of Antietam after the great battle of September, 1863,
may be taken as representative:

Let him who wishes to know what the war is look at this series of illustrations.
These wrecks of manhood thrown together in careless heaps or ranged in

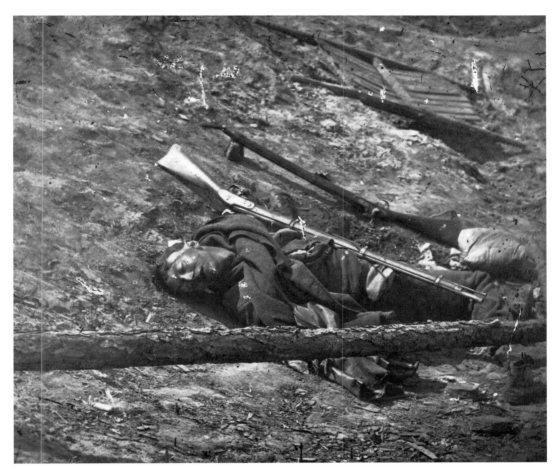

32 Mathew Brady

Dead Boy in the Road at Fredericksburg, May 3, 1863
Brady's photographers, in the aftermath of the battle, took a great many images of the dead, strewn across trenches, rifles nearby. Casualties in the Civil War were staggeringly high, and such images, viewed by the public, were both fascinating and repelling—bodies twisted into grotesque shapes, bones being buried long after the flesh had been picked clean—offering a view of the harsh and bloody reality of war that had previously been hidden beneath a veil of propaganda. Stereoscopic views would have been especially vivid.

ghastly rows for burial were alive but yesterday . . . It was so nearly like visiting the battlefield to look over these views, that all the emotions excited by the actual sight of the stained and sordid scene, strewed with rags and wrecks, came back to us, and we buried them in the recesses of our cabinet as we would have buried the mutilated remains of the dead they too vividly represented.[3]

Holmes's reaction points to the vividness of the images themselves, but their shock to the general public who were not veterans of the battle-field must have been multiplied by virtue of their direct contradiction of the previously accepted images of war. Paintings of the day portray not death and disfigurement, but the heroic struggle of soldiers who, though wounded, are not defeated; the injured are not pictured in the dirty and crowded field hospitals where they nursed their wounds, but in cleanly sketched hospitals; we see not the maimed infantryman lying in a ditch but the soldier being sent off to battle by his loved ones with a kiss and the respect due to a warrior. Photography was, in short, changing fundamentally (though not permanently) the conception of war, revealing, as Holmes put it, 'what a repulsive, brutal, sickening,

hideous thing it is, this dashing together of two frantic mobs to which we give the name of armies'.[4] For Holmes the ends finally did justify the means, but the war as photographed would have a continuing effect, entering into the imagery of Stephen Crane in *The Red Badge of Courage* several decades later, and contributing to a standard of objectivity and truth that would serve as the foundation of an insurgent realism in the late nineteenth century.[5]

But as long as the war wounds were fresh, the photographs of the war by Brady and others would elicit an ambivalent response. Certainly there was fascination: 'You will see hushed, reverend groups standing around these weird copies of carnage, bending down to look in the pale faces of the dead, chained by the strange spell that dwells in dead men's eyes.'[6] Yet there was also revulsion and anger, especially when the photographs of nearly skeletal bodies, barely alive prisoners held in the South's Andersonville prison, were published in 1864 [**33**]. Though many bought copies of the images, the end of the war brought an end to any desire to look back on the horror, and Brady never recouped his original investment. Years later, in 1875, with Brady in debt, Congress appropriated funds to purchase the Brady collection, perhaps the greatest collection of pictures of any historical event, at a fraction of its value.

Brady's work reached the public in a variety of ways—through periodicals, through prints sold in galleries, and through Brady's own lantern slide lectures. Yet one of the most lasting and monumental works of this photographic generation was the published collection of images produced by Alexander Gardner, *Gardner's Photographic Sketch Book of the Civil War* (1866).[7] Gardner, who had managed Brady's Washington studio and also his battlefield operations, left his employ in 1863, apparently in a dispute over credit for the Brady images. Taking several of Brady's best photographers with him, including Timothy O'Sullivan, Gardner set up a rival operation that resulted in a systematic survey of the war, with each photograph credited scrupulously to the camera man and to the printer. (O'Sullivan made forty-five of the images in the *Sketch Book*.)

Gardner's collection covers the war from beginning to end: from the massed wagons of the troops at an encampment and the camp scenes behind the battle lines, to the makeshift pontoon bridges over rivers; from the dirt forts of the field soldier to the generals' grander accommodation; from the line of cannons ready to fire to the line of Confederate prisoners taken after a battle. (The camera was too slow at this time for photographers to take action shots, but the soldiers obligingly took their positions and posed for the cameraman, simulating the requisite battle scene.) Above all, Gardner showed the ruins of war—destroyed buildings, dead horses littering farmyards, corpses strewn across a battlefield.

33 Anonymous

Frank Leslie's *Illustrated Newspaper*, 18 June 1884

These photographs—translated to the cover of Leslie's newspaper, were commissioned by the US Congress to record the horror of the prisoners' treatment in the Rebel prison. Photographed without clothes so as to reveal their state of near starvation, the gaunt figures are granted a modest covering. Following public demand and a Congressional investigation after the war, the commander of the Andersonville prison was hanged. Before the half-tone process, such engravings were the usual means of rendering photographs in the press, but the artist inevitably removed the stark texture of reality from the images, leaving them less shocking than the actual photos.

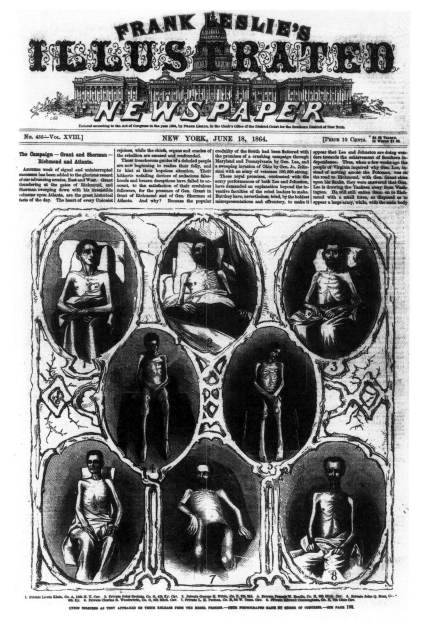

But the *Sketch Book* raises vexing questions about the meaning of photography in the nineteenth century, centring on the issue of photographic truth. Certainly the reader of the volume would have no reason to doubt the authority of the images Gardner presents, nor to question the assertion that prefaces the book, which privileges the visual authority of photography over the less objective renderings of prose: 'Verbal representations of such places or scenes, may or may not have the merit of accuracy; but photographic presentments of them will be accepted

by posterity with an undoubting faith.' And posterity has indeed accepted the images as 'accurate', until the investigations of William Frassanito and others disclosed that some of the most famous images were either misrepresentations or contrived. Gardner's caption for 'The Harvest of Death', for example, describes a 'devilish' scene of shattered bodies stripped of their shoes, while affirming that these 'Rebels' 'paid with life the price of their treason' [34]. Most likely these were Union soldiers, however, but that fact would have been too painful for Northern readers. Softening the horror of the scene, Gardner managed to offer a concluding 'useful moral': 'It shows the blank horror and reality of war, in opposition to its pageantry.' In another photograph, a corpse is identified as a Union sharpshooter; in the next image the same body, moved to another position on the battle-field, is identified as a 'Rebel' sharpshooter. Or an image purporting to be the 'Field Where General Reynolds Fell', depicts a scene that couldn't possibly be that particular field where the famous general was slain.[8] Why these prevarications?

What they serve, perhaps, is Gardner's larger purpose, to create a narrative that not only had complete coverage of the principal incidents (hence the inclusion of the demise of Reynolds) but a coherence and moral authority that would provide an acceptable meaning to a war that had disastrously claimed so many lives. Gardner's prose captions, on pages facing the photographic print, place the frozen images into moving narratives that open up the drama of the war; they stimulate the imagination of the viewer by inventing imagined emotions on the part of the wounded and dying; they paint pictures that dramatize the natural atmosphere of the moment; and most importantly they moralize the story of the war. Thus the Confederate army is turned into 'Rebels' who needed to be rightfully punished and consequently died tortured deaths far from home, while the Union army was portrayed as loyal soldiers who generally died peaceful deaths, thinking of their loved ones.

Gardner's *Sketch Book* raises the even larger question of how words and images work together to create photographic meaning. While images in a family album might stand alone, uncaptioned, we generally have the benefit of some text when 'reading' a photographic image, even if it is just a descriptive title. That verbal context gives us a cue as to how we might respond to the work. In the documentary and photojournalistic modes, the caption is a necessary accompaniment of the image, explaining exactly what we are looking at, and also, very often, telling us how to feel about the image. Yet at the same time the caption, or other text surrounding an image, interprets the visual representation for us and by doing so limits the range of possible meanings we might ascribe to the photograph.

Stopping motion

American culture in the last decades of the nineteenth century was on the threshold of a communication revolution that would make the transmission of information through the combination of printed image and word—the foundation of illustrated newspapers and magazines, books, and posters—one of the most powerful instruments of persuasion in modern society. Three innovations in the technology of photography came together to make this possible: the development of fast film and fast shutter speeds capable of stopping motion; the development of flash photography, allowing for the photographing of interior spaces; and the invention of printing techniques that would allow for the reproduction of the image photomechanically, without the intervention of the hand of the artist. Photography became, through these changes, a medium that literally changed the way we saw the world—in both scientific and sociological terms.

The camera's ability to capture motion—a function of film sensitivity, shutter speed, and the capacity of the lens to gather light—is something we take for granted. Yet before the 1870s, something as simple and commonplace as the way a horse galloped was a mystery. It was simply too fast for the eye to see. In fact, that puzzle became the catalyst for the elaborate experiments in time and motion undertaken

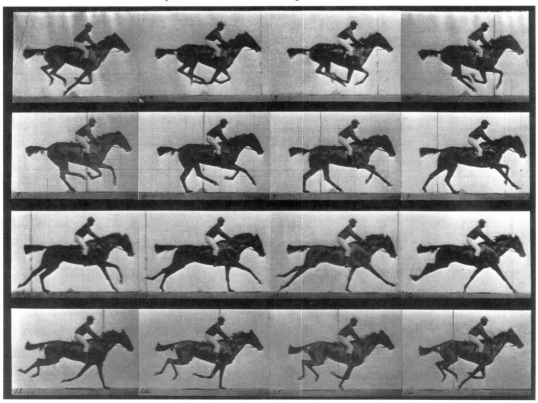

Emigrating from England, Muybridge began his career in San Francisco in the late 1860s as a landscape photographer, but ten years later, working with Leland Stanford's support, he was fully immersed in his studies of animal movement. In 1884 he was invited to Philadelphia to work on his motion studies at the University of Pennsylvania, where he was constantly changing and improving his photographic apparatus. He arrived finally at a format that was typically a three-angled simultaneous view of the subject, exposed in a series of twelve shots that were then arranged in a grid-like display. In Philadelphia, working at the zoo and with human subjects at the University of Pennsylvania, Muybridge eventually completed a vast catalogue of studies, published in various formats, along with his own wide-ranging essays on the history of literary and artistic representations of motion. Inspired by the 'zoetrope', which produces an illusion of motion in a revolving drum, Muybridge created (in 1880) the 'zoopraxiscope', which was capable of projecting an endlessly repeated motion before an audience. These experiments led Edison, in 1889, to the invention of the kinetograph, a camera capable of capturing extended motion, and hence narrative, by making use of George Eastman's new gelatin celluloid film.

While Muybridge's zoopraxiscope laid the foundation for the motion picture, his grid structures and frozen images became the basis of further scientific study of motion and its applications. In the early twentieth century, Frank Gilbreth developed his own 'time and motion studies', extending Muybridge's work to create a more systematic analysis of workers' movements in various tasks. The applications of Gilbreth's studies brought an unsettling appreciation of speed to the workplace—unsettling, that is, to the worker. Muybridge's success at freezing motion also became the foundation for Harold Edgerton's experiments of the 1930s. Using a sequential flash device that he invented, Edgerton eventually produced startling images such as the crown-like formation as a drop of milk hits the liquid surface, or a bullet smashing an apple at 1/3000 of a second; Edgerton revealed a world through microphotography that had multiple scientific and technical applications and was also vastly beautiful and vastly appealing to readers of *Life* magazine and *National Geographic*, where they were published. Muybridge's grids, a purely functional format, have in themselves had a continuing aesthetic fascination, with many twentieth-century artists deeply influenced by the grid structure in their work, which sometimes, as in Sol LeWitt, openly acknowledges Muybridge's influence.

36 Eadweard Muybridge

Galloping Horse, Motion Study—Sallie Gardner, Owned by Leland Stanford, Running at a 1.40 Gait over the Palo Alto Track, June 19, 1878

The sixteen successive images here complete the cycle of the horse's movement, reading from left to right, and down the page, with the second and third frames demonstrating the simultaneous elevation of all four hooves in the air. All of Muybridge's studies of animal (and human) locomotion were structured in a grid, allowing for the close study of individual phases of movement; other students of motion (Edward Marey in France, as well as Muybridge's Philadelphia supporter, Thomas Eakins) preferred to use a single plate with multiple, overlapping exposures.

by Eadweard Muybridge in California. Muybridge, known for his inventive technique as a landscape photographer, was hired by Leland Stanford, the wealthy railroad magnate and horse enthusiast, to settle a wager he and some friends had made: were all four feet off the ground at once, or not? Muybridge experimented with a variety of methods to capture the fluid motion of the racing horse, finally arriving at success using highly sensitive glass plates in full sunlight, together with a tripping mechanism that would release the shutters on a battery of cameras successively as the horse moved across a track.

At 1/500 of a second, the horse was revealed to have all four legs off the ground, but not in the traditionally rendered 'rocking horse position' with legs extended; rather, the legs were gathered under the horse

and were for a moment completely off the ground. Muybridge had begun his experiments in 1872 and—after leaving the country from 1874 to 1877—he returned and achieved definitive results, broadcast to the world on the front page of *Scientific American*, in 1878. (Muybridge had left the country following his acquittal on the charge of murdering his wife's lover, an act he openly admitted.)

Photography in the popular press

In the last decades of the nineteenth century, the range of the camera was being extended through the application of flash photography. Although early experiments with electric batteries and with magnesium wire proved successful in the 1860s, it was not until the 1880s that magnesium flash powder became commonly available as a portable light source, and it was not replaced by the electric flash bulb until the 1920s. Flash powder had its problems—acrid smoke, an intensely harsh light producing high contrast, the risk of accidental fire—but it became the means of opening up a new field of photography: social documentary. When Jacob Riis's earliest experiments in investigative photography were published in 1888, they were headlined aptly in the *New York Sun* as 'Flashes from the Slums'.

The third significant innovation of the 1880s was the development of the half-tone process of reproducing photographs directly. Although there had been printed photographs in the 1860s (e.g. the beautiful Woodburytype), that process was limited to images and could not reproduce words and pictures on the same page.[9] The half-tone screen, which broke the continuous tones of the photographic image into a pattern of light and dark dots (or, in an earlier form, vertical lines), could integrate words and pictures on the same page, but it was not picked up by the press immediately because of their fear that with rapid changes in technology, this early process would soon become obsolete. Yet there was a tremendous popular audience for illustrated news in America. As Edward Wilson, the editor of *The Philadelphia Photographer*, observed, 'The daily and weekly papers, the periodicals, and printed matter of every sort with which we are literally deluged at every turn, depend largely for their interest upon illustration.'[10] Well into the twentieth century, photographs and hand-drawn illustrations shared the page in American periodicals, with the latter gradually being displaced as photo reproduction techniques improved. Apart from such changes, the difference between a woodcut and a half-tone was immense, in terms of how a viewer might respond: missing from the woodcut were the texture and detail and tonality of the photographic image that would combine to achieve the effect of authenticity and provide the visual foundation for *belief* in the image.

Riis, Hine, and social documentary

One of the first to take advantage of these technological changes was Jacob Riis, whose *How the Other Half Lives* was published in 1890 as a hybrid text, with thirty-five plates—eighteen of which were line drawings and seventeen half-tone photographs. Riis, himself an immigrant from Denmark who had learned English in night school, had entered photography through his work as a journalist covering the roughest immigrant neighbourhoods of New York. Looking beyond the criminal element itself to the causes of crime, Riis joined a growing number of reformers who saw the environment as a determining force, an incubator of immorality, disease, and crime; by 1880, over a million immigrants had crowded into about 37,000 tenements, and Riis hoped, by publicizing their plight, to bring about social change. His target was the landlords, whom he sought to pressure through public opinion and direct appeal, urging them to lower their profit margin and improve conditions, though in the end it took legislation, as usual, to effect some modest changes.

Riis was not, in the beginning, a photographer, and many works attributed to him initially we now know were done by hired professionals. Eventually he did teach himself how to make photographs, taking advantage of the magnesium flash powder to illuminate interiors never before pictured [**37**]. Riis saw himself as a kind of tour guide to the slums, eager to show his audience—the privileged half—the real life of the 'other half'. Through vivid slide lectures and exhibitions, as well as through magazine articles and books, Riis probed beneath exteriors that might not look horrific enough, exposing the roots of crime and

37 Jacob Riis

Sabbath Eve in a Coal Cellar, Ludlow Street, early 1890s
Riis's Jewish subject celebrates the Sabbath with traditional braided bread (challah). Other signs of domesticity—utensils, tablecloth, the hat hanging on a peg—indicate an effort to maintain tradition and dignity in this makeshift household. But the stunned look on his face reminds us of how invasive Riis and his magnesium flash powder could be, hell-bent on securing touristic images of the Bowery inhabitants.

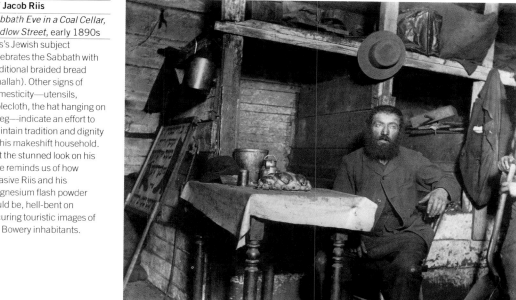

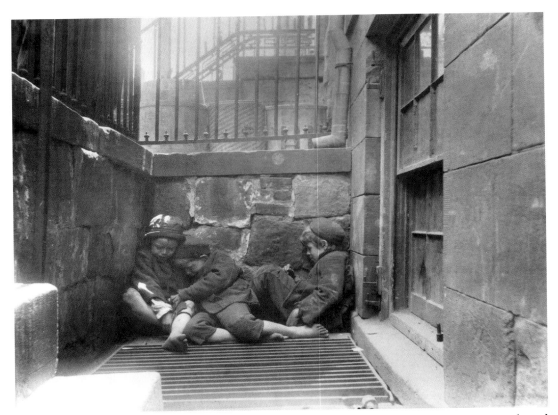

*Street Arabs in Sleeping
Quarters*, 1890

One of Riis's frequent subjects
was the child asleep in the
streets. Homeless boys, called
Street Arabs, were sometimes
fortunate enough to find
shelter as newsboys or in
orphanages; but more
generally they lived on the
streets, sleeping in improvised
spaces. Taken in broad
daylight, this photo, like many
other 'candid' shots by Riis,
was undoubtedly set up and
posed by the photographer.

disease: windowless rooms sleeping as many as ten persons, shared kitchens, privies in the basement, rubbish-filled backyards and the generally filthy living conditions of the newly arrived immigrants. Just how deliberate, how 'artistic' a photographer Riis was, has been a debatable point, some seeing an intention beyond the purely functional in his work. What seems more certain is that Riis used the camera as a perfect instrument for his own, and our, curiosity about the cultural 'other'. Riis takes us down into the basements, where many were forced to live, and into backyards crowded with ramshackle huts; he takes us up to the roofs, where the poor were driven to escape the heat of summer; and he takes us into the narrow alleyways separating the tenement houses. And Riis showed us as well the sweatshop labour that was forced upon the population of the slums, especially upon the children—sewing clothing, sticking labels on bottles, and so forth.

Occasionally, Riis's subjects are performing for the camera—a teenage gang rehearsing a mugging of an innocent; children huddled together in broad daylight, pretending to be asleep [38]. More often, however, the subject is caught by surprise like a deer in headlights, dazed by the flash of light and the intrusion into his or her living space, however humble. Viewing Riis's work now, we might feel uncomfortably voyeuristic, our privileged gaze turning these powerless others

into the object of our compassion, or pity, or condescension. Riis himself seems to have had no such ambivalence, nor, we presume, did his contemporaries. Riis was motivated by the high ideals of the reformers of the time, and he is capable of real compassion on behalf of his subjects; at the same time, however, he seems quite comfortable, in *How the Other Half Lives*, characterizing the various ethnic groups in terms that seem very close to caricature: 'Like the Chinese, the Italian is a born gambler'; of the Jews, he says, 'Money is their God'; he appreciates the African American's good points, while at the same time acknowledging 'his ludicrous incongruities, his sensuality and his lack of moral accountability'. Looking through the impersonal and objective lens of the camera, Riis could not help seeing with the prejudiced eyes of his contemporaries.[11]

To understand Riis and his time, we must also understand the complex reality of early social documentary, and its inherent assumption of moral and aesthetic superiority. The photographs in Riis's published works are there to authenticate the text, to offer the visual 'proof' that what the narrative claims is 'true'. Where the text offers a combination of impersonal statistics and supportive anecdote, the pictures offer the concrete universal, to borrow a term from literary discourse, a particular image that stands for the more general conditions being exposed.

The relationship between text and image is somewhat differently construed in the work of Riis's great successor in the social documentary tradition, Lewis Hine. Beginning his career in photography fifteen years after Riis's *How the Other Half Lives*, Hine's early work—New York apartments, sweatshops, and street scenes—bears some resemblance to Riis's. And like Riis, Hine is especially interested in the children of the slums (and in the workforce generally)—the vice they are exposed to; the dangerous factory jobs for under-aged children; the ruination of young lives [39]. Hine's understanding of visual communication, however, is more sophisticated than Riis's, growing out of his work as a teacher at the Ethical Culture Society School in New York. Though he understood the power of photography to effect social change (analogous to the persuasive uses of the image in advertising, as he saw it), Hine envisioned the camera as the foundation of a practical and theoretical pedagogy: while still a teacher, he began using the camera as an instructional aid—taking students out on field trips where the focus might be anything from the geological features of a surrounding landscape to the economic life of the ports and markets of New York. To Hine, the camera afforded training for the eye in looking at things and, taking the results back to the classroom, in analysing the underlying forces behind surface images. And students would also gain training in hand and eye coordination (hands-on learning enjoyed an early popularity among progressive educators around the turn of the

39 Lewis Hine

Making Human Junk, c.1915
Working for the National Child
Labor Committee, Hine
photographed frequently in
factories, surreptitiously
documenting children who
were being subjected to
dangerous and deadening
factory jobs. Hine's montage of
pictures and words
communicates a clear
message: the children
themselves are the 'product' of
the factories, who
subsequently expect society to
bear the social cost of the
children's exploitation.

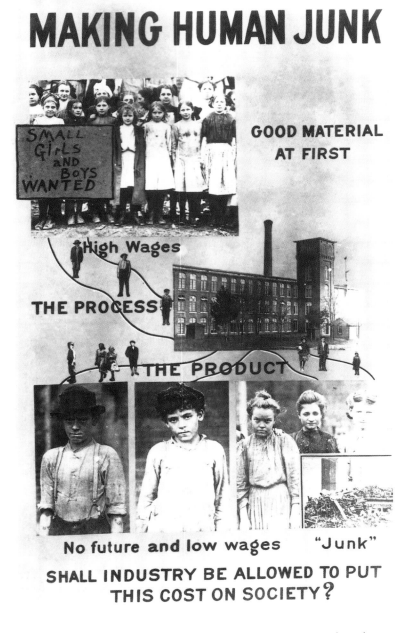

century) and in appreciating the laws of composition, as found in great
artworks that could serve as models for the young photographers.
Hine's articles, appearing in educational journals, were among the first
to promote the educational uses of the camera, based on his under-
standing that the attention given to a picture could be more effective in
focusing awareness than the reality itself.[12]

40 Lewis Hine

*Playground, Boston, c.*1909
Hine used the speed of the new cameras to freeze motion in many of his images of children at play in the city. These children are not working in factories (as were so many of Hine's children subjects) and the image acknowledges their vitality and joy as they do what children should do. Hine's pictorial sense shows their movement to us in a complex pattern of criss-crossing lines against a clear background.

Hine's work exemplified better than Riis's the advantages of directly combining words and images: constructing posters, for example, Hine would compose a sentence that 'reads' both visually and verbally, the words directly supporting the images, creating a kind of primitive picture-story [**39**]. Hine's work for the National Child Labor Committee and other progressive organizations appeared in a variety of publications within the left cultural spectrum, including the influential *Survey*, where he published a regular feature called 'Time Exposures', which combined photograph and text, the one visualizing the subject concretely, the other supplying the supporting evidence and arguments. Hine also expounded the virtues of photography within a pedagogical context, as in 'Photography in the School', written for the *Photographic Times* (August 1908).

Hine differs most radically from Riis, however, in his attitude towards his subjects. Where Riis placed his in a separate box, emphasizing their difference from us, Hine tried to get the viewer to see a humanity shared with the subjects.[13] Though given an individualized treatment, these portraits are entitled so as to emphasize their representative quality—e.g. 'Young Russian Jewess', or 'A Pittsburgh Miner'. We can see this in the striking portraits Hine did at Ellis Island, where the photographer empathically grants his subjects a beauty that was not generally accorded to the lowly immigrants, as in

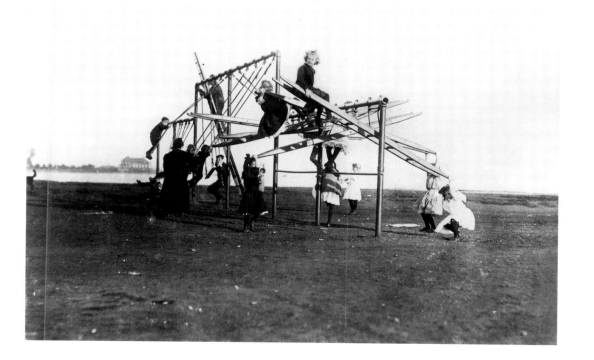

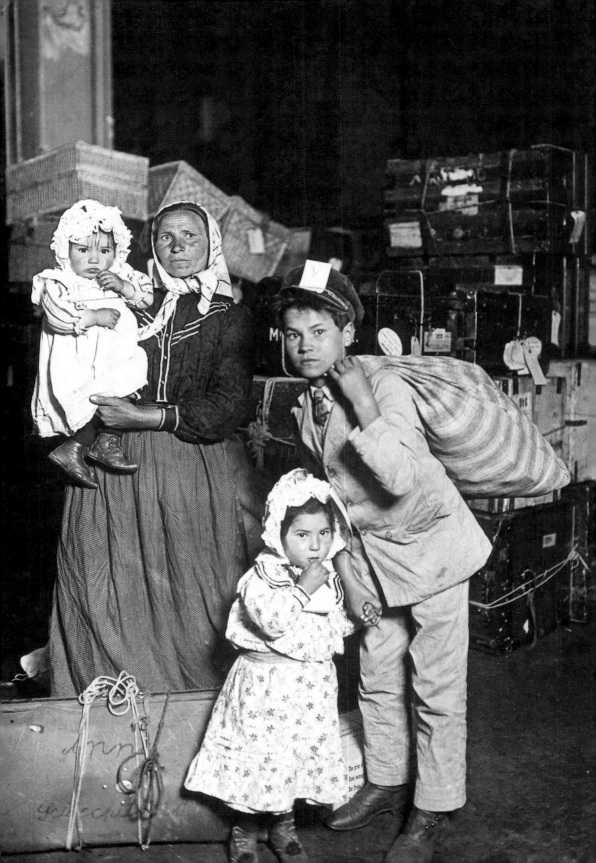

'Looking for Lost Baggage, Ellis Island, 1905' [**41**]. Hine's steelwork-ers are similarly endowed with a strength and honesty that is designed to subvert the prevailing view of immigrant workers at the time, who were considered by white middle-class America generally to be a special category of sub-humanity. Ironically, Hine's pictures appeared in journals that carried articles representing this derogatory view of the workers, suggesting the complexity of the early twentieth-century cultural moment. Hine's motivation can be read from a speech that he gave to the Conference of Charities and Corrections in Buffalo in 1909, where, quoting the English novelist George Eliot, he argued for an aesthetic of realism that incorporated the worn hands and weather-beaten faces of the labourers; they too, he affirmed with Eliot, must be made part of the 'the reign of art'.[14] And Hine at his best—as in his photographs of children at play—captures a vivacity in the common life by framing it within the formal symmetry of his composition [**40**].

The information environment

Riis and Hine were not alone during the late nineteenth and early twentieth centuries in bringing the increasingly popular subject of the worker into the progressive press. Frances Benjamin Johnston was, along with Jesse Tarbox Beals, one of the few women able to make a career photographing for the periodical press, including among her varied subjects stories on ironworkers and women in the mills. But Johnston's most celebrated series was taken in 1899 to publicize the work of the Hampton Institute in Virginia, which offered industrial training to poor blacks and Indians. Her dignified and serene treat-ment of these scenes of work lifts the enterprise to an idealistic level, reinforced by the often symmetrical design of her compositions [**42**]. Yet underneath the surface of her pictures a narrative of cultural trans-formation is being revealed, featuring the erasure of native cultures and the reinscription of the dominant white culture of disciplined work, where the outsider would be welcomed—at least as a worker.

As the picture press exploited the new printing technologies, pho-tographs became more and more a staple of ideational consumption. What did it mean to bring pictures of the world into the American home? There was, inevitably an opening-up, an extraordinary insertion of global consciousness into the middle-class parlour. With the smaller Graflex camera introduced in 1898—a single-lens reflex camera with speeds up to 1/1000 of a second and film up to 5″ × 7″—the mobility of the photographer was insured. The new technology allowed for the creation of a new sensationalistic category, spot news, in which random events were captured, with a premium on the first picture, the 'scoop', of a newsworthy happening. Newspapers were also

42 Frances Benjamin Johnston

A Class in Dressmaking, Hampton Institute, Hampton, Virginia, 1899
Johnston, one of the first women photojournalists, photographed a wide range of subjects for the periodical press, from workers to celebrities. Her most celebrated series was the photographs she took in 1899 to promote the Hampton Institute, a school for African Americans and Native Americans. The posed figures in this dressmaking class, enacting their work, are typical of Johnston's dignified treatments (many of them group portraits) demonstrating the training methods of the school.

43 Arnold Genthe

On the Ruins, Chinatown, San Francisco, 6 April 1906
Genthe, an extremely well-educated German immigrant from an upper-class background, was fascinated by San Francisco's Chinatown and spent the early part of his career creating one of the first photo-ethnographies of a community. When the earthquake struck, he lost most of his possessions, including his cameras, but he managed to borrow one and made a number of striking shots that show us, in the immediate aftermath of the quake, the dazed inhabitants looking around in bewilderment at their ruined city.

developing in their daily coverage such regular features as sports, fashion, and portraits. By the first years of the new century, William Randolph Hearst's *San Francisco Examiner*, along with his other papers, was proving the truth of the young Hearst's 1887 strategic analysis: 'Illustrations embellish a page, they attract the eye and stimulate the imagination of the masses and materially aid the comprehension of an unaccustomed reader and thus are of particular importance to that class of people which the *Examiner* claims to address.'[15]

The public's appetite for catastrophe was especially strong, and it was accordingly impressed with the coverage, including the few pictures of Arnold Genthe, of the 1906 San Francisco earthquake and consequent fire. Genthe had done a series of photographs of San Francisco's Chinatown—a remarkable record of street life and customs—which he fortunately had placed in safe storage. Recovering from the daze of the moment, he was able to take at least a few pictures of the demolished city and its stupefied inhabitants [**43**]. But the most significant event of the early twentieth century, World War I, went largely unvisualized by the press, except in the imagined drawings of artists. Photographers were forbidden by the English and French to photograph the action and could capture only the ruined aftermath. Long after the war was over, the hundreds of photographs taken by soldiers in the trenches surfaced, to provide a vivid retrospective.[16]

After the war, the progressive movement that had pulled social documentary into the mainstream of photojournalism dissipated as the new industrial economy brought a consumer society that boomed along as though it would never end. Moving away from social documentary during the 1920s, the newspapers and news magazines expanded their pictorial coverage with improved printing technologies, and the foundation was consequently in place for the vibrant renewal of the social documentary impulse during the Great Depression of the 1930s. The deflation of the economy at that time would again send the progressive photographer out into the field to come back with the news of what had happened, a story we will pick up again in a later chapter.

A Photographic Art

Photography is so powerfully at the centre of the arts today, both as medium and as inspiration, that it may be hard to imagine a time when it was not. Throughout the nineteenth century and into the twentieth, the camera was generally considered marginal to the arts, and the struggle to establish its aesthetic identity within the gamut of artistic modes was a deliberate one. Early photographic professionals did indeed *claim* an association with the arts—more than one daguerreotype gallery styled itself the 'Photographic Temple of the Arts'—and a few photographers with aesthetic ambitions during the first several decades created images modelled directly on painting: still-life arrangements, posed tableaux emulating narrative painting, portraits. But these efforts, however artistic, were clearly derivative. Meanwhile, many painters valued photography—but chiefly as a tool, useful to supply an image for an artist to work from in constructing a painting. As Van Deren Coke and Aaron Scharff have demonstrated, numerous artists worked directly from photographs that were taken either by themselves or others, though the painter might presume some licence with the image, omitting or adding according to the requirements of the imagination.[1]

As long as a three-dimensional perspectival view of reality remained the agreed-upon goal for two-dimensional representation, photography was an indisputable model, so effortlessly successful that French painter Paul Delaroche could famously observe at the advent of the medium, 'From today, painting is dead.' And indeed for several decades in the mid- to late nineteenth century, painting and photography seemed to have converged on the same paradigm, in which both painter and photographer were translating the view through the window (or camera lens) into two dimensions. By the late nineteenth century that had certainly changed, and painting was evolving in ways that specifically and inventively departed from realism. It might be tempting to think of Impressionism, Cubism, Surrealism, and later Abstraction, as all escapes from photographic realism, but that would be an oversimplification, not least, of course, because it supposes photography to be itself a static medium. In fact, stylistic change has been constant within photographic art, sometimes influenced by painting

and sometimes independently generated. And a more reasonable assumption might be that both painting and photography have, from time to time, shared a common shift in aesthetic modes.

Pictorialism

The Pictorialist movement of the last decades of the nineteenth century demonstrates the strongly kindred spirits of painting and photography at that time, bonded in their sentimental, pastoral, literary, and escapist tendencies. That kinship is best illustrated by Henry Peach Robinson, the most influential advocate of artistic photography in the 1870s and 1880s. Many of the cultural currents linking England and the United States flowed towards America at this time (as opposed to the twentieth century, when they tended to flow outwards to England), and the Englishman Robinson was widely promoted in the United States by *The Philadelphia Photographer*, which championed pictorial photography. Choosing sentimental genres (e.g. mourning pictures) or pastoral subjects, Robinson composed his photographs as if they were paintings. In fact, as he revealed to his professional brethren in his manual of instruction, Robinson would first conceptualize the scene, then sketch it in with pencil, then pose his models individually, putting together a final composite image which he would then rephotograph. Robinson was simply following the rules of composition, as understood at the time, but instead of painting his figures, he was photographing them as the final product.

Such posed tableau were, however, not common among American photographers, who generally preferred to look at natural scenes in the light of aesthetic values. As camera size shrank and the chemistry of photography became more portable and manageable, photography became the hobby of choice for hundreds of serious amateurs, who began taking their cameras into the fields and countryside, photographing picturesque woodland scenes, streams, gardens, houses, and bucolic farms [44]. What became commonplace within the camera clubs towards the end of the nineteenth century would extend into the broader popular taste in the early twentieth century, especially in the work of Wallace Nutting, who specialized in recapturing a sense of America's rural past in hand-coloured prints. Offering a refuge from the harshness of a growing industrial America, Nutting was also, not coincidentally, a promoter of the Colonial Revival in home furnishings at this same time.

As early as 1886 the Philadelphia Photographic Society organized America's first international exhibition of photography, including submissions from both American and European amateurs.[2] Two overlapping practices within the discourse of Pictorial photography were evolving in the late nineteenth century: the picturesque natural scenes

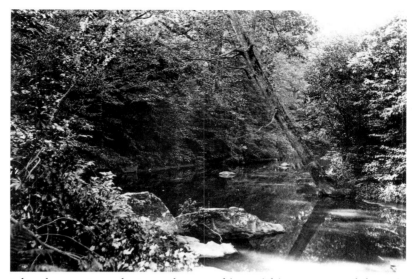

44 Charles S. Bradford, Jr
Landscape, 1890
Bradford was born into a wealthy Philadelphia family, but lived much of his life in West Chester amid a flourishing amateur photography association. Going out into nature, the serious amateur would return with the trophy of a moment in which trees, water, and land would seem to harmonize in the beauty of a scene. His rich platinum prints were exhibited at the 1886 Photographic Salon, held in the Academy of Fine Arts, the earliest exhibition of photographs as artworks in Philadelphia. Bradford's forest photographs did much to aid the conservation campaign in Pennsylvania.

taken by amateur photographers working within a camera club environment; and a narrower, more élitist conception of 'Pictorialism', one that evolved into an art photography movement that connected with the Aestheticism of *fin de siècle* Europe. It is this latter notion of Pictorialism, emerging out of the amateur movement under the leadership of Alfred Stieglitz, that by the end of the century would take photography into the art museums. This was by no means an easy transition, however, and the turn-of-the-century amateur movement was marked by internecine struggles. Over the years, with the exhibitions rotating among several host cities, a tension developed between the more artistic photographers and those advocating a broader practice of photography, including the scientific. Eventually, with Stieglitz and several of his associates from New York and Boston leading the way, the standards for exhibition were pushed far enough towards the aesthetic to cause considerable dissatisfaction among the more traditional members. In this context, Stieglitz drew his band away from the amateur scene, with its regional themes, to establish in 1902 a group called the Photo-Secession (modelled after similar European groups), which pushed Pictorialism towards a more intense aestheticism that was part of a larger international movement.

The Photo-Secession

Underlying the Aestheticism of the Photo-Secessionists was a deliberate effort to elevate photography to the level of the fine arts by answering the most troubling and most fundamental criticism of the medium: its mechanical nature. How, critics had argued for decades, could photography be an art when it was produced by a machine? Art—so went the argument—requires the workings of the hand, in

Blessed Art Thou amongst Women, 1899
A mother bends down to offer final guidance and blessing to her daughter, who is poised symbolically in a doorway, about to enter the world. The contrasting dress of the figures is reinforced by their contrasting postures. Käsebier often clothed her subjects in a literary or narrative structure; in this case the lines are from St Luke and are uttered by Elizabeth upon seeing Mary, who has just been informed that she shall conceive a child, the Son of God. The ritual moment in the Käsebier photograph suggests the purity of the young girl as she enters the world.

service to the artist's imagination; it is not a merely literal record of reality. As long as photographers were using the camera to create pictures that imitated the canons and themes of the fine arts, the medium could go only so far in establishing its claim. To demonstrate that photography was an art, photographers must overcome the mechanical nature of the medium and exhibit the photographic print as a handmade object. Accordingly, the sharp-focused, straightforward print was set aside; instead, photographers experimented with processes like gum-bichromate that softened the surface of the print, or toning processes that left a silver or golden hue; instead of a clear window on reality, the photographer strove for a more dreamy, soft-focused view. And at times, in order to show the artist's hand at work, the surface of the negative might literally be scratched to simulate the look of an engraving. Nature was represented, but the emphasis was on the mood of the scene, often enhanced by a moonlit view; the sentimental genre scene was replaced by more 'elevated' subjects drawn from mythology

and the Bible; no longer was photography taken to be a mirror of reality, but rather a reflection of the artist's subjectivity, which served the cause of Beauty.

Among the dozen or more Photo-Secessionists initially affirmed by Stieglitz, three stand out: Gertrude Käsebier, F. Holland Day, and Edward Steichen. Käsebier, one of the most widely praised of the original Photo-Secession, began exhibiting with the Boston Camera Club in 1896. Whether she was photographing the sculptor Rodin, the notorious and sensual Evelyn Nesbit (Stanford White's mistress), or the privileged of her own class, Käsebier interpreted her subjects through poses that captured a defining moment in masses of white and dark shadow. Other times—as in 'Blessed Art Thou amongst Women' (1899)—Käsebier constructed symbolic tableaux that reveal her kinship with Edith Wharton and her sensitivity to women's social lives.[3]

F. Holland Day, also a member of the Boston Camera Club in the 1890s, was born into great wealth and could indulge his own eccentric tastes and interests. His sensitive portraits featured masterful chiaroscuro effects and psychological portrayals of his subjects' dreamy states. Meanwhile, Day's taste for young boys led him to posing his semi-nude models in staged aesthetic allegories based on mythological and exotic African themes [**46**]. But his most notorious series was motivated by a desire to imitate Christ, which Day did, literally, by constructing a crucifix and himself portraying Jesus on the cross. (He also

46 F. Holland Day

Ebony and Ivory, 1897
As the title suggests, this photograph is structured in oppositional terms: the contrast between black and white, between the classical era and the present; between the heroic posture of the statuette and the quietly meditative posture of the model; between the 'primitive' and the 'civilized'. Day is exoticizing the African American here, placing his model on a leopard skin, evoking through his title the realms of Africa, an attitude that was not uncommon in the decadent *fin de siècle* period.

did a series of close-up portraits, *The Seven Last Words of Christ*.) Day was inevitably misunderstood, his work was deemed blasphemous, and the photographer retreated from the Boston press. For a short time he had a leading role in photographic circles, culminating in the New School of American Photography exhibition (1901) in London, which he organized. But Day was soon eclipsed by Alfred Stieglitz as leader of the new photography movement and did little after 1904.[4]

One of the photographers most heavily exhibited by Day in London was Edward Steichen, with thirty-five prints. But it was in association with Alfred Stieglitz that Steichen's early career most significantly developed. Coming from Milwaukee, Steichen aspired to be a painter, and a 1901 photographic self-portrait shows him, in a deeply Romantic work, 'with brush and palette'. But gradually, from his first photographs in 1895, Steichen switched his allegiance to photography, establishing himself as one of the leading Pictorialists in Stieglitz's circle, his work being featured in a double issue of *Camera Work* in 1913. Steichen's images at this time were filled with moonlight and moody landscapes, and with deep shadows that dramatized the subjective vision of their creator. In Paris he photographed some of the leading artists, including Rodin, whose bound figure of human consciousness, *The Thinker*, was treated with a subtle tonality that was a sign of the Symbolist movement [**47**].[5]

Alfred Stieglitz

Surely the central figure in photography in these years, from the late 1890s through the 1920s, was Alfred Stieglitz, whose career encom-

passed a variety of roles—photographer, editor, exhibitor—and whose influence extended well beyond photography into the broader cultural life of the country. Going to Germany to study engineering, Stieglitz was soon attracted to photography, experimented tirelessly with the medium, and began winning European competitions in the 1880s. This early exposure to European culture was important in giving Stieglitz an international perspective and an openness to avant-garde art, but he would become, after overcoming his initial reluctance to return to the United States in 1889, a staunch cultural nationalist: 'I was born in Hoboken', he wrote for a 1921 exhibition of his work. 'I am an American. Photography is my passion. The search for Truth my obsession.' In fact, Stieglitz united in himself a number of tendencies, most notably a strongly élitist desire to elevate photography to the level of the fine arts, combined with a belief in the democratic potential of the medium to reach out beyond the single print to a larger audience. Eschewing commercialism, Stieglitiz fashioned himself as a purist, though not a simple aesthete; he was a charismatic figure, celebrated by some and reviled by others.

We can take the measure of Stieglitz the cultural figure by looking first at his role as perhaps the strongest advocate for the exhibition of photography in museums, a role that climaxed in his organization of the International Exhibition of Pictorial Photography in Buffalo's Albright-Knox Gallery in 1910. By then Stieglitz had already begun to exhibit avant-garde European art at the Little Galleries of the Photo-Secession ('291') in New York, aided by Steichen, who, after 1906, began sending back to Stieglitz from Europe the new French art by Matisse, Rodin, Picasso, Braque, and others, several years *before* the 1913 Armory Show brought these figures all together in an explosive exhibition. Stieglitz closed 291 in 1917—a moment when the modern

Stieglitz and *Camera Work*

Stieglitz's frustration with the amateur eclecticism of the camera clubs led him to found, in 1903, *Camera Work*, one of the most celebrated of avant-garde periodicals and an expression of Stieglitz's own goals. In *Camera Work*, Stieglitz made visibly concrete his argument that photography should stand among the other arts as an equal, publishing—in the finest photogravure printing possible—the work of the major Pictorialists who were part of his own exclusive Photo-Secessionist circle, along with the work of the new French painters and sculptors whose Cubist innovations were changing the nature of art. And, too, in *Camera Work* Stieglitz published reviews and criticism of the arts, including photography, as well as other avant-garde writings, including the first publication in the United States of Gertrude Stein. The direction in which Stieglitz was moving, however, gradually alienated his subscription base (amateurs interested in the more traditional and comprehensible pictorial photography) and he was forced to close *Camera Work* in 1917, along with the 291 gallery. Although the battle seemed at that moment to have been lost, the modernist movement that Stieglitz had nurtured would bloom in the 1920s and 1930s.

Cubism and photography

Following Cezanne's advice to paint the underlying forms in nature—the cylinder, the sphere, the cone—Picasso and Braque began experiments around 1905 that resulted in the development of Cubist painting, which soon spread its influence to sculpture and photography. The photographer could not *create* abstract forms in the manner of the painter, but he or she could 'discover' them by framing the subject so as to bring out the abstract shapes of the scene. In practice, this meant employing the close-up to cut off a view of the whole subject and offering the viewer a section that held together as an abstract composition, organized both through geometrical shapes and the patterning and echoing of one detail against another. Stieglitz, in looking back years later on his 1907 *The Steerage*, represented his vision as having been, in effect, Cubist: 'A round straw hat, the funnel leaning left, the stairway leaning right, the white draw-bridge with its railings made of circular chains—white suspenders crossing on the back of a man in the steerage below, round shapes of iron machinery, a mast cutting into the sky, making a triangular shape ... I saw shapes related to each other. I saw a picture of shapes and underlying that the feeling I had about life.'[6]

48 Alfred Stieglitz

The Steerage, 1907

Taken on board an ocean liner bound to Europe with returning immigrants, *The Steerage* has often been read, or misread, as a portrayal of the journey to America. Stieglitz, feeling alienated from his family (who were travelling first class), was fascinated by the people in the lower steerage class, who occupied the top and bottom levels pictured here. The picture, seen by Stieglitz as a pattern of shapes, enjoyed great celebrity when it was published as a photogravure in the 1915 issue of *291* as a symbol of the new modern photography, both in subject and style.

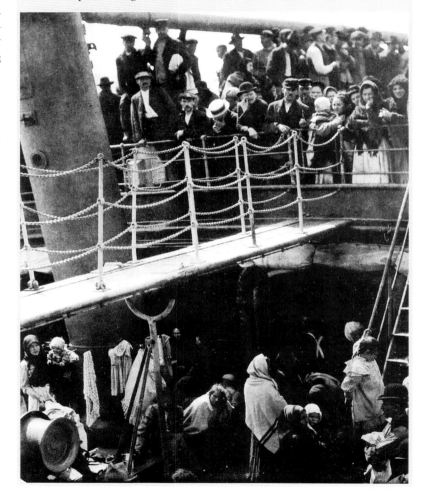

49 Alfred Stieglitz

Winter—Fifth Avenue, New York, 1893

Stieglitz waited hours for this moment, with the carriage moving dramatically toward the viewer. Challenging himself to capture extremes of weather, Stieglitz tested the limits of the camera; he then experimented in the darkroom, printing this image many times, varying the severity of the snow. He even eliminated, in one version, the vertical lines on the left.

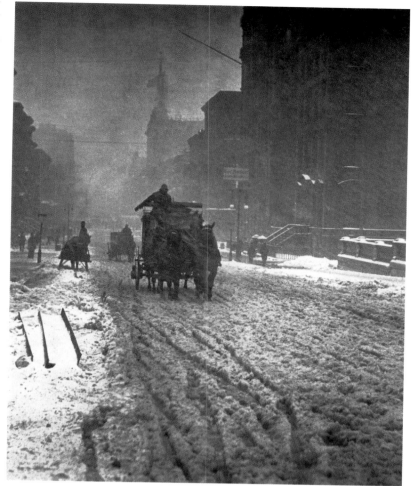

art he had advocated seemed not to have sustained its audience—but he resumed his gallery career at a more propitious moment with the Intimate Gallery (1925–9), and after that with An American Place (1929–46).

But if Stieglitz the exhibitor was important as a seminal figure in the world of the arts, he was most important as a photographer. His own early work, following his return to the United States, featured urban street scenes, subjects that were close to those of contemporary documentarians yet were approached with a far more conscious aestheticism. What is remarkable is that, for nearly two decades, while celebrating the work of the Pictorialists, with their traditionally 'Aesthetic' subject matter and soft-focused imitations of Impressionism, Stieglitz was himself producing work that was avowedly 'straight'— that is, devoid of the manipulations of the photographic plate that were so common among the Pictorialists. Instead of the literary subjects, the pastorals, the still-life images that were modelled on paintings and

were part of an older aesthetic vocabulary, Stieglitz was helping to invent the new language of modernism, with its celebration of the machine and of the urban scene—the streets and skyscrapers of a growing New York, the ferry boats and railroads, the airplanes and ocean liners. Instead of the soft-focused view and the manipulated surface, Stieglitz was testing the limits of what the camera, *as a mechanical instrument*, could do—photographing in extreme weather conditions (snowstorm, wet rainy nights) and working in the darkroom to bring out what was already there in the print. He was also learning a virtue of the camera that was all but ignored by the Pictorialists—its ability to capture the frozen moment. Waiting in a snow storm for hours, Stieglitz took a picture of a coach coming towards him with the arm of the driver extended at just the right angle [49]; waiting for a ferry to dock, he released the shutter just as the bow of the boat was approaching, nearly touching, the pier. In effect, Stieglitz was inventing the vocabulary of twentieth-century photography, with its celebration of the moment in time that could be seized propitiously by the speed of the new cameras. (Stieglitz used the vernacular term 'snapshot' in titling some 1910 photographs; Cartier-Bresson would describe the same thing later on as the photographer's effort to capture the 'decisive moment', a concept that influenced later generations of twentieth-century photographers.) Rather than dismiss, as did so many other serious amateurs, the hand-held camera as a threat to the aesthetic purity of pictorial photography, Stieglitz embraced it as a new vernacular instrument with its own unique virtues of portability, ease of use, and speed. In matters of form as well, Stieglitz was changing the composition of the photograph, juxtaposing lines and circles in a given image to create the internal visual rhythm that would mark so much of twentieth-century photography, as in his famously 'Cubist' image, *The Steerage* (1907).

And yet again Stieglitz broke new ground by expanding the modernist sense of what photography was, beyond the single image and into the multiple images that composed the photographic series, several of which he sustained during the years after World War I. One such series, carried out for approximately two decades, was the portraits of artist Georgia O'Keeffe, which became an extended collaboration between the two [50]. (O'Keeffe and Stieglitz met in 1916 and, after Stieglitz had divorced his wife, married in 1924.) Another was the series of cityscapes Stieglitz took from the Shelton hotel window where he lived for some years, capturing the changing light and structures of the city. Yet another was the clouds at his summer home in Lake George, a series of abstract images that he called 'Equivalents'. Equivalents, to Stieglitz, were external forms, often abstract cloud shapes, that corresponded to inner spiritual and emotional states [22]. It was photography approaching the condition of music, under the

influence of Ralph Waldo Emerson's transcendentalism, whereby natural facts were symbols of spiritual attitudes and conditions.

Paul Strand

Though Stieglitz was a famously cantankerous character, dogmatic in his opinions, he was also a generous sponsor and advocate of artistic genius: he was supportive over many years of the painters who gathered around his galleries (John Marin, Marsden Hartley, Arthur Dove, O'Keeffe) and, important to the history of photography, it was Stieglitz who promoted the career of Paul Strand. In the last two issues of *Camera Work* (and with a concurrent exhibition at 291), Stieglitz printed a number of photographs by the young Strand, whose prints were introduced with appropriate fanfare: his work, Stieglitz wrote, 'was rooted in the best traditions of photography'. He has added something of 'real significance . . . The work is brutally direct. Devoid of all flim-flam; devoid of trickery and of any "ism."' His photographs, Stieglitz affirmed, 'are the direct expression of today'.[7] Strand, for his part, denounced the 'handwork and manipulation' of Pictorialism, embracing instead the 'purity' of photography, which meant for him

51 Paul Strand

Shadows. Twin Lakes, Connecticut, 1915

Inspired by Cubism, Strand undertook a *Shadows* series during the summers of 1915 and 1916 which sought to emulate in photography some of the abstract effects of Cubism, translating three dimensions into two. 'I did not have any idea of imitating painting or competing with it but was trying to find out what its value might be to someone who wanted to photograph the real world.' Unlike Coburn's vortographs, Strand was aiming here at a tension between representation and abstraction.

52 Paul Strand

Man, Five Points Square, New York, 1916

Strand's candid image, taken with a concealed lens on the side of the camera, brings us uncomfortably close to the face, thus confronting in the modernist mode a direct fact. (The off-focus lends some aesthetic distance.) Strand was photographing in a lower-class neighbourhood, and the vacant stare, suggesting boredom and despair, offers an unprecedented glimpse into another person's life. The brutality of the candid intrusion anticipates some of Walker Evans's subway photographs, taken several decades later.

seeing clearly 'the limitations and at the same time the potential qualities of his medium'.[8]

If Strand's work was rooted, as Stieglitz suggested, in the best traditions of photography, it was not entirely by accident: his teacher at the Ethical Culture Society School had been Lewis Hine, who had taken Strand and his other students to Stieglitz's 291 gallery. Strand's dual inheritance—of the documentary tradition and the modernist tradition—had thus been instrumental in shaping a vision that was fresh and, most importantly, outside the parameters of the pictorial tradition. From Stieglitz, Strand may have picked up a respect for the camera's ability to freeze motion while adhering to a consciousness of form; from Hine he may have taken a documentary interest in the characters and lives of average people caught by the camera on the street.

Above all, he was inspired by his exposure to Cubism, and his experiments in abstract photography anticipated the movement, over the next two decades, to assert the photographer's vision in a modernist idiom of two-dimensionality and abstraction [**51**]. But the pull of the human subject was too strong for Strand, and he brought back into his work the lessons of abstraction combined with his deeper feel for the lives of ordinary people. Through the close-up, Strand broke through the polite distance separating the viewer from the subject, whose clothing and unaware face could be studied in extreme detail [**52**]. (In

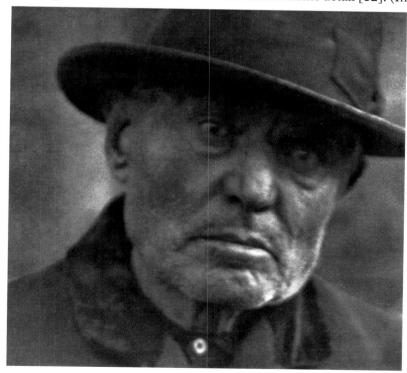

53 Paul Strand

Truckman's House, New York,
1920

Strand's application of Cubism is evident in photographs like this, which put the whole scene in sharp focus and, with extreme foreshortening and a long depth of field, create the illusion that three dimensions have been tilted up to form a strongly geometrical two-dimensional space. Choosing subjects that have been outside the boundaries of the conventional aesthetic of the beautiful, Strand has framed the view so as to pick up the rhythmical shapes of the three sheds at the bottom and the three billboards at the top.

making these close-up shots, Strand used a camera with a dummy lens, allowing him to stand next to his unaware subject and shoot him or her out of the real lens on the side of his camera, seemingly pointing straight ahead. Evidently Strand was not as devoid of trickery as Steiglitz thought he was.) Strand's approach to the urban scene was equally inventive. Inspired by the machine age and by the changes taking place in the vernacular landscape, Strand looked at such non-traditional (and non-pictorial) subjects as telegraph poles, street corners, automobiles, and building sites [**53**]. Many of these urban subjects, photographed from sharp overhead angles, came back into the silent film Strand made with the painter/photographer Charles Sheeler in 1921, *Manhatta*, one of the first art films made in the US.[9]

Modern photography: abstraction vs. the object

The art photography of the 1910s and 1920s, across a spectrum of seem-ingly quite diverse activity, evinced a shared acceptance of the camera on its own terms. Following Stieglitz and others, a new aesthetic evolved that affirmed the virtues of 'straight photography' (little manipulation of the print) and an acceptance of the two-dimensional-ity of the picture space of the photograph, which led eventually to an emphasis on abstract form.

One centre of activity was the Clarence H. White School of

Photography. White had been a leading member of the Photo-Secession, whose photographs, whether of indoor scenes or outdoor, portrayed a leisure class whose lives were delicately poised on the edge of poetry and symbolism [54]. But White broke with Stieglitz after the 1910 Buffalo show, establishing himself eventually as a teacher of far greater catholicity than the aggressively purist and dominating Stieglitz. White had begun teaching photography at Columbia University Teachers College in 1907 and went on to establish his own school in 1914. Using John Dewey's 'project method', students would go out and photograph the mundane aspects of their surroundings, organizing their perceptions so as to emphasize, in innovative ways, the two-dimensional format of the image. The White School, which included over the years Margaret Bourke-White, Laura Gilpin, Dorothea Lange, Paul Outerbridge, Ralph Steiner, Karl Struss, and Doris Ulmann, was by design eclectic, encouraging a wide range of styles from Pictorialism to documentary, and encompassing fine art and commercial art.

Following the explosive Armory Show of 1913, the seeds of abstraction were in the air, and they began to settle and take root in photographic practice over the next two decades. Strand's experiments in Connecticut had been published in the 1917 *Camera Work*, but they were not alone, for White's students had also begun to experiment with abstract designs.[10] The aesthetic premise was artist Max Weber's, a teacher at the White School, who held (following art historian Ernest Fenollosa) that 'photography is flat space art, as is drawing, painting or printing'.[11] Whatever the subject—still life, city life, portraits—students were to 'bring as much of the abstract into [their] expression as the photographic means will allow'.[12]

Alvin Langdon Coburn, who had offered critiques at the White School in 1914 and 1915, was also moving in this direction, and—inspired by Ezra Pound in England—created what he called 'vortographs', the first non-representational camera images made.[13] Coburn, who had begun his career in the early 1900s as a Pictorialist, had moved to photographing the modern city, using dramatic aerial angles. Picking up on the new currents in the art world after 1913, he began experimenting with a kaleidoscope device in front of the lens, producing his radically original vortographs which, with their sharply angled planes of light and shade, reduced photography to its abstract essentials [55]. Coburn exclaimed: 'Why, I ask you earnestly, need we go on making commonplace little exposures of subjects that may be sorted into groups of landscapes, portraits, and figure studies? Think of the joy of doing something which it would be impossible to classify, or to tell which was the top and which the bottom!'[14]

Another White student, Paul Outerbridge, who began his formal studies in 1921, would push photography even further in the same

54 Clarence White

Ring Toss, 1899

Picking up on a familiar genre scene, White's photograph captures the intimacy of the playroom and the contrasting postures of the girls at play. The composition is framed around the open space of the floor, with the opposing figures of the ring stand and the girl across a diagonal; the glare of the light in the window and off the floor contrasts with the darker areas. In this, and in other pictures around this time, White transforms what appears to be an everyday moment into a nearly symbolic one.

55 Alvin Langdon Coburn

Vortograph No. 3, 1917

Coburn's short-lived experiments in abstract photography were inspired by an enthusiasm for Cubism and the machine. Using a kaleidoscope attached to his lens, Coburn created a series of images that often feature symmetrical patterns of light and shadow. The vortographs have an edge of technological futurism, in keeping with the Vorticist movement in Britain at the time, one of whose enthusiasts was poet Ezra Pound, whose profile appears in several of the vortographs.

56 Paul Outerbridge

H.O. Box, 1922

Outerbridge has set up his breakfast cereal box of H.O. oats in such a way that the brand name is barely visible. Instead, the elaborate lighting flattens the three-dimensional form into an irregular polygon, which casts a shadow that is almost a mirror image of the box. Meanwhile, the lower left edge of the box is made to disappear in darkness. This geometrical *trompe l'œil*, a play of light and shadow, is typical of Outerbridge's extraordinary experiments in the early 1920s.

Rayograph, 1922

Taken without a camera, Man Ray's mysterious rayographs resulted from laying common three-dimensional objects on a light-sensitive paper and exposing them briefly to light. The object, blocking or filtering the light, leaves the paper white, while the exposed area is blackened by the light. Though Henry Fox Talbot had experimented with this technique earlier in the nineteenth century, it came back into vogue among European modernists, with Christian Schad's 1918 abstractions and the later photograms of Moholy-Nagy.

direction: his views of New York and his still life images are similar to those of others in the White school—cropped to emphasize abstract patterns and geometrical shapes—but his simultaneous experiments in what he called 'semi-abstraction' resulted in some extraordinary images, patterns of light and shadow in which the clear line between the two was gradually erased, through the subtlest gradations of tone [56]. Outerbridge adapted his eye to the market-place, gaining many commercial accounts by 1924, in which the abstract and fragmented treatment of the object dramatically focused the viewer's attention.

Yet another fellow-traveller in abstraction was Man Ray, with whom Outerbridge became friendly when the two were working in Paris during the late 1920s. Man Ray, born Emmanuel Radnitsky in Philadelphia, had moved to New York with his family. There he met Alfred Stieglitz in 1910 and became friendly with Duchamp, Picabia, and the other foreign and native Dadaists.[15] Moving to Paris in 1921, Man Ray came under the influence, a few years later, of the French Surrealists (André Breton, Antonin Artaud, Tristan Tzara) and 'invented', through serendipitous discovery, his famous rayographs.[16] The rayograph images—produced by placing objects directly on a light-sensitive paper and exposing the image—were eerily evocative and an instant hit with the Surrealists, to whom the mysterious images appealed as a kind of pictorial map of the unconscious [57]. Man Ray also explored during the 1920s and 1930s another kind of avant-garde imagery, the enigmatic subject: drawing upon Duchamp's incongruous juxtapositions of everyday objects, Man Ray photographed wrapped

objects, visual puns, and strangely juxtaposed things, years before conceptual art had a name.

While Coburn, Outerbridge, Man Ray, and others (e.g. Francis Bruguière) were exploring the subjective dimensions of the image—blurred lines, dream-like juxtapositions, the subtle shadings of abstract figurations—Edward Weston was moving in the opposite direction, towards a more objective photographic realism centred on a clear presentation of the object. In a sense both of these contrary movements derived from the amplitude of Stieglitz, who had located his own vision theoretically at the intersection between the two axes: a straightforward imaging of external reality that nevertheless expressed an 'equivalent' meaning relating to the inner life.

Weston, like others of his generation, had made the move from an early soft-focus Pictorialist style in the 1910s to the revelation of realism in the early 1920s; a 1915 modern art show in San Francisco was the initial catalyst, but the larger influence behind his reinvention was Stieglitz. Coming from California, where he had operated a successful portrait studio until 1922, Weston travelled across the country to New York, where he met Stieglitz and Strand. He had been moving towards abstraction for several years (albeit soft-focused), but after New York his focus sharpened, shifting away from the subjective formulation to a harder-edged portrayal of the object itself. Few of Weston's images exploited the snapshot capacities of the camera; instead, using a large-format view camera, Weston carefully lighted his still-life subjects (or portraits) so as to reveal the depths of shadows and subtleties of light reflecting off the surface [**58**]. Weston's work—'previsualized' in the

58 Edward Weston

Peppers, 1929

Weston's peppers, like many of his other still-life subjects, are framed close to the subject, but our view is not otherwise truncated or abstracted. Weston revelled in the natural shapes, especially when they might suggest some underlying erotic energy or metaphor. Thus while the 'thingness' of the object is revealed through the sharp focus and sculptural lighting, the suggestive quality is also maintained.

camera, leaving nothing to chance, deliberately created to achieve a given effect—was dazzling in its technical assurance. 'Without subterfuge, nor evasion, neither in spirit, nor technique, I have recorded the quintessence of the object or element before my lens—rather than an interpretation—a superficial phase, or passing mood.'[17] Yet as much as Weston aimed at rendering the 'quintessence of the object', it was the psychological aspects of his art that strikingly engaged the viewer.

Weston's posed peppers seemed to be embracing amorously, his rocks and seaweed revealed the sensuous details of their surface to the viewer. Where Strand would frame his subjects up close, creating a new formal composition out of the lines and curves of the object—whether machine or plant—Weston was more likely to let the object reveal its own structure, standing back far enough to frame it tightly, but on its own terms, whether it was the spiral sections of a chambered nautilus or the gothic layered structure of an artichoke. Weston's nudes were no less sensual than his peppers, but here the photographer had the advantage of being able to pose his more pliable subject in shapes that reinvented the human figure, making it unfamiliar in its beauty. Focusing intently on the intimate forms of plants, rocks, spiders' webs, trees, and nudes, Weston, along with Strand, was revealing the 'thingness' of natural things, working thus at the opposite extreme from the dreamy erasures of reality that the earlier Pictorialists had fancied. This was the American version of the New Vision or New Objectivity in European photography, which was giving a more extreme abstract shape—through constructivist angularity and foreshortening—to the formal representation of things.

Weston's dedication to revealing the maximum detail together with the maximum simplification, as he put it, necessitated the use of a sharp focus and small aperture. At its smallest opening, this is designated the f.64 stop on the camera lens, and this term became the name of a group of largely West Coast photographers who, along with Weston, were dedicated to similar goals of sharp-focused objectivity and realism. Yet within the group, styles varied considerably, from the curvaceous flower close-ups of Imogen Cunningham [59] to the high-contrast mechanistic abstractions of Willard Van Dyke to the subtly toned landscapes of Ansel Adams. The goals of Group f.64 were parallel to those of the Precisionist painters of the 1920s and 1930s, who also saw in the machine a kind of aesthetic ideal, symbolized in the sharp lines and geometric shapes of their compositions, whether the subject was organic or technological in nature.[18]

Modernism after World War II

Modernist formalism, displaced to some degree by the more socially oriented impulses of the 1930s, survived underground during World

War II and surfaced again in the 1950s, which turned against the political and social concerns of the earlier decades, in a variety of mutations. Minor White, for example, brought a technique of strong lines and subtle tonal gradations to his close-up abstractions of rocks and walls, imbuing them with a weight of subjectivity that borrowed theoretically from Stieglitz's idea of 'equivalents' [60]. Aaron Siskind, making the journey from documentary photography in the 1930s, emerged as another abstractionist in the 1950s, inspired by the parallel movement in painting. Harry Callahan, influenced by Ansel Adams, Stieglitz, and Moholy-Nagy (at Chicago's Institute of Design, where Callahan taught during the 1950s), brought a minimalist, pristine sensibility to his studies of nature and his series of portraits of his wife, Eleanor. Ray Metzker, after studying under Callahan in Chicago, emerged in the 1960s and 1970s as one of the most inventive of formalists, interested especially in urban scenes.

60 Minor White

Sun and Rock, 1948

This aerial view of the surf deliberately prevents us from knowing exactly what we are looking at; instead, White contrasts the opacity of the black rock forms, seen as abstract shapes, against the luminescence of the sun rippling off the water. White, like Aaron Siskind, liked to crop his found images up close, removing the descriptive context, in order to create an aesthetic composition; the mysterious and otherworldly quality also is typical of White's effort, following Stieglitz, to lift photography into a symbolic, spiritual realm.

Meanwhile, the Surrealist current of 1930s modernism also continued underground, surfacing in the work of Frederick Sommer and Jerry Uelsmann. Sommer's Southwest imagery—horizonless desert landscapes, close-ups of animal parts—evoked a post-nuclear world where destruction and desolation seemed unavoidable. Uelsmann's sensibility, lighter and more playful, was brought to bear on a range of subjects and scenes that teased the viewer to decipher images that seemed, from a literal standpoint, 'impossible'. With his mastery of combination printing, Uelsmann's constructions rubbed shoulders with the conceptual art popular during the 1960s and 1970s.

By the middle of the twentieth century, the arrival of photography as an art form was fully certified, as could be seen in the pages of *Aperture* magazine, founded in 1952. *Aperture* reproduced photographs in a generously printed fine-art format and affirmed, under editor Minor White (1952 to 1975), a harmony between the spiritual meaning of the image and its concrete form. Photography's arrival was visible as well in the high profile the medium took on at the Museum of Modern Art under the leadership of John Szarkowski (Director of Photography from 1962 to 1991), whose formalist inclinations expanded photography to encompass vernacular images. The modernism of the early twentieth century had opened the door to the appreciation of photographic

art on its own terms, rather than as a medium imitating painting. By mid-century, modernism had reverberated throughout photographic practice in one way or another, and the distinctive character of camera vision had become the basis for a new aesthetic of photography.

Photography and Society

6

From the very first images taken of city streets, the camera has been an instrument that could offer an incontrovertible description of social conditions. But its conscious use for that purpose in America waited, as we have seen, until Jacob Riis, at the end of the nineteenth century, and Lewis Hine, later on, undertook more systematic records of urban life, pointing the way towards reform. Hine's work for *The Survey*, as Alan Trachtenberg has argued, 'reflected a new idea in the reform movement', a shift away from a conception of individual pauperism to a broader notion of systemic problems (e.g. child labour) 'which required legislative intervention and professional expertise'.[1] Yet by the 1920s the force of the progressive movement, with its efforts at social reform among immigrant groups, had dissipated in the atmosphere of hostility towards all foreigners that followed America's involvement in World War I. The liberal attitudes and documentary strategies of a Lewis Hine were in eclipse, while the more self-consciously avant-garde modernist photographers, influenced by the new European art movements emanating from Germany and France, created a new space for photography within the art world.

By the early 1930s, the political climate had changed once again, taking a radical turn as a new generation of photographers, in response to the shock of the Great Depression, moved back once more to the social scene, trying to understand the disruptions and changes forced on American society by massive unemployment, drought, and starvation. These social changes brought documentary photography to the centre of American culture, with ramifications that would extend to all of the arts.[2] The work of these photographers was not, however, simply a revival of the documentary tradition of Riis and Hine, though Hine especially was generally a well-known and respected figure. Having absorbed the aesthetic transformations of modernism, this younger generation of social documentarians was able to produce work that was stylistically more self-conscious than the more straightforward Riis and Hine, yet still very much aware of the documentary tradition, and extending even further the ambitious social survey programmes of the earlier period.

Detail of 75

Documentary in the 1930s

One exemplary figure who carried this tradition into the 1930s while also absorbing the currents of 1920s modernism, was Berenice Abbott. Coming from the Midwest, Abbott had arrived around 1920 in New York's Greenwich Village, where she fell into a Bohemian set of writers and artists that included Malcolm Cowley, Kenneth Burke, and Djuna Barnes, as well as the pre-eminent Dadaists, Marcel Duchamp and Man Ray.[3] Escaping from the commercialism of American life, Abbott, along with a cadre of 'expatriates', went to Paris in 1921, where, looking for work, she became a photographic assistant to Man Ray, who was operating a successful portrait studio. Over the years, Abbott, who initially knew nothing about photography (thus fulfilling Man Ray's first job qualification), was eventually taking her own portraits of the leading European artists and intellectuals. And in Paris, Abbott also made the acquaintance of Man Ray's neighbour, the ageing French photographer Eugène Atget, whose archive of Parisian street scenes, taken over many years, fascinated Abbott. Atget appealed to the Surrealist sensibility by virtue of the mysteriously evocative (and often deserted) scenes and store fronts he recorded; yet he was also—and this is what struck Abbott—documenting the real world, in all of its intensely perceived detail. After eight years in Paris, inspired by the prevailing European excitement about the rapidly evolving civilization of the United States, with its towering skyscrapers and vibrant machinery, Abbott returned to New York with a determination to do for that city what Atget had done for Paris. In the face of the dramatic transformations of the urban fabric, Abbott conceived a plan, carried out over the next decade, of photographing New York City—encompassing the five boroughs, but mainly concentrating on Manhattan. With funding from the Works Progress Administration from 1935 to 1939, Abbott succeeded in documenting a moment in New York's history when the nineteenth-century neighbourhoods were rapidly being overshadowed by giant skyscrapers; when the harbours and seaways were being supplemented by vast motorways and bridges; when old shops in ethnic neighbourhoods competed with the mass-advertised goods of an increasingly national consumer economy; when the class divisions of American society were starkly visible in the differences between the poor outlying neighbourhoods of the boroughs and the glamorous central districts of Manhattan.

The resulting book, *Changing New York* (1939), portrayed the simultaneously existing layers of time in the great metropolis, including juxtapositions of old and new architecture, ornate and modern, the hanging clothesline, the streamlined bus station, the mid-town intersection crowded with pedestrians, the deserted neighbourhood streets [61]. Abbott displayed New York in panoramic shots that encompassed the skyline, and in tightly framed articulations of the negative

space between tall buildings, and in the details (doorways, shop windows, signs) that made up the urban texture. Abbott's formal strategies showed the influence of Atget in their respect for the object in front of the camera lens, simply portrayed; but they also showed the influence of modernist formalism, in their delight in abrupt angles, geometric shapes, and contrasts of foreground and background.

Where Abbott strove to encompass the whole of New York life, a more politically focused representation of streets and neighbourhoods—especially working-class areas—characterized the documentary programme of one of the most important organizations of the 1930s and 1940s, the Photo League. The Photo League emerged in 1936 out of the earlier leftist organization, the Workers' Film and Photo League, whose purpose was to supply moving footage and still photos that promoted the workers' struggle, as part of a larger international movement. In 1936, the film-makers suffered an internal

62 Walter Rosenblum

Girl on a Swing, 1938

Rosenblum, at one time a president of the Photo League, was a noted photographer and educator who, early in his career, fell under the influence of Lewis Hine. His girl on a swing is similar to Hine's efforts to capture the play of children in the city, but the younger photographer frames the girl within the dramatic context of the dark underside of the bridge, using strong diagonals to emphasize the moment of extension. The human spirit, triumphing in the midst of the urban environment, was a frequent theme of the Photo League in the 1930s.

dispute and divided into two groups; the still photographers also at this time split off into their own Photo League, a self-supporting camera club, photo school, and gallery, headed by Sid Grossman and Sol Libsohn. The Photo League expanded through the 1930s and 1940s, enlisting the older generation of Lewis Hine, Paul Strand, and Edward Weston, along with rising younger photographers like Ansel Adams, Richard Avedon, Helen Levitt, Lisette Model, and Walter Rosenblum. A culminating exhibition in 1948, This Is the Photo League (300 prints by ninety photographers), was a celebration of straight photography, and although it was criticized in some quarters for what was taken to be a 'preoccupation with the seamy side of life',[4] it was by and large acclaimed for exposing the raw urban scenes through the sensitive eyes (and feelings) of the photographer, focusing on discovered moments that were outside of the idealized imagery of 'advertised America', and invisible to the more sensational daily papers [**62**].[5] Though the exhibition included nature photographs by Strand, Weston, and Ansel Adams, it was primarily an occasion to proclaim the centrality of 'documentary' to American culture, and to reach back to Mathew Brady and Jacob Riis for the foundations of the tradition. Not long after this triumphant exhibition, the Photo League disbanded

63 Aaron Siskind

From *The Most Crowded Block in the World* series, 1940

Siskind was working in the context of the New York Photo League when he and Max Yavno undertook the *Most Crowded Block* project in 1940. The series documented the lives of Harlem residents on the street, in their shops, in dance halls, union halls, and in their homes. In this image of a man resting or sleeping, Siskind shows us the relatively comfortable surroundings that African Americans were able to create within the Harlem community; the celebrity photos on the wall suggest the pervasiveness of Hollywood ideals.

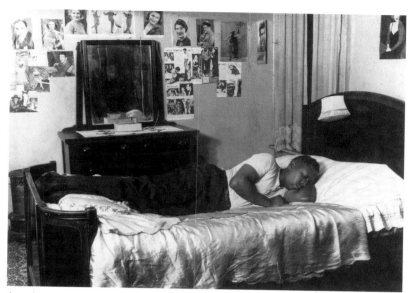

(1951), a victim of the paranoid post-war political climate, in which the US Attorney General could, in 1947, allege that the group was a 'communist and subversive organization'.

Among their projects the Photo League undertook a series of neighbourhood surveys in which street life would be featured, along with people inside their homes. One such project, begun in 1936, was a study of Harlem undertaken over a three-year period by a production unit called the Feature Group, led by Aaron Siskind. Another Harlem project, begun by Siskind in 1940 with photographer Max Yavno and black writer Michael Carter, was called *The Most Crowded Block in the World*. Although not published at the time, Siskind's photographs were eventually collected as *Harlem Document* in 1981, a portrayal of the vibrant culture of Harlem during the 1930s that featured performers at the Savoy Ballroom and the Apollo Theater as well as scenes of religious worship, street vendors, political rallies and marches, labour union meetings, and so on. Working inside their homes, Siskind also revealed the quiet, reflective moments of his subjects, all of which added a significant dimension to the more typical documentary images of streets and buildings. Siskind's work, while in the same tradition as Lewis Hine (a revered Photo League figure), showed the influence of the more dramatic angles and formal strategies of modernism.

The Farm Security Administration

If the Photo League occupied the left end of the political spectrum during the documentary 1930s, more to the centre was the work of the Federal government's Farm Security Administration documentary project (FSA), under the direction of Roy Stryker. Stryker was brought

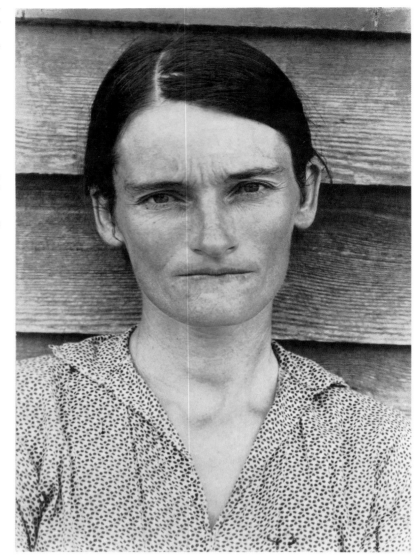

in by Roosevelt's close adviser, Rexford Tugwell, in 1935 to provide pictures that would support the goals of the Resettlement Administration (later changed to Farm Security Administration), including loans to farmers, housing projects, agricultural information, conservation efforts, etc. Stryker worked with about a dozen photographers at any given time, sending them out to different regions across the United States equipped with background information as well as 'shooting scripts' containing detailed instructions on what was needed. The resulting images were made available, free of charge, to news magazines and newspapers and for local exhibitions. The FSA archive—about 165,000 prints, 265,000 negatives, and 1,600 colour slides—constitutes perhaps the greatest collection in photographic history.

65 Walker Evans

Washstand with View onto Dining Area of Burroughs Home, Hale County, Alabama, 1936

Evans here celebrates the beauty of the simple household objects in this view of a farmhouse kitchen, creating a seductive image. It poses the dilemma of the lyrical documentary style that the photographer espoused: the image beautifies an environment that in other respects we must view as harsh and limiting. Agee deals with these issues extensively in the text of *Let Us Now Praise Famous Men*, in which this image appears. Subsequent scholarship (James Curtis) suggests that Evans may have moved objects around in order to achieve the perfection of his interior Alabama photos.

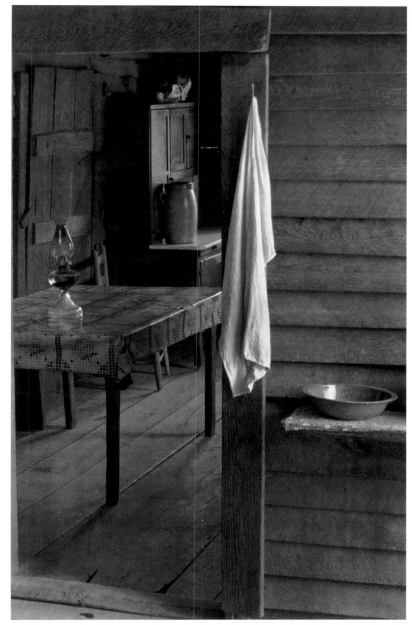

Among the photographers Stryker hired, only Walker Evans had a prior reputation, though several others were soon to join him in creating some of the most dramatic, widely seen, and memorable images of the Depression era—Dorothea Lange, Ben Shahn, Arthur Rothstein, Russell Lee, Jack Delano, Marion Post Wolcott, and John Vachon. Evans had begun his career in the late 1920s, and his early work— close-ups of commercial signs, fragments of buildings, architectural studies, street snapshots—revealed his mastery of the modernist idiom

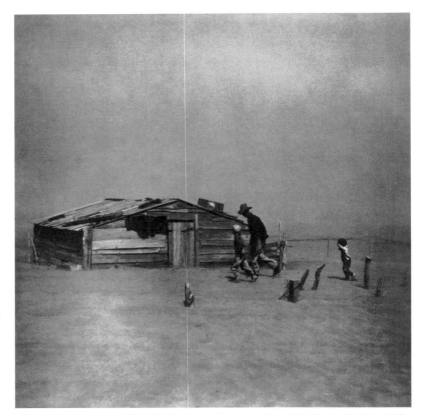

of abstraction as well as his interest in capturing the flow of urban life. These resources—unique to the FSA group—he brought into his work for Stryker, producing images that had an elegance of composition and technical brilliance. Evans favoured architectural images and landscapes, but his eye was always alert for formal resonances—repetitions, contrasts—within the image, and for the odd detail of signage or furnishings. Evans's portraits—especially the ones he made for *Let Us Now Praise Famous Men*, a collaboration with James Agee—have become icons of the 1930s, symbols of the dignity and hardship of the Southern farmer during the Depression.

Most of the FSA photographers felt deeply supportive of the goals of the government and engaged willingly in what we would now call government propaganda (Evans was an exception and produced some of the agency's greatest work by emphasizing his own individualistic vision); but to the Republicans of the Roosevelt era, support of the Federal government's liberal policies was anathema, and they tried repeatedly to close down the work of the FSA, succeeding at last during World War II, when it was renamed the Office of War Information in 1942. (In order to preserve the massive archive, Stryker managed to get it all transferred to the Library of Congress.) By then, the OWI's direction had shifted from representations of deprivation that would

justify the liberal Roosevelt policies to much more positive images of American life and of the war at home that would justify the United States' increasing involvement in the global conflict.

Although the ostensible motive of the FSA photographers had been to gather images relating to the agricultural policies of the government, in practice Stryker and his crew quickly developed a much broader conception of their documentary project: they were to provide a sociological portrait of American life, including all social classes, covering urban as well as rural areas. Their goal was to create a picture of America guided consciously by the sociological approach of Robert Lynd, whose *Middletown* had been a pioneering ethnography of an American city. In fact, the ideological centre of the FSA project was the small town, which represented to Stryker (as embodied in Walker Evans's photographs, especially) an image of America's past and values that was to be an anchor during the stormy years of the Depression.

The individual photographers working under Stryker each had his or her own concerns and stylistic strategies, but in general one might characterize the FSA/OWI notion of documentary as a deeply humanistic portrayal of social life, consciously constructed within the tradition of realism, with its empathetic depiction of everyday life and

The documentary photo book

The 1930s saw the rise of the photo book, an amalgam of text and images that epitomized the documentary mode. There was no single formula for putting together word and picture. Margaret Bourke-White and Erskine Caldwell collaborated on one of the first widely reviewed and celebrated volumes, *You Have Seen Their Faces* (1937),[6] but their use of confessedly fabricated quotes as captions for the photographs (as well as the racist undercurrent), has vitiated the book for many later readers. Dorothea Lange and Paul Schuster Taylor's *An American Exodus* (1939)[7] was partly a response to Bourke-White; it had a more meticulous standard of quotations and text joined to images that depicted the Dust Bowl migrations. Archibald MacLeish, in *Land of the Free* (1938),[8] reversing priorities, wrote a poem to 'illustrate' the FSA photographs he used, which were, he felt, overwhelming. And Richard Wright, also struck by the power of the FSA images chosen by Edwin Rosskam, wrote and re-wrote the text of *12 Million Black Voices* (1941),[9]

seeking to find the perfect rhythmical relation between word and image. Walker Evans's *American Photographs* (1938)[10] asserted the primacy of the images, which were sequenced not in terms of any external narrative but in terms of a visual progression; this set a new standard for photographic books, enlarging the meaning of any given image by virtue of what preceded it and what followed it. (Frank's *The Americans*, and others, would follow Evans's example.) But the triumph of the genre during this period was James Agee and Walker Evans's *Let Us Now Praise Famous Men* (1941),[11] presenting its subjects—three Alabama tenant farmer families—in a series of portraits and environmental shots without any captions whatsoever; the photo section was followed by Agee's extraordinary text, an examination not only of the desperate conditions of rural poverty but also of the dignity and beauty of the farmers' lives; and, not least, it was a self-examination of the whole genre of documentary and its motives.

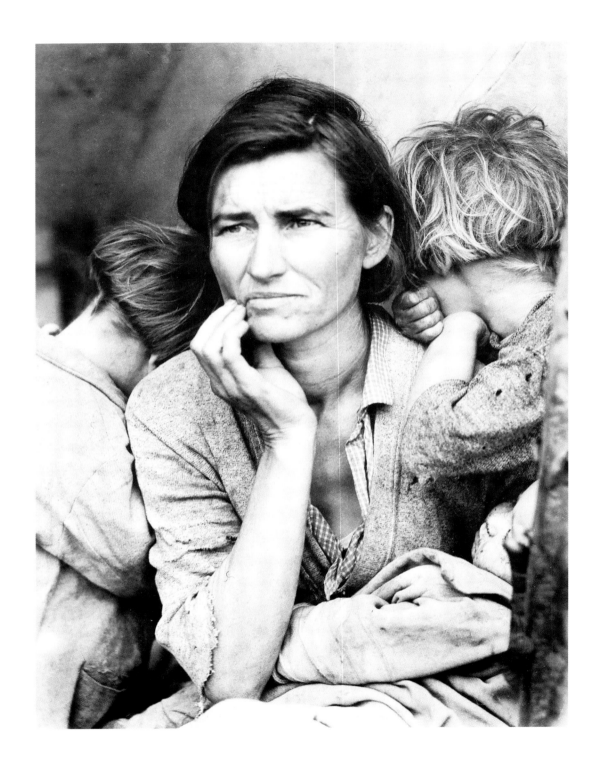

67 Dorothea Lange

Migrant Mother, Nipomo, California, 1936

Lange's portrait quickly became a celebrated icon of the Depression, embodying the pathos of the migrants' situation and their determination. Lange found the woman and her children in a squatter camp near pea fields where the crops had frozen, forcing the family to sell their car tyres to buy food. Approaching the family, Lange made several shots, eventually positioning the children at the sides, with their faces turned away so as not to distract us from the central figure, whose hand is delicately touching her chin. The image has been adapted and modified by other ethnic groups around the world.

its knowing understanding of social class. The American scene, in all its variety, was captured by the FSA photographers, with a balance between the more generally descriptive images and the more immediate portraits of individuals. Where Riis and Hine had responded to the changing composition of American society, focusing their attention on the new urban immigrant populations, the photographer in the 1930s was responding to conditions in the heartlands of America. Yet in other respects certain assumptions were continuous, from Riis to the FSA: a documentary genre was created with an understanding that the individual functioned as an emblem, a representative of a type and of a condition. To that end, the photographer was empowered to 'direct' the picture story, arranging people and things so as to get the 'truthful' image that looked unarranged; in any case, the photograph wasn't necessarily literally true, they would say, but it did represent the general truth of social conditions at the time.

After the FSA/OWI operations were shut down, Stryker went on to develop a broad-based documentary programme for the Standard Oil Company that continued through the 1940s, surveying the changing American scene across the whole of the country, with some obligatory coverage of the oil industry as well;[12] and while some of his photographers from the FSA continued to work with him, others went on after the war to work for the great picture magazines of the times—*Life*, *Look*, *Fortune*—which had also come into being in the 1930s.

The Family of Man

In some ways the culmination of the documentary movement of the 1930s and 1940s was the Museum of Modern Art (MoMA) show organized by Edward Steichen in 1955, The Family of Man, the most popular photography show ever to be held.[13] Working with photographer Wayne Miller, Steichen selected 503 images by 273 photographers from 68 different countries. The images were solicited in a global call for submissions; and they were culled from the archives of the Farm Security Administration, from the National Archives, and from the files of *Life* magazine. After its US showing, The Family of Man toured Europe, Africa, Asia, and Russia under the auspices of the United States Information Agency, which saw it as an affirmation of American values (as against cold war Russia) and of a global harmony that was the 'answer' to the strife and ravages of World War II. Steichen, whose first show as curator of photography at MoMA this was, had been inspired by the exhibition of FSA photographs at New York's Grand Central Station in 1938, which convinced him of the power of photography to excite a universal emotional response and even to move the viewer to action.

The title of the show, The Family of Man, taken from a line by poet

Title page, The Family of Man exhibition catalogue, 1955

The scope and scale of the Family of Man exhibition was monumental, and the exhibition catalogue proclaimed its importance in terms readily understood within American popular culture: 'the greatest photographic exhibition of all time'. Wynn Bullock, a philosophical photographer given to poetic imagery, provided the image for the title page, which was paired with a literary caption—this from Genesis—setting the pattern for the use of image and text throughout. Carl Sandburg's 'Prologue' also announced the grandiloquent tone of the exhibition: 'A camera testament, a drama of the grand canyon of humanity, an epic woven of fun, mystery and holiness—here is the Family of Man!'

U.S.A. Wynn Bullock

And God said, let there be light Genesis 1:3

The Family of Man

The greatest photographic exhibition of all time
— 503 pictures from 68 countries —
created by Edward Steichen for
The Museum of Modern Art, New York

Carl Sandburg (Steichen's brother-in-law), fitted the intent of the exhibition and catalogue perfectly: by showing the sameness of love, childhood, family, work, play, suffering, and death throughout the world, Steichen was emphasizing the commonalities of human experience, 'the essential oneness of mankind throughout the world', as Steichen put it.[14] But critics of the exhibition saw this emphasis on oneness as an erasure of cultural differences, a flattening of human variety into a mythical sameness, and a denial of the problematic specificities of politics and class.[15] Nevertheless, in its own political context, coming soon after the war and organized by a photographer who had taken an active part in the war effort, The Family of Man clearly did strike a universal chord, enhanced by Steichen's use of the familiar magazine format used by *Life* and others, of a rhythmic layout that varied the size of the image and of an interweaving of literary texts to

serve as thematic organizers of the exhibition. And no one could dispute the stark choice that the exhibition seemed to pose, as images of an atomic mushroom cloud and of the United Nations made clear: we can destroy ourselves or we can live in harmony.

Representing the African American

The idealism of The Family of Man was nowhere more evident than in its treatment of blacks. There were, not surprisingly, more than a few images of Africa included by photojournalists, some of which are used to illustrate tribal life; more surprising, and more impressive, was the inclusion of a number of images of African Americans by photographers like Consuela Kanaga, Helen Levitt, Leon Levinstein, Wayne Miller, and Roy DeCarava: sensitive portrayals of moments of intimacy between mother and child or between two lovers, moments of street play, moments of loneliness, and a suite of jazz photographs.

Though not explicitly political, these images were consonant with the changing treatment of blacks in the national media [**69**]. W. Eugene Smith's heroic treatment of a black Southern midwife, 'Nurse Midwife: Maude Callen Eases Pain of Birth, Life and Death',[16] a 1951 *Life* magazine feature story, for example, signalled a more positive representation of a group that had been either ignored or, worse

Picture magazines

The documentary movement of the 1930s found its largest audience in the growing number of picture magazines developed during the 1930s, the chief of which was *Life*, founded in 1936, and followed soon by *Look* in 1937. Building on the 1920s European tradition of photojournalism and on the American March of Time Newsreels, *Life*'s photographers covered stories that ran the gamut from the sensationalistic to the everyday. The chief vehicle, the picture story, was a series of a dozen or so photographs, together with text, arranged so as to catch the eye in a pleasing visual format that alternated the sizes of images. During the Depression of the 1930s, *Life* acknowledged the hard times of the country as part of the total picture, but during the 1940s and 1950s the image of America became more uniformly positive, a celebration of the nation's pulling together for the war effort, of its growing economy, and subsequently of its burgeoning post-war consumer society. In *Life*'s pages there was little social or labour conflict, and scant mention of minorities; instead, America enjoyed a consensus culture at the centre of which was the middle-class family—mom, dad, two kids, all white and Christian—who were fond of sports and Hollywood movies and celebrities, and whose view of the world placed America's democracy on high, and increasingly in cold war conflict with a monolithic notion of communism that was emerging out of Soviet Russia. *Life*'s photographers were sent all over the world, often accompanied by writers, but decisions about which pictures to use and in which arrangement were made at home by an editorial committee who kept one eye on its advertisers. *Life* remained popular up to the 1960s, when increasing competition from television eroded its audience. It folded in 1972, only to be revived as a monthly in 1978.

'Weary but watchful, Maude sits by as mother dozes', 1951

The image is from a photographic feature on nurse midwives that Smith did for *Life* magazine. His purpose in pursuing this story was twofold: to advocate advanced training for midwives and to demonstrate the professional excellence of a black woman in a Southern community health system. Smith normally liked to set up his pictures, directing the subject, but in this case the midwife's pace was so fast and concentrated that Smith could only follow and shoot as much as he could; still, by photographing from this angle and compressing the space of the room, he managed to convey the drama of the patient's need and the patience and dedication of the midwife.

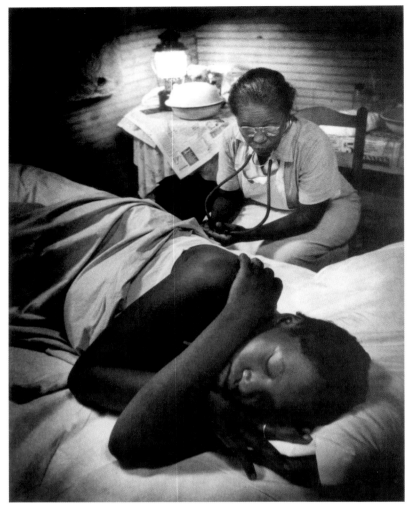

still, treated largely in terms of racial stereotypes—black share-croppers, menial servants, porters, 'Mammies', and various demeaning comic images.[17] More positive and sympathetic treatments of African American life had been rendered by the FSA photographers, most notably in Gordon Parks's 1942 portrait of Ella Watson, which showed the Washington charwoman at home, at worship, on the job, and with her family [**70**]. Parks's often reproduced portrait of Watson posed in front of an American flag, responds implicitly to Roy Stryker's challenge to photograph racism in America, for it portrays, ironically, Ella Watson's loyalty to a country in which her father had been killed by a lynch mob and she had suffered far more than her share of family deaths and misfortunes.[18] Otherwise, the violence and racism of American life had to be read into the depictions of extreme poverty and deprivation that form part of the story, at least, of Richard Wright's epic folk history, *12 Million Black Voices* (1941), which uses

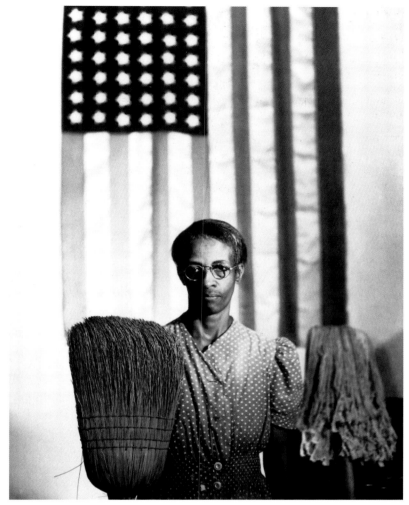

photographs taken largely from the files of the FSA by Edwin Rosskam.[19]

Parks was not the only black photographer who was producing innovative portraits of the black community during the 1930s and 1940s. Photographing in New York City, Robert H. McNeill traced the fortunes of black women looking for work during the Depression. McNeill's 1937 series, *The Bronx Slave Market*, which portrayed the employer and the potential employee, had a biting political edge that virtually assured that it would be published only in a black periodical.

In the same year as The Family of Man—1955—Roy DeCarava's *Sweet Flypaper of Life* was published, and it marked a turning point in African American photography.[20] Previously, black photographers had worked largely within the boundaries of journalism and commercial photography, the latter represented most notably by James Van Der Zee, whose imaginative studio portraits and group portraits

significantly enriched these popular genres and provided—along with many other black photographers—evidence of the new racial self-identity called for by Alain Locke in *The New Negro* (1925).[21] DeCarava's sensitive portrayals of Harlem life achieved a poetic representation commensurate with Langston Hughes's accompanying text: his images featured dramatically dark shadows and abstract atmospheric forms, out of which his figures emerge and half-emerge; to the extent that they transcended the literalism of social documentary, they reflected a general post-war shift towards a more personal, more abstract view of things, a move away from the more political motives of the 1930s. DeCarava's representation of the black community sounded a note of independence that has continued in post-war African American photographic art.

Robert Frank

Yet another photographer from the Family of Man exhibition, represented by several images, was destined a few short years later to move social documentary into another realm altogether, where many others would follow. Few would now dispute that Robert Frank's *The Americans* (1959)[22] was the most influential single photography book of the post-war era. While Steichen's exhibition was establishing an optimistic vision of the American future, joined to a future of global harmony, Swiss-born photographer Robert Frank was travelling across the US on a Guggenheim Fellowship, capturing scenes that revealed an America riven by racial conflict, loneliness, boredom, religious enthusiasm, and histrionic politics; it was a place where teens congregated around juke boxes, parked in drive-in movie theatres; a place where the television set was becoming the centre of attention wherever it was put; Frank's America was largely a picture of public space—streets, buildings, parks, hospitals, elevators, diners, gambling casinos—and, above all, the road. In a perfect match, Jack Kerouac, the acclaimed author of *On the Road*, wrote the introduction to Frank's American edition; and the Beat writers' alienation from middle-class American values, their suspicion of the power of corporations and of technology, their celebration of the moment's insight, all found a visual equivalent in Frank's volume: 'he sucked a sad poem right out of America onto film, taking rank among the tragic poets of the world'.[23] Frank saw things that some American reviewers were loath to admit, but it was also Frank's loose and spontaneous style that challenged the more conventional documentary traditions still current at the time. Photographing into the light, capturing the glare of reflected light, tolerating blurred motion and areas of deep indecipherable shadow, and favouring an off-centre framing and a sometimes tilted horizon, Frank seemed deliberately to break the rules of 'good' photography.

71 Robert Frank

Elevator—Miami Beach,
1955

Frank's deft perceptions and speed allowed him to capture images on the run that seemed to contain their own narratives. At the centre of this image, in focus, is the elevator girl's thoughtful, dreamy, yet vacant expression; she is surrounded by the blurred, rushing figures of the people around her. Frank used blurs and deep shadows to capture a more spontaneous vision of American life, one much celebrated by Jack Kerouac, who was particularly taken with the elevator girl, 'sighing in an elevator full of blurred demons'.

To Frank, the street was a place of endless fascination and revelation and in this, at least, he was building upon a tradition in American photography that could be traced back to the street people of Riis and Hine and to the urban snapshots of Alfred Stieglitz; but it was Paul Strand who provided a clearer starting point, with his close-up portraits (taken surreptitiously) of people on the street or sitting on benches. More directly, it was Walker Evans's snapshots that provided a model for Frank. We think of Evans most characteristically in terms of his portraits of buildings, objects, and people, taken in the patient gaze of his 8″ × 10″ view camera; but Evans also used the smaller, lighter, and infinitely more portable 35 mm camera to arrest scenes of immediate interest, often taken on the streets of New York [**72**]. (In addition, Evans conducted more formal and deliberate experiments in street photography, shooting passers-by in the same format and from the same spot, in Chicago and in Detroit.) And it was Evans's 1938 collection, *American Photographs*, that probably provided the inspiration for Frank's similarly entitled *The Americans*.[24]

At the same time that Frank was travelling across the country, keeping the photographic notebook that would eventually become *The Americans*, William Klein was pushing his own—even more extreme—work in a similar direction. Klein, who has been only marginally recognized in the US though much celebrated in Europe, began as a painter and abstract photographer; returning in the early 1950s to New York from France, where he had studied with Fernand Léger, Klein created

72 Walker Evans

Girl in Fulton Street, New York, 1929

Evans, fascinated by the streets of New York in the late 1920s, picked his subject out of the crowd and took several candid shots of her. Surrounded by the chaos of city life—the shop windows, the construction cranes, the signs, the street traffic—the well-dressed woman stands dramatically still, her gaze fixed intently on something outside the frame. In *American Photographs*, Evans matched this photo with the one before it, featuring a little girl with a similar expression.

Weegee

In the 1930s tabloid journalism began to make an impact. It relied heavily on the attractive power of sensational images, together with a simple text, to sell newspapers. The photographs of Weegee, seen in the daily New York newspapers, epitomized the genre, focusing on several broad themes: the underside of urban life—the seedy bars, the prostitutes, the gangsters, the murders; dwarfs and freaks; the unexpected, whether accident, fire, a street caving in beneath a cab; and the glamorous celebrities who attracted mass interest, from Hollywood to Frank Sinatra. Shot with a strong flash and in starkly contrasting black and white, Weegee's images anticipate *film noir* both in subject and style, while his own collection of images, *Naked City*,[25] with text by the photographer, became the subject of a movie and (later) television show. Weegee was interested in the act of looking itself, and often featured the voyeurism of city life as his subject. Colouring all was his own irony and detachment, a survival tool for the modern city dweller caught in the often violent machinery of urban life. Elevated from photojournalism to the museum, Weegee's striking images were exhibited during his lifetime at the Photo League and the Museum of Modern Art and, since then, at many other museums.

Usually it is the subject that catches our eye in a Weegee image, and subsequent generations of viewers, beyond the first impact of the daily newspaper, have found in his photographs permanent records of human nature—moments of vulnerability, of sorrow, of loneliness, of joy, of amazement, of relief, of fear, and of bravado. Sleeping with a police radio next to his bed, Weegee often arrived at the scene of an event before anyone else, leading some to joke that he must have used a Ouija board (supposedly a means of spirit communication) to divine the future—hence the name, Weegee. Weegee's persona seems to have fascinated his contemporaries almost as much as it has fascinated later generations: tough, smart, at times sentimental, cigar in mouth, Weegee is the epitome of the hard-boiled photographer. In later years, Weegee was inspired by his own elevation to museum status and undertook a series of trick photographs, featuring biomorphic shapes and surreal distortions. Results were mixed.

73 Weegee

'Their First Murder, 9 October 1941', from *Naked City*, 1945

In chapter four of *Naked City*, 'Murders', Weegee included a number of images of murder victims as well as several shots featuring the crowd of onlookers on the streets of New York. Here Weegee's frame contains a range of emotions, from demonic curiosity and glee to anxiety and grief. The jumble of faces adds to the chaotic feelings of the moment. Weegee's caption: 'A woman relative cried . . . but neighborhood dead-end kids enjoyed the show when a small-time racketeer was shot and killed.'

74 William Klein

Ynette, New York, 1955
Picking up where Frank left off, Klein emphasizes the chaos of twentieth-century urban life, the chance conjunction of people and circumstances in a moment of time. Nevertheless, there is an order here, not at first apparent, whereby the picture is bisected into two halves vertically: the women talking on the right are balanced by the figure on the left, who is refracted through the glass window. Meanwhile, the strong diagonals in the lower left are balanced by the shadows on the lower right.

images of the city that were ostentatiously 'bad' photographs, charged with the energy of the tabloids and a feel for the grotesque that reminded one of Weegee. Using a wide-angle lens, Klein encompassed within his frame the chaos of urban life, with motion from edge to edge; figures close to the lens were deliberately distorted, other figures were often blurred; there were abrupt transitions and angles, with a heavily grainy print texture. By such means, violating the 'rules' of good photography, Klein captured the chaos and everyday violence of urban life, where children play dramatically with toy guns pointed at the camera or at the head of another child.

New documentary photography

While Klein was relatively unknown to Americans in the 1950s and 1960s, Garry Winogrand, who likewise exploited the wide-angle lens, quickly gained recognition by virtue of his association with John Szarkowski, curator of photography at the Museum of Modern Art and—succeeding Steichen—the most influential curator of the 1960s and 1970s. Eschewing the high art tradition of Stieglitz and the institutionalized vision of Steichen, Szarkowski affirmed the individual photographer's unique eye, whether or not it originated as 'high' art or vernacular, a position that resonated with the cultural moment. Winogrand—who worked commercially as a photojournalist—erased

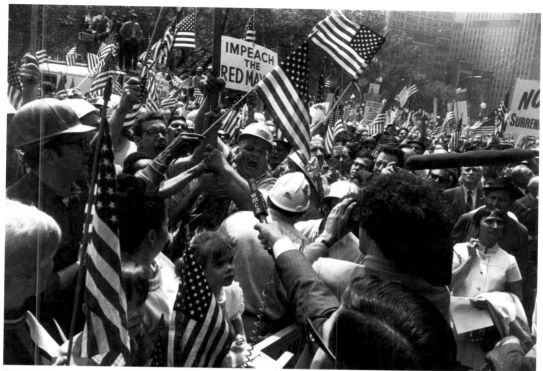

75 Garry Winogrand

Hard-Hat Rally, New York,
1969

Winogrand's typically wide-angle lens forces the eye to look away from the centre of the image, scanning the whole. Despite the seeming chaos there is, however, a clear centre: the enraged worker in the hard hat who is voicing his support for the US government (against the onslaught of the peace movement); the hand reaching in with a microphone from the lower right points to him, as does the long microphone coming in from the right. But there is another centre, counterposed to the hard hat, and that is the little girl's quiet stare at the media personnel in front of her. The 'Red Mayor' was moderate Republican John Lindsay who, given the right-wing sentiments of the crowd, was viewed as a communist.

the distinctions between genres and aesthetic categories: 'Neither snapshot, document, landscape, etc. are descriptions of separate photographic aesthetics. There is only still photography with its own unique aesthetic. *Still photography* is the distinctive term.'[26] The uniqueness of photography, to Winogrand, is established inevitably by virtue of the camera's mechanical quality, which translates three-dimensional reality into a special kind of seeing. Or, as Winogrand put it in his typically gnomic way, 'I photograph to see what the world looks like photographed.'[27]

Winogrand, along with Frank and Klein, was redefining the nature of photography by placing the spontaneity of the photographer at the centre of the photographic act: freezing motion, these photographers were catching meaning on the fly, creating an aesthetic order out of the seeming disorder in the scene before them. The process of photographic seeing and shooting was inherently experimental, its method trial and error: thus Winogrand would typically overshoot, resulting in a plethora of contact sheets. From these he would choose some thematic filter to catch the hundred or so images needed to create a book. Doing 'photography' would now mean, according to Winogrand, two deliberate stages: first, take the picture; second, choose the series of pictures to create the desired effect. *Public Relations*, for example, is thematically unified around the notion of how people relate to one another in public places, how celebrities relate to their publics, how

76 Lee Friedlander

Albuquerque, New Mexico,
1975

Friedlander takes subjects that seem almost anti-photographic, totally lacking in visual interest, and transforms them into subtle formalistic compositions. Here, the nondescript intersection, aggressively void, occupies the centre of the image, with the streets creating a nearly symmetrical foreground pattern. Overhead, the lights and lampposts extend into space, compressing the depth into a two-dimensional plane punctuated by delicate lines. Though drawn from the vernacular landscape and seemingly a random slice of life, Friedlander's pictures are clearly meticulously planned.

politicians relate to the news media, and so on. Covering the late 1960s and early 1970s, when demonstrations for and against the Vietnam War were part epic battle and part circus show, Winogrand captured the full drama of that political moment through his sharp-focused, all-inclusive frame, his unerring timing, and his sly irony [**75**].

Szarkowski's 1967 New Documents exhibition and catalogue at MoMA included Winogrand and two other younger photographers—Lee Friedlander and Diane Arbus—each of whom addressed themselves to the social landscape, but in entirely different ways. Friedlander, like Winogrand, found his subject in public spaces—shop windows, city streets, airports, tourist monuments, public buildings, suburban neighbourhoods, amusement parks, and such like; but where Winogrand contained the drama of human motion in a frozen moment of perception, Friedlander was much more interested in the interaction between person and space. There may be no human presence in a Friedlander image, or there may be a group, as at a sporting event; but in either case, Friedlander is looking for a moment when the camera lens can frame the visual play of form against form. Friedlander uses the camera to explore a particular kind of photographic seeing, in which the compression of three-dimensional space into a flat picture plane results in oddly compelling juxtapositions—of shape against shape, of the intersection of a street lamp and a fire hydrant and a dog, of the reflected surface of a window against the view through the window [**76**]. And—no small distinction—Friedlander may be the

first photographer to record the obstructions of vision in public space: instead of standing aside to get the 'correct' view, the unobstructed view, Friedlander will accept the back of the head blocking his view as part of the picture; he will photograph the dense thicket of bushes obscuring our view of the building behind it. This requires on his part an exact pre-visualization of what the picture will look like, not unlike the calculations of Edward Weston before his still-life subjects, only Friedlander is dealing with the chaos of the contemporary vernacular landscape. In fact, what is most compelling about Friedlander is the banality of his subjects, rising at times to the sublime, as in the photograph of a deserted gasoline station, bereft of any pumping islands; or in the image of the McDonald's outlet, near a railroad crossing, the scene traversed by a single solitary pedestrian going—somewhere. One either loves these pictures, or not.

The elegance and banality of Friedlander, in which the photographer's view is constantly on display, are completely at odds with the spectacular and obsessive subject matter of Diane Arbus, in which we forget the photographer altogether as we stand in awe of her subjects. Arbus is one of the few photographers of the late twentieth century to acquire the status of a legend, in part, at least, because of her suicide in 1971 (aged 48), which seemed to validate a vision focused relentlessly on

77 Diane Arbus

A Jewish Giant at Home with His Parents in the Bronx, NY, 1970

Here, Arbus steps back to give us the larger picture of the 'giant', Eddie Carmel, and his family, in order to sharpen the contrast between the 'normality' of the man's background and his ungainly size. Photographed from below, Arbus emphasizes the man's height, as he seems almost to touch the ceiling; meanwhile the lighting creates a menacing shadow on the wall behind him. But the key to the picture is the distance between the parents and their son, whom they look upon with a seeming awe and terror. Arbus herself viewed these 'freaks of nature' with awe, as they coped with their exceptional fates in a world that would often think of them as strange and frightening.

the dispossessed, the socially marginal, on those whom the mainstream of society regards as freaks—giants, dwarfs, tattoo artists, twins, men dressed as women, women as men, the mentally retarded, etc. Coming from an advantaged background herself (her family owned a Fifth Avenue department store), Arbus seemed to arrive at her subject matter naturally, as if she had seen through the hollowness of social privilege to the bottom line of human existence. To Arbus, her subjects were themselves like 'aristocrats', in having survived the traumas that 'normal' people might fear. To Arbus, and to an American audience in the late 1960s and 1970s that had seen the emergence of a counter-culture that had radically questioned what was true and of value, the outcast from society seemed to embody a kind of heroic status, an emblematic sainthood.

Arbus's technique was disarmingly simple: she placed herself any-where from a close-up position to a point far enough away to reveal a full standing figure [77]. The subject would generally confront the camera, eyes forward and challenging. Meanwhile, her preferred square format provided a neutral frame for the central revelation of the human subject itself. Yet there is a frequent tendency to overgeneralize the Arbus type, as if they are all 'freaks' of the same genre. In fact, Arbus's attitude towards her subjects seems to have been divided: when they are socially marginal figures, Arbus is usually most empathetic in her portrayal. But a fair number of her subjects are those for whom she felt little sympathy—those whom we might view as 'beautiful', 'aver-age', or simply vain of their appearance. She had the knack of making these subjects look faintly ridiculous; and there are yet others for whom our response is itself ambivalent—do we laugh or cry?—as we, and perhaps Arbus herself, are not quite sure how to respond to a given subject or situation, a response not unlike the one elicited during the 1960s by black humour or the theatre of the absurd.

The 1960s and 1970s were marked not only by the alienation of Arbus or the irony of Friedlander. There was also, at the other extreme, a strong commitment to social change, a revival of the passion of the 1930s, visible in the work of the photographers who covered the civil rights struggles of the decade. Some of the most powerful images of the period are those reflecting the social transformations in the South, as African American Freedom Riders, joined by whites, tested Federal laws guaranteeing integration in public transportation and other previ-ously segregated places, against the resistance of Southern law, custom, and tradition. The march on Washington in 1963, the Ku Klux Klan bombing in Birmingham a month later, the sit-ins at lunch counters, the breaking of traditions and boundaries at schools—all of these trau-matic events were captured by photographers in magazines and newspapers that were solidifying public opinion behind the efforts of the protestors. One such photographer was Danny Lyon, the first staff

78 Danny Lyon

Atlanta, 1963–4

The political clarity of the picture and the drama of the moment are captured here in one of many photographs by Lyon that document the civil rights movement from the perspective of the movement itself. Lyon shows, in other photographs, demonstrations and sit-ins, meetings, idle moments, and the aftermath of violence. Lyon's caption: 'One of high school student Taylor Washington's numerous arrests is immortalized as he yells while passing before me. The photograph became the cover of SNCC's [Student Nonviolent Coordinating Committee's] photo book, *The Movement*, and was reproduced in the former Soviet Union in *Pravda*, captioned "Police Brutality, USA".'

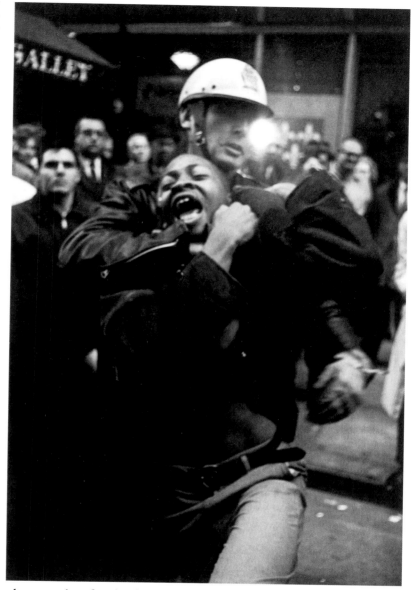

photographer for the Student Nonviolent Coordinating Committee (SNCC), who covered the movement from the inside, recording the moments of determination, of sadness, of terror, during the course of the early 1960s. He brought together his work in a 1992 volume, combining his narration together with documents relating to the struggles: *Memories of the Southern Civil Rights Movement*.[28]

Later in the 1960s, Bruce Davidson, who had also covered the civil rights movement of the 1950s as a photojournalist, brought his large view camera and tripod to a neighbourhood in Manhattan, photographing the streets, the people, the interiors, of this one location, in a

79 Bruce Davidson

Untitled, 1970

Working within the tradition of urban documentary, Davidson photographs people in their homes and on the streets, but his approach typically emphasizes some dramatic angle or contrast, giving his images a formal interest as well. Like many of Davidson's images, this one, from the book *East 100th Street*, features large areas of deep shadow, as he foregrounds the wall of the apartment building against the open sky above and the surrounding apartment houses beyond. The picture gains its immediacy from the boy running with his kite, an image of freedom and play—but in this case limited by the length of the rooftop.

study whose geographical focus recalled Siskind's studies of Harlem ('Most Crowded Block'). By making himself deliberately visible, Davidson was refusing the usual privilege of the photographer, to shoot and run. Instead, he was there to make himself, at least temporarily, a part of the community. The resulting volume, *East 100th Street*,[29] is rooted in the tradition of documentary that Jacob Riis began in the 1880s, but Davidson's attitude towards his subjects is completely different: where Riis looked at them from a position of social superiority, Davidson tries to level the field; where Riis evinced subtle (and sometimes not so subtle) disdain for his subjects, Davidson was

80 Helen M. Stummer

Sharell Showing Easter Dress to Grandmother, n.d.

Stummer, returning to a neighbourhood in Newark over many years, has recorded the lives of its inhabitants with empathy, showing us here the girl's pride in her new dress from an angle that includes the watchful look of, one presumes, a member of her family. Stummer is deliberately bringing into the same frame the girl's fine dress and the kitchen range.

strongly empathetic, showing us the full range of their lives, in a way that they—the subjects—could accept and approve [79]. (As they did, according to Davidson, when the exhibition was mounted.[30]) In Davidson's street, we see sadness, we see determination, but we don't see defeat or despair. His subjects allow him to view their intimate lives and their loves, and the photographer pictures his subjects in surroundings that reveal the distance between the dream of domesticity and the reality.

A similar motivation informs Helen M. Stummer's Newark project, begun in 1980; she has returned repeatedly over the years to follow the course of peoples' lives in one particular section of one of the most impoverished sections of Newark. Looking at her subjects with empathy and understanding, and with a shrewd sense of the circumstances of their lives, she focuses on the 'dignity, beauty, and hope that continue to live despite the desperate battle for survival'.[31]

America seen from the outside

The distance between the dream and the reality is even greater, far greater, in the documentary project of Jacob Holdt, *American Pictures* (1992).[32] There is no harsher or bleaker picture of America than that produced by Holdt, who hitchhiked around the country in the early 1970s, living largely off the generosity and bounty of strangers, while he documented conditions of poverty that are among the most shocking and disturbing images ever made about American life. Holdt's view—like that of Robert Frank before him—is that of an outsider; moreover, like Jacob Riis, Holdt is Danish and not unaware of the parallels between himself and his fellow countryman and photographic predecessor. But where Riis assimilated into American society, adopting the perspective of a reformer from within the culture, Holdt remained adamantly an outsider, looking with perpetual astonishment at the savagery of racism in the United States.

Some of Holdt's early pictures were published by the Black Panthers, but on his return to Denmark, Holdt displayed them as part of a slide show in his father's church. (His father, like Riis's, was a minister.) And Holdt would continue to present his work in that format, providing a narration to accompany the images (as Riis did, in fact), eventually expanding his presentation to recordings, music, automated slide projection—a well-travelled show on college campuses in the US throughout the 1990s. Holdt's personal presence is oddly understated, yet at the same time charismatic, carrying the audience into his world through the force of his perceptions and the honesty of his declarations about himself. That honesty is at the centre of the printed volume, *American Pictures*, published first in Denmark in the late 1970s, and expanded into an English language version in the 1990s. Holdt narrates

81 Jacob Holdt

Untitled, n.d.

Sitting forlornly amidst the rubble of his room, Holdt's subject seems the epitome of despair. The television set, whether working or not, is behind him, with a vase of flowers, real or artificial, on top. Virtually every photograph in Holdt's *American Pictures* is of human subjects, most of them impoverished and broken. But there are others where Holdt shows us the determination and vitality of the ghetto; and still others where we see the social context surrounding it— the middle class, the upper class, the extremists of the Ku Klux Klan, and so on.

his own travels through the quite contrasting social worlds of the US— for he is adopted not only by the poor, but also, on occasion by the middle class and wealthy, and not infrequently by women who are charmed by this foreigner. (At one point he is briefly engaged to a Rockefeller; but he escapes gratefully back into the ghettos.) Holdt's descriptions of the brutality of America's racist society are detailed and vivid, and they provide the context for the pictures, which show the Native American and, chiefly, the African American underclass of the US as tired, defeated, sick, injured; but also loving, determined, playful, politically engaged. It is not a simple portrait, and it gains strength from its complexity and contradictions, and above all because of the cumulative effect of the hundreds of pictures Holdt presents. The layout of *American Pictures* is not designed to feature individual photographs, nor to show them as 'art'; in fact, Holdt's style can best be described as unsubtle, at times brutishly naïve. Even so, the intent is to elide aesthetic issues, to make the content, the literal reality of the images, speak to the viewer in language that is unembellished. *American Pictures* is one of the most powerful indictments of racism, but it is also a work that refuses to take a scolding tone, as Holdt discovers in himself the grounds of white racism, implicating the reader as well, white or black, in the complex violence of our racist society.

Holdt focuses primarily on the lives of his subjects. Yet another

strong statement by a foreign photographer, *The New American Ghetto* by Camilo José Vergara,[33] focuses on the environment of poverty, the urban ghetto, and its transformations over the last twenty years of the twentieth century. Berenice Abbott had, in the 1920s and 1930s, observed the rapid changes in the material fabric of the American city and had sought to record the moment before it passed unrecorded. Vergara's point is different: to show the change itself, from 'before' to 'after', creating in effect a kind of time-lapse photography that reveals the way whole areas in our cities have decayed into ruins, or have been flattened and cleared, or else—on occasion, however infrequent—been successfully rebuilt.

Like Holdt, Vergara presents his images in a narrative context that insures their meaning. But where Holdt's narrative is impassioned, anecdotal, and revolves around his own interaction with his subjects, Vergara's aims for a more objective description of social change in the last decades of the twentieth century. And once again, this strong and comprehensive view of American urban life is conditioned by Vergara's outsider perspective as well as by his academic background in sociology. Vergara, born into a wealthy Chilean family that eventually lost its fortune, was educated in the United States thanks to the generosity of still wealthy relatives. Graduating from Notre Dame, he came to New York City in the 1960s and began taking street photographs in the rundown neighbourhoods of the city. But Vergara was dissatisfied with his photographs, which he saw as part of the general failure of photojournalism at the time, which could show always the same surfaces but failed to provide any real understanding of social change or of the deeper issues of urban decay.

Beginning in 1977, Vergara took thousands of colour slides and photographs, concentrating primarily on parts of New York City; on Newark, New Jersey; Chicago, Illinois; Camden, New Jersey; Detroit, Michigan; and Los Angeles, California. Returning to these areas over the years, Vergara observed that his accumulated record of many thousands of photographs began to cohere around certain themes—'housing, commerce, industry, institutions, parks, and vacant land. As my work progressed, other subjects surfaced—for example, responses to the environment, expressions of cultural identity, and traces of history in the form of discarded objects.'[34] The resulting volume reflects that analytic organization and is a virtually unique combination of word and image: mixing personal narrative, description of place, and sociological analysis, Vergara raises profound questions about the cost of racism and the future of our cities. At the same time, the visuals in *New American Ghettoes* have a deliberate, formalist edge to them: images of the same place at different times are paired on the same page or across two pages; thematically related images are grouped together for comparative effect; certain powerful single

images occupy half a page, shared with text. Vergara deliberately employs full lighting, avoiding shadows, to achieve maximum descriptive effect. Moving from the urban panorama to the streetscape to the single building to the close-up, Vergara offers a variety of perspectives on his subject, shooting in both black and white and in colour. Yet, finally, there are no easy answers in sight. With giant skyscrapers abandoned in the central downtown areas of cities like Detroit, the solution is elusive: preserve them as monuments to a passing age, as Vergara suggests? Or raze them and start all over again, a solution requiring massive capital. Vergara demonstrates the power of documentary photography to enter into the most important dialogues about the future of American civilization.

Bearing witness

To examine American civilization in the late twentieth and early twenty-first century is to see it, inevitably, as part of an interconnected global culture; and documentary photography, addressing itself to the most ambitious themes of our time, has itself likewise taken on a global perspective. Thus America is only part of the story in Sebastião Salgado's *Workers* (1993),[35] the Brazilian photographer's critique of our global economy and a monumental homage to the industrial worker. To understand workers in any particular part of the world, from South Dakota slaughterhouses to Ukrainian automobile factories, from the

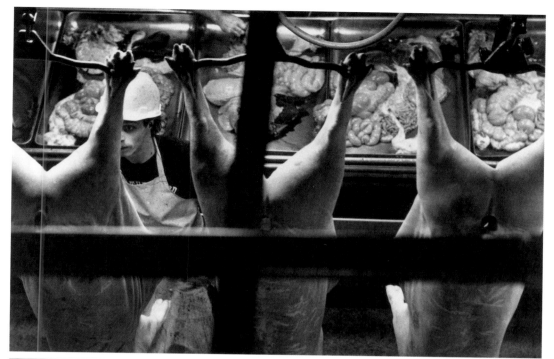

83 Sebastião Salgado

Slaughterhouse, Sioux Falls, South Dakota, United States, 1988

Salgado's strong sense of composition is evident here: the three pigs, hung upside down, divide the picture space vertically, while the horizontal space is divided by a foreground structure and (in the background) by the vats for the innards. Catching the eye of the worker, Salgado creates an image of intense—and slightly demonic—concentration. His dramatic sculptural lighting turns an image of slaughter into an image of beauty.

gold mines of Brazil to the irrigation projects of India, one must view them as part of an interconnected global economy that reflects the domination of the First World over everywhere else. Salgado's celebration of the worker is at the same time an indictment of global capitalism.

Salgado's images balance an often sensationalistic and shocking subject matter against an alluring aesthetic treatment [83].[36] And if he arouses at times an ambivalent response in the viewer, he is not alone among contemporary documentary photographers, who are all dealing with the same dilemma: how to establish an equilibrium between style and subject, how to attract the eye to the often repellent subject matter but not distract the attention by self-conscious aestheticism.

Susan Meiselas solves the problem in a different way: where Salgado works on an epic scale, with frequently huge panoramas and striking tableaux, Meiselas operates at a closer distance to her subject, looking for the key moments that tell the story. In her first book, *Nicaragua,*[37] a study of the violent overthrow of the Somoza regime from June 1978 to July 1979, Meiselas uses colour to great effect: an orange red fire blazing in the middle of a neighbourhood intersection; the red hat of a guerrilla; a child staring up at the yellow, blue, and green plastic GI Joe toys [84]. Meiselas portrays the complacency of the ruling élite, the determination of the ragtag revolutionaries, the fighting in streets littered with corpses, the horrors of mutilation, and the eventual triumph of the guerrillas. Where Salgado, Vergara, and Holdt insert themselves

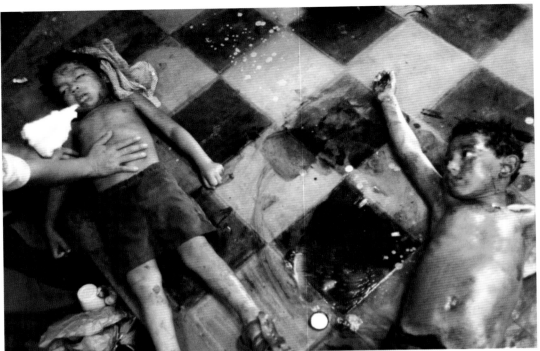

84 Susan Meiselas

Children Rescued from a House Destroyed by 1,000-pound Bomb Dropped in Managua. They Died Shortly After, 1978–9

Meiselas frames her subjects tightly, concentrating our attention on the main point of interest. In this case, the boy on the right reaches towards his friend on the left, who is close to death. The helplessness of the children, lying dazed on the floor, is mitigated only by the hand reaching in to help from the left, though it is in fact too late. The monochrome nature of the print moves it into an almost dream-like space. Meiselas uses colours sometimes to saturate her prints, either in green, or orange, or—as in this case— an ochre.

into the report, exploiting the subjective dimensions of the observer, the design of *Nicaragua* is more studiously objective: the pictures appear without captions in the first part of the book. And in the second, they appear again, in miniature black and white format, with captions underneath, thus separating the shock and impact of the photos from our informed response and understanding of them in context. In addition, Meiselas supplies a variety of documentary sources, printed in telling excerpts, that provide the primary materials for an understanding of the Nicaraguan revolution and its background.

Many other American photojournalists have chosen to bear witness to the horrors of the late twentieth century, from David Duncan in the Vietnam War, to most recently, James Nachtwey. During the last decade of the twentieth century, Nachtwey travelled throughout Europe and Africa (Bosnia, Romania, Rwanda, Somalia, Sudan) photographing the ravages of war, ethnic strife, dictatorships, and hunger. The results, in the massive volume, *Inferno*,[38] are horrific, in a photographic tradition that stretches from Brady and Gardner's Civil War battlefield scenes to the Nazi concentration camps to the killing fields of Vietnam and Cambodia. Nachtwey's images are probably more shocking and stupefying than anything we have seen previously, showing us the monstrous treatment of children abandoned in hospitals for the incurable (Romania) or the slaughtering of the Tutsis by the Hutus in Rwanda [**85**]. The human body has never seemed as expendable, as fragile and tortured a vessel, as Nachtwey shows it to be. *Inferno* is shot

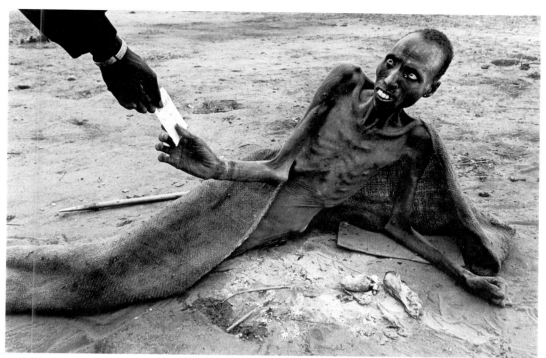

85 James Nachtwey

Somalia, 1992

Nachtwey's composition is simple and strong. A hand reaching in from the left, either giving or receiving a piece of paper, seems to have some significance. But what can it mean, given the context, in which the man lies near death from starvation? Nachtwey is not afraid to push our sensibilities to the breaking point, portraying the true ghoulishness of war, starvation, torture, mutilation, as he has forced himself to look at it.

exclusively in black and white, the images grainy and grey. And with captions presented at the very end of the book only, the images must be confronted without text initially, forcing us to encounter them without the mediation of language. (The captions—and Nachtwey's brief introductions to each section—are descriptive, understated; the images are allowed to express the full emotional weight.) Some images are given a two-page spread; others are placed four to a page, with the intention of creating a kind of pictorial narrative, building to a cumulative effect, rather than placing the burden on one image only.

Nachtwey is dealing with the problem of all documentary photography in the twentieth century, articulated first by Susan Sontag in *On Photography* (1977):[39] how to overcome our habituation to shocking images, how to make us feel the burden of our own responsibility. Certainly, in terms of content, these are among the most disturbing images ever photographed; but they are also constructed in a way to excite the eye, with strong angles and frequent use of aerial perspective, preventing the dullness that might otherwise come from looking at hundreds of photographs. Nachtwey employs close-ups of mutilated faces, full body photographs of corpses, and images of persons left to die, whether in the open field, the closed room of a hospital, or in the remains of buildings and towns. As despairing as these images are, Nachtwey's purpose is to change the viewer's attitudes towards these deadly struggles, to provoke feelings of outrage that can be translated into political action, to restore order where none could be found. These

are not photographs of America, but they are made for American eyes, one might say, demanding that the fortunate First World not excuse itself from moral responsibility because it cannot 'see' the evil in the rest of the world. As Nachtwey explained in an interview, 'It's meant to be a kind of visual archive, so that this work will enter into our collective conscience and our collective memory.'[40]

It would be easy to despair in the face of the conditions that are the bread and butter of documentary photographers; and it might be equally easy to argue that the effect of photography is minimal, that it is the vestigial, ritual expression of a liberal political philosophy that has proved its powerlessness to change the world; that its primary function is to assuage the conscience; that after all, as Martha Rosler argues, 'Documentary, as we know it, carries (old) information about a group of powerless people to another group addressed as socially powerful.'[41] Refusing to perpetuate such 'victim photography', Rosler constructs, instead, her own documentary about the Bowery—'The Bowery in Two Inadequate Descriptive Systems'.[42] This, as its title suggests, deconstructs the twin pillars of documentary—the word and the image—calling our attention to the process of naming and seeing and describing reality, rather than to the reality itself. Such exercises in irony are useful in bringing us back to first principles, but they also, by critiquing the notion of charity, paradoxically open the door to a kind of moral lassitude.[43] If we deny the possibility of documentary photography to change, or at least modify, the way we see things, we deny the possibility for any discourse at all and consequently of any political movement. Yet it remains to be seen whether the liberal documentary tradition can yet survive into a new century in which cynicism is not only the privilege of intellectuals but also and even more emphatically of politicians.

One indication that documentary photography maintains its function as a kind of social glue comes from the innovative project, *Here Is New York: A Democracy of Photographs* (2001). Formulated in the wake of the 11 September 2001 World Trade Center catastrophe, the mission was to solicit photographs from all sources—professional and amateur alike—dealing with the incidents and effects of the attack. It is particularly interesting that the organizers stress the democratic nature of this exhibition, affirming in the collective mission of the project a way of reconstituting the bonds of society:

in keeping with its democratic and truly populist nature, which the organizers feel is not only appropriate to the events of 9.11.01 but intrinsic to their understanding, all of the pictures are hung identically, unframed and without names, stressing the fact that the significance of the exhibition lies in its content, in its breadth and its multiplicity—not in the source or significance of any one image or group of images.[44]

A later development was the invitation to every photographer to contribute the story of the photograph on videotape, for public access and archival storage. On display at several storefront locations, in New York museums, and on the internet, the exhibition features thousands of photographs, which can be purchased, with proceeds going to the WTC Relief Fund. The ongoing and ever-expanding exhibition of photographs not only involves large numbers of people in the creation of the series but creates a kind of community of photographers and viewers, focused on the tragedy of September 11 and its aftermath, and dealing with its implications for all aspects of our lives, from the everyday to the broadest view of global culture. In creating a common experience, the exhibition builds on the tradition of documentary photography to inform and educate, but the project removes issues of power and authority from the table, hence the subtitle, 'a democracy of photographs'. The unprecedented collaboration restores a necessary social function to documentary photography just at the moment when one might have thought it was entering a stage of profound self-doubt.

Versions of the Self: Memory, Identity, Autobiography

7

To see a photograph is, inevitably, to see a picture of the past. And this quality of the photographic image—its ability to preserve indefinitely a record of what happened—contributes to that strange space we enter when we look at old photographs, as if we are nearly there, nearly at that moment when the picture was taken. For this reason, the camera has functioned ever since its invention as a kind of time machine, bringing us back in time to a moment in our own past lives, or in the past lives of our loved ones; and we may look back even further, into our ancestors' lives, distant in time and place from our own. Many of the mental images we have of our lives in the past are in fact based on the photographs that remain for us to look at: seeing them, we might remember the recorded moment, or, looking more closely, we may see things in the image that we did not initially remember, but that can tell us much. Not surprisingly, photography has functioned—whether for amateurs creating a photo album or for artists creating a photo-autobiography—as a medium for self-representation and, looking backward, for the construction of memory. Yet given the nature of the camera as a mediating instrument, the photographic image is not quite the clear window into the the self or into the past that one might naïvely assume it to be.

Memorial photography

Still, the evidentiary and memorial power of photography is confirmed by the early practice, quite widespread in the mid- to late nineteenth century, of photographing the deceased. Coming at a time when 'mourning pictures'—which simulated a living moment in the bereaved family's history—were not uncommon among those who could afford them, the camera provided a rather different image of death. Limited by the fact of the corpse itself, the photographer typically sought to portray the deceased as sleeping—at times on a bed, at times (for children) in the arms of a parent, and at times in a coffin [86]. The softening of death in this manner allowed the mourner to feel some

Detail of 92

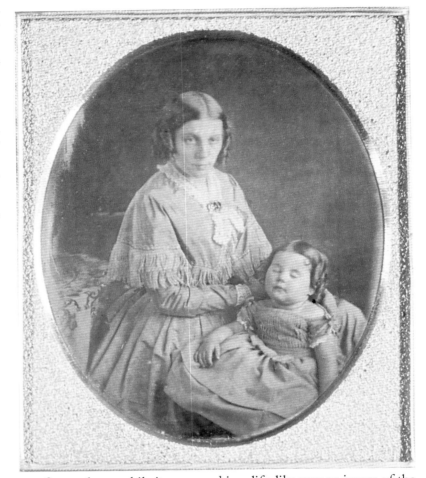

comfort, at least, while it preserved in a life-like way an image of the lost loved one. 'By heliography, our loved ones, dead or distant, our friends and acquaintances, however far removed, are retained within daily and hourly vision', Marcus Aurelius Root wrote in 1864. 'To what extent domestic and social affections and sentiments are conserved and perpetuated by these "shadows" of the loved and valued originals, every one may judge.'[1] And, as anthropologist Jay Ruby has pointed out in his study of mortuary photography, the practice has continued throughout the twentieth century to our own time, though seldom openly admitted by its practitioners.[2]

We are now accustomed to seeing photographs of the dead in jour-nalistic photographs, where they bear witness to the accidents and violence of contemporary life. But the corpse can still have the power to shock us as a subject, especially when it is rendered fetishistically, as an aesthetic object. Drawing upon the tradition of mortuary photog-raphy, contemporary photographer Andres Serrano did a series in 1992, *The Morgue*, in which the convention of the sleeping corpse is

*The Morgue (Pneumonia
Death)*, 1992

The disturbing subject here is
in conflict with Serrano's
exquisitely aesthetic
treatment, which uses
symmetry, a sharp contrast
between the white head cover
and the dark skin, and the
lighting of the head so as to
leave one side in shadow, the
other reflecting light. Looking
up at the head from the chest,
the sight fills the frame,
pushing us uncomfortably
close to the subject.

sustained, but also turned upside down [**87**]. Serrano's intent is not to comfort us by the resemblance of the dead person to a sleeping body, but to defamiliarize and depersonalize the dead body. Serrano's subjects, victims of disease or violence, are photographed up close, so close as to make us uncomfortable with, yet keenly aware of, the materiality of the body—the flesh, pores, skin colour, weight of the flesh. Forced to contemplate the body as the quintessence of dust, as sullied flesh, the spiritual dimension of the sentimental tradition in American death photography evaporates.

Within the tradition of memorial photography, the work of taking the picture is performed by the professional photographer, while the work of memory is performed by the subject's family. These two functions, of photographing and remembering, are brought together, however, in the family album, where pictures of family and friends are created by the family itself and where the meaning of the pictures derives from and depends upon the shared intimate knowledge of the family. (Nothing demonstrates the dependent meaning of the family album more surely than the album that is picked up in an antique store long after the sponsoring family itself has dispersed to oblivion: images that had once held the whole of a life's memories and sentiments are

transformed into opaque signs, telling us little or nothing about the individual pictured.) The practice of collecting images into an album for personal use and sharing originates in the 1850s and 1860s, when images taken by photographers and often sold in photographic galleries were put into albums of tintypes, *cartes de visite*, etc. This type of album is, of course, quite different from the self-authored album, where the maker or makers tell the story of themselves and their family. The latter type of album—which develops in the 1890s and continues to our own time—reflects a radical shift in photographic practice, from the professional to the amateur, a shift that coincides with (and is caused by) the invention of cameras that afforded the user an ease of operation and portability that had previously been impossible.

Family albums

The amateur's interest in photography may be primarily aesthetic (the camera clubs fostered this type of work, beginning in the latter part of the nineteenth century) or, more commonly, it may consist in a desire to document the person's own life and family. With the increasing speed of the camera around the turn of the twentieth century, it became possible to photograph a range of subjects not previously recorded by amateurs: leisure scenes around the home, featuring subjects in a relaxed and sometimes unposed state; formal parties and celebrations, where the subjects may be lined up for a group photograph; the extended family of favoured pets, posed and unposed; special events, such as graduations or homecomings; family adventures at the beach, at amusement parks, or camping. Tourist pictures were (and still are) especially popular, with the subject standing like a prop in front of one famous site after another, emblematizing, one might say, the conspicuous consumption of leisure. These types of images, and others, form the common currency of photographic family albums for a hundred years, beginning around 1900.[3] While the similarities among these albums point to the power of convention in the making of self-images, the need to confirm a certain average existence, and sometimes an ideal family life, may also be evident, especially when the albums are constructed in the face of otherwise powerful national stereotypes, as is the case with African American family albums, for example. As photographer Clarissa Sligh puts it, 'I rarely saw anything positive about blacks in the newspaper. Making a family album was, for me, a reaction to all the negative imagery that was in the daily newspapers, one way of resisting those stereotypes.'[4]

One of the chief cultural agents in creating the family album in America was the Kodak camera. The snapshot camera revolutionized the taking of pictures by virtue of its simplicity and ease of operation, so easy that children could take pictures, especially in the popular

2404

TO PUBLISHERS:

Please insert this advertisement in your publication as per written order. Be sure it occupies contract position.

EASTMAN KODAK CO.

If it isn't an Eastman, it isn't a Kodak.

The Story of the

KODAK ALBUM

It's the intimate, personal story of the home—a picture story that interests every member of the family. And the older it grows, the more it expands, the stronger its grip becomes; the greater its fascination.

Ask your dealer or write us for "At Home with a Kodak."

EASTMAN KODAK COMPANY,
ROCHESTER, N. Y., *The Kodak City.*

89 Carrie Mae Weems

'Dad and Son-Son', from
Family Pictures and Stories,
1978–84

The relaxed pose of father and
son makes this family portrait
look like a conventional
snapshot, a picture of filial
piety; but Weems's caption, a
tale of violence and mayhem,
seems to contradict the image,
calling into question the 'truth'
of photographs. We might
wonder about what other
secrets lie hidden beneath
seemingly peaceful family
photos. The caption reads:
'Hands down, Dad and Son-
Son really love one another.
But when they're drinking
things have been known to get
out of line, ya know. Well, the
last time they were on "full,"
one thing led to another and
before anyone knew what was
happening, they'd both
whipped out pistols and
boom!! Fired on one another!
When the smoke cleared there
was daddy laying on the floor
wounded and Son-Son
standing over him holding his
head crying, "Daddy, daddy,
I'm sorry." Look, I'm telling you
my folks can get way crazy.'

Hands down, Dad and Son-Son really love one another. But when they're drinking things
have been known to get out of line, ya know. Well, the last time they were on 'full', one thing led to
another and before anyone knew what was happening, they'd both whipped out pistols and boom!!
Fired on one another! When the smoke cleared there was daddy laying on the floor wounded and
Son-son standing over him holding his head crying, "Daddy, daddy, I'm sorry." Look, I'm telling
you my folks can get way crazy.

'Brownie' model—sold in 1900 for one dollar, with film available at fifteen cents for a roll of six. More often, children were themselves the subjects of the family's photographic records, with the taking of pictures becoming, as Nancy Martha West has put it, 'an obligatory act of preserving memories as defense against the future and as assurance of the past'.[5] With Kodak's object being to put the camera into as many hands as possible, their advertising campaigns pictured the camera as a witness to 'the fishing trip, the ball game, the picnic party, the dog and the pony and even the dolls and Teddy bears', as one advertisement put it.[6] Family gatherings, holidays, travel, and vacations—all were to be recorded by the camera and placed ultimately in albums that would be treasures to look back upon, bonded securities of family identity.[7]

The family snapshot has inspired the work of several late twentieth-century photographers, who, like other artists, have drawn on the popular arts and vernacular forms ('low' art) for their own 'high art' work. Using what visual anthropologist Richard Chalfen calls 'home media' as a foundation, photographers have explored issues of identity and family as well as issues of representation and memory—all preoccupations of postmodernism. Carrie Mae Weems, the African American artist, is one example of this turn to the snapshot, and indeed all of her work has a visually straightforward quality, coupled with an underlying political purpose that is often conveyed through the joining of words and text in a conceptualist format. Impelled by the need to put her own family forward, against the stereotyped image of blacks, Weems is not afraid to record a range of emotions and relationships. *Family Pictures and Stories* (1978–84) is just that—pictures accompanied by stories—a form that draws on Weems's own background in folklore as well as her family tradition of telling stories. 'Dad and Son-Son', for example, shows us a picture not unlike what we might find in anyone's album, but underneath that placid, posed exterior, the narrative tells (in short compass) of explosive violence, of love, of shame and forgiveness [89].

Transforming the family snapshot

Where Weems's connections are to the world of folklore, Richard Avedon's are to the worlds of fashion and popular culture. One of the great photographers of the twentieth century, Avedon has explored the portrait in much of his work, and not least in a series based on his father, *Jacob Israel Avedon*, the subject of a 1974 exhibition at the Museum of Modern Art. Avedon's portraits are, deliberately and self-consciously, explorations of character and of the peculiar moment that is the moment of photography: 'A photographic portrait is a picture of someone who knows he's being photographed, and what he does with this knowledge is as much a part of the photograph as what he's

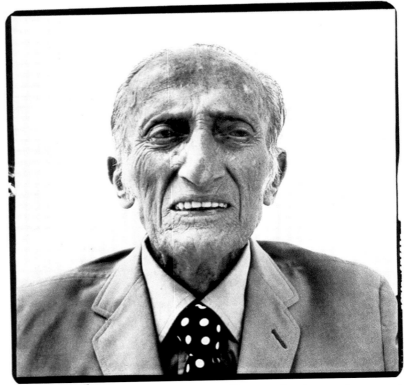

wearing or how he looks.'[8] Unlike Weems, Avedon eschews text, relying instead on the power of the image itself to convey the complexity of meaning he is intending to represent. With his series of portraits of his father, Avedon evokes the traditions of family snapshots, except that these pictures look nothing like family snapshots: taken close up, and with uncompromising clarity of focus, they reveal the stages by which Avedon's father, suffering from terminal cancer, moved towards death [**90**]. The knowledge of that fact, on the father's part and on the son's, gives this series a tragic dimension that transcends the individual portrait, as we meditate on the connections between humans that are and are not contingent on the flesh.

Where Weems and Avedon take the family picture in the direction of something we might call 'truth', others have taken it in the direction of fantasy and the imagination. In a room occupied by simple furnishings and an indistinct portrait of a married couple on the dresser, an old woman—the presumed occupant of the room—turns away in a blur from a young woman standing beside her who is stolidly flashing her exposed breasts to the photographer. What can be going on, we wonder? Emmet Gowin, who made this photograph of his wife Edith and her grandmother Rennie Booher, in the latter's home, frequently took his family as his subject, exploiting the rural Virginia environment where he lived during his early years. Gowin, a major figure who

91 Emmet Gowin

Edith and Rennie Booher,
Danville, Virginia, 1970
In this image some unspoken
communication between the
photographer and his wife
Edith resulted in her
spontaneously baring her
breasts, as if to return us,
amidst the banality of the
setting, to the generative
power of sexuality that is the
foundation of the family, or to
the difference between youth
and old age. Gowin's work
often takes us to another level
of psychological or
metaphysical experience.

is generally underestimated, often took the conventions of the snap-shot as his starting point, subtly changing the 'rules' of snapshot composition, or lighting, or the 'desired' expression of his subjects, or the expected background. In many of these Virginia family pictures, Gowin's wife Edith is the photographer's collaborator, and her look back into the eye of the camera—and into the eyes of the viewer—reverses, or at least challenges, the power of the male gaze behind the camera, opening up a dimension of self-revelation and autonomy that is otherwise denied to the subject. Gowin, an admirer of James Agee's *Let Us Now Praise Famous Men*, manages to find a photographic equiv-alent of Agee's powerful renderings of the poetic and the sacramental in everyday life, even as he translates some of Agee's conscientious ruminations on the power of the observer over the subject.

Sally Mann, inspired by Gowin, has also taken her family as her main subject; like Gowin, she too has moved on to landscapes, although with different results. Mann began her most famous series, *Immediate Family*, in 1984, sustaining it for twelve years while she explored the intimate lives of her children, as well as their Virginia home in the Shenandoah Valley [**92**]. (In a concurrent series, still in progress, Mann has portrayed with equal intimacy her own marriage.) Using an 8″ × 10″ view camera and working in black and white, Mann's prints are

92 Sally Mann

Easter Dress, 1986

At the centre of this image, the photographer's daughter stands, primly holding out her new dress, white against the otherwise dark and vaguely threatening surrounding landscape. Her posed figure is framed by the randomness of the scene: an old man at the left, in motion (her grandfather?); her little sister looking down, her brother in a costume, a dress of some sort on a clothesline, and a nondescript animal in motion behind her. The innocence of the central figure, surrounded by the confusion of the everyday, is a frequent strategy of composition for Mann.

sensuously produced, startling in their romantic chiaroscuro effects, atmospheric renderings, and formal surprises. Still more startling are their revelations of the world her children move through, a world that is common enough to merit easy recognition—insect bites, cuts, and bruises, bed wetting, playing at being grown-up, or just lying around; yet a world that also can take on an edge of danger and the grotesque, as Mann moves in for a close-up of a boy's torso stained with popsicle-drippings, or magnifies the stitches on a wound. The body is, finally, Mann's subject, its sensuous experience in the Southern heat of Virginia, its contacts with the earth and water, or with dead animals, and its knowing posturing before the camera's eye.

Mann's work has been widely celebrated, but there has also been an undercurrent of moral concern, a questioning of the legitimacy of portraying children in poses that are at times precociously sexual and created specifically for the camera's eye. 'The sitter has no idea what the photographer is doing with them or to them under that hood', as Mann has herself admitted.[9] Yet the children have given their consent to these pictures, as Mann has affirmed, and seem none the worse for them. In any case, the photographer has enlisted her family in acts of collaboration that evoke with tenderness the difficult poetry of growing, living,

and dying. Mann has carried on her exploration of the drama of the South in her more recent landscape photographs of Virginia, Georgia, Mississippi, and Louisiana, sensuous gelatin silver prints, in which deep shadows and luminous light evoke a sense of place that is filled with nostalgia and mystery.[10]

Letting the subject speak

Where does the 'meaning' of the photograph reside? In the reading of a member of the family, or in the subject's? In an outsider's reading? There is no single answer to that question, of course, but we must wonder, in viewing intimate images of family, if even the photographer and subject would share a sense of the image's meaning. We can only wonder, however, for the subjects of these photographs by Weems, Avedon, Gowin, or Mann are essentially mute, pictured for us, but not speaking to us. What would they say if they saw these images and could reflect on each one? The very notion that the photographer might allow his or her subjects actually to speak for themselves is a relatively new one, but it has become of increasing interest as the dynamics of the power relationship between photographer and subject have become of greater and greater interest. Allowing their subject to speak is exactly what another group of photographers has been trying to do in recent years, thus exploring the nexus between photographer, subject, and image, and opening up the medium of photography beyond the silent image alone to something more like what W. J. T. Mitchell calls an 'imagetext', defined as 'composite, synthetic works (or concepts) that combine image and text'.[11]

One of the first to explore this composite imagetext was Jim Goldberg, a social documentarian photographer, who in the late 1970s began photographing people at the lower end of American society, in transient hotels, asking them to look at the pictures he had made of them and reflect on their lives in captions that ultimately were handwritten on each page, along with the photographic image. Goldberg's initial effort—to construct a myth of 'noble poverty'—soon gave way to a sense of the despairing conditions that entrap the poor, and he turned his attention, for relief and for the sake of comparison, to the wealthy. The title of his resulting 1984 volume, *Rich and Poor*,[12] suggests the essential question Goldberg is exploring in this powerful study: What difference does it make whether one has money or not? Can poor people be happy without the material goods of our consumer society? Can rich people be happy surrounded by these same goods and privileges? Goldberg began by wanting to affirm some generally optimistic sense of American society and its possibilities, but ended by producing a book that is far more complex and in some ways more despairing than any we might imagine, as the pain on both sides of the social divide is

We are a contemporary family.
We don't want to be ~~part~~ of the masses.
We want to live with style!

JoAnn Roberts

93 Jim Goldberg

'We are a contemporary family . . .', from *Rich and Poor: Photographs by Jim Goldberg*, 1985
The environment, in Goldberg's work, often tells us more than the subject alone would be able to communicate. Here, two ordinary people (and their ordinary baby) are posing on their bed, in a room that seems devoid of decoration, save for the cactus plants; we wonder if their own words are congruent with what the picture is saying.

revealed, in both pictures and texts. Yet while there is no perfectly consistent correlation here between happiness and wealth, in general those with money feel more power and self-satisfaction, than those at the lower end, whose powerlessness becomes evident to us and to them [93]. And occasionally, functioning as a social satirist, Goldberg allows his subjects to hang themselves with the rope of their complacency, as when a wealthy artist affirms, 'If you want to stunt your growth, be rich'.

Though the pictures and texts convey an impression of objectivity in this act of collective self-representation, Goldberg is shrewd enough to admit, in an 'Afterword', his own power of manipulation. Given his hours of interviewing, he was, he realizes, directing the way his subjects would think about their lives, based on the questions he would

ask. And one might conclude that the final comments his subjects have written on their respective pictures reflect Goldberg's own attitudes as much as they do his subjects'. But in fact there is no predictable pattern, no uniform response to these portraits of the self: across the social divide, some reflect on the dreams that seem unfulfilled by the picture's image, while others affirm their dreams for the future; where some see the sadness of their bodies and lives, others proclaim their own beauty; and some are aware of the contradiction between how the picture makes them appear and how they feel inside. Where two people are pictured (sometimes in a marriage, sometimes as master and servant) Goldberg often prints two facing images of the pair, with two sets of responses. Again, the results are not uniform, and often not what we, as viewers, might think as we look at the pictures. Some are even aware that these are the photographer's own versions of their lives and that they are responding to that subjectivity. 'I don't like this picture. I was acting for the photographer. I am not a lonely person in a busy room. I have spunk.'[13] Can we believe it? Or is the picture of the lonely girl on the bed a 'truer' image of her life? Can any one picture sum up our lives—or can anyone sum up his or her life in a single reflection? Can we trust, one wonders, Goldberg's effort to present the subject's emotional 'essence'? Finally, Goldberg wants to implicate us—the viewer—in this circle of interpretation, aware of the multiple subjectivities involved and yet seeking some sort of illumination that might break the boundaries between us.

A similar purpose motivates two other projects from the mid-1990s which explore a narrower social niche than Goldberg's—the lives of the homeless: Howard Schatz's *Homeless: Portraits of Americans in Hard Times* (1993) and Mary Ellen Mark's *A Cry for Help: Stories of Homelessness and Help* (1996).[14] And in both cases, the photographs of the homeless are accompanied by the subjects' own words, speaking about their lives, their trials, and their hopes. Yet there are differences: Schatz's photographs have a studio quality to them, ennobling their subjects through careful lighting against a black background [94]. Schatz wanted to depict the homeless not as types, but as individuals, and he uses a sharp focus to bring out details with clarity. They are similar in that respect to Andres Serrano's homeless series, though Serrano uses colour and a life-size format. Unlike Serrano's, Schatz's subjects are allowed to speak, and their stories, because they are longer than Goldberg's very brief reflections, give us a fuller sense of their being. Mary Ellen Mark's portraits were taken in homeless shelters and were published on behalf of the HELP organization (Housing Enterprise for the Less Privileged), founded by the US government in 1986 as a model for transitional homeless care. Mark's treatment of her subjects is not unlike her characteristic documentary approach: the drama of the unusual, the eye-catching is what she is after, whether in

94 Howard Schatz

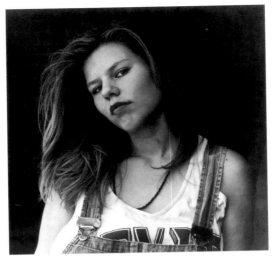

Penny Rodriguez, 18, San Francisco, California, 1993
The caption reads, in part: 'I live in the park. I try to get a place to stay. I hustle. I try to stay alive. I get things and sell them for a higher price. Weed, crack, little dresses; I go in shops and steal, and I sell it for a lower price. I've been living like this for about three years. I was abused. All through my life. It still happens now. My parents are well off in money, but they're not well off in the brain. My parents are separated; my mom, her main concern is herself. And my father, it's the same thing; he wants his needs met, and they don't need to have a child. I stayed with my boyfriend, hustled, and did a lot of things I regret . . . I'm pregnant . . . I'm going to have the baby, and I'm going back to school.'

the background setting or wall decorations, the gesture or posture of her subjects, the angle of her approach or her composition. Her book likewise uses text based on interviews with the subjects (conducted by an assistant), although the pairing of textual voice and image subject is not always congruent.

Goldberg, Schatz, and Mark allow their subjects to help construct our response to their images through the inclusion of the subjects' own voices, though in each case the photographer maintains his or her position as creator of the image—and the book. Photographer Jim Hubbard goes one step farther, crossing the boundary that keeps the camera in the photographer's hand. Working among homeless shelter children, Hubbard discovered the children's fascination with his camera and conceived the idea of putting the machine into their own hands. This is not an entirely new idea. In 1964 the visual anthropologist Sol Worth, following Malinowski's much earlier injunction to 'grasp the native's point of view' (1922), made the distinction between a 'documentary' (made by an anthropologist) and a 'Bio-Documentary' (made by the subject). Advocating the latter method as a necessary dimension of understanding the world view of the Native American, Worth in 1966 conducted the Navajo Filmmakers Project, in which motion picture cameras were put into the hands of Navajo Indians.[15] In putting still cameras into the hands of the homeless children with whom he was working, Hubbard was motivated by a slightly different purpose—to allow the children to express themselves, to allow them the sense of empowerment that comes from framing your own perception, stepping back and distancing yourself from the immediate environment; and some of Hubbard's youngsters developed a strong interest in becoming photographers themselves [**95**].

We can also, according to Hubbard (who is reiterating Worth's premise), understand the children's world better through their own

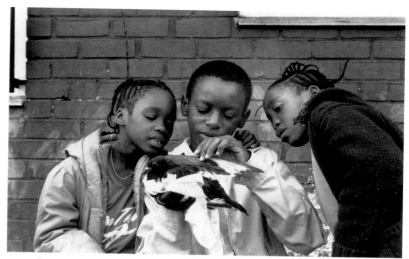

95 Charlene Williams

Untitled, 1990

The photographer was eleven years old when she took this image. The caption reads: 'My favorite picture that I took: that's me and my brother and my sister with a pigeon. My brother had found a pigeon, and the pigeon had been shot in the wing. My brother was trying to fix it, so I just told my brother to look at it, and I just put the timer on, focused it, and I ran over there to get into the picture. I want to be a photographer . . .' The response of another viewer is also recorded: 'I saw your picture, Birds, in the exhibition in New York. I saw it from way across the room and felt drawn to it . . . The girl on the left, her teeth show, like she understood pain and in that instant, experienced it for the bird.'

eyes than we could through the eyes of a professional photographer, for the children have the trust of their subjects in a way that an outsider might not. Whether or not this is true—after all, photographers also can gain their subjects' trust—Hubbard is helping his subjects, as they photograph their family and immediate neighbourhood, to produce a kind of extended family album and to identify themselves with the power of the image-maker, who fashions the view that others see. We might question how autonomous this view really is, given that the photographer may well influence the 'naïve' picture taker simply by the mode of instruction he or she employs, suggesting, however subtly, what makes a 'good' picture. Nevertheless, the voicing of the subject—through subject-authored captions or through the subject's taking of pictures—represents a conscious break with tradition and a healthy enlargement of the discourse of photography. Forcing a collaboration between photographer and subject, it ultimately tells us more about the subject's identity than we would otherwise know, and allows the individual to represent his or her self in a way that would otherwise not have taken place.

That these efforts to photograph the powerless in our society were initiated during the Reagan–Bush era is no accident: during the 1980s and early 1990s Congress worked hard to cut funding to housing, social services, job training, education, health care, and mass transit, resulting in a huge increase in the numbers of homeless people in American cities. Photographers' attempts to increase their visibility was part of a larger effort by private citizens, in the face of government indifference, to help the poor and homeless.

Besides this effort by photographers like Schatz and Mark to incorporate the homeless into the 'family of man', the family album has expanded its meaning in other ways as well. The album in the traditional sense—a bound book with pages of photos pasted in—is, at the

Yet another expansion of the family album genre is visible at Lorrie Novak's website, *Collected Visions* (http://cvisions.nyu.edu/mantle/index.html), begun in 1996. Novak, a photographer and installation artist, had earlier discovered the power of projecting her own family photographs, elaborately staged and accompanied with music, in a darkened room. She then extended the notion to the web, collecting several thousand family images from viewers who wished to contribute them. The images are sorted into various groups (e.g. 'childhood memories', 'family folklore', 'family secrets') and they are indexed so that the viewer can retrieve them in various other groupings (e.g. 'parents and children', 'pets', 'birthday party', 'crying or pouting', and also by time period). Viewers are invited to submit their own responses, stories, reflections, to the website for inclusion; and they are invited to submit their own family pictures, with or without a written text reflecting on them. Novak's intention in mounting this extended family album is to exploit the internet as a site of interaction among strangers who, using this vehicle, are willing to share their intimate memories with the world. Where Steichen had willed into being a 'Family of Man' from the collected visions of photographers around the world, Novak has opened the door to viewers to participate in the making of a giant virtual family album, and bring their own memories, pictures, responses. The whole process is an aleatory one—depending on chance encounters within the structure of the framework.

We know that people respond to their own family albums with stored memories—the narratives associated with each image—and also with a sense of discovery at times, as they think themselves back into a past time.[16] What Novak has discovered, to our surprise and perhaps even shock, is the interchangeability of family images. The surrogate images, retrievable in standard generic categories, act as catalysts for the viewer's memory. Novak's work raises some profound questions about the relationship between photography and memory: what memories make up the individual? Is there a limit to the range of memories that will be triggered by photographs? Is it the very generic quality of these family album images that allows them to function as surrogates? There is obviously no 'correct' response to these images, but does the owner's response have a certain 'authority' that the others don't have? It is almost as if the cyberspace album posseses a diffused collective personality of its own, seeking some sort of validation.

beginning of the twenty-first century, still very much with us. But it is being complemented by the digital album, as images are transferred to CDs and files. More spectacularly, it is being translated into web pages open to the whole world to browse. So, for example, doing a search of 'Family Snaps' yields well over a hundred thousand websites—with some 'hosted' by commercial companies—mounted by ordinary people who are happy to share their memories not only with their families and friends, but with strangers as well, who may find themselves fascinated yet mystified by these typical representations in a genre they recognize as familiar, but with faces unknown. Perhaps the most extraordinary example of this trend is Lorrie Novak's *Collected Visions*, an internet family album, inviting the viewer—from anywhere—to contribute captions and photos.

Expanding the self-portrait

The photographic representation of the self, a practice that is embedded in our everyday culture from albums to the internet, has been taken to more complex extremes by certain photographic artists who have translated the vernacular habits of self-recording into the art of the self-portrait, often with an obsessive edge to it. A range of practices can be seen in the work of Nan Goldin, Andy Warhol, Sol LeWitt, and Francesca Woodman.

Nan Goldin's *I'll Be Your Mirror*[17] (occasioned by a 1996 show at the Whitney Museum) begins with a series of self-portraits in the mirror, establishing the theme that dominates this retrospective volume covering twenty years of her work: for the photographer's gaze—calm, impassive, non-judgemental—is directed at herself as much as at the social life she follows, the demi-monde of fashion and prostitution, of drug addiction and HIV, of punk art, ballrooms, bedrooms, and bathrooms [**96**]. But the second 'frame' for this volume is the set of pages that follow, two wrinkled pictures of her sister taken from a family album (a memorial tribute), followed by dozens of snapshots, taken by Goldin from her teen years and on, arranged as a collage. The whole of Goldin's work is a kind of extended family album, a loving tribute and record of her close friends and associates (many dead from AIDS), that portrays a world that is very far from the 'normal' lives we might associate with family photography. Trying to preserve her own innocent eye, accepting what she sees, Goldin strives for a kind of realism that holds the mirror up to our society: 'What I'm interested in is capturing life as it's being lived, and the flavor and the smell of it, and maintaining that in the pictures.'[18]

Goldin's attraction to the social margins places her in a line that originates with Lisette Model and Diane Arbus, but Robert Frank's

96 Nan Goldin

Self-portrait Battered in Hotel, Berlin, 1984

In addition to reflecting her social world, Goldin often mirrors herself, as here. Staring directly into the mirror, the photographer offers herself as victim and witness, her black eyes unashamedly documenting the brutality of a relationship. At the edge, another reflection adds yet another witness to the revelation. Somewhat incongruously, the strand of pearls suggests a social occasion, in the past or future.

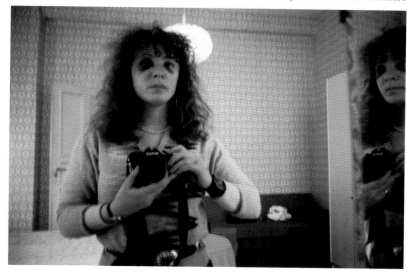

synoptic *The Americans* also stands behind her work, with its admittedly narrower scope. But where Frank explores the public world—roadside bars, parks, streets—Goldin's narrative examines the private interior spaces occupied by the fringes of a wasted youth culture, recalling Larry Clark's portrait of the outlaw drug culture of the 1960s, *Tulsa*.[19] Though individual pictures by Goldin can be powerful, it is their cumulative effect that can finally overwhelm the viewer, and Goldin's descriptive narratives can function like stills in some ongoing motion picture. In fact, Goldin's first major work, *The Ballad of Sexual Dependency*,[20] evolved through several versions as a slide show with accompanying music, and the book versions of her works have had a similar exemplary narrative quality. (In later works she has focused on the lives of individuals rather than a cross-section of society.)

Like Goldin, Francesca Woodman acquired the status of a cult icon in the late twentieth century, but where Goldin's camera recorded a densely emotional social world, Woodman focused largely on her solitary self, crafting her work within a feminist discourse that examines the way the female has been pictured by the male gaze and by society generally. Extremes of seductivity and sexuality, exaggerated and parodied, run throughout her work, along with more formal and abstract explorations of the body in relation to the containments of space. Woodman's career was cut short abruptly by her suicide in 1981 at the age of 23, but with the Wellesley College show in 1986, Woodman became celebrated (mythologized, A. D. Coleman would say) by influential critics like Rosalind Krauss and Abigail Solomon-Godeau.[21] Woodman's images, influenced by Surrealism, have a literary quality at times, as they pose the body often in conjunction with quasi-symbolic objects and employ a caption that serves as a conceptual bridge to the image. And, typically, Woodman employs an extravagant and self-reflecting image, as in *I could no longer play, I could not play by instinct* (c.1977), where she seems to comment implicitly on the traffic in imagery that inevitably defines the self in the late twentieth century. Caught in the act of self-mutilation, Woodman 'bleeds' photography.

Andy Warhol occupies an immense space in twentieth-century art, and at the centre of his interest was the notion of the replica, or perfect representation—whether of a Campbell's soup can, a Brillo box, or a dollar bill, a newspaper advertisement or front page, and so forth. The camera—the machine for making a copy of reality—naturally fascinated him, and he used existing photographs as the subject for a good many of his multiple silkscreen representations, turning the head of Marilyn Monroe, Elizabeth Taylor, or Chairman Mao into pop icons. And, like Goldin, Warhol often carried a camera with him, copiously documenting his social life, his friends, and himself. Warhol returned to the photographic self-portrait throughout his career and was especially fascinated with the photo booth and with the polaroid, both of

97 Francesca Woodman
I could no longer play, I could not play by instinct, Providence, 1975–78

Woodman cuts off the body at the neck, compelling us to focus on the partially revealed breasts under a black robe; in the right hand is a knife, quivering and blurred, as if it has just cut open the woman's chest. But along with blood, what seems to be coming out of the body is a roll of developed film, as if from a drugstore photo booth, with several images of a woman's face—presumably the woman pictured here. Open to a variety of interpretations, this image obviously suggests Woodman's self-destructive impulse, yet it distances us from the act by the substitution of photographic prints for the woman's life blood.

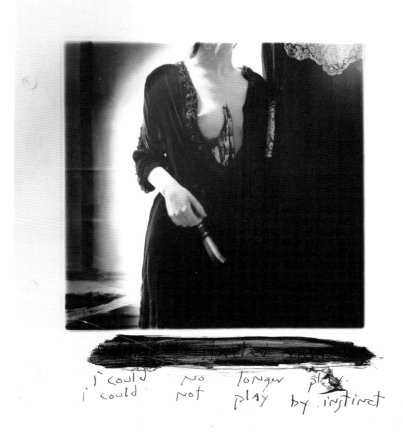

which carried the 'aura', if we can reverse Walter Benjamin, of the mass-produced object. Warhol's use of the photographic portrait thus had the deliberate and paradoxical effect of subverting the realism of the photograph and its representation of individuality, turning the individual self into an imitation of the mass thing. If Warhol was, as he often stated, striving for the sublimity of the machine and the perfection of mechanical form, his polaroid self-portraits, at once tactile and lifeless, embody the subversive and paradoxical quality that Warhol perfected [**98**].

Sol LeWitt, known primarily as a minimalist sculptor and graphic artist, likewise embeds his self in a world of images, but his strategies for controlling the pictured world result in a far different self-portrait than Warhol's. LeWitt's *Autobiography*[22] is a picture of the artist that has seemingly eliminated all photographs of the artist himself. Instead he is 'represented' in this volume by over 120 pages of photographs of

the artist's home, each page containing a grid of nine pictures. (There are a few pages with partial grids.) Unifying the collection of images on any given page is some category that LeWitt has invented to contain the images: windows, electrical devices, radiators, plants, chairs, books, artworks, audio tapes, the contents of his refrigerator, shoes, and so on. Underlying the entire book is the concept of the grid, which LeWitt uses to organize the space on every page, and which he 'finds' in household objects of every type and description: shelves of books, stitches in a crochet pattern, wine rack, waffle iron, maps of the city, printers' blocks, and—here and there—postcards of Muybridge. Muybridge is of course the inventor of the photographic grid, and his influence on artists of the twentieth century has already been noted. LeWitt's formal adaptation of Muybridge—which has nothing to do with motion studies and everything to do with ways of organizing information—is an aesthetic and conceptual strategy, and one that LeWitt pursues with brilliant inventiveness.

There is no text in *Autobiography*, the images themselves are captionless, the pages unnumbered. But standing behind the volume is the genre of the family photograph album, the gathering of images that collectively define the individual. At times the association is more explicit than at others, as in the page featuring office signs, photographs, mementoes, referring, one presumes to LeWitt's father, a physician [**99**]. We know ourselves also, LeWitt is saying, through our family pictures, and LeWitt treats his own with deference and also with irony, viewing them as artefacts, conventions of self-representation that distance us from the past as much as they bring us into it. Drawing on the

This page is, like all of the
volume, structured in grid
form. Some of the images on
the page are 'still life'
collections of objects; others
documentary images
presenting old family
photographs. LeWitt is always
playing with frames and with
the concept of framing, and
each page, like this one, is
carefully constructed in terms
of balance and symmetry. If we
are known through our things,
then LeWitt has fully revealed
himself in this series, despite
the artist's total absence from
these pictures.

power of the family album as a testimony to the endurance of memory
and the endurance of the self, LeWitt manages to have it both ways,
maintaining his irony towards the world of images that do—and do
not—represent us.

The camera has woven itself into the texture of our lives so completely
that we can hardly conceive of an event 'happening' unless it has been
photographically recorded. So also with our sense of ourselves, our
ancestors, our families: we know them, we know ourselves, through the
images that we and others have taken. We study them, we ruminate
about them, we remember them, and they constitute, in a way, the
silent narrative of our lives.

Photographing Fictions

8

The mainstream interpretation of photographic history in the twentieth century, deriving from Beaumont Newhall, argued that the camera was, as a mechanical medium, inherently objective in its recording of the world, and that any photographic art should consequently derive its essential character from the representation of 'reality' in more or less literal terms.[1] Of course the spectrum of possibilities, given this premise, was fairly broad, ranging from the 'straight photography' aesthetic of Stieglitz to the more Cubistic experiments of Strand; from the sharp-focused representation of objects in Weston to the subtle clarity of an Ansel Adams landscape; and from the documentary tradition of the FSA photographers to the more poetic work of Robert Frank in the 1950s. Newhall might concede the importance of a strong subjectivity on the part of the photographer, but the photographer's attention, for Newhall, must be on the representation of reality and not on the depiction of anything remotely fantastic.

By the 1970s, the history of photography was being rewritten, by A. D. Coleman[2] among others, so as to recapture a previously marginalized tradition that was more than incidental to the development of the medium. In fact, by the end of the twentieth century, the tables had turned quite dramatically, and the practice of fiction photography was a strong, if not dominant, strain in American art photography.

Photographers in the mid-nineteenth century, as noted earlier, had used the camera to pose models and construct still-life tableaux that were directly imitative of painting; and this practice of 'art photography' continued through the nineteenth century, mutating into the Pictorialist aesthetic that pervaded photography around the turn of the nineteenth and into the early twentieth century. Running parallel to this 'high art' tradition, there was a tradition of fantastic photography that was less frankly imitative of the fine arts and drew more on currents in popular culture, as can be seen primarily in the very popular stereograph cards that flooded the market from the 1870s onwards [**100**]. Paralleling vaudeville to some degree and anticipating the movies as well, these stereograph cards often drew on religious iconography—from devils in hell to angels in heaven—but usually with an edge of comedy. Apart from posing models and photographing them

Detail of 112

39. THE CHILD'S DREAM.

100 Anonymous

The Child's Dream, 1880

The child is surrounded by visions of delight—toy dolls, tea set, drum, while the figure of Santa Claus watches benignly over her. This photograph of a 'dream' was a clear set-up, but other fantastic images—of ghosts, for example—were sometimes taken by gullible viewers as the real thing. Photography was used frequently as a vehicle for fantasy during the late nineteenth century.

in extraordinary settings, the photographer might also construct elaborate 'table top' tableaux, using dolls (e.g. 'Eight Little Maidens', a series of twelve views, published in 1895 by French in Lawrence, Kansas).[3] Although an illusion was aimed at, the artifice of these scenes was part of the pleasure, for there was no pretence of 'realism' here. Meanwhile, after the turn of the century, the homegrown surrealism of trick photography, made popular by William H. Martin in Kansas, disseminated bizarre improbabilities far and wide, thanks to the decision in 1907 by the post office to allow postcards to be sent with the picture on one side and writing on the other.[4]

Somewhat closer to popular realism and melodrama were the staged scenes of domestic comedy that could also be found in the stereograph cards. Much of this work also had a narrative quality, either as a sequence of images or with a narrative or poetic text accompanying the card photographs. And it was only a short step from the stereo card sequence to the nickolodeon, the revolving wheel of hundreds of cards, with its anticipation of some of the genres, plots, and acting styles of early cinema.[5] Perhaps the most ambitious of these early fiction photographers was Alexander Black, whose photo fictions anticipated the nascent motion picture industry and appeared in literary periodicals at the end of the nineteenth century [**101**].[6] Combining a fictional narrative text with photographs, Black staged his models in everyday scenes to illustrate the accompanying text. 'The pictures would be primary,' Black wrote, 'the text secondary. Again the pictures would not be art at all in the illustrator's sense, but simply the art of the *tableau vivant* plus the science of photography . . . [The effect of reality arises] not from the suspended action of isolated pictures but from the blending of many.'[7] Black's new form lost its momentum as a genre with the ever-growing popularity of moving pictures, but the photo narrative would

101 Alexander Black

From '"Miss Jerry", The First
Picture Play', *Scribner's
Magazine*, September 1895

Transposing the theatricality of
Victorian melodrama to
photography, Black staged
distinct tableaux at key points
in the action. Lacking
continuity, however, the
images are indecipherable
without the accompanying
text, which narrates the action
being broadly portrayed. Black
uses the present tense,
incorporating the characters'
nuances of perception and
feeling in a combination of
dialogue and description.

When the story opens
Holbrook and his daughter
have been in New York again
for five years enjoying the
fruits of the miner's success,
and the first cloud of mis-
fortune appears in the shape
of a letter from the mine re-
porting probable disaster.
Moreover, Holbrook's New
York investments have not
turned out favorably. It be-
gins to seem as if the miner
and his daughter must make
some radical changes in their
way of living, yet Holbrook
clings to the hope of avert-
ing disaster. The thought
of confronting Geraldine
with misfortune fills him
with peculiar distress.

When she surprises him
in his painful reverie, he
starts guiltily, slipping the
letter into his pocket and
muttering some common-
place about being late for
the office. But she reads
the new trouble in his face,
and the Colorado postmark
on the envelope, which he has
not taken from the table,
confirms her suspicions of
trouble at the mine.

On the same morning
Kate, the maid, announces, in
much excitement, that there
is "a pirate in the hall."
The "pirate" turns out to
be a picturesque person who
lounges in with a strange
mixture of assurance and
diffidence in his manner, and
who drawls, "I guess this *is*
Jerry!"

"Yes, it is!" exclaims
the girl; "and is this you,
Pink?" she adds, extending
her hand, which the pictur-
esque person, to the distress
of the maid, grasps fervent-
ly. With increased astonish-
ment Kate hears the pirate
say, "Waal, I'll be hanged
if I'd knowed yer, Miss Jer-
ry, yer got to be such a
woman!"

VOL. XVIII.—37

return towards the end of the twentieth century, reinvented (without
any realization of the precedent) in the hybrid genres of postmod-
ernism. Lewis Baltz's remark seems especially apt in this context: 'It
might be more useful, if not necessarily more true, to think of photog-
raphy as a narrow, deep area between the novel and film.'[8]

As visual entertainments were channeled into the moving pictures

in the early twentieth century and as photography—under Stieglitz's influence—struggled to establish itself as an art form worthy of the museums, the fictional impulse in photography became dormant. Where it does come to the surface, during the 1920s and 1930s, it appears in the guise of Surrealism. Man Ray, exposed to the aesthetic currents of Paris, used photography (as he did painting) as a vehicle for his whimsical, proto-Conceptualist compositions, in which ordinary objects—a metronome, a mirror, a mask, a walnut—might be transformed into visual metaphors and puns.[9] Another major figure in this genre during the same period was William Mortensen. But while Man Ray's stature, enhanced by his associations with European Surrealism, has only grown with the years, that of Mortensen has fared rather less well. Mortensen was a strong and articulate advocate of fantastic photography in the United States during the 1930s, at the centre of a heated debate with Ansel Adams and other champions of a more objective photography. Although Adams may indeed have been influenced by Mortensen's technical virtuosity, the latter's preference for psychological allegories was written out of the history of photography as constructed by Newhall, where Adams, Weston, and the f.64 group

triumphed.[10] It was only with A. D. Coleman's rediscovery of Mortensen in the late 1960s and of the conflict between these two strains in photography, that we have come to recognize what has been lost.[11] Mortensen directed his models in ways that evoked the erotic symbolism of nineteenth-century art and the archetypal struggles of male and female forces, as well as the inner struggles of the mind.

Against the prevailing mainstream of straight photography, other American Surrealists were attracted to the tradition of fantastic and allegorical photography, most notably Clarence John Laughlin in the 1940s and 1950s, whose densely poetical images, occasionally making use of composite techniques, were accompanied by texts that articulated a psychological narrative, a parable, or exemplum. Ralph Eugene Meatyard, beginning as a modernist under the influence of Ansel Adams and Aaron Siskind, began in the 1950s and 1960s to create evocatively staged still lifes burdened (at times overburdened) with psychological meaning; while Jerry Uelsmann, also taking off from the modernist platform and (like Meatyard) inspired by Henry Holmes Smith's teachings, developed his own techniques for combining prints in the darkroom, resulting in seamless transitions from the real to the surreal. Others in the 1960s and 1970s (e.g. Ralph Gibson, Les Krims, Lucas Samaras) were also experimenting with staged tableaux, conceptualist images, and humorous incongruities. The problem with all of this work—from Laughlin to Uelsmann—is that it risks falling into sentimentality and a kind of bogus mysticism. Despite the virtuosity of the printing techniques, it is only as strong (or as weak) as the artist's imagination and taste. Nevertheless, this current of subjective or Surrealist photography, like Freud's return of the repressed, speaks to the photographer's need to get beyond the surface to some deeper reality that lies buried beneath the polite veneer of our society.

Duane Michals

The strongest figure of these years, extending into the 1970s and 1980s, was Duane Michals. Avoiding, for the most part, the pitfalls of sentimentality (at least in his earlier work), Michals brought a humour and irony to fiction photography that coaxed a slow but steady shift in the premises of photography in the late twentieth century. Claiming an affinity with the short story and the poem, Michals is a conceptualist photographer, whose characteristic forms are the singular image with text or the sequenced narrative, based on some metaphysical conceit. Thus, in *The Spirit Leaves the Body* (1968), Michals begins with a nude figure, supposedly a corpse, at rest in a room and proceeds in seven frames to portray a superimposed 'spirit' rise up and take leave of the body; in fact, the room does seem, at the end, far more empty than it was in the first frame. In *Things Are Queer* (1973), Michals begins with a

scene in a bathroom, and in successive images moves ever backward, reframing the original scene in a series that ends where it began, a reflexive structure resembling the turns of a Moebius strip that could go on infinitely. Michals often plays with mirrors, with doubling, and with the magic of darkroom manipulation that can turn a 'realistic' photograph, by successive steps, into a purely imaginary object.

Though Michals came on the photographic scene in the late 1960s as an original, he has not hidden the line of aesthetic heroes whom he has idolized. First among them must be the Belgian Surrealist Magritte, whose painted paradoxes of representation inspired Michals's own stagings of illusion. Michals did a series of portraits of Magritte, as a homage (published in 1981 as *A Visit with Magritte*),[12] but one can find in Michals echoes of the whimsy of Joseph Cornell and the playful ironies of Lewis Carroll as well. Michals is frequently on the edge of humour, though it is often most successfully a black humour, for death is unabashedly one of his obsessions. In this, as in his homosexual affinities, Michals feels a deep kinship with Walt Whitman, whose work he has also illustrated photographically.

Michals cares nothing for the fine art print. (He has earned his living as a fashion and portrait photographer.) Rather, he has taken freedoms with the photographic image, at times painting on it, at other times providing a handwritten text to frame it conceptually. If Michals freed photography in the late twentieth century to deal once again with subjectivity, he did so by a knowing and ironic exploration of the limits of realistic representation. One photograph, a painted image of a pipe, is called—as a homage to Magritte—*Ceci n'est pas une photo d'une pipe*. Another offers the photograph as 'proof' (as it indeed can be in a court of law) of the truth of reality and the truth of sentiment, though at the same time Michals undercuts the assertion and throws us back on the essential and inescapable illusions of the medium [**103**].

The *locus classicus* of this position is a work that is, we might say, the theoretical and philosophical foundation for the new fiction photography, and appropriately it serves as a frontispiece for Michals's most important book, *Real Dreams* (1976):[13] 'A Failed Attempt to Photograph Reality'. This work is pure text, written by hand, and lacking any image whatsoever, which is precisely the point:

How foolish of me to have believed that it would be that easy. I had confused the appearances of trees and automobiles and people with reality itself and believed that a photograph of these appearances to be [*sic*] a photograph of it. It is a melancholy truth that I will never be able to photograph it and can only fail. I am a reflection photographing other reflections within a reflection. To photograph reality is to photograph nothing.

And yet, as pessimistic and seemingly defeated as the photographer seems in this work, the absolute zero of this position paradoxically, in a

This photograph is my proof. There was that afternoon, when things were still good between us, and she embraced me, and we were so happy. It had happened. She did love me. Look, see for yourself!

103 Duane Michals

This Photograph Is My Proof, 1975

Michals's writing binds with the image to form a composite 'imagetext' that communicates by the combination of word and picture. The caption reads, 'There was that afternoon when things were still good between us, and she embraced me, and we were so happy. It had happened. She did love me! Look, see for yourself!' The irony of the photographic 'proof' here is that the speaking voice (and the image) do not literally belong to Michals, but to the created fictional persona in the image. Here the evidentiary power of photography is deliberately, and slyly, subverted by the fiction of the image.

way, frees him completely: if reality cannot be represented, then anything else—the play of the imagination, the ideas of the poet—can be. 'Unscrew the locks from the doors, unscrew the doors themselves from their jambs',[14] Whitman said. And in Michals's work (do we call it a poem? an anti-photograph? Or simply a text?) he does precisely that.

Joel-Peter Witkin

Once the door is open, the subject matter as well as the premises of photography can change. Whitman brought startling new facts into the sentimental house of nineteenth-century poetry ('The suicide sprawls on the bloody floor of the bedroom, | I witness the corpse with its dabbled hair, I note where the pistol has fallen');[15] and the same can be said for Joel-Peter Witkin, whose work in the 1980s and 1990s startled and enthralled an audience that was not yet immune to the shock of the grotesque. Witkin's subjects fall into two major categories: the living and the dead. For the latter, Witkin combs medical museums and morgues for his models, creating often startling still-life arrangements, for example, the split halves of a head kissing each other, or a severed arm in the midst of a table arrangement, or a corpse set up to evoke St Sebastian. (Here too Whitman anticipated Witkin: 'The

malform'd limbs are tied to the surgeon's table, | What is removed
drops horribly in a pail.'[16]) For his living tableaux, Witkin solicits his
models from a spectrum of abnormalities, including those suffering
from deformed limbs, missing legs, and obesity. At times, consistent
with postmodernist habits of appropriation, Witkin will pose his living
models to mimic some well-known painting—from Velázquez's *Las
Meninas* to Grant Wood's *Portrait of Nan*; at other times, they will
enact some fantasy—Witkin's or his model's—that reveals buried fears
or simply the whimsy of a depraved mentality, as in his literal staging of
Testicle Stretch with Possibility of a Crushed Face. There is, as that last
title suggests, an edge of black humour in Witkin, a perspective that
carries over into his autobiographical anecdotes ('When I grew up in
Brooklyn, I was eight before I went to a neighbor's and saw that cats
had two eyes') and that is evident as well in the outrageous, over-the-
top quality of his work [**104**].

 Witkin's subjects are often painful to look at and at best have a puz-
zling, densely metaphoric quality that stops us dead, as if we have
wandered into a studio run by the team of Hieronymus Bosch, Goya,
Weegee, and Woody Allen. These are unabashedly contrived images,
and Witkin will sketch them out in advance of posing his subjects.
The black and white image is then meticulously crafted to give it a
nineteenth-century antique aura—the negative is roughened around

the edges, scratched, and the final print is coated with beeswax and polished to a fine finish. (Witkin does about ten images a year.)

Witkin has provoked, and continues to provoke, a divided response: while some have proclaimed him the *poète maudit* of the late twentieth century, a genius of the perverse, others have seen a laborious effort to entertain a jaded audience by exhibiting a host of taboo subjects. In fact, Witkin gives us permission to stare, he compels us to stare, at the human body in extreme states, both natural and artificial, evoking at once a fascination and repulsion. And the repetitious quality of the work, one elaborately contrived spectacle after another, suggests the effort to overcome the repulsion by repeatedly confronting the darkest fears of the psyche. Moving us closer to our dread of the real thing Witkin provides at the same time the safe aesthetic distance of the gallery experience.

Witkin himself suggests a religious purpose to his work, and indeed the figures of Christ, of Mary, and of St Sebastian, among other Christian martyrs, haunt his imagery: 'Those who understand what I do appreciate the determination, love and courage it takes to find wonder and beauty in people who are considered by society to be damaged, unclean, dysfunctional or wretched. My art is the way I perceive and define life. It is sacred work, since what I make are my prayers.'[17] But Witkin does more than merely 'appreciate' his subjects: he manipulates them into fantasies of his own devising with the deliberate intention of shocking us. Only by remembering the shocking literalism of some of the medieval portrayals of Christ, both sculptural and two-dimensional, can we grant the photographer a kinship, however distant, with the tradition of religious art. The religious defence has not prevented the Christian Coalition from protesting against Witkin's receipt of a $20,000 grant from the National Endowment for the Arts in 1993.

Cindy Sherman

Another artist to emerge around 1980 as one of the central figures in fiction photography—indeed one of the key figures in the arts generally—was Cindy Sherman. Witkin, Sherman, and an increasing number of young photographers were working in what critic A. D. Coleman called, in an influential 1976 essay, 'the directorial mode'.[18] Citing the work of Les Krims, Samaras, and Michals, Coleman gave a name to the photographer's *directing* the scene in front of him or her, and consequently undermining the practice of photographic realism. Coleman traced the lineage of this work back to the art photography of H. P. Robinson, but he was careful to acknowledge that photographers have always engaged in direction, from home snapshots to documentary photography, and that it was a matter of extending the range of photographic control at the end of the continuum. Photographers

working in the directorial mode, Coleman made clear in a follow-up essay in the late 1980s, are not to be confused with film *auteurs*, since all photographers function in that way to begin with.

But the early work of Cindy Sherman ironically begs that very question, since she entitles her first major series, *Untitled Film Stills* (1977–80), suggesting that the works in question were shot as stills for some unknown, unnamed film. In any case, the subjects in *Untitled Film Stills* are obviously posed by the photographer, as if caught in a high dramatic moment of some generic black and white B film of the 1950s or 1960s: a woman lies languidly on a bed; an intellectual woman sits in a chair, in the midst of speaking; a sensual teenager sits on a window sill looking out on the world; a woman takes a challenging stance in a doorway. In each case, Sherman has posed her model in a way that tempts us to supply the cinematic narrative from which this is a 'still photograph'.

What makes the series remarkable is the fact that each of these posed women, looking quite different one from another, are images of the photographer herself, whose self-portraits these are (if we can stretch the term) and who often deliberately exposes the artifice by allowing us to see the controlling cable for the shutter release. Sherman's notorious reticence about explaining her work, even minimally, allows us the freedom to entertain any number of plausible constructions. One might be to focus our attention on the ways women are pictured in the media, the ways they are made (in films, especially) the object of our mediated gaze, and the variety of roles they are given or give themselves, yet all in a way stereotypes. Sherman's virtuoso embodiments, appropriating the popular imagery of film and TV, have argued for a new kind of postmodern personality, one in which the self, mirroring the myriad images in the media, has become destabilized, protean, a chameleon.

Going beyond her first series, Sherman created a second series of female portraits in the early 1980s, each likewise frozen in a moment, called simply *Untitled* (each image is also given a number). Again, the

105 Cindy Sherman
Untitled Film Still #21, 1978
Mimicking the staged process shots typical of Hollywood movies (star photographed against fixed background) and shooting from below to accentuate the drama of the captured moment, Sherman impersonates a state of concern or anxiety in the midst of a scene of the utmost banality. The artifice of the construction, including the simulacrum of emotions, places the whole within an ironic frame.

106 Cindy Sherman
Untitled, #216, 1989
The photographs in Sherman's *History Portraits* series are based on Renaissance paintings, all of which evoke the textures, colours, clothing, poses, and flesh tones of the originals. In each case, Sherman changes some particular of the subject's body by the addition of an artificial component. In this case, the fake breast, oversized and full with milk, stands ready to succour the infant, changing what might be a dignified moment of maternal solicitude into an incongruously bawdy exposure. It is this aspect of the body, Sherman might be suggesting, that is suppressed in the traditional portraiture of the period.

107 Cindy Sherman
Untitled, #264, 1992
Sherman's sex pictures parody the conventions of erotica—the 'inviting' pose, the exposed genitalia, breasts, even the masked face; but here everything is discordant and exaggerated, the symbols of sexuality made artificial and disconcerting. The mask, through which the eyes look out luridly, has a sado-masochistic aura, while a face stares down strangely, from the upper right corner. Only the draped gown suggests the traditional odalisque.

refusal to specify the particulars allows us to interpret this virtuoso series in several possible ways, and in this case, the photographer explores inward psychological states, meditative moods, melancholy ruminations by 'characters' who occupy a variety of social positions, from sensuous female awakening to the morning after, to several portraits of a boyish, transgendered figure. By 1983, Sherman's work was growing stranger, with the photographer pushing towards a range of female characters that encompassed extremes of fashion—clowns, vamps, vixens, cabaret singers—usually in the realm of caricature.

Then in 1985 things got 'worse' for Sherman's personae, and women as victims of violence and molestation began to surface in various guises. Sherman was going over the top on gore and repellent imagery, dismembered parts, ghoulish types, animal transformations, and madness: a face barely legible is covered with an indistinct mix of blood and guts; a body is transformed into a horned creature. Sherman seems to have taken a break of sorts in 1989–90, when she produced a series of large photo portraits, all staging herself in the guise of 'historical' figures, from the early Renaissance on, large colour portraits in full dress, and of both sexes, that cast herself in an array of indistinct but evocative roles based on art-historical precedents from the full range of the history of portraiture [106]. Many of these portraits used prosthetic devices, and the artificial construction continued in Sherman's next series, *Sex Pictures*, to focus even more of our attention [107]. Influenced by Hans Bellmer's grotesque doll constructions, a mainstay of 1930s Surrealism, Sherman developed her own doll series, applying prosthetic devices to herself, creating false and confused anatomies that put the female body into a series of indistinct horror scenarios. In these images from the early 1990s, Sherman's imagery evoked the excesses of comic book violence and mock pornography, forcing us to confront the underside of popular culture and the psychic energies that fuel it.

The trajectory of Sherman's career has moved her from the relatively 'normal', roles based on popular culture models, to the world of madness, violation, pornography, and death, and while it is easy to see the progression, it is difficult to say exactly what it all means. Exploring the range of representations in Western popular culture and art, Sherman seems to have been intent on pushing farther towards the grotesque, as if the persona herself might be taking a violently downward spiral. But if we were to step back and assign some social meaning to this progression, we might see in it a dark counter-narrative to the deification of wealth and the perfection of materialism in the Reagan–Bush years. In this, Sherman seems in some ways akin to Witkin, who seems likewise intent on picturing an opposing, nightmare vision to our commercialized garden of earthly delights.

Constructing scenes, fabricating images

'What, after all, is our American culture in the late twentieth century?' these photographers seem to have asked themselves. If one direction leads us deeper and deeper into what might be construed as a national psyche driven mad by modernity, then the other direction of directorial photography takes us into the world of social representation itself, the world of advertising where the imagery of the self is constructed for us through the myriad images that surround our daily lives. Techniques of

A great many contemporary photographic artists (and painters too) employ a technique called 'appropriation', in which they take an existing image and bring it into their own work of art. In a sense, artists have always used this technique, borrowing concepts and images from earlier artists, alluding sometimes to their predecessors. The difference is that for the contemporary artist, the existing work is taken in a much more literal way into the new work, so that the viewer is expected to see what has been appropriated in a more specific sense. The contemporary artist wants the viewer to see his or her own work, but also the preceding work, with an effect that is purposefully conflicting: on the one hand, we are to see the continuity between the past and the present; but we are also, on the contrary, to see the distance between our time and the time of the original image, whether it is a painting, a photograph, or something else. Photography allows for appropriation in two ways: firstly, by replicating or otherwise reproducing a particular image that might become part of a new work. And secondly, by taking the idea of the original, whether a scene or a human figure, and modelling a present work upon it. In the contemporary practice of appropriation there is a sense of 'belatedness'—of living after some earlier, more significant time, suggesting that all we can do, in our own time, is draw upon the images of the past to form our own consciousness of the present. Joel-Peter Witkin, Cindy Sherman, Sherrie Levine, David Levinthal—all use appropriation techniques, though in quite different ways.

parody, evident in different ways in the work of Witkin and Sherman, surface again in the far different work of such photographers as Laurie Simmons and David Levinthal, who have taken the comfortable and false world of our advertising dreams and turned them inside out, as if they might be the real world.

Laurie Simmons, like Sherman (and Barbara Kruger and Sherrie Levine, to be discussed in the next chapter) is part of the feminist critiquing of the image that took place in the early 1980s, continuing through the 1990s. And for Simmons, like Sherman in this too, the door opened by Michals inverted the whole nature of photography by turning representation away from the world as seen to the world as represented. 'I think of scientific veracity as an idea from the past', Simmons has declared, deliberately rejecting the whole idea of the 'actual' as inherently paradoxical: 'an actual what? An actual retouched photo? An actual collaged photo? People are much more willing to believe that pictures lie than that they can express any kind of truth.'[19] For Simmons a 'sense of inauthenticity' pervades all experience, given our failure to live up to the expected social roles that are given us, whether 'the strong athlete, the successful business man, the graceful dancer, the nurturing homemaker, even the artist'.[20]

Accordingly, Simmons turns to the world of 'surrogates'—the models, puppets, and dolls that became popular as kids' toys during the 1950s, and that became the models for social development in the late twentieth century. Simmons's ingenuity lies in setting up her figures so

108 Laurie Simmons

The Music of Regret IV, 1994
At the centre of this group of admiring males is the female, coyly smiling. The men appear wooden (they are of course literally wooden), their expressions suggesting the frozen social glance of the male, appraising female quality. Simmons may also be evoking Marcel Duchamp's famous *Large Glass,* or *The Bride Stripped Bare by Her Bachelors, Even,* an allegory of male–female desire and frustration, which anticipates the postmodern mechanization of love.

as to parody social situations or act out literally some conventional wisdom (e.g. 'clothes make the man'), letting us see in the stark simplicity of the figures the geometry of social forces that act upon the individual. The artifice of Simmons's tableaux is of course obvious, but they strain towards a kind of everyday realism that leaves us somewhere between the real and the fake, as in *The Music of Regret (IV)* (1994), where the female doll (modelled on Simmons herself) is surrounded by a sextet of admiring males, of whom she is the cynosure [**108**]. This model of conventional social relations—the value of the female being derived from the power of the male gaze, here multiplied six times—is parodied by a knowing Simmons, who can look at this process as one that is the mark of her early years and of the 1950s perhaps, a period and an attitude that Simmons, along with her feminist generation, has transcended.

Levinthal sets up his *tableau vivant* as a scene filled with action and framed by the trees at either side. Mimicking the construction of Civil War battle paintings, the conflicting flags are at the centre, and the figures assume a variety of bellicose postures. Putting some figures out of focus enhances the 'realism' of the scene, which clashes all the more with the plastic artificiality of the *mise-en-scène*.

David Levinthal likewise focuses his attention on artefacts of popular culture, but for Levinthal, the re-creation of a 'realistic' scene, using obviously fake plastic props, is not so much a means of exploring the self and its roles as it is a means of exploring, and critiquing, the structure of social reality as it has been formed by twentieth-century institutions. Levinthal's subjects originate in the toys and playthings of the 1950s, plastic representations of suburban homes and of the cities, of school rooms and scout camps, of circus people and Roman warriors, all built by the toy manufacturer, Louis Marx & Company. More recently, he has turned his attention to Barbie dolls, shot as fashion models. Mirroring American popular culture, Levinthal is forcing us to look again at what we have taken for granted, the archetypes that have shaped generations of children in the late twentieth century. Using the soft features of the plastic action figures, he is also inserting the viewer into the historical world of Marx toys: from Ben-Hur to the American Revolution, from the Civil War to World War II (his first book, with his college friend, cartoonist Garry Trudeau, was *Hitler Moves East*, in 1977).

Levinthal's images have a cinematic quality, like stills from a movie, and the action and violence in them seem archetypal, if not generic.

They evoke a multi-layered response: these are toys, we know, but they draw us into a world that seems more and more real the more we stare at them. Each image is like a frame from a larger narrative of action that we must ourselves imagine, and the process of looking evokes the same process of imagining that we might, as children, have gone through while playing with such toys. At the same time, we draw back from the fantasy, aware that Levinthal is constructing a critical image of American culture and its consumption of plastic history. Enhancing the 'realism' of these scenes is Levinthal's skilful use of differential focus, which draws our attention to one small area of interest and leaves the rest of the image blurred; this is the way a movie camera might record a scene, and the mimesis of mimesis, paradoxically, intensifies our sense of 'realism', even while the declared inauthenticity of the photograph captures our interest. In the end, Levinthal seems as much interested in issues of representation as he is in the cultural critique. Not surprisingly, a major influence on Levinthal in the 1970s was Duane Michals, who licensed a generation of fiction photographers, and whose ironic narratives and self-reflexive habits have informed Levinthal's quite different imagery.

Magritte's shadow, cast on Michals, has also fallen on Sandy Skoglund, whose environmental installations have a quality of the absurd, of the contradictory, that recalls the Belgian Surrealist's exploration of the paradoxes of representation. Skoglund, coming of age in the late 1970s, began her career as a conceptual artist, experimenting with repeated forms and serial imagery. Like Claes Oldenburg, she found inspiration in the banalities of everyday life, and like Levinthal she was attracted to commercial colour photography. But Skoglund's work taps into a level of fantasy that is all her own—rooms invaded by plastic spoons, hangers, socks, as if these mundane objects were out of control and taking over the inhabitable space. Skoglund's installations typically feature a brightly monochrome room, which might be filled with dozens of sculpted floating goldfish, or an array of monochrome cats, squirrels, or dogs—frozen into various moments of activity.

Skoglund's work exists on several boundaries simultaneously: on the edge between popular culture and high conceptual art; on the edge between dream and reality; and on the edge between installation and photography. It is hard, for example, to decide what exactly the 'work' is: is it the installation (and Skoglund installations have been seen in many museums)? Or the photograph of the installation, which often inserts actual people into the scene, and which always accompanies whatever installation there might be? To Skoglund, the construction exists in order to be photographed from one particular angle, which the artist is constantly checking as she builds the set; and in an exhibition that contains the actual scene and its photographic representation, one becomes aware of the tension between the three-dimensional 'reality'

110 Sandy Skoglund

Walking on Eggshells, 1997
The room suggests a magical
space, yet one that has been
rendered meaningless to the
two women who are about to
conduct their ablutions. The
image seems to beg for an
allegorical reading, and one
such might be, that when the
mysteries become illegible,
when the world becomes
drained of magic, we lose the
lightness of being and can only
break these eggs.

and the two-dimensional image that is, you might say, the *raison d'être* of the scene itself [**110**].

Skoglund's tableaux confront us enigmatically, demanding to be read at the same time that they withhold their obvious meaning. In *Walking on Eggshells* (1997), her most complex and elusive image, Skoglund features a monochrome bathroom, with sculpted bathtub, sink, and toilet, and with a floor filled edge to edge with empty eggshells; a track of footsteps and broken shells leads from the front edge of the photograph to the rear. Skoglund's two female figures, both nude, have just walked on these eggshells, *en route* to their ablutions, breaking dozens of them on the way. The snakes and rabbits leave them intact, though they have a vaguely menacing presence in the room, as if they have overrun the place. The hieroglyphic wallpaper features ancient folk drawings of rabbits and snakes, reminding us of their symbolizing opposing qualities of innocence and experience, good and evil, polarities of consciousness and myth, from the Egyptians to our Western iconographic culture. Here they seem to be conversing intimately. Yet where once human beings responded with anxiety and a sense of danger and possibility to these symbolic animals, now the greatest source of tension in the room is the eggshell floor itself, which

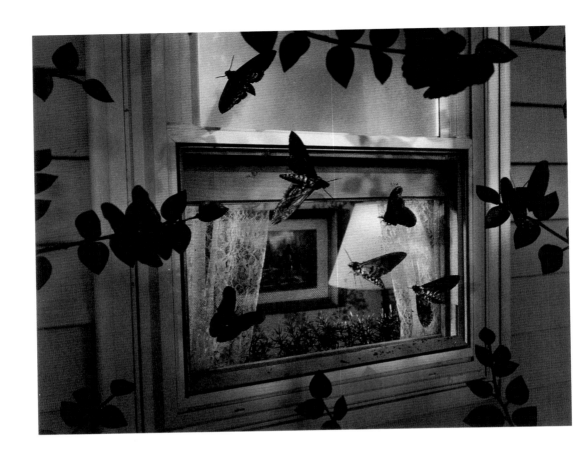

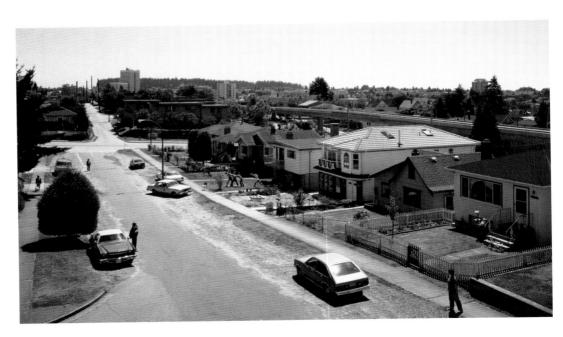

111 Gregory Crewdson

Untitled, 1994
The eerily mystifying view—
from outside a house, through
a window and into a room—
looks 'real' until a second look
reveals the careful
arrangement of pieces that
compose an odd scene—in
this case large flying insects
that seem to be drawn to the
window. The leaves also seem
to be encroaching on the
domestic scene within, as if
nature here is somewhat
errant, and almost out of
control.

can only crack again as soon as one of the frozen models moves. In a way, this complex tableau is a picture of the human condition, as we tread lightly surrounded by ancient (but no longer meaningful) signs.

At the edge of illusion

In most works in the directorial mode, the manipulation of the subject and the frankly fictional nature of the image are evident on first look. But there is a kind of *trompe l'œil* effect possible also within this fictional mode, and with the work of a small group of other photographers, the manipulation is not apparent at first; the point in fact is to create the illusion that what is pictured is unvarnished reality or even a 'documentary' image. Gregory Crewdson, for example, might spend days constructing the scene he will photograph, often building it out of a real location, the more ordinary the better. Everything looks 'normal', suburban even, until we notice something that might be oddly out of place, or in some way discordant. Balanced between the probable and the improbable Crewdson's photographs evoke a vague sense of dread and open up a space of confusion and wonderment.

Another such photographer, Canadian Jeff Wall, carries the staged tableau to its epic conclusion, basing his startling compositions on art-historical precedents from European painting. Controlling every facet of the scene to be imaged, from lighting to colour to posing of subjects, employing on occasion digital manipulation, Wall constructs scenes that parody tabloid representations of violence, war, and domestic conflict. Though Wall's scenes read like part of a longer narrative, often involving chance elements, they are meticulously staged so as to rule out anything accidental. In this world, vaguely menacing, edged with the uncanny and coloured by black humour, the artist is king. Yet this is a world that is also connected, via the filament of illusion, to the real world of social upheavals, police actions, and armies of the night, in which a disquieting stillness freezes the action.

The aestheticism of these fiction photographers should not conceal their frequent covert tendency to use the imagination as a vehicle for conducting a broad critique of modern social arrangements. If there is an anti-photographic motivation in this kind of work, refusing the camera's indexical connection to the real world, this work can still have the power to make us see things we have not seen before, both in the imagined worlds of these artists and in the world of popular culture and representation to which they are obliquely tied. To the photographic fiction artists of the late twentieth and early twenty-first centuries, the camera can be used to create works of art that exploit the nature of literal photographic representation, while at the same time they explore the constructions of the imagination.

112 Jeff Wall

Eviction Struggle, 1988
In this quiet suburban street
scene, the artist has given us a
glimpse of a moment that
contains elements of high
drama. Given the title—
Eviction Struggle—one can
imagine the participants, those
evicted at least, to be on the
edge of despair and disorder.
The body language, seen from
a distance, is intensely
charged, although it is
submerged by the surrounding
placidity of the scene. Across
the street—witness to this
potential chaos—is a lone
figure, staring thoughtfully and
perhaps trying to piece the
whole thing together.

Photography and the Image World

In a famous essay published in 1859, Oliver Wendell Holmes looked prophetically into the future, extrapolating from the growing numbers of photographic images to a time when the image would replace the real thing: 'Form is henceforth divorced from matter', he wrote with playful exaggeration.

In fact, matter as a visible object is of no great use any longer, except as the mould on which form is shaped . . . There is only one Coliseum or Pantheon; but how many millions of potential negatives have they shed—representatives of billions of pictures—since they were erected! Matter in large masses must always be fixed and dear; form is cheap and transportable . . . Every conceivable object of Nature and Art will soon scale off its surface for us. Men will hunt all curious, beautiful, grand objects, as they hunt the cattle in South America, for their *skins*, and leave the carcasses as of little worth.[1]

Holmes may not have realized how close he was in fact to the day when George Shiras III, once a hunter, would put down his rifle and pick up his camera, publishing the results in a landmark pictorial article in the July 1906 *National Geographic Magazine*, 'Photographing Wild Game with Flashlight and Camera', featuring over thirty black and white images of Michigan deer and other animals.[2] And he may have overestimated the ease with which human beings would abandon the quest to possess matter. But he did not overestimate the exfoliation of images that would take place over the next one hundred years and its consequence—'such an enormous collection of forms that they will have to be classified and arranged in vast libraries, as books are now'.[3] Of course we have already gone beyond Holmes's imagined image archives to the immense pictorial population of the world wide web, and Holmes's playful prophecies seem to knock on the door of the virtual reality technologies of our own time.

Holmes anticipates, as if looking into the twentieth century, not only the surrogate universe of images, but the new meaning of photography as a medium capable of disseminating a single image widely to an entire society. As Alan Trachtenberg has written, Holmes represents a 'transition in thinking about photography, from the era of the unique daguerreian object to that of the mass-produced image'.[4] Some

Detail of 120

thirty-five years after Holmes's essay, what he had only imagined, had come about in the growing library of stereograph cards: images of agriculture; the Arctic and Antarctic regions; automobiles and aviation; botany and the Boer War; bridges, cattle, caves, and the circus; copies of artworks and costumes; pictures of dare-devils and disasters; electrical engineering and erotica; fires, fishing, and food processing; geology, horses, hunting, and Indians; monuments and musical instruments; naval images and the Negro; parades, personalities, and prisons; railroads and religions; schools and colleges, ships, and skeleton leaves (an aesthetic rage); images of sports, technology, toys, transportation, volcanoes, wars, whaling, and yachting. And more.[5] As the ubiquitous stereograph was gradually replaced by the picture magazine, these subjects would migrate into the pages of mass-circulation periodicals, while the growing movie industry would take up the more dramatic subjects in both documentary and fiction form.

Taking the reproduction of photographic images as a whole throughout American society in the early twentieth century—in the illustrated press, in advertisements, billboards, movies, copies of artworks, books, reports, brochures, and so on—one can see the creation of what French theoretician Guy Debord would call in 1967 'the society of the spectacle',[6] a culture in which the 'simulacrum', the representation of the thing, would gradually displace the thing itself as the most powerful generator of desire. One can see this taking place in several spheres simultaneously in the early twentieth century, most notably in the realm of magazine advertising and corporate self-representation; in the creation of the theatrical (and then Hollywood) celebrity and in its counterpart, the criminal celebrity.

Photography and consumer culture

Of all the myriad projections made at the dawn of photography regarding its applications in the realms of science, the arts, education, and travel, there was little if any speculation about its possible use in connection with advertising, which became, in the twentieth century, one of the major photographic industries. The camera had been used almost from its very beginnings as an excellent device for documenting *things*—objects on a shelf, works of art, pieces of lace. And card-mounted photographs of elaborate displays of manufactured products, by the post-Civil War period, became visible as surrogates for the actual objects—in store windows and in the hands of travelling salesmen, who were thus saved the trouble of carrying the objects themselves on their travels. By the turn of the century, with the technology of photographic reproduction in newspapers and magazines advancing quickly, photographs came more and more to replace hand-drawn illustrations in advertising products. These were not merely

Ide Collar, 1922

The elegant curve of the collar is set off against the chequerboard background, creating a new aesthetic object, an abstract composition. At the same time, the lighting softens the form of the collar, giving it a sculptural presence. Outerbridge practised his alchemy on a variety of commercial products, turning them into art objects.

descriptive pictures: they were pictures of desire, and some human interest was often added to the photograph of the object—not infrequently a pretty girl—thus establishing a link that would be confirmed during the course of the twentieth century, between the *thing* and a vague sense of desire. During the 1920s, the 'naturalistic' advertisement competed with the new modernist photography, which attracted interest in visually arresting ways—by isolating the object in abstract space (e.g. Outerbridge's famous Ide collar, set out on a chequerboard), emphasizing dramatic angles and accentuating form, using sculptural lighting and tricks of scale to give an alluring glamour to the product [**113**]. With Edward Steichen leading the way, followed by Man Ray, Paul Outerbridge, Francis Bruguière, Charles Sheeler, and others, the visual vocabulary of modern advertising was being expanded dramatically, erasing distinctions between high art and popular art and disseminating the new modern art (or at least echoes of it) widely throughout mass society.

114 Deborah Turbeville

Krakow, 1998

This image, an advertisement for a dress by Olivier Theyskens, won one of *Life* magazine's 1999 Eisenstaedt Photography Awards. Turbeville's model, wearing an antique cotton lace dress, stands stiffly, like a mannequin with raised arms, and is framed by two formally attired men who seem to be baffled by her demeanour; meanwhile a nondescript army officer sits dazed to one side. Partly a homage to Polish director, Tadeusz Kantor, and partly to Bruno Schulz, the image is puzzling and intriguing, while focusing our attention on the gauzy dress.

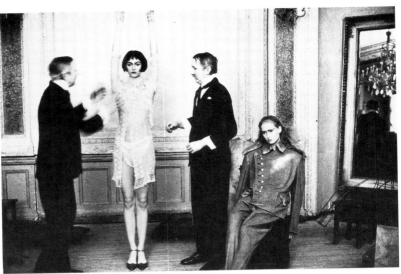

Advertising throughout the twentieth century continued to mirror changing cultural taste, from the Depression dramatizations of anxiety (and its obverse—the salvific power of streamline design) to the post-war optimism of the rocket age.[7] And the traffic between art photography and advertising has continued to be strong through the late twentieth century and into the twenty-first. Indeed, many photographers have established reputations in both worlds simultaneously—e.g. Irving Penn, Richard Avedon, Annie Liebowitz, Duane Michals—with the connections between the commercial style and the non-commercial being sometimes obvious and sometimes not. At times, it is not clear whether one is looking at an 'art' photograph or an 'advertising' image, which may be the ultimate triumph of commercial photography. For example, a 1999 fashion photograph by Deborah Turbeville, taken in Krakow's Potocki Palace, draws on theatrical traditions and features players from the recently disbanded theatre group, Cricot 2, whose stagings often involved the haunting of the present by figures from the past. It is not at all clear what is being advertised, nor is it clear what the 'meaning' of the image is, all of which is fine, as long as we stop and look.

In its perpetual quest for the eye-catching image, the advertising photograph seizes upon currents in the aesthetic culture and blows them up into exaggerations of stylistic modes and vocabularies, overpowering the consumer's sensibility. Photography is continuous with fashion here, and what is being sold is as much lifestyle as product. At times, in the effort to fix our attention, the fashion photographer will go way over the top, as in Melvin Sokolsky's grotesquely floating models, or Richard Avedon's extensive *New Yorker* fashion portfolio, a series of 'horror' tableaux featuring a beautiful model in designer clothes, variously flirting with and fleeing a quite animated skeleton.[8]

Avedon's spread has a cheeky irony about it, and so avoids what might otherwise be extravagantly bad taste. But the fashion photograph, in its omnivorous appetite for chic imagery, not infrequently crosses the line into absurdity and the outlandish. A case in point is Carter Smith's photographic narrative-cum-fashion series, 'Wild Boys: Haunting Images of the Great Depression and the Desperate Young Men Who Rode the Rails Inspire the Style of Today's Adventures'.[9] Using the black and white look of Depression-era documentary, and inspired by a 1997 documentary, *Riding the Rails*, Smith features portraits and action shots of young vagabonds riding railroad cars in $600 sport jackets and $800 sweaters.[10] (This practice has been termed 'docufashion'.) More disquieting, in a way, is Andres Serrano's giant colour portraits (60″ × 49½″) of homeless men, *Nomads* (1990), in which the photographer treats his subjects with respect bordering on idolatry, posing and lighting them so that they appear like fashion models, although a close look reveals they are wearing authentically tattered and stained clothing, not Ralph Lauren's 'distressed' garments.

Celebrity

There is of course a connection between the world of advertised consumer products and the world of the celebrity: the latter is very often used to sell the former. We are so accustomed to celebrities—from movie stars to politicians—associating themselves with products, that we accept the association as part of the star's larger identity, if not obligation. (For some reason, it has become acceptable for some sports stars—for example tennis players and racing car drivers—even to carry corporate logos directly on their clothes, as if their talents were

somehow 'sponsored'.) But celebrity, to be established in the first place, requires by definition to be communicated via the mass media, using photography, either in newspapers or magazines. We should credit Mathew Brady, during the daguerreotype era, with the first clear conception of how to exploit the new medium of photography to create a pantheon of celebrities, in his publication series, *The Gallery of Illustrious Americans*. And after Brady, the invention of new formats for paper prints, from the *cartes de visite* to the larger cabinet-size photographs, resulted in the merchandising of images of celebrities by photo entrepreneurs like Napoleon Sarony, who specialized in theatrical personalities. Adoring the star, identifying hungrily with his or her persona, the fan could at least take home an image as a souvenir. The advent of picture magazines took it one step further, creating a format for stars to be periodically created and forgotten, according to the currency of the moment, a process that continues into our own day in a variety of formats, from movie fan magazines to broader-circulation gossip magazines.

At the core of photographic myth-making, since the 1920s, has been the Hollywood studio portrait, a form perfected by several photographers whose imagings were crucial in fashioning the aura of movie stars in American culture. The major studios—Paramount, MGM, RKO—all had their staff photographers, whose job it was to create an image of longing and desire, of mystery, of seduction or innocence. Using minimal props—a cigarette, a flower—photographers like George Hurrell, Clarence Sinclair Bull, and Eugene Robert Richee relied largely on their ability to pose their subjects to suggest infinite charm, infinite grace, infinite confidence [115]. The key was dramatic lighting and deep shadow, creating a composition of black and white that framed the elegance of the subject, whose dress and hair were the studied creations of skilled studio artisans. Though they appeared to be celebrations of the individual, magnifying the mystery and power of the star, in fact the studio photographs were the product of a system in which costume designer, make-up artist, director, and photographer collaborated to create the fiction of a power greater than merely mortal.

Standing behind the fabrication of celebrity in America, whether Hollywood or sports stars, political or business personalities, was the media industry—tabloid newspapers, magazines, and eventually television—that created fame by projecting images that would certify the latest face as an object of fascination. Andy Warhol's silkscreen replications of iconic photographs of the famous—Liz Taylor, Marilyn Monroe, Mao Zedong—took celebrity itself as their subject, reproducing the image until it became (like any word pronounced repeatedly) virtually nonsense, a sign devoid of its referent. Warhol's deconstruction of the celebrity photograph was only half of the equation, however, for at the same time he was using the camera on its own

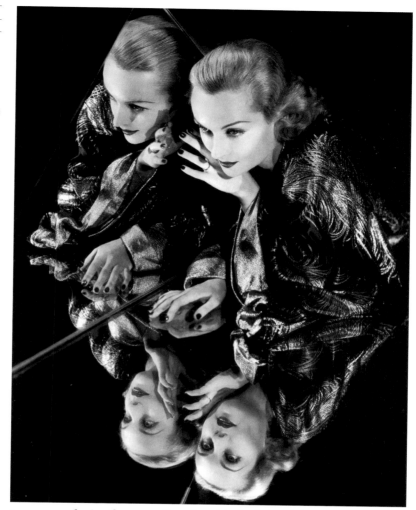

terms as a device for recording, in a kind of visual diary, the incessant round of parties and events that came to occupy his life. Yet Warhol's massive self-documentation (much of it now in the Warhol Museum in Pittsburgh) and the self-importance that lay behind it was in tension with the self-effacing persona he cultivated. Just as Duchamp had taken the everyday object and transformed it (by his signature) into a 'readymade' work of art, so Warhol took the found photograph, the newspaper image or celebrity shot and, by his manipulations, turned it into high art. Warhol's influence especially on the postmodern aesthetic of the copy and multiple has been immense.

Fame and infamy

The power of the mass media is such that the particulars of fame almost become matters of indifference: the genius and the criminal can

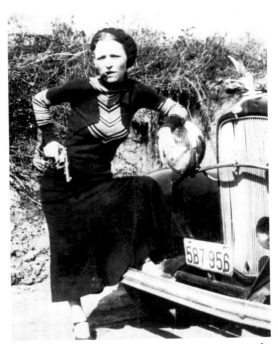

stand side by side in the tabloids, the two ends of the spectrum of social visibility. As early as 1890 ruffians and thieves in the Lower East Side of New York were eager to show their tricks to Jacob Riis's camera, hoping for a brazen notoriety. When Bonnie Parker stood before the camera, flaunting the powers of the female body and her power to transgress the norms of social decorum, she did so with a knowing wink, aware of the pose as the embodiment of a self-created moment, a statement that says to the world: 'I'm here. Come and get me' [**116**]. Better the opportunity to represent oneself than to be represented by the police camera, which turns the criminal into a number, a profile or a full-face image, devoid of expression, captive of the lens and its power to classify and objectify the individual within a fixed social hierarchy. Weegee, who often got to his criminal subjects after they had been rendered violently lifeless, also liked to take them on the run, at the moment of their capture, when they were still feeling the impulse to protect their privacy, the privilege of the law-abiding. But Weegee's camera intrudes on his subjects, and many (though not all) shrink from the publicity, drawing a curtain where society wants it torn away, trying to preserve intact some remnant of the self that has not yet been served up to the mass media [**117**].

One of the most interesting ruminations on the subject of forced notoriety is Angela Davis's essay, 'Afro-Images: Politics, Fashion, and Nostalgia',[14] in which Davis recounts the way her own image, blazoned on FBI Wanted posters in the early 1970s, became a sign and symbol of black revolutionary politics, picked up by *Life* magazine and other

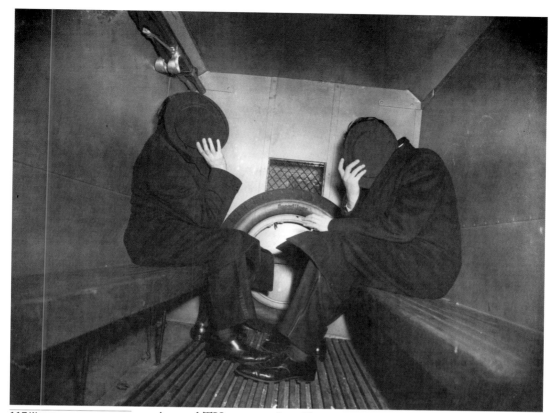

117 Weegee

Untitled, from *Naked City*, 1945

Weegee asserted the right, as a news photographer, to capture anyone's image, no matter the circumstances. He took photos in darkened movie theatres, on empty beaches at night (using infra-red film), or of people sleeping on park benches. He was especially zealous when it came to those arrested by the police, who were trying desperately to maintain their anonymity. Weegee's caption in *Naked City* reads: 'In Top Hats—In Trouble, Charles Sodokoff, 28, and Arthur Webber, 32, both Brooklynites, use their toppled toppers to hide faces as they take free ride to Felony Court. Boys were tippling at Astor Bar Saturday night when they decided to slide down banisters for fun (???). Cop was called and they assaulted him.'

print and TV news outlets. Even more—given her unmistakable Afro hair style—it became a mass media artefact, commodified some twenty years later by the clothing industry to promote '1970s fashion nostalgia',[15] which effectively eroded the historical meaning of the image. The mass media, capable of disseminating visual information on an unprecedented scale, is also the machinery by which stereotypes are indelibly created.

The postmodern world of images

One might say that the world of desire that sustains the consumer economy, and that depends upon the photographic image, entails a willing suspension of disbelief. In this we grant the epistemological foundation of the image a degree of separation from the ordinary 'reality' we live in. To quote the prescient Holmes again, 'Form is henceforth divorced from matter.' What seemed keenly exciting in 1860, however, by 1960 had come to seem the source of our peculiar contemporary condition (in the medical sense): as the mass media have flooded the world with images—from movies to television, from newspapers to magazines, from posters to billboards—a sense of dislocation, of unreality, of floating in a miasma of simulacra began to

afflict the aesthetic sensibility. 'Where everything is transformed into images,' as Roland Barthes wrote, 'only images exist and are produced and consumed.' The effect, Barthes argues, is that this mutation into images 'completely de-realizes the human world of conflicts and desires, under cover of illustrating it'. And the result is 'an impression of nauseated boredom'.[16]

This alteration of the twentieth-century sensorium is, one might say, the starting point for the new critical practice embedded within contemporary art photography, one that takes its point and purpose to be the deconstruction of the photographic image. We can discern two contrary impulses within the contemporary moment: in one direction, the photograph itself, in its material existence, is taken as the object of renewed interest, as if the artist is in pursuit of something like the lost original aura of photography; while the other practice, in the opposite direction, starts with the found image and builds from there.

In the first direction, which we might call photo-reflexive photography, the processes of picture making are themselves foregrounded by

119 David Hockney

Sunday Morning, Mayflower Hotel New York, Nov. 28, 1982

Hockney's composition here is in tension between Cubism and traditional perspective: we understand the space in the room in terms of perspective, looking deep into the distant centre of the image. Yet we also see the fragmented planes that compose the whole, the jagged edges and seams that force the eye to move deliberately, rather than smoothly, over the whole.

the photographer. Direct photography—images captured on large-scale paper without a camera—is one expression of this photo-reflexive impulse, as practised, for example, in the multi-layered works of Martha Madigan, whose poetic sun photograms evoke some of the earliest heliographic processes, blending bodies and leaves [**118**].

Another example of the return to original sources is the revival of the daguerreotype in the hands of many contemporary artists, most notably the photographer/painter Chuck Close, whose whole career has been built upon an examination of the nature of photographic vision. And yet another example is the use of the giant Polaroid camera, dubbed Moby C and as big as a room, which produces prints with extraordinary detail; Joe McNally's portraits of the firemen and other municipal workers involved in excavating the World Trade Center disaster were taken in this mode and widely exhibited in 2002.

Yet another example of the photo-reflexive mode is the work of artist David Hockney, which critiques our fundamental assumptions about the way we see using a camera. What is a representation made by a camera? What are its limitations? What are its possibilities? What does a camera see? These questions have occupied Hockney as a photographer since the early 1970s.[17] Hockney's argument is that we cannot look at photographs for very long because they are taken in a split second, 'there's virtually no time *in it*'.[18] The logic here may be somewhat elusive: we do after all look for a long time at some photographs taken in a split second, studying the conjunction of movements

and forms captured in the frame. But there is some point to Hockney's argument that a painting invites a more prolonged act of attention if only because the paint was laid down over time and there is more to look at in terms of texture. Along these same lines, however, earlier photographic printing processes—platinum, gravure, bichromate—gave the photograph a texture that could also engage our attention. In any case, Hockney's thinking motivated his discovery of the multiple-view collage, which solved the problem in two ways. First, creating a multi-image picture took time to construct. (Hockney used Polaroid SX-70 prints.) Second, it took time to look at, as the eye moved around the composition, marking continuities and discontinuities, angles and fragments, the whole seeming more like a work of analytic Cubism than anything else passing as 'photography'. Hockney has experimented

with several formats: two or three images joined together; a dozen or so large images, composing an irregular frame; dozens of smaller photographs put into a rigid grid structure; and the free-flowing collage structure of *Sunday Morning, Mayflower Hotel New York, Nov. 28, 1982*, with the ironic self-inclusion of the photographer in the mirror [119].

Hockney's roots in painting might have contributed to the freshness of his perspective on photography as a medium. Likewise, the Starn twins, Mike and Doug, have worked in this same photo-reflexive mode, at the intersections of photography and painting, creating works that interrogate the nature of the medium while attracting attention in the wider world of painting, sculpture, art galleries, and museums. The Starn twins, coming out of art school, focused their attention in their photographic work both on paper as image and construction as subject. The photograph was, first of all, an art object, a thing, with a materiality that had previously been discreetly marginalized. Drawing their inspiration at times from the history of art, and at other times from their own immediate world, the Starns used the darkroom as a laboratory for layering and colouring the print; they then treated the print itself, the paper, to a folding and creasing that gave it a texture and presence of its own, insisting that we look at (and not just through) the surface of the image. (The print might be rectangular; but it might also be cut into randomly angular shapes.) The work was then itself constructed, with individual prints taped together, stitched together, nailed on to a surface, anyway attached, forcing one to observe the artefact first, the subject second [120]. The Starns burst the frame as well, shaping it eccentrically to accommodate the idiosyncrasies of each composition. In effect, as one critic has observed, the Starns were restoring to photography the 'aura' that Walter Benjamin had said was missing, lending to their work both a postmodernist critical edge and the evocation of the Romantic nineteenth century.[19]

Media imagery as found art

Self-reflexive photography is one response to our postmodern crisis in representation. The appropriation of images—whether from the history of photography, or painting, or from the contemporary mass media—is another, and it has been one of the salient characteristics of photographic practice in the late twentieth and early twenty-first centuries, a response by artists to the postmodern condition, in which any direct representation of reality seems suspect, and in which consequently our attention is focused on the image. In this view, our experience itself seems inevitably mediated and the representation has seemed to replace the real thing. Hence it is the ubiquitous mediated

121 Robert Heinecken

TV Newswomen, 1986
Heinecken's two columns are matched, so that facial expression in column B is mimicked in column A. The head movements seem choreographed, but they are actually the result of Heinecken's extreme attentiveness to the nature of news broadcasting. The differences are minute, Heinecken seems to be saying with an edge of humour, as we try to find sources of information that have some objective validity.

122 John Baldessari (next page)
The Overlap Series: Street Scene (With Cosmic Event), 2000–1

Two very different images are overlapped here: a mundane downtown street scene and an undefined 'cosmic event'—an asteroid bombarding the earth? The eruption of the diagonal into the earthly sphere occurs twice: once in outer space and once on earth, as the picture itself 'crashes' into the street before us. The overlapping area blends the cosmic scene and the earthly, forcing us to look at this as an aesthetic contrivance, enigmatically juxtaposing the two extreme perspectives on human habitation.

representation—in television, film, magazines, and newspapers—that has become the prime subject, as well as material, of contemporary art.

One of the first photographers to take this turn—as early as the 1960s—was Robert Heinecken, who focused his attention on the television screen. So pervasive is its presence that the screen has become naturalized in our culture, an aspect of our surroundings that we take for granted, hardly noticing when it is on or off. Yet its structures of thought, language, analysis, narrative, pervade our consciousness. Stepping back from the screen to a critical distance, Heinecken has cast a sceptical and humorous eye on television's images, paying particular attention to the presentation of the news. Heinecken's photo constructions frequently make use of columns of identical television sets, stacked up, and displaying on each an image of a newscaster. But with the screens showing us essentially mirror images, Heinecken's critique of the homogeneity of television culture suggests the loss of individuality not only on the part of the viewer, but on the broadcasters' part as well, as if all are serving the same machine.

To Heinecken, the screen image is a kind of found art, to be observed, recorded, and re-arranged. John Baldessari likewise often finds his materials not in the 'real world' but in the world of media, using video stills, newspaper and magazine ads, news photos, and so on—favouring images that come from our collective, public lives; and like Heinecken, he uses seriality, multiples, and photo-collage techniques. But Baldessari's roots in the West Coast avant-garde (with close associations with Allan Kaprow and Nam June Paik), along with his disposition towards conceptualist art, have given to his work a more puzzling, whimsical, almost Dadaist quality, while he pursues his exploration of questions about representation and language that have been at the centre of postmodernist practice. Like Warhol, Baldessari uses the found art of journalistic photography in his work, removing the news image from its original context and placing it within his own structure of boxes and shaped frames. But where Warhol typically went for the sensational image (car crash, electric chair), Baldessari favours the utterly banal, e.g. the nondescript small town civic event. Beginning as a conceptualist, Baldessari has developed a variety of darkly humorous and witty strategies that question the relationship between sign and referent. In many of his works, he superimposes round white stickers on his subjects' faces, thus obliterating their identities and teasing the viewer.[20] In other works, like the Overlap Series, he will juxtapose images that seem utterly unrelated, challenging the viewer to find meaning and coherence in what appears initially to be disjunctive [122]. Where the images actually overlap, Baldessari suggests at least a formal coherence, creating a new idea whose meaning goes beyond its composite elements.

Richard Prince's subject matter, like Baldessari's and Heinecken's, is

found imagery, but his main interest lies in magazines and especially in advertising. Working for *Time-Life* in the 1970s, where his responsibility was to clip editorials from magazines in order to give them to *Time-Life* writers, Prince was living for a good part of his day in a mediated world. (Weegee had started out as well by working in a newspaper photography section, looking for hours at tabloid photos.) Immersed as he was in this factitious world, Prince became, like a denizen of Plato's cave, removed from the 'reality' outside of the media. By default, he began photographing ads that caught his eye as if they might be the whole of existence [**123**]. By cropping the advertisement in a particular way, or by shooting it at an angle or out of focus, Prince's own aesthetic and sensibility could dominate the world of the ad. Fascinated by the unreality of the ads, yet at the same time aware of their power to create a new, willed reality, Prince's work began to take on a strongly paradoxical edge: he was capturing some of the appeal of the mediated world yet he was also framing it ironically. Starting with an advertisement, itself a highly artificial creation produced in endless multiple copies, Prince was creating his own original art; dependent on the copy, Prince was returning the viewer to some more 'original' view of the work.

Prince's work has taken a variety of forms within the range of imagery based on advertising—collages of photographs, thematically linked images, work that draws upon the contemporary art practices of formalism and Abstract Expressionism. Assuming the persona of the artist-rebel, Prince has worked at the edges of banality and cliché, playing off the old, and creating new forms of art that let us see the mediated world of advertising and desire in fresh and startling ways. Prince's penchant for jokes and for works based on jokes offers yet another angle for understanding his place in the contemporary art

scene: working at the border between the trivial and the profound, between the mock-heroic and the heroic, Prince has spoken of our need to distance ourselves from the world of popular culture. The cowboy rides the herd, lasso poised in the air, with a kind of mythical ease and confidence that has always, in case we have forgotten, been a product of the willing and wilful American imagination.

The work of Heinecken, Baldessari, and Prince is part of the larger movement in the contemporary arts towards the world of popular culture as a source of inspiration and concern. Pop art's appropriation of commercial mythology, at once a dependency and a critique, is yet another sign of the movement that has been taking place in the arts since the early twentieth century, a breaking down of the borders between high and low art. Barbara Kruger's work—part of the broader spectrum that we've been considering—is also distinctly different from these others. Kruger appropriates advertising imagery (preferring to work generally in black and white), cropping and fragmenting as it suits her purposes, but her trademark move is to superimpose a 'slogan' on top of the image. Parodying the layout of advertisements, Kruger positions her slogans at an angle, with a solid contrasting background to set off the bold and simple typography. The 'speaking voice' in Kruger is usually a female one, addressing very often a male sensibility, in terms of protest, remonstrance, and warning. Kruger's work is moralistic, a social critique of contemporary society, and very often addressed to the viewer in the second person. Kruger's frequent themes are feminist, critiques of shopping and of the ideology of consumption, of female submissiveness to the mythology of male superiority, of the warrior culture of America. Using the style and imagery of advertising, Kruger's work is itself a kind of advertising, and she has taken advantage of her capacity to communicate quickly and deftly, as in the poster,

124 Barbara Kruger

Untitled (Your Body Is a Battleground), 1989
Kruger's designs have a simplicity and directness that is borrowed from advertising, as are the sumperimposed words. But the messages she is sending are far from the traditional 'advertising' sentiments. We are not being solicited to desire or buy anything; rather, we must experience a kind of heightened Brechtian consciousness, an alienation from the image and its language. (Kruger's work was a poster for a Washington march.) Familiar ad language is balanced by visuals that are simple, yet also paradoxically familiar and strange. In this case, the negative image is mirrored by the positive.

'Your body is a battleground,' promoting a 1989 demonstration in Washington [124]. And Kruger's work has elsewhere appeared where we might usually expect to see mass advertising—on billboards, on bus and subway ads, and so on. It seems only fair, then, that the advertising industry should itself turn around and co-opt Barbara Kruger, as it has done, making itself seem (or trying to) *au courant*, hip, part of the scene, part of the irony of the avant-garde.

Perhaps the ultimate example of appropriation is Sherrie Levine, who has approached the question of photography's aura from a more abstractly theoretical angle than the others we have been looking at. Levine's basic approach is to reproduce, literally to rephotograph, existing classics of modern art, treating them like the 'readymades' that Duchamp had, earlier in the twentieth century, selected out of the hardware store and turned into 'artworks'. Duchamp's signature was the instrument to achieve this transformation, and that is likewise the case with Levine, who signs each work, as if it is an original by herself. But they are all copies, replicas, whether as sculptures (Brancusi, Duchamp) or, what concerns us here, photographs. Walker Evans's Alabama portraits are perhaps her best-known works—and also Evans's—and that is precisely the point. Taking works we are sure to recognize, Levine is approaching aesthetic icons in something of the same spirit that Duchamp did when he drew the moustache on the Mona Lisa. But there is a reverence for the originals here as well, or at least an appreciation of their authority and presence in the tradition. Levine's images, photographed from reproductions in art books, are thus twice removed from 'reality'. By signing them, she is claiming 'authorship' while at the same time obviously disclaiming it, thus offering the viewer an object that can only provoke a paradoxical response: are these works of art? Or merely copies? If the latter, then how do they earn their museum status? If the former, wherein lies their originality? Levine's work enters the critical discourse of postmodernism with a blank challenge, daring us to take her work seriously and—if we do—challenging us to rethink what it is exactly that we are valuing in it.

Levine is herself an original, one might say, by virtue of subverting the whole idea of originality. And it is only fair that her own work should in turn have provoked a similar challenge, suggesting an endless regression or meta-reflection on the notion of 'originality'. Michael Mandiberg, for one, turns the tables on Levine by establishing his own world of the reproduction, taking Levine's own work as its objects. And it is not coincidental that this work should have its existence on the internet, where the infinitely reproducible nature of the image (not to mention the infinitude of images) is constantly before us. Mandiberg's website (www.aftersherrielevine.com/images9.html) invites us to download his 'art' according to specified instructions, and to download as well a certificate of 'authenticity', that the individual who has

retrieved the image will sign himself, thus 'authenticating' a copy of a copy, and certifying its legitimacy. At this point, the whole notion of originality has been mocked to death, reminding us that postmodernism does have its dead ends. The exchange between high art and popular art (and advertising), which began in the early twentieth century, thus continues to supply the currency of communication, a sign of the confused realms of contemporary culture and of the artist's ambiguous status as participant and critic.

After this, what?

Conclusion:
Post-photography

<div style="font-size:3em">10</div>

As Lewis Hine famously observed, 'while photographs may not lie, liars may photograph'.[1] Hine may have exaggerated the objectivity of the camera, discounting the distorting potential of the instrument, but at least the machine is immune to ethical, commercial, or aesthetic motivations and to that extent has a moral purity not built into the human construction. And indeed the history of photography is burdened with deceptive practices—as well as credulous viewers—from Gardner's Civil War manipulations to the ghost and fairy photographs of the turn of the nineteenth century and on into the manipulated political images of the twentieth century, with figures cut out as they fell from disfavour. While most of these practices were perpetrated upon the innocent, it has not been uncommon, from the late nineteenth century until today, for portrait photographers to 'retouch' an image, flattering a subject with his or her full approval, if not upon demand. (Though it should be said that the practice was opposed by some purists, when it first took hold in the nineteenth century.) In short, traditional photography has always been subject to the photographer's direction in front of the camera and to his or her manipulation of the print in the darkroom. Moreover, as Rejlander and Robinson demonstrated,[2] segments of prints could be put together to form a composite image, a new whole that did not previously exist in reality before.

Yet these photographic misrepresentations were, after all, exceptions that proved the rule, and photography has held from its advent —perhaps until now—the authority of fact, establishing for painting and even for literary realism the standard of 'objectivity'. With its ability to record light in smooth and continuous gradations, to frame a viewpoint that mimicked the eye's distortions of vision (for example distant objects smaller than objects close up), and to encompass the whole of a scene with every detail intact, photography quickly became assimilated to 'natural' vision and achieved a kind of psychological verisimilitude that has been hard for us to give up. We knew something happened, or something existed, because we could see a photograph of it. Lacking that standard, we might believe in XYZ and all the other fabrications of the imagination that passed for 'fact' in the centuries before photography.

Detail of 125

But if the advent of photography was one major turning point in the framing of modern conceptions of 'the real', we may now be on the verge of another, equally significant turning point: with the twentieth century receding quickly behind us, we are gradually shifting from the analogue world of roll film that dominated the last hundred years to a brave new digital world where the image is coded on computer chips—whether in still cameras or in the video camera. Are we, in the twenty-first century and as a result of the digitization of images, at a point where we might say, with a nod to Delaroche, that from this digital moment, photography is dead? And are we consequently in the midst of a transformation in modes of visual representation whose epistemological significance we have yet to grasp? I do not mean to equivocate on this matter, but the answer may be yes *and* no.

What is the difference between film and digital modes? Both a film camera and a digital one can produce the 'same' picture (more or less) of the same scene, as it might be printed out using either process on photographic paper. But a digital image, stored as 'information', is then infinitely malleable, subject to the manipulation of the software operator who can enlarge areas of the image, shrink others, move pictorial segments from here to there, import pieces of an image from outside, joining the original to a different image, change colours, and so forth.[3] The change from film to digital is partly, then, a matter of degree; but it is also one of kind, for the new technology casts doubt in many ways on the whole premise of photography: that there is a one-to-one connection—an indexical relation, as it has been called—between what is in front of the lens and what is in the picture. There are certainly continuities between analogue and digital photography (and analogue photographers could also manipulate prints), but the difference, if I can put it this simply, is that in the analogue era, we would assume that a manipulated image was the exception to the rule; in the digital era, we must assume that the non-manipulated image is the exception to the rule. The difference lies, then, in the kind of belief we bring to the image, the kind of knowledge-assumption we make about what an image represents to us.

Pedro Meyer's *The Strolling Saint, Nochistlan, Oaxaca, 1991–92* depicts a scene that is, in terms of realism, impossible; as a proposition about reality, it is false [**125**]. Saints don't float legless above the pavement. As a work of the imagination, however, Meyer's image can strike us powerfully, an image of a blessed presence amid the mundane circumstances of a street corner. What gives the image its edge is Meyer's exploitation of the attributes of realist photography that we take as a guarantee of 'realism': the shadow cast by the saintly figure, the texture of the walls, the frozen motion of the mother and child and of the foreground figure on the right, strangely wrapped in a blue tarp. And here is where digital photography goes beyond something like Duane

125 Pedro Meyer

*The Strolling Saint,
Nochistlan, Oaxaca,
1991–92*

The space in Meyer's
photograph seems 'real',
though the wall itself seems
oddly forbidding. Other things
also seem odd: the mother and
child walking up the steps
seem shrunken, while the
strolling saint (floating, really) is
larger than life and free of
gravity. Meyer demands that
we puzzle over this image,
sorting out its probable and
improbable components and
meanings.

Michals's *Real Dreams*, with its less polished effort to exploit the possibilities of trick photography in the service of the imagination. Where Michals lets us see the rough edges of his transformations, Meyers strictly maintains the illusion by showing us a scene that is in most respects 'real'. So we are left with a paradox: the work is both possible and impossible, occupying a space in photography that is similar to Magritte's illusionistic paintings.

But the difference between a Michals image and a Meyers is, from another perspective, minimal: both are ostensibly works of the imagination that frankly exhibit the subjective workings of these photographers' respective minds, and the key word here is 'frankly'. No one is really fooled by these images, whether based in film or in a digital medium.

That is not the case when it comes to images that purport to give us a picture of the real world. In that case, the viewer's expectation is that the image is 'true', and if it is then discovered to be false—as a result of digital editing—then we may rightly feel that we have been the victims of a deception, that the rhetorical contract between image-maker and viewer has been violated. One of the first instances of this practice, seemingly innocent enough, came when it was revealed that *National Geographic*, long esteemed for its photographic coverage of exotic places and peoples, had altered a photograph of the pyramids at Giza on a 1982 cover: shifting the image from a horizontal to a vertical

format, the editors moved the pyramids closer together; wanting a picturesque element to dress up the scene, they added camels. Likewise, the *Day in the Life* books put a cowboy on its cover, digitally altering an existing image in order to compress the scene, bring the cowboy closer to a tree and enlarge the size of the moon—improvements over nature and over the original that the editors defended proudly, saying that they made the covers 'more dramatic and more impressive'.[4]

It may seem a relatively minor issue whether a magazine cover—which people expect to be an artefact designed to attract the eye—changes a photograph without informing its readers. But the implications, when the subject has a political dimension, can be of some significance. Even before digital photography came to dominate the news, photographic 'evidence' might be contested: The image of Lee Harvey Oswald (purportedly taken by Mrs Oswald) that appeared on the 21 February 1964 cover of *Life* magazine—standing in a garden and holding a rifle—has been contested by some photographers on the grounds that the shadows seem inconsistent with the idea of a single sun. On 4 January 1989, when the United States shot down two Libyan MiG-23s, the photographic 'evidence' that one of the planes was armed with missiles was contested by Libya's UN Ambassador, whose final claim was that the pictures were 'fabricated . . . directed in the Hollywood manner'. (The fact that the pictures were nearly indecipherable was not an issue.)[5]

The power of photography in the discourse of public affairs derives from its being a credible witness. When the original image is based in digital code, the ease of altering an image is even greater, and consequently our trust in photography as a medium of truthful, objective representation, our belief that what we see before us actually was there or actually happened, is undermined. For a variety of reasons (cost, efficiency, accuracy) digital cameras are replacing 35 mm negatives in police use, and digital images have been accepted in American courtrooms, if authenticated by an expert. (Currently a 100 per cent guarantee of authenticity is not required for a photo to be admissible as evidence.) But, as one report puts it, 'because the pixels can be digitally manipulated without detection, the integrity of evidence presented in courts is threatened', and it is not unlikely that standards will change.[6] Outside of a court of law—where the threshold for authenticity is far lower—it is easily conceivable that scepticism, if not cynicism, may weaken the power of documentary photography to authenticate the reality of events [126]. So great is the suspicion of US technology and media expertise in certain parts of the world that it is not uncommon for those hostile to American foreign policy to suspect that photographic or video evidence of, say, terrorist incidents has been fabricated—no matter how ludicrous this may seem to the eyes of the West.

If it should happen that the currency of photography is thus

126 Anonymous

Tourist Guy, 2001

This image of a plane about to crash into the World Trade Center—purportedly found in the ruins of the building—appeared on the internet shortly after 11 September 2001 and may be the most widely known 'urban legend' or hoax on the internet. The date in the lower right corner is correct—09-11-01—but it appears to be digitally inserted into the picture. And many have pointed out that the wrong type of plane is flying into the wrong tower; that the observation deck was not open at that time in the morning; that the man's clothing is for the wrong season, and so forth. Nevertheless the plausibility of the image, digitally constructed, convinced many thousands of its authenticity—for a while, demonstrating how easily duped we may be.

devalued, the loss to civilization may be far greater than may at first appear. What, after all, is our evidence that such and such a thing *has happened?* We have relied on photography to bring us news, often horrible news, unbelievable news, of the events of the twentieth century and, so far, of the twenty-first. And that is precisely the point: the news of recent times has been so unbelievable that it would be far more reasonable, far more in line with 'common sense', even, not to believe the atrocities of our time—from the Vietnam War to mass starvation in the Sahel region of Africa, to the massacres in Rwanda, the 'ethnic cleansing' in Bosnia, the destruction of the World Trade Center, and so on to the internecine wars of the Middle East. John Taylor asks the essential question here: 'If the central moral as well as material fact of our time is the production of mountains of corpses, what is the role of newspapers in bringing these dead into existential focus?' And his answer is that newspapers form 'a basis for public knowledge' that is indispensable.[7] Taylor is arguing against Susan Sontag's contention (in *On Photography*) that a glut of horror pictures produces a kind of 'compassion fatigue', a neutralizing of the horrific content, that is also the result both of the photograph's aesthetic values and of a widespread lack of political awareness (on the viewer's part) of the situations being depicted. Taylor contends, on the contrary, that photographs of horrible events establish essential 'ethical reference points' (the phrase is Sontag's), and that the decisions of editors and journalists are 'important markers of certain kinds of civility'. His point is that in representing horror one cannot be 'polite', and that pictures do (and must) shock us in order to get our attention.[8]

Photography offers us an essential, and even indispensable, record of events that must become part of the public discourse; the photographer's social function—so long as we believe the image before our eyes—is to witness events that often exceed our ability to even imagine. James Nachtwey's *Inferno* and Sebastião Salgado's *Migrations*, for example, are two books appearing at the end of the twentieth century that describe vividly, and horribly, the wayward suffering, especially of children, in Romania, Bosnia, Zaire, Chechnya, Kosovo, Rwanda, the

Sudan, Ecuador, and Guatemala. The cumulative effect of such pictured horror, from the Holocaust on, has been to reconfigure our sense of what, after all, *the human* is. And yet, we view these images differently from those of concentration camps right after World War II. As Henry Allen writes,

back then we thought that photographs of the Holocaust—the same bulldozers, barbed wire, and terrible stares we see here [in Nachtwey's images]—showed us a freakish exception to the enlightened rule that mankind is inherently good and progress is inevitable. These photographs seem to ask if the Holocaust was in fact the rule, and if the discarded notion of mankind's inherent depravity goes further than liberal optimism in explaining the man-made madness of the last hundred years, and of however many centuries there are to come.[9]

Does this mean that such photographs have the power to persuade us towards good action in the world? We would be naïve to think this will always be their effect, as was demonstrated by a collection of photographs of lynchings that appeared in 2000, *Without Sanctuary: Lynching Photography in America*. Viewing these images does not give one a high opinion of one's fellow man [**127**]. The victimized bodies are horrific to contemplate, suspended from rope and often whipped, mutilated, burned. And although the lynchers and authorities often gave out the information that the African American victims were being punished for sexual crimes, such crimes were rarely proved and more often the lynching was punishment for expressing political attitudes that might overtly challenge the white power structure. Just as horrifying, if not more so, is the frequent appearance in these

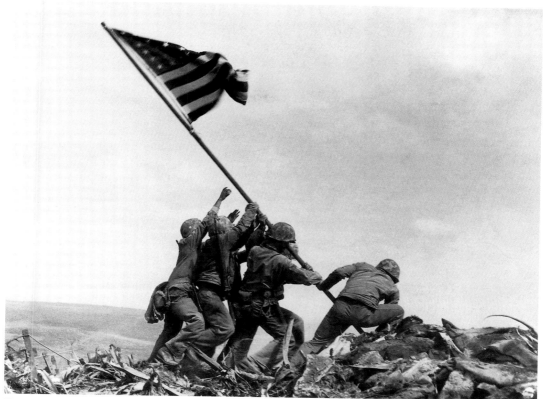

128 Joe Rosenthal

Iwo Jima—Old Glory Goes Up on Mt. Suribachi, February 23, 1945

One of the most widely seen photos ever made, this image summed up the heroism of the American fighting troops in the Far East; perfect in its composition and in the captured moment, it quickly became an emblem of the war, the centre of a fundraising campaign, and has been widely reproduced in stamps, posters, and sculptural monuments. Yet for many years it was believed to have been a 'staged' photo, perfect because it was directed by the photographer. The confusion may have arisen because the photo is not in fact the first image taken of a flag raising on Iwo Jima. The original flag was too small, the military deemed, and another was sent up to replace it. It is this second raising that Rosenthal happened to capture.

photographs of the perpetrators of such acts, standing proudly, sometimes smiling, as if they had declared themselves heroes and protectors of the white race. And indeed lynching images were sent as postcards to friends and relatives, as souvenirs and trophies of the white man's superiority, though some local and state authorities felt the practice was giving the South a bad name and prohibited it. (In 1908 a US Post code forbade the sending of 'matter of a character tending to incite arson, murder or assassination'.[10]) Clearly the image of horrific torture might evoke one response in one viewer and a completely opposite one in another.

Yet some Southerners' awareness that such images would defame the South speaks to the question of their ultimate political meaning. If they are viewed as signs of a depraved civilization by enough people, then the standard for conduct might be gradually changed and codes of civility renegotiated. Certainly by the time they appeared in this volume and in its accompanying exhibition, confronting Americans with a sense of their past that was more often swept under the rug, a sense of outrage, even if historically centred, was freshly provoked. It is by confronting such images in the public sphere that the measure of civility—and of civilization—is taken.

Images that achieve a certain notoriety, even iconic status, often

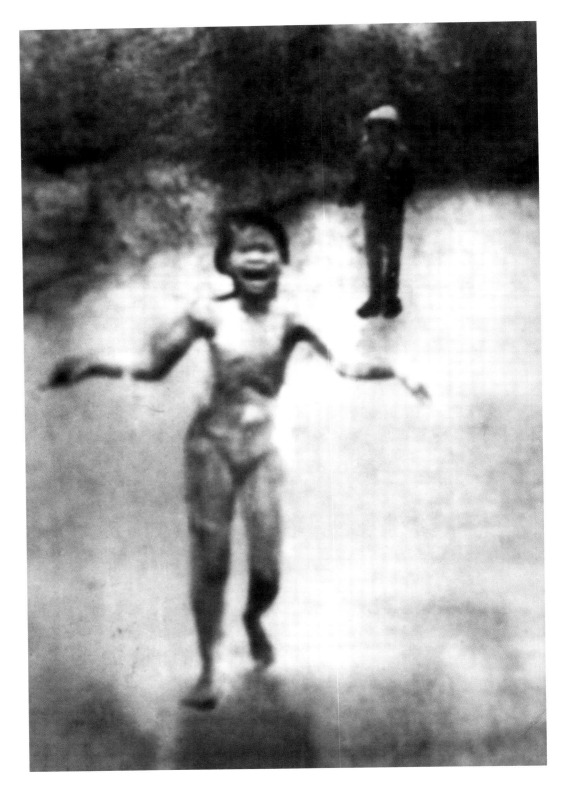

Muniz eliminates the figures surrounding the naked girl, and he 'misplaces' the figure of the soldier behind her, but this rendering of the girl herself is remarkably close to the original. Out of context, the image might stand in, as a *trompe l'œil*, for the real photograph, but it is twice removed from reality. What gives authority to a photograph? Muniz seems to be asking. The fact that we might need to authenticate an image as a photograph, and after that as an unaltered image, places the contemporary viewer in an uncertain, shifting place *vis-à-vis* historic reality.

seem in retrospect to sum up a whole period of cultural history, as Dorothea Lange's *Migrant Mother* (1936) does for the Depression; or as Joe Rosenthal's 1945 planting of the American flag at Iwo Jima (*Iwo Jima—Old Glory Goes Up on Mt. Suribachi*) does for World War II; or as Bob Jackson's *Jack Ruby Shooting Lee Harvey Oswald* (24 November 1963) does for the Kennedy era. Our collective national memory of the Vietnam War is anchored by a few extraordinary photos as well: John Paul Filo's *Kent State—Girl Screaming over Dead Body* (4 May 1970); Eddie Adams's *General Loan Executing a Vietcong Suspect* (1 February 1968); and Huynh Cong (Nick) Ut's *Children Fleeing a Napalm Strike* (8 June 1972).[11] What they 'mean', however, is not necessarily fixed or stable over time. Rosenthal's Iwo Jima has been subject to controversy for decades [128]; a mystery still clouds Ruby's shooting of Oswald; Eddie Adams's execution photo (which won a Pulitzer Prize) quickly became a symbol of the brutality of the Vietnam War, deeply tarnishing General Loan's image and self-esteem, though that was far from the photographer's intention at the time. One of the most widely seen images of the war (also winning a Pulitzer) was Nick Ut's naked girl, running agonizingly towards the camera, suffering burns from napalm accidentally dropped by South Vietnamese pilots on their own countrymen. The power of the photo derives from the image of her vulnerable nakedness, the pain on her face, the isolation of the figure, arms out unconsciously mimicking, as Vicki Goldberg observes, the crucifixion.[12] The clothed boy on the left, his face a mask of pain and weeping, reinforces the sense of a general nightmare.

This image, after appearing in many forms, including a poster, eventually found its way into *The Best of Life* (1973), where it was seen and contemplated, among many others, by Vik Muniz. Muniz, himself new to the country, was 'learning' America through its most celebrated vehicle for creating a national self-image and he would draw these photographs repeatedly. His 1989 photograph, *Memory Rendering of Tram Bang*, is based on a drawing Muniz did from memory, having lost the book in the summer of 1989 [129]. Muniz's copy is, first of all, a demonstration of the degree to which photographic moments may become blazoned indelibly in the mind, as if they had the inevitably of a great work of art. Yet it is the distance between the original and the copy that is itself the subject of this work, and the fact that it is a 'fake' immediately undermines the authenticity of the image as a picturing of the reality of war. It is, if anything, an allusion to the horror of war, but our attention is drawn to the aesthetic and conceptual characteristic of the work as much as to its subject.

While we might accuse Muniz of trivializing a momentous record of the brutality of the Vietnam War, it might be taken, contrarily, as a tribute to that record. And it speaks as well to our sense, after the twentieth century, that the image has entered the historical record as an

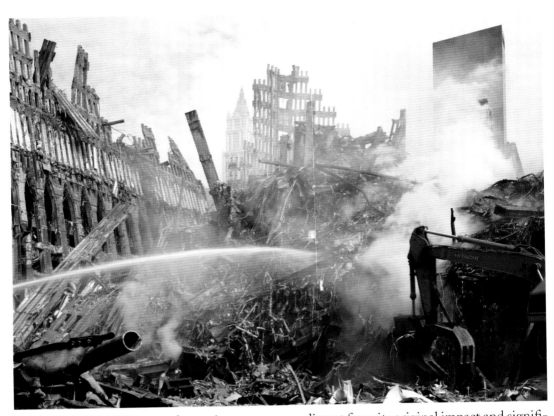

130 Joel Meyerowitz
World Trade Center, Archive Project, 2001

After persistent effort and many ruses, Meyerowitz was finally able to gain access to 'ground zero' during the clean-up phase of the World Trade Center disaster and took a series of photographs that dramatize the awesome and gigantic scale of the ruins. Yet there were elements of the sublime in these scenes, as Meyerowitz saw them, and he did not exclude the compositional elements (framing, balance, colour) that make this a powerful and even 'beautiful' picture, however sinister the context.

artefact on its own terms—distant from its original impact and significance, yet rendered here as a symbol with a broader meaning than being solely about Vietnam. As photography enters into the discourse of civility and into the currency of twenty-first-century politics and culture, its status as a truth-telling medium is far from negated. Yet it exists within a context of conceptual understanding and media sophistication that give it resonance along many other lines as well. It may be premature to say that we are living now in a 'post-photographic' age, despite the digitization of photography, for the illusions that the image can render have not yet been rendered irrelevant by the advancing picture-making technology of the computer. Nevertheless, it is a growing part of our contemporary consciousness that photography's function within our culture is at a crisis moment whose outcome is not yet certain. And our awareness of photography's intricate interweaving with our sense of reality—and unreality—is an essential part of our contemporary consciousness.

This was nowhere more evident than following the events of 11 September 2001, when the magnitude of the disaster at the World Trade Center could hardly be expressed by the television screen. Again and again, the networks re-played the footage of the second plane going into the second tower and of the collapse of the buildings into ghastly

rubble. But the immediacy of the live media prevented them from coming to terms with the overall significance of the story. That function was served by the news magazines, which used heavily illustrated articles to depict the catastrophe from its initial stages to the work of recovering bodies, removing debris, and—later on—reconciling ourselves to the loss and moving beyond that to resolution. Still photographs were powerful signifiers in other ways too: images of the missing covered the streets of Lower Manhattan following the event, advertising the sense of loss, made tangible through these images of loved ones; and photographs of the heroic rescue workers allowed us to celebrate something, at least, in this bleak event. Meanwhile, Joel Meyerowitz—well known as a sensitive formalist and pre-eminent photographer of place—produced a body of work that quickly came to seem 'representative' and was sent out to tour the world by the U.S. State Department [**130**].

Most remarkable, perhaps, was the creation of *Here Is New York: A Democracy of Photographs*. Beginning soon after the event, a gallery in Manhattan collected photographs relating to 9/11 from anyone, ultimately gathering approximately 5,000 images from 3,000 photographers, both amateurs and professionals. Images were archived digitally and sold for $25 over the internet and at shops around New York, with proceeds going to charity. About a year after the event, the galleries closed and a book was produced, with 1,000 images, to stand as a record. As a collective documentary project, the scale of *Here Is New York* was uniquely broad; another claim is worth noting, that 'whereas after other events of this magnitude one striking picture has sometimes come to stand for, or to symbolize, what happened, the one picture which will probably come to stand for the World Trade Center tragedy will be all of these pictures.'[13] One wonders whether we might indeed be moving beyond the very notion of a 'definitive' photograph or whether one will yet surface that seems to say it all; nevertheless, the very effort to move the record beyond the professional documentary or news photographer to this broad array of picture makers expresses not only the inescapable significance of the event but also the democratization of photography both as a medium of communication and as a means of coming together.

That all of this could happen in the new age of digital photography is all the more remarkable, for it speaks to the continuing faith in the power of the medium to convey reality and to evoke its meanings, not definitively, but with a sense of the inexhaustibility of meaning itself.

Notes

Preface

1. The four major histories of photography all treat American photography as part of the general narrative, but without any effort to create a coherent national treatment. See Beaumont Newhall, *The History of Photography: From 1839 to the Present* (New York: Museum of Modern Art; Boston: Little, Brown, 1982); Naomi Rosenblum, *A World History of Photography*, rev. edn. (New York: Abbeville Press, 1989); Robert Hirsch, *Seizing the Light: A History of Photography* (Boston: McGraw Hill, 2000); and Michel Frizot (ed.), *A New History of Photography* (Köln: Könemann, 1998). In addition, there are two more specialized volumes that frame the subject within national boundaries: Martha A. Sandweiss (ed.), *Photography in Nineteenth-Century America* (Fort Worth, TX: Amon Carter; New York: Abrams, 1991) and Jonathan Green, *American Photography: A Critical History, 1945 to the Present* (New York: Abrams, 1984).

2. *After Art: Rethinking 150 Years of Photography*, with essays by Chris Bruce and Andy Grundberg (Seattle: Henry Art Gallery, University of Washington, 1994), 10.

Introduction

1. Townsend Luddington (ed.), *A Modern Mosaic: Art and Modernism in the United States* (Chapel Hill: University of North Carolina Press, 2000), 358.

2. Sean Wilentz, 'The Rough Rider', *The New Republic* (28 July 1997), 41. Wilentz is reviewing Robert Hughes's *American Visions: The Epic History of Art in America* (New York: Knopf, 1997), which, he claims, slighted photography in its account of the connections between American art and history.

3. Photographs are 'the group's image of its own integration', says Pierre Bourdieu, who links the spread of photography to the family and especially to the photographing of children and of family events.

Photography: A Middlebrow Art, translated by Shaun Whiteside (orig. pub. 1965; Stanford, CA: Stanford University Press, 1990), 26.

4. See Roland Barthes: 'The photographic paradox can then be seen as the co-existence of two messages, the one without a code (the photographic analogue), the other with a code (the "art," or the treatment, or the "writing," or the rhetoric, of the photograph).' 'The Photographic Message', *Image Music Text* (New York: Hill and Wang, 1977), 19. Also see W. J. T. Mitchell, *Picture Theory* (Chicago: University of Chicago Press, 1994), 282–5; and Allen Sekula: photographic meaning 'is always a hybrid construction, the outcome of an interplay of iconic, graphic, and narrative conventions'. 'The Traffic in Photographs', *Photography against the Grain: Essays and Photo Works, 1973–83* (Halifax: The Press of the Nova Scotia College of Art and Design, 1984), 81. On Barthes and the prevailing binary thinking about photography, see also Geoffrey Batchen, *Burning with Desire: The Conception of Photography* (Cambridge, MA: MIT Press, 1997), 192.

5. Vicki Goldberg explores this angle, looking at a series of individual images, in her illuminating *The Power of Photography: How Photographs Changed Our Lives* (New York: Abbeville Press, 1991). I consider these issues more fully in 'Where Is Photography?', *The Photo Review*, vol. 19 (Fall 1996), 13–15.

6. Abigail Solomon-Godeau, *Photography at the Dock: Essays on Photographic History, Institutions, and Practices* (Minneapolis: University of Minnesota Press, 1991), xxiv.

7. Aaron Scharf, *Art and Photography* (New York: Penguin Books, 1986); Van Deren Coke, *The Painter and the Photograph: From Delacroix to Warhol* (Albuquerque: University of New Mexico Press, 1972).

8. David Hockney, *Secret Knowledge: Rediscovering the Lost Techniques of the Old Masters* (New York: Viking Press, 2001).

Chapter 2. Presenting the Self

1. Edgar Allan Poe, 'The Daguerreotype', in Jane M. Rabb (ed.), *Literature and Photography: Interactions 1840–1990* (Albuquerque: University of New Mexico Press, 1995), 5.

2. The stereoscope—a viewer designed for a card with two pictures, side by side, that produce a three-dimensional effect when seen from the proper distance—was around as a toy before photography, but was adapted to the new medium in the 1850s. It remained hugely popular, though eclipsed briefly by the *carte de visite*, throughout the nineteenth century, and featured a large variety of subjects, including views, dramatic enactments, artworks, etc.

3. Oliver Wendell Holmes, 'The Stereoscope and the Stereograph' (1859), in Alan Trachtenberg (ed.), *Classic Essays on Photography* (New Haven, CT: Leete's Island Books, 1980), 79–80.

4. For a full account of Brady's career, see Mary Panzer, *Mathew Brady and the Image of History* (Washington, DC: National Portrait Gallery/Smithsonian, 1997), on which I have drawn.

5. Robert Southworth, 'Address', quoted in John Wood, *The Daguerreotype: A Sesquicentennial Celebration* (Iowa City: University of Iowa Press, 1989), 13.

6. See Charles Colbert, *A Measure of Perfection: Phrenology and the Fine Arts in America* (Chapel Hill: University of North Carolina Press, 1997).

7. Emerson to Carlyle, 14 May 1846, in Rabb, *Literature and Photography*, 17.

8. Quoted in Floyd Rinhart and Marion Rinhart, *The American Daguerreotype* (Athens, GA: University of Georgia Press, 1981), 254–5.

9. See Jay Ruby, *Secure the Shadow: Death and Photography in America* (Cambridge, MA: MIT Press, 1995).

10. See Alan Trachtenberg, 'Likeness as Identity: Reflections on the Daguerrean Mystique', in Graham Clarke (ed.), *The Portrait in Photography* (London: Reaktion, 1992), 188.

11. Walt Whitman, 'Visit to Plumbe's Gallery', 2 July 1846, in Rabb, *Literature and Photography*, 21.

12. 'The attention of citizens and strangers, whether wishing pictures or not, is invited to the collection of likenesses of eminent public men contained in the Gallery. The number now in possession of the subscribers is about three hundred, and additions are continually being made.' [A list follows.] Advertisement for National Miniature Gallery, Anthony,

Edwards and C., 1844. Reprinted in Rinhart and Rinhart, *The American Daguerrotype*, 83.

13. *Humphrey's Journal of the Daguerreotype*, 15 June 1853.

14. 'Brady, The Grand Old Man of Photography: An Interview by George Alfred Townsend' (*The World*, 12 April 1891, 26, reprinted in Beaumont Newhall (ed.), *Photography: Essays and Images* (New York: Museum of Modern Art, 1980), 46.

15. The most famous such production is Hugh Diamond's English study, 'On the Application of Photography to the Physiognomic and Mental Phenomena of Insanity' reprinted in Sander L. Gilman (ed.) *The Face of Madness: Hugh W. Diamond and the Origin of Psychiatric Photography* (New York: Brunner/Mazel, 1976).

16. See Alan Trachtenberg, in *Reading American Photographs: Images as History, Mathew Brady to Walker Evans* (New York: Hill and Wang, 1989).

17. See Michelle Shawn Smith, *American Archives: Gender, Race and Class in Visual Culture* (Princeton, NJ: Princeton University Press, 1999), 53–112.

18. See Alfred L. Bush and Lee Clark Mitchell, *The Photograph and the American Indian* (Princeton, NJ: Princeton University Press, 1994).

19. See Christopher Lyman, *The Vanishing Race and Other Illusions: Photographs of Indians by Edward S. Curtis* (New York: Pantheon, 1982).

20. The 'reverse' of Curtis's effort was the programme at the Carlisle Indian School, where arriving Indians were photographed in their native dress, and then again on their graduation, wearing 'white' clothes: the sartorial transformation was a proud record of the school's 'civilizing' function. See Brian W. Dippie, 'Representing the Other: The North American Indian', in Elizabeth Edwards, *Anthropology and Photography, 1860–1920* (New Haven, CT: Yale University Press, 1992), 136.

21. Edward Curtis, 'General Introduction', *The North American Indians* (New York: Johnson Reprint Corp., 1970, *c.*1907–30), xiii–xiv.

22. Curtis, ibid., xv.

23. 'Our portraits set the standards for high-quality, lasting images with important features that include our nine-point quality check system, durable no-fade coating and a 100% guarantee of satisfaction. From wallet-sized keepsakes to wall-sized portraits, we offer the styles people prefer in the sizes best-suited for framing, gift-giving and family record

keeping. Olan Mills also provides the extra details, such as custom and artistic hand finishes, canvas and brushstroke styles, that give great portraits an added touch of perfection.' (www.olanmills.com/about/about.asp)

24. See Sandra S. Philips, *Police Pictures: The Photograph as Evidence* (San Francisco: San Francisco Museum of Modern Art/Chronicle Books, 1997); and Catherine A. Lutz and Jane L. Collins, *Reading National Geographic* (Chicago: University of Chicago Press, 1993).

Chapter 3. Viewing the Landscape

1. Reverend H. J. Morton, 'Photography in the Fields', *The Philadelphia Photographer*, 1 (May 1864), 65–6; quoted in Peter Bacon Hales, 'American Views', in Martha Sandweiss (ed.), *Photography in Nineteenth Century America* (Ft. Worth, TX: Amon Carter Museum; New York: Harry N. Abrams, 1991), 209. I am indebted to Hales's essay for its account of the view tradition.

2. William Henry Jackson, 'Time Exposure', in Vicki Goldberg (ed.), *Photography in Print: Writings from 1816 to the Present* (New York: Touchstone, 1981; reprinted Albuquerque: University of New Mexico Press, 1988), 169.

3. R. H. Vance, *Catalogue of Daguerreotype Panoramic Views in California* (New York: Baker, Godwin and Company, 1851), 4; quoted in Peter Palmquist, 'Silver Plates on a Golden Shore', in John Wood (ed.), *The Daguerreotype: A Sesquicentennial Celebration* (Iowa City: University of Iowa Press, 1989), 150.

4. Daniel Wolf (ed.), *The American Space: Meaning in Nineteenth-Century Landscape Photography* (Middletown, CT: Wesleyan University Press, 1983).

5. Weston J. Naef, *Era of Exploration: The Rise of Landscape Photography in the American West, 1860–1885* (Buffalo, NY: Albright-Knox Art Gallery; New York: Metropolitan Museum of Art, 1975).

6. Estelle Jussim and Elizabeth Lindquist-Cock, *Landscape as Photograph* (New Haven, CT: Yale University Press, 1985).

7. Merry A. Foresta, *Between Home and Heaven: Contemporary American Landscape Photography* (Washington, DC: National Museum of American Art and Albuquerque: University of New Mexico, 1992), 44–5.

8. E.g. the studio of the Langenheim brothers in Philadelphia and the Watkins or Muybridge studios in San Francisco.

9. Thomas Moran, 'The Relation of Photography to the Fine Arts' (*The Philadelphia Photographer*, 1865) quoted in Hales, 'American Views', 208.

10. See Weston J. Naef, *Era of Exploration: The Rise of Landscape Photography in the American West, 1860–1885* (Buffalo, NY: Albright-Knox Art Gallery; New York: Metropolitan Museum of Art, 1975), 19–20.

11. See *This Is the American Earth*, the book based on the exhibition of the same title by Ansel Adams and Nancy Newhall (San Francisco: Sierra Club, 1955); and Eliot Porter's hugely popular and expensive book *In Wildness is the Preservation of the World* (San Francisco: Sierra Club, 1962); on Ansel Adams, see Jonathan Spaulding, 'The Natural Scene and the Social Good: The Artistic Education of Ansel Adams', *Pacific Historical Review*, 60 (February 1990), 15–42.

12. Marcus Aurelius Root, *The Camera and the Pencil* (Philadelphia, 1864), 25, quoted in Mary Panzer, *Philadelphia Naturalistic Photography, 1865–1906* (New Haven, CT: Yale University Art Gallery, 1982), 3. I am indebted to Panzer's account of the Philadelphia club and naturalistic photography.

13. Edward L. Wilson, editor of *The Philadelphia Photographer*: 'We should learn to select and combine and arrange the material before us, so as to secure the most pleasing result.' ('Our Picture', *The Philadelphia Photographer*, 12 (May 1875), 137; quoted in Hales, 'American Views', 225.)

14. The tradition of women landscape photographers, emerging out of the Pictorialist movement, is explored by Judith Fryer Davidov in *Women's Camera Work* (Durham, NC: Duke University Press, 1998), esp. chapter VI, 'The Body's Geography: Female Versions of Landscape', which argues the place of a female perspective, uniting viewer and landscape in the work of photographers like Brigman and Käsebier. Brigman: 'Compact, squat giants are these trees, shaped by the winds of the centuries like wings and flames and torso-like forms . . . unbelievably beautiful in their rhythms . . . Into these tree and rock forms the sensitive yet hardy feminine figure took its place with sculptural fitness.' Brigman, 'Foreword', 30 July 1939, Stieglitz Archives, Beinecke Library. Quoted in Davidov, ibid. 317.

15. See Hales on Teich postcards, 'American Views', 241–2; meanwhile, the grand-style landscape tradition continued in the stereograph sets of companies with global sales—Keystone, Underwood and Underwood, American Stereoscopic

Company—who sold to schools, libraries, settlement houses, etc., often using travelling salesmen. See William C. Darrah, *The World of Stereographs* (Gettysburg, PA: W. C. Darrah, 1977).

16. King opposed Darwin's view of the more gradual, uniform changes in the earth's surface.

17. Rosalind Krauss has argued that O'Sullivan's images were made for purposes of scientific and government survey and should not be considered 'art'; against Krauss, Estelle Jussim and Elizabeth Lindquist-Cock maintain that even though O'Sullivan was creating pictures primarily for government reports, he nevertheless followed certain aesthetic canons, a view supported by Weston Naef and Joel Snyder. See Rosalind Krauss, 'Photography's Discursive Spaces: Landscape/View', *College Art Journal* (Winter 1982), 311–19; Estelle Jussim and Elizabeth Lindquist-Cock, *Landscape as Photograph* (New Haven, CT: Yale University Press, 1985); Joel Snyder, *American Frontiers: The Photographs of Timothy H. O'Sullivan, 1867–1874* (Philadelphia, PA: Philadelphia Museum of Art, 1981).

18. See Mark Klett *et al.*, *Second View: The Rephotographic Survey Project* (Albuquerque: University of New Mexico Press, 1984).

19. The act of seeing, measuring, what is before one arrives at its most conscious (and playful) point in the work of Kenneth Josephson. Extending his own arm into the scene before the camera, Josephson holds a measuring stick, as if to 'match' the length of the stick with the 'corresponding' scene in the distant mountains and with its schematic representation. See Kenneth Josephson and Sylvia Wolf, *Kenneth Josephson: A Retrospective* (Chicago: Art Institute of Chicago Museum, 1999).

20. See John Pfahl and Peter Bunnell, *Altered Landscapes: The Photographs of John Pfahl* (San Francisco: Friends of Photography, 1981).

21. See Robert Adams, *The New West: Landscapes along the Colorado Front Range* (Boulder: Colorado Associated University Press, 1974).

22. Jonathan Green, *American Photography: A Critical History, 1945 to the Present* (New York: Harry N. Abrams, 1984), 165–6.

23. See Allan Sekula, 'The Instrumental Image: Steichen at War', *Photography Against the Grain* (Halifax: Press of the Nova Scotia College of Art and Design, 1984).

24. Terry Evans, *Prairie: Images of Ground and Sky* (Kansas: University Press of Kansas, 1986);

Emmet Gowin—Photographs (Philadelphia Museum of Art; Boston: Bulfinch Press, c.1990)

25. Letter from Evans to Merry Foresta, September 1990, quoted in Merry Foresta, *Between Home and Heaven: Contemporary American Landscape Photography* (Albuquerque: University of New Mexico Press, 1997), 47.

26. Richard Misrach, *Violent Legacies: Three Cantos* (New York: Aperture, 1992).

Chapter 4. Seeing and Believing

1. 'Topics of the Day: About Ourselves', *New York Daily Graphic* (4 March 1853), quoted in Michael L. Carlebach, *The Origins of Photojournalism in America* (Washington, DC: Smithsonian, 1992), 150.

2. Daguerreotypes of the earlier Mexican War (1847) surfaced many years later, in the 1920s, but were not published during their own time either as lithographs or wood engravings. Only portraits of the military leaders were published, in John Frost's *Pictorial History of Mexico and the Mexican War* (Philadelphia: Thomas, Cowperthwaite, and Company, 1849). See Will Stapp, '"Subjects of strange . . . and of fearful interest": Photojournalism from Its Beginnings in 1839', in Marianne Fulton (ed.), *Eyes of Time: Photojournalism in America* (New York: New York Graphic Society, 1988), 8–10.

3. Oliver Wendell Holmes, 'Doings of the Sunbeam', *Atlantic Monthly*, 12 [July 1863], reprinted in Newhall, *Photography: Essays and Images*, 73.

4. Newhall, ibid.

5. See Miles Orvell, *The Real Thing: Imitation and Authenticity in American Culture, 1880–1940* (Chapel Hill: University of North Carolina Press, 1989), 127.

6. 'Brady's Photographs: Pictures of the Dead at Antietam', *New York Times* (20 October 1862), 5. Quoted in Carlebach, *The Origins of Photojournalism*, 93.

7. Alexander Gardner, *Gardner's Photographic Sketch Book of the Civil War* (Washington, DC: Philp and Solomons, 1866; reprint edition, New York: Dover Press, 1959).

8. See William A. Frassanito, *Gettysburg: A Journey in Time* (New York: Scribner, 1975) and *Antietam: The Photographic Legacy of America's Bloodiest Day* (New York: Scribner, 1978).

9. Invented in England in 1864, the Woodburytype produced much-admired continuous tones, using a pigmented gelatin base and a mould process.

10. 'Copyright and the American

Photographer', *Wilson's Photographic Magazine*, vol. 37, no. 525 (September 1900). Quoted in Carlebach, *The Origins of Photojournalism*, 165.

11. Despite the stereotyping in the text, we never find the comical visual stereotypes of street types that photographers like Sigmund Krausz in Chicago were producing at the same time.

12. See, for example, Lewis Hine, 'Photography in the School', *Photographic Times*, 40 (August 1908), 227–32.

13. Maren Stange places Riis's work within the tradition of surveillance photography, imposing a 'domineering, touristic, even voyeuristic perspective'. Maren Stange, *Symbols of Ideal Life: Social Documentary Photography in America, 1890–1950* (Cambridge: Cambridge University Press, 1989), 23. Also see Miles Orvell, 'Lewis Hine and the Art of the Commonplace', in Orvell (ed.), *After the Machine: Visual Arts and the Erasing of Cultural Boundaries* (Jackson, MS: University Press of Mississippi, 1995), 42–56.

14. Lewis Hine, 'Social Photography: How the Camera May Help in the Social Uplift', *Proceedings, National Conference of Charities and Corrections* (June 1909), 358.

15. Michael L. Carlebach, *American Photojournalism Comes of Age* (Washington, DC: Smithsonian, 1997), 14.

16. Estelle Jussim, '"The Tyranny of the Pictorial": American Photojournalism from 1880 to 1920', in Marianne Fulton (ed.), *Eyes of Time: Photojournalism in America* (New York: New York Graphic Society 1988), 64.

Chapter 5. A Photographic Art

1. Aaron Scharf, *Art and Photography* (New York: Penguin Books, 1986); Van Deren Coke, *The Painter and the Photograph: From Delacroix to Warhol* (Albuquerque: University of New Mexico Press, 1972).

2. See Mary Panzer, *Philadelphia Naturalistic Photography, 1865–1906* (New Haven, CT: Yale University Art Gallery, 1982), 8–10.

3. On Käsebier, see Judith Fryer Davidov, *Women's Camera Work: Self/Body/Other in American Visual Culture* (Durham, NC: Duke University Press, 1998).

4. In 1904, a fire destroyed much of his work. On Day, see Estelle Jussim, *Slave to Beauty: The Eccentric Life and Controversial Career of F. Holland Day, Photographer, Publisher, Aesthete* (Boston: D. R. Godine, 1981).

5. Steichen's extraordinary career extended for six decades, going through several major phases, from art photography to advertising to military aerial photography, to curatorial work. See Steichen, *A Life in Photography* (New York: Bonanza, 1984).

6. 'How *The Steerage* Happened' (1942), reprinted in Nathan Lyons (ed.), *Photographers on Photography* (Englewood Cliffs, NJ: Prentice Hall, 1966), 129.

7. Stieglitz, in *Camera Work*, 49/50 (1917); reprinted in Paul Strand, *Paul Strand: A Retrospective Monograph* (Millerton, NY: Aperture, 1972).

8. Strand, in *Camera Work*, 49/50 (1917); reprinted in Jonathan Green (ed.), *Camera Work: A Critical Anthology* (Millerton, NY: Aperture, 1973).

9. Strand took up the moving camera in the 1920s and continued to work as a cinematographer into the 1930s, including his work on Pare Lorentz's early government documentary film, *The Plow that Broke the Plains* (1935).

10. See Bernard S. Horne's photograph, *Design*, in *Photo=Graphic Art*, vol. 3, no. 2 (1916). Reprinted in Bonnie Yochelson, 'Clarence H. White, Peaceful Warrior', *Pictorialism into Modernism: The Clarence H. White School of Photography*, edited by Marianne Fulton (New York: Rizzoli, 1996), 66.

11. Max Weber, 'The Filling of Space', *Platinum Print*, vol. 1, no. 2 (December 1913); quoted in Yochelson, 'Clarence H. White', 58.

12. Max Weber, 'Design', *Photo=Graphic Art*, vol. 3, no. 1 (June 1916); quoted in Yochelson, ibid., 58.

13. The name 'vortograph' was taken from the futurist British art movement, Vorticism, led by Pound and Wyndham Lewis. See Hugh Kenner, *Pound Era* (Berkeley: University of California Press, 1971).

14. A. L. Coburn, 'The Future of Pictorial Photography', *Photographs of the Year 1916*, 23–4; repr. in Nathan Lyons (ed.), *Photographers on Photography* (Englewood Cliffs, NJ: Prentice Hall, 1966), 54.

15. See Dickran Tashjian, *Skyscraper Primitives: Dada and the American Avant-garde, 1910–1925* (Middletown, CT: Wesleyan University Press, 1975).

16. Christian Schad simultaneously discovered the technique, but failed to capitalize on it as fully as did Man Ray.

17. Edward Weston, 'Statement', *Edward Weston/Brett Weston Photographs* (Los Angeles: Los Angeles Museum, 1927); reprinted in Peter Bunnell (ed.), *Edward Weston on*

Photography (Salt Lake City, UT: Peregrine Smith Books, 1983), 46.

18. Precisionist Charles Sheeler's photographs and paintings, landscapes and still lifes, converged in a sharp-focused style that in many ways anticipated photo-realism and was rooted in an appreciation of the vernacular object and architecture. See Gail Stavitsky (ed.), *Precisionism in America, 1915–1941: Reordering Reality* (New York: Abrams, in association with the Montclair Art Museum, 1994), especially essays by Ellen Handy, 'The Idea and the Fact: Painting, Photography, Film, Precisionists, and the Real World', 40–51, and Miles Orvell, 'Inspired by Science and the Modern: Precisionism and American Culture', 52–9.

Chapter 6. Photography and Society

1. Alan Trachtenberg, *Reading American Photographs* (New York: Hill and Wang, 1989), 195. The name itself, *The Survey*, was symptomatic of this more synoptic approach, and it confirms Allen Sekula's observation that, after the turn of the last century, 'photographic archives were seen as central to a bewildering range of empirical disciplines, ranging from art history to military intelligence'. Allen Sekula, 'The Body and the Archive', in Richard Bolton (ed.), *The Contest of Meaning* (Cambridge, MA: MIT Press, 1989), 373.

2. See William Stott, *Documentary Expression and Thirties America* (New York: Oxford University Press, 1973); and Miles Orvell, 'Introduction', in Orvell (ed.), *After the Machine: Visual Arts and the Erasing of Cultural Boundaries* (Jackson, MS: University Press of Mississippi, 1995).

3. I am drawing here upon Bonnie Yochelson's introduction to *Berenice Abbott: Changing New York* (New York: Museum of the City of New York and the New Press, 1997).

4. Excerpt from the *New York Times* review by Jacob Deschin, reprinted in 'Press Notices on "This Is the Photo League" Exhibition', *Photo Notes* (Spring 1949), 7.

5. See Leo Hurwitz's review, 'This Is the Photo League', ibid. 2.

6. Margaret Bourke-White and Erskine Caldwell, *You Have Seen Their Faces* (New York: The Viking Press, 1937).

7. Dorothea Lange and Paul Schuster Taylor, *An American Exodus: A Record of Human Erosion* (New York: Reynal and Hitchcock, 1939).

8. Archibald MacLeish, *Land of the Free* (New York: Harcourt Brace and Co., 1938).

9. Richard Wright, *12 Million Black Voices: A Folk History of the Negro in the United States* (New York: The Viking Press, 1941).

10. Walker Evans, *American Photographs* (New York: Museum of Modern Art, 1938).

11. James Agee and Walker Evans, *Let Us Now Praise Famous Men* (Boston: Houghton Mifflin, 1941).

12. For an interpretation of the Standard Oil Project, see Nicholas Lemann, *Out of the Forties* (New York: Simon and Schuster, Fireside, 1985).

13. I am drawing on Eric Sandeen's *Picturing an Exhibition: The Family of Man and 1950s America* (Albuquerque: University of New Mexico Press, 1995).

14. Edward Steichen, *Introduction, Family of Man* (New York: Museum of Modern Art, 1955), n.p.

15. See, for example, Allen Sekula, 'The Traffic in Photographs', *Photography against the Grain: Essays and Photo Works* (Halifax: The Press of Nova Scotia College of Art and Design,1984), 77–101.

16. 'Nurse Midwife: Maude Callen Eases Pain of Birth, Life and Death', *Life* vol. 31, no. 23 (3 December 1951), 134–45.

17. Bill Gaskins, 'The World according to *Life*: Racial Stereotyping and American Identity', *Afterimage*, 1993; reprinted in Gabriella Ibieta and Miles Orvell, *Inventing America: Readings in Identity and Culture* (New York: St Martin's, 1996), 480–91; also see James Guimond, *American Photography and the American Dream* (Chapel Hill: University of North Carolina Press, 1991), 197–200; Wendy Kozol, *Life's America: Family and Nation in Postwar Photojournalism* (Philadelphia, PA: Temple University Press, 1994).

18. See the series by Parks on Watson in *Documenting America: 1935–1943*, edited by Carl Fleischhauer and Beverly W. Brannan (Berkeley: University of California Press, 1988), 226–39. Negro enrollees in the Civilian Conservation Core were also pictured sympathetically. See Maren Stange, 'Publicity, Husbandry, and Technocracy', in *Official Images: New Deal Photography* (Washington, DC: Smithsonian Institution Press, 1987), edited by Pete Daniel, Merry A. Foresta, Maren Stange, and Sally Stein. But Nicholas Natanson demonstrates the general neglect of black subjects in the FSA files: *The Black Image in the New Deal* (Knoxville: University of Tennessee Press, 1992).

19. Some of the strongest images in that volume—a horrific Georgia lynching, Harlem looters, race riots in Detroit—are from the

news media, which is not surprising, given the FSA's effort to avoid directly political imagery.

20. See Maren Stange, 'Illusion Complete within Itself: Roy DeCarava's Photography', in Townsend Ludington (ed.), *A Modern Mosaic: Art and Modernism in the United States* (Chapel Hill: University of North Carolina Press, 2000), 279–305.

21. *The New Negro* anthology was originally a special issue of *Survey Graphic* magazine (March 1925). For Van Der Zee, see Deborah Willis *et al.*, *Van Der Zee: Photographer 1886–1983* (New York: Harry N. Abrams, 1998).

22. First published in France, *Les Américains*, Textes réunis et présentés par Alain Bosquet (Paris: R. Delpire, 1958); *The Americans*, with an introduction by Jack Kerouac (New York: Grove Press, 1959).

23. Jack Kerouac, 'Introduction' in Frank, *The Americans*, 9.

24. See Tod Papageorge, *Walker Evans and Robert Frank: An Essay on Influence* (New Haven, CT: Yale University Art Gallery, 1981). During the late 1930s and early 1940s FSA photographer John Vachon also captured his spontaneous observations of the street in images that would occasionally find their way into the popular press. See Miles Orvell (ed.), *John Vachon's America, from the Depression to World War II: Photographs and Letters* (Berkeley: University of California Press, forthcoming, 2003).

25. *Naked City* (New York: Essential Books, 1945).

26. Jonathan Green, *The Snapshot*, (Millerton, NY: Aperture, 1974), 84.

27. Barbara Diamonstein, *Visions and Images: American Photographers on Photography* (New York: Rizzoli, 1982), 185. Another Winogrand apothegm: 'The way I understand it, a photographer's relationship to his medium is responsible for this relationship to the world is responsible for his relationship to his medium.' Quoted in Garry Winogrand, *Public Relations* (New York: Museum of Modern Art, 1997), 110.

28. Danny Lyon, *Memories of the Southern Civil Rights Movement* (Chapel Hill: University of North Carolina Press, 1992).

29. Bruce Davidson, *East 100th Street* (Cambridge, MA: Harvard University Press, 1970).

30. The reaction to Allon Schoener's contemporaneous landmark Metropolitan Museum of Art exhibition, Harlem on My Mind: Black America, 1900–1968, was far more controversial. Making extensive use of photographs of Harlem by black photographers, the exhibit was applauded by some African Americans for its serious treatment of black culture, while others decried the absence of blacks from the planning process. Meanwhile, conservative art critics denounced the 'political' nature of the exhibition in the high art precinct of the Met, while some Jewish leaders denounced the putative anti-Semitism of the introduction by a young African American writer. See Schoener, *Harlem on My Mind* (1968; reprinted with new introduction by Allon Schoener, New York: The New Press, 1995).

31. For a sample of Stummer's Newark project, see www.hmstummer.com/newark.html.

32. Jacob Holdt, *American Pictures: A Personal Journey through the American Underclass* (Copenhagen: American Pictures Foundation, 1992).

33. Camilo José Vergara, *The New American Ghetto* (New York: Routledge, 1995).

34. Ibid. xiv.

35. Sebastião Salgado, *Workers: An Archeology of the Industrial Age* (New York: Aperture, 1993).

36. See Miles Orvell, 'Documentary and the Seductions of Beauty: Salgado's Workers', in Orvell, *After the Machine: Visual Arts and the Erasing of Cultural Boundaries* (Jackson, MS: University Press of Mississippi, 1995), 97–112.

37. Susan Meiselas, *Nicaragua* (New York: Random House, 1981).

38. James Nachtwey, *Inferno* (New York and London: Phaidon Press, 2000).

39. Susan Sontag, *On Photography* (New York: Farrar, Straus, Giroux, 1977).

40. Interview with Elizabeth Farnsworth, *Online NewsHour*, A Conversation with . . . 16 May 2000. www.pbs.org/newshour/gergen/jan-june00/nachtwey_5-16.html

41. Martha Rosler, 'In, Around, and Afterthoughts (On Documentary Photography)', in Rosler, *3 Works* (Halifax: The Press of Novia Scotia College of Art and Design, 1981), 73.

42. Martha Rosler, 'The Bowery in Two Inadequate Descriptive Systems [1974–75]', in Rosler, *3 Works*.

43. Rosler, ibid. 72: 'Charity is an argument for the preservation of wealth . . . an argument embedded in a matrix of Christian ethics.' See Miles Orvell, 'Don't Think of It as Art: The Legacy of *Let Us Now Praise Famous Men*', in Orvell, *After the Machine*, 69.

44. *Here Is New York* flyer; also see www.hereisnewyork.org

Chapter 7. Versions of the Self: Memory, Identity, Autobiography

1. Marcus Aurelius Root, 'The Camera and the Pencil', in Vicki Goldberg (ed.), *Photography in Print: Writings from 1816 to the Present* (New York: Touchstone, 1981; reprinted Albuquerque: University of New Mexico Press, 1988), 148–9.

2. See Jay Ruby, *Secure the Shadow: Death and Photography in America* (Cambridge, MA: MIT Press, 1995).

3. See Richard Chalfen, *Snapshot Versions of Life* (Bowling Green, OH: Popular Press, 1987).

4. Clarissa Sligh, Interview with Deborah Willis, 30 August 1995, quoted in Willis, 'A Search for Self: The Photograph and Black Family Life', in Marianne Hirsch (ed.), *The Familial Gaze* (Hanover, NH: University Press of New England, 1999), 109. Extending the notion of the family album to the community as a whole, the collective self of the African American community has been seen in the work of such photographers as James Van Der Zee, who portrayed the full range of Harlem life during the early decades of the twentieth century. The discovery of his work has opened up whole new fields of investigation and understanding of the way commercial photographers have provided a self-image for minority communities. See Deborah Willis, 'Introduction', in Willis (ed.), *Picturing Us: African American Identity in Photography*, (New York: The New Press, 1994); Willis, 'A Search for Self: The Photograph and Black Family Life', in Hirsch (ed.), *The Familial Gaze*; and Willis, *Reflections in Black: A History of Black Photographers, 1840 to the Present* (New York: Norton, 2000).

5. Nancy Martha West, *Kodak and the Lens of Nostalgia* (Charlottesville: University Press of Virginia, 2000), 13.

6. Advertisement for the Brownie camera, *Youth's Companion*, 1909. Reprinted in West, ibid. 107.

7. Michelle Shawn Smith sees the family album and amateur photography as crucial to the social reproduction of the white middle-class family and an extension of the maternal role that was congruent with the eugenic programme that would reproduce a 'great race'. See *American Archives: Gender, Race, and Class in Visual Culture* (Princeton, NJ: Princeton University Press, 1999), 122.

8. Richard Avedon, 'Henry Kissinger', www.richardavedon.com/interviews/index.html

9. Quoted in Lyle Rexer, 'Marriage under Glass: Intimate Exposures', *New York Times*, 19 November 2000 (section 2, p. 41).

10. Sally Mann, Mother Land: Recent Landscapes of Georgia and Virginia (Edwyn Houk Gallery, New York, 1997). Another exhibition series is entitled: Deep South: Landscapes of Mississippi and Louisiana (1999).

11. W. J. T. Mitchell, *Picture Theory: Essays on Verbal and Visual Representation* (Chicago: University of Chicago Press, 1994), 89. For Mitchell, 'Image/text' denotes a 'rupture in representation', while 'image text' signifies a composite and 'image-text' designates '*relations* of the visual and the verbal'.

12. Jim Goldberg, *Rich and Poor* (New York: Random House, 1985).

13. Ibid., n.p.

14. Howard Schatz, *Homeless: Portraits of Americans in Hard Times* (San Francisco: Chronicle Books, 1993); Mary Ellen Mark, *A Cry for Help: Stories of Homelessness and Help* (New York: Touchstone Books, 1996).

15. See Sol Worth and John Adair, *Through Navajo Eyes: An Exploration in Film Communication and Anthropology* [orig. pub. 1972], with a new introduction, afterword, and notes by Richard Chalfen (Albuquerque: University of New Mexico Press, 1997).

16. For an extended discussion of family photography, especially in connection with memory see Marianne Hirsch, *Family Frames: Photography, Narrative, and Postmemory* (Cambridge, MA: Harvard University Press, 1997). See also Chalfen, *Snapshot Versions of Life*.

17. Nan Goldin, *I'll Be Your Mirror* (New York: Whitney Museum of Art, 1996).

18. Ibid. 452.

19. Larry Clark, *Tulsa* (New York: Grove Press, 1971).

20. Nan Goldin, *The Ballad of Sexual Dependency* (New York: Aperture, 1986).

21. See Francesca Woodman: Photographic Work, exhibition organized by Ann Gabhart in collaboration with Rosalind Krauss, with a catalogue essay by Abigail Solomon-Godeau (Wellesley, MA: Wellesley College Museum, 1986). A. D. Coleman's opinion is expressed in A. D. Coleman, *Depth of Field: Essays on Photography, Mass Media and Lens Culture* (Albuquerque: University of New Mexico Press, 1998), 30.

22. Sol LeWitt, *Sol LeWitt Autobiography 1980* (New York: Multiples; Boston: Lois and Michael K. Torf, 1980).

Chapter 8. Photographing Fictions

1. See Beaumont Newhall, *The History of Photography: From 1839 to the Present* (New York: Museum of Modern Art; Boston: Little, Brown, 1982).

2. A. D. Coleman, 'The Directorial Mode: Notes towards a Definition', in Coleman, *Light Readings: A Photography Critic's Writings, 1968–1978* (New York: Oxford University Press, 1979) and 'The Image in Question: Further Notes on the Directorial Mode', in Coleman, *Depth of Field: Essays on Photography, Mass Media, and Lens Culture* (Albuquerque: University of New Mexico Press, 1998).

3. See William C. Darrah, *The World of Stereographs* (Gettysburg, PA: W. C. Darrah, Publisher, 1977).

4. For examples of Martin's work (e.g. men in cars hunting down and roping a giant rabbit) see http://www.photographymuseum.com/talltale.html

5. For lantern slide shows anticipating movies, see the Eastman House website, especially: www.geh.org/fm/precin/6042-1631-3258r/pre-cinema-lantern-slides.html

6. Alexander Black, '"Miss Jerry," The First Picture Play', *Scribner's Magazine*, vol. 18, no. 3 (September 1895), 348–60.

7. Ibid. 348.

8. Quoted by Mark Haworth Booth in Lewis Baltz, *Rule without Exception* (Zurich: Fotomuseum Winterthur; New York: Scalo Verlag, 1993), 77.

9. In one image, Man Ray pictured literally the celebrated Surrealist exaltation of the beautiful as 'the chance encounter, on a dissecting table, of a sewing machine and an umbrella', a phrase attributed to Isadore-Lucien Ducasse (the Comte de Lautréamont).

10. In the final edition of his standard history of photography (1982), Newhall did at last acknowledge Mortensen, albeit dismissively, when he mentions that his 'anecdotal, highly sentimental' work was a stimulus for the reactive formation of Group f.64. Newhall, *The History of Photography*, 192.

11. See 'Conspicuous by His Absence: Concerning the Mysterious Disappearance of William Mortensen', in Coleman, *Depth of Field*, 53–61. Also see Larry Lytle, 'The Command to Look: The Story of William Mortensen, Part II', www.thescreamonline.com/photo/photo08-01/mortensen/index.html#f7

12. Duane Michals, *A Visit with Magritte* (Providence, RI: Matrix, 1981).

13. Duane Michals, *Real Dreams: Photo Stories* (Danbury, NH: Addison House; Rochester, NY: distributed by Light Impressions, 1976).

14. Walt Whitman, *Song of Myself, Leaves of Grass and Selected Prose*, ed. John Kouwenhoven (New York: Modern Library, 1950), 43.

15. Ibid. 29.

16. Ibid. 34.

17. Quoted in Salon article on Witkin: http://login.yahoo.com/config/exit?.src=ym&.lg=us&.intl=us&.done=http%3a%2f%2flogin.yahoo.com%2fconfig%2fmail%3f.intl%3dus%26.lg%3dus

18. Coleman, 'The Directorial Mode'. See also Coleman's later thoughts on the directorial mode, where he is at pains to distinguish it from auteurism in 'The Image in Question', the final version of an essay published in many versions from the late 1980s onwards, in Coleman, *Depth of Field*.

19. Quoted in Beth Biegler, 'Surrogates and Stereotypes: Allan McCollum and Laurie Simmons, under the Rubric of Post-modernism', http://home.att.net/~allanmcnyc/Beth_Biegler.html. Originally published in *East Village Eye*, December/January 1986.

20. Ibid.

Chapter 9. Photography and the Image World

1. Oliver Wendell Holmes, 'The Stereoscope and the Stereograph', reprinted in Vicki Goldberg (ed.), *Photography in Print: Writings from 1816 to the Present* (New York: Touchstone, 1981; reprinted Albuquerque: University of New Mexico Press, 1988), 112.

2. See Finis Dunaway, 'Hunting with the Camera: Nature Photography, Manliness, and Modern Memory, 1890–1930', *Journal of American Studies*, 34 (August 2000), 207–30.

3. Holmes, 'The Stereoscope', 113.

4. Alan Trachtenberg, 'Photography: The Emergence of a Keyword', in Martha Sandweiss (ed.), *Photography in Nineteenth-Century America* (Fort Worth, TX: Amon Carter Museum; New York: Harry N. Abrams, 1991), 43.

5. See William C. Darrah, *The World of Stereographs* (Gettysburg, PA: W. C. Darrah, Publisher, 1977).

6. Guy Debord, *Society of the Spectacle* (Detroit: Black and Red, 1970).

7. See Paul Marchand, *Advertising the American Dream: Making Way for Modernity, 1920–1940* (Berkeley: University of California Press, 1985); Jeffrey Meikle, *Twentieth Century Limited: Industrial Design in America,*

1925–1939 (Philadelphia, PA: Temple University Press, 1979); Jackson Lears, *Fables of Abundance: A Cultural History of Advertising in America* (New York: Basic Books, 1994).

8. See Ingrid Sischy, 'Style: Mr. Bubble', *The New York Times Magazine* (24 September 2000), 83–91; and Richard Avedon, 'In Memory of Mr. and Mrs. Comfort', *The New Yorker* (6 November 1995), 130–55.

9. Carter Smith, *New York Times Magazine* (12 September 1999), 111–22.

10. The text by Bob Morris mentions Ralph Lauren's Polo Jeans, 'washed, pilled and even ripped. Call it distress for success' (ibid. 122).

11. See David Nye, 'The Fragmentation of the Photographic Subject: Images of Workers', in David Nye and Christen Kold Thomsen (eds), *American Studies in Transition* (Odense, Denmark: Odense University Press, 1985), 56–7. See also Sally Stein, 'The Graphic Ordering of Desire: Modernization of a Middle-Class Women's Magazine, 1914–1939', in Richard Bolton (ed.), *The Contest of Meaning* (Cambridge, MA: MIT Press, 1989), 145–62; and Carol Squires, 'The Corporate Year in Pictures', in ibid. 207–20.

12. See Lewis Hine, *Men at Work* (orig. pub. 1932; New York: Dover Publications 1977).

13. See Andreas Feininger, *Industrial America, 1940–1960* (New York: Dover, 1981); F. Jack Hurley (ed.), *Industry and the Photographic Image* (New York: Dover, 1980); Sebastião Salgado, *Workers* (New York: Aperture, 1993).

14. Angela Davis, 'Afro-Images: Politics, Fashion, and Nostalgia', in Deborah Willis (ed.), *Picturing Us: African American Identity in Photography* (New York: The New Press, 1994), 171–9.

15. Ibid. 177.

16. Roland Barthes, *Camera Lucida: Reflections on Photography* (New York: Hill and Wang, 1981), 118–19.

17. More recently, Hockney has studied the effects of optical devices on the development of the realist tradition of Western painting. See David Hockney, *Secret Knowledge: Rediscovering the Lost Techniques of the Old Masters* (New York: Viking, 2001).

18. David Hockney, *Cameraworks* (New York: Knopf, 1984), 9.

19. Andy Grundberg, 'Mike and Doug Starn', in Grundberg (ed.), *Mike and Doug Starn* (New York: Harry Abrams, 1990), 35.

20. Baldessari has used these bubbles on many of his photographic works, beginning in 1985, in an installation for the Carnegie International Exhibition, *Buildings = Guns = People: Desire, Knowledge, and Hope (with Smog)*. 'I was a little worried about using someone's face, as I did not want to get sued, and I didn't know exactly where these photographs were coming from, so I used stickers I had lying around to obliterate the faces; and I felt so good I just kept on doing it.' Coosje van Bruggen, *John Baldessari* (Los Angeles: Museum of Contemporary Art, 1990), 187.

Chapter 10. Conclusion: Post-photography

1. Lewis Hine, 'Social Photography', in Alan Trachtenberg, *Classic Essays on Photography* (New Haven, CT: Leete's Island Books, 1980), 111.

2. Oscar G. Rejlander's most famous composite was *Two Ways of Life* (1857), an illustration of which can be found in most world histories of photography (see, for example, Robert Hirsch, *Seizing the Light: A History of Photography* (New York: McGraw-Hill, 2000), 124); Henry Peach Robinson's combination albumen print, *Carrolling* (1887) and his planning sketch for it can be found in Beaumont Newhall, *The History of Photography: From 1839 to the Present* (New York: Museum of Modern Art; Boston: Little, Brown, 1982), 77; also see Naomi Rosenblum, *A World History of Photography* (New York: Abbeville Press, 1984), 228, for an unfinished collage of a sketch and albumen print by Robinson.

3. See Geoffrey Batchen, *Burning with Desire: The Conception of Photography* (Cambridge, MA: MIT Press, 1997): 'Even if photography as a separate entity may be fast disappearing, the photographic as a vocabulary of conventions and references lives on in ever-expanding splendor' (216).

4. Rick Smolan, quoted in Sheila Reaves, 'Digital Retouching', *News Photographer*, January 1987, 26.

5. William J. Mitchell, *The Reconfigured Eye: Visual Truth in the Post-Photographic Era* (Cambridge, MA: MIT Press, 1994), 23.

6. Colleen Danos, Kent Pankey *et al. Report on Trends in the State Courts*, State Justice Institute, 1999, 31. www.ncsc.dni.us/is/98-99final.PDF There is currently software that can determine whether or not a digital image has been altered, though one can imagine that levels of expertise in interpreting data may vary.

7. John Taylor, *Body Horror: Photojournalism, Catastrophe, and War* (New York: New York University Press, 1998), 194.

8. Ibid. 195–6.

9. Henry Allen, 'Seasons in Hell', *The New Yorker* (12 June 2000), 108.

10. James Allen and Hilton Als, *Without Sanctuary: Lynching Photography in America* (Santa Fe, NM: Twin Palms, 2000), 195.

11. Copies of all these images can be seen in Vicki Goldberg's *The Power of Photography: How Pictures Changed Our Lives* (New York: Abbeville Press, 1991).

12. Ibid. 243. I am indebted to Goldberg's discussion of the images mentioned here for its treatment of the political context.

13. Michael Shulan, 'Introduction', *Here Is New York: A Democracy of Photographs*, http://hereisnewyork.org/gallery/bookintro.asp

Further Reading

The literature on American photography has grown enormously over the past twenty-five years, and this list attempts to provide some guidance to that literature for further study, especially of the topics treated in the individual chapters. There is no attempt to be exhaustive here, but rather to provide a few key sources for a multiplicity of topics. References cited in the preceding chapters are not mentioned again here, unless they are of some broader value.

Listings for the first chapter cover collections of primary readings as well as general histories of photography and more specialized histories of American photography. For the remaining chapters, the major topics include: (Chapter 2) the daguerreotype era and the portrait; (Chapter 3) landscape photography; (Chapter 4) photojournalism and documentary photography of the nineteenth and early twentieth centuries; (Chapter 5) art photography, including Pictorialism and modernism; (Chapter 6) documentary photography and photojournalism from the 1930s to the 1950s; (Chapter 7) photography, memory, and identity; (Chapter 8) fiction photography and the 'directorial mode'; (Chapter 9) postmodern photography's appropriation of images; (Chapter 10) digital photography and the problem of 'truth'.

Chapter 1. Introduction

Bolton, Richard (ed.), *The Contest of Meaning: Critical Histories of Photography* (Cambridge, MA: MIT Press, 1989).

Clarke, Graham, *The Photograph* (Oxford: Oxford University Press, 1997).

Frizot, Michel (ed.), *A New History of Photography* (Cologne: Könemann, 1998).

Goldberg, Vicki (ed.), *Photography in Print: Writings from 1816 to the Present* (New York: Touchstone, 1989; 2nd edn. Albuquerque: University of New Mexico Press, 1988).

Green, Jonathan, *American Photography: A Critical History, 1945 to the Present* (New York: Abrams, 1984).

Guimond, James, *American Photography and the American Dream* (Chapel Hill: University of North Carolina Press, 1991).

Hirsch, Robert, *Seizing the Light: A History of Photography* (Boston: McGraw Hill, 2000).

Hulick, Diana Emery with Joseph Marshall (eds.), *Photography 1900 to the Present* (Upper Saddle River, NJ: Prentice Hall, 1998).

Jenkins, Reese, *Images and Enterprise: Technology and the American Photographic Industry 1839–1925* (Baltimore, MD: Johns Hopkins University Press, 1975).

Mitchell, W. J. T., *Picture Theory: Essays on Verbal and Visual Representation* (Chicago: University of Chicago Press, 1994).

Newhall, Beaumont (ed.), *Photography: Essays and Images* (New York: Museum of Modern Art, 1980).

Orvell, Miles, *The Real Thing: Imitation and Authenticity in American Culture, 1880–1940* (Chapel Hill: University of North Carolina Press, 1989).

Rabb, Jane, *Literature and Photography: Interactions 1840–1990* (Albuquerque: University of New Mexico Press, 1995).

Rosenblum, Naomi, *A World History of Photography*, rev. edn. (New York: Abbeville, 1989).

Shloss, Carol, *In Visible Light*: *Photography and the American Writer, 1840 to 1940* (New York: Oxford University Press, 1987).

Solomon-Godeau, Abigail, *Photography at the Dock: Essays on Photographic History, Institutions, and Practices* (Minneapolis: University of Minnesota Press, 1991).

Taft, Robert, *Photography and the American Scene: A Social History, 1839–1889* (New York: Macmillan, 1938; repr. Dover Press, 1964).

Trachtenberg, Alan (ed.), *Classic Essays on Photography* (New Haven, CT: Leete's Island Books, 1980.

Trachtenberg, Alan, *Reading American Photographs* (New York: Hill and Wang, 1989).

Chapter 2. Presenting the Self

Foresta, Merry A., and John Wood, *Secrets of the Dark Chamber: The Art of the American Daguerreotype* (Washington, DC: Smithsonian Institution Press, 1995).

Gidley, Mick, *Edward S. Curtis and the North American Indian Incorporated* (Cambridge: Cambridge University Press, 2000).

Lyman, Christopher, *The Vanishing Race and Other Illusions: Photographs of Indians by Edward S. Curtis* (New York: Pantheon, 1982).

Newhall, Beaumont, *The Daguerreotype in America*, 3rd edn. (New York: Dover, 1976).

Panzer, Mary, *Mathew Brady and the Image of History* (Washington, DC: National Portrait Gallery/Smithsonian, 1997).

Rinhart, Floyd, and Marion Rinhart, *The American Daguerreotype* (Athens, GA: University of Georgia Press, 1981).

Ruby, Jay, *Secure the Shadow: Death and Photography in America* (Cambridge, MA: MIT Press, 1995).

Rudisill, Richard, *Mirror Image: The Influence of the Daguerreotype on American Society* (Albuquerque: University of New Mexico Press, 1971).

Sobieszek, Robert, *Ghost in the Shell* (Cambridge, MA: MIT Press, 1999).

Trachtenberg, Alan, 'Likeness as Identity: Reflections on the Daguerrean Mystique', in Graham Clarke (ed.), *The Portrait in Photography* (London: Reaktion, 1992).

Wood, John, *America and the Daguerreotype* (Iowa City: University of Iowa Press, 1991).

Chapter 3. Viewing the Landscape

Foresta, Merry, *Between Home and Heaven: Contemporary American Landscape Photography* (Washington, DC: National Museum of American Art and Albuquerque: University of New Mexico Press, 1992).

Hales, Peter Bacon, *William Henry Jackson and the Transformation of the American Landscape* (Philadelphia, PA: Temple University Press, 1988).

Hales, Peter Bacon, 'American Views', in Martha Sandweiss (ed.), *Photography in Nineteenth-Century America* (Worth, TX: Amon Carter Museum; New York: Harry N. Abrams, 1991).

Jussim, Estelle and Elizabeth Lindquist-Cock, *Landscape as Photograph* (New Haven, CT: Yale University Press, 1985).

Klett, Mark (with Gordon Bushaw and Rick Dingus), *Second View: The Rephotographic Survey Project* (Albuquerque: University of New Mexico Press, 1984).

Krauss, Rosalind, 'Photography's Discursive Spaces: Landscape/View', *College Art Journal* (Winter 1982), 311–19.

Naef, Weston J., *Era of Exploration: The Rise of Landscape Photography in the American West, 1860–1885* (Buffalo: Albright-Knox Art Gallery, 1985).

Panzer, Mary, *Philadelphia Naturalistic Photography, 1865–1906* (New Haven, CT: Yale University Art Gallery, 1982).

Snyder, Joel, *American Frontiers: The Photographs of Timothy H. O'Sullivan, 1867–1874* (Philadelphia, PA: Philadelphia Museum of Art, 1981).

Wolf, Daniel, *The American Space: Meaning in Nineteenth-Century Landscape Photography* (Middletown, CT: Wesleyan University Press, 1983).

Chapter 4. Seeing and Believing

Carlebach, Michael L., *The Origins of Photojournalism in America* (Washington, DC: Smithsonian, 1992).

Carlebach, Michael L., *American Photojournalism Comes of Age* (Washington, DC: Smithsonian, 1997).

Frassanito, William A., *Gettysburg: A Journey in Time* (New York: Scribner, 1975).

Frassanito, William A., *Antietam: The Photographic Legacy of America's Bloodiest Day* (New York: Scribner, 1978).

Goldberg, Vicki, *The Power of Photography: How Photographs Changed Our Lives* (New York: Abbeville Press, 1991).

Jussim, Estelle, '"The Tyranny of the Pictorial": American Photojournalism from 1880 to 1920', in Marianne Fulton (ed.), *Eyes of Time: Photojournalism in America* (New York: New York Graphic Society, 1988).

Rosenblum, Walter, Naomi Rosenblum, and Alan Trachtenberg, *America and Lewis Hine, Photographs 1904–1940* (Brooklyn: Brooklyn Museum and New York: Aperture, 1977).

Smith, Shawn Michelle, *American Archives: Gender, Race, and Class in Visual Culture* (Princeton, NJ: Princeton University Press, 1999).

Stange, Maren, *Symbols of Ideal Life: Social Documentary Photography in America, 1890–1950* (Cambridge: Cambridge University Press, 1989).

Stapp, Will, '"Subjects of strange . . . and of fearful interest": Photojournalism from Its Beginnings in 1839', in Marianne Fulton (ed.), *Eyes of Time: Photojournalism in America* (New York: New York Graphic Society, 1988)

Wexler, Laura, *Tender Violence: Domestic Visions in an Age of U.S. Imperialism* (Chapel

Hill: University of North Carolina Press, 2000).

Chapter 5. A Photographic Art

Bunnell, Peter (ed.), *Edward Weston on Photography* (Salt Lake City, UT: Peregrine Smith Books, 1983).

Coke, Van Deren, *The Painter and the Photograph: From Delacroix to Warhol* (Albuquerque: University of New Mexico Press, 1972).

Davidov, Judith Fryer, *Women's Camera Work: Self/Body/Other in American Visual Culture* (Durham, NC: Duke University Press, 1998).

Frank, Waldo, Lewis Mumford *et al.*, *America and Alfred Stieglitz: A Collective Portrait* (New York: The Literary Guild, 1934).

Fulton, Marianne (ed.), with text by Bonnie Yochelson, *Pictorialism into Modernism: The Clarence H. White School of Photography* (New York: Rizzoli, 1996).

Green, Jonathan (ed.), *Camera Work: A Critical Anthology* (Millerton, NY: Aperture, 1973).

Greenough, Sara and Juan Hamilton, *Alfred Stieglitz, Photographs and Writings* (Washington, DC: National Gallery of Art, 1983).

Greenough, Sarah with essays by William C. Agee *et al.*, *Modern Art and America: Alfred Stieglitz and His New York Galleries* (Washington, DC: National Gallery of Art; Boston: Bulfinch Press, 2000).

Homer, William Innis, *Alfred Stieglitz and the American Avant-Garde* (Boston: New York Graphic Society, 1977).

Jussim, Estelle, *Slave to Beauty: The Eccentric Life and Controversial Career of F. Holland Day, Photographer, Publisher, Aesthete* (Boston: D. R. Godine, 1981).

Lowe, Sue Davidson, *Stieglitz: A Memoir/Biography* (New York: Farrar, Straus, Giroux, 1983).

Peeler, David, *The Illuminating Mind in American Photography: Stieglitz, Strand, Weston, Adams* (Rochester, NY: University of Rochester Press, 2001).

Scharf, Aaron, *Art and Photography* (New York: Penguin Books, 1986, *c.*1968).

Stange, Maren (ed.), *Paul Strand: Essays on His Life and Work* (Millerton, NY: Aperture, 1990).

Steichen, Edward, *A Life in Photography* (New York: Bonanza, 1984).

Tomkins, Calvin (ed.), *Paul Strand: Sixty Years of Photographs: Excerpts from Correspondence, Interviews, and Other Documents* (Millerton, NY: Aperture, 1976).

Whelan, Richard (ed.), *Stieglitz on Photography, His Selected Essays and Notes* (New York: Aperture, 2000).

Chapter 6. Photography and Society

Barth, Miles (ed.), *Weegee's World* (New York: Little, Brown, 1997).

Brannan, Beverly W. and Carl Fleischhauer, *Documenting America: 1935–1943* (Berkeley: University of California Press, 1988).

Curtis, James, *Mind's Eye, Mind's Truth: FSA Photography Reconsidered* (Philadelphia, PA: Temple University Press, 1989).

Daniel, Pete, Merry Foresta, Maren Stange, and Sally Stein (eds), *Official Images: New Deal Photography* (Washington, DC: Smithsonian Institution Press, 1987).

Guimond, James, *American Photography and the American Dream* (Chapel Hill: University of North Carolina Press, 1991).

Hunter, Jefferson, *Image and Word: The Interactions of Twentieth Century Photographs and Texts* (Cambridge, MA: Harvard University Press, 1987).

Kozol, Wendy, *Life's America: Family and Nation in Postwar Photojournalism* (Philadelphia, PA: Temple University Press, 1994).

Natanson, Nicholas, *The Black Image in the New Deal* (Knoxville: University of Tennessee Press, 1992).

Orvell, Miles, 'Weegee's Voyeurism and the Mastery of Urban Disorder', in Orvell (ed.), *After the Machine: Visual Arts and the Erasing of Cultural Boundaries* (Jackson, MS: University Press of Mississippi, 1995).

Puckett, John Rogers, *Five Photo-Textual Documentaries from the Great Depression* (Ann Arbor, MI: UMI Research Press, 1984).

Sandeen, Eric, *Picturing an Exhibition: The Family of Man and 1950s America* (Albuquerque: University of New Mexico Press, 1995).

Stange, Maren, *Symbols of Ideal Life: Social Documentary Photography in America, 1890–1950* (Cambridge: Cambridge University Press, 1989).

Stott, William, *Documentary Expression and Thirties America* (New York: Oxford University Press, 1973).

Chapter 7. Versions of the Self: Memory, Identity, Autobiography

Adams, Timothy Dow, *Light Writing and Life Writing: Photography in Autobiography* (Chapel Hill: University of North Carolina Press, 2000).

Barthes, Roland, *Camera Lucida: Reflections on Photography* (New York: Hill and Wang, 1982).

Chalfen, Richard, *Snapshot Versions of Life* (Bowling Green, OH: Bowling Green State University Popular Press, 1987).

Conger, Amy, *Campañeras de México: Women Photograph Women* (Riverside, CA: University Art Gallery, 1990).

Davidov, Judith Fryer, *Women's Camera Work: Self/Body/Other in American Visual Culture* (Durham, NC: Duke University Press, 1998).

Gover, C. Jane, *The Positive Image: Women Photographers in Turn of the Century America* (Albany: State University of New York Press, 1988).

Hirsch, Marianne, *Family Frames: Photography, Narrative, and Postmemory* (Cambridge, MA: Harvard University Press, 1997).

Hirsch, Marianne (ed.), *The Familial Gaze* (Hanover, NH: Dartmouth and New England University Press, 1999).

Rosenblum, Naomi, *A History of Women Photographers* (New York: Abbeville Press, 1994).

Rugg, Linda, *Picturing Ourselves: Photography and Autobiography* (Chicago: University of Chicago Press, 1997).

Tucker, Anne (ed.), *The Woman's Eye* (New York: Knopf, 1973).

West, Nancy Martha, *Kodak and the Lens of Nostalgia* (Charlottesville: University Press of Virginia, 2000).

Willis, Deborah (ed.), *Picturing Us: African American Identity in Photography* (New York: The New Press, 1994).

Willis, Deborah, *Reflections in Black: A History of Black Photographers, 1840 to the Present* (New York: Norton, 2000).

Chapter 8. Photographing Fictions

Coleman, A. D., *The Grotesque in Photography* (New York: Ridge Press and Summit Books, 1977).

Coleman, A. D., 'The Directorial Mode: Notes toward a Definition', in Coleman, *Light Readings: A Photography Critic's Writings, 1968–1978* (New York: Oxford University Press, 1979).

Coleman, A. D., 'The Image in Question: Further Notes on the Directorial Mode', in Coleman, *Depth of Field: Essays on Photography, Mass Media, and Lens Culture*

(Albuquerque: University of New Mexico Press, 1998).

Hoy, Anne H., *Fabrications: Staged, Altered, and Appropriated Photographs* (New York: Abbeville Press, 1988).

Notes from the Material World: Contemporary Photomontage (Sheboygan, WI: John Michael Kohler Arts Center, 1992).

Visual Paradox: Truth and Fiction in the Photographic Image (Sheboygan, WI: John Michael Kohler Arts Center, 1988).

Chapter 9. Photography and the Image World

Benjamin, Walter, 'The Work of Art in the Age of Mechanical Reproduction', in Benjamin, *Illuminations* (New York: Harcourt, Brace and World, 1968).

Grundberg, Andy, *Crisis of the Real: Writings on Photography since 1974* (New York: Aperture, 1999).

Marincola, Paula, *Image Scavengers: Photography* (Philadelphia, PA: Institute of Contemporary Art, 1982).

Sontag, Susan, *On Photography* (New York: Farrar, Straus, Giroux, 1977).

Chapter 10. Conclusion: Post-photography

Batchen, Geoffrey, 'Ectoplasm: Photography in the Digital Age', in Carol Squiers (ed.), *Over-Exposed: Essays on Contemporary Photography* (New York: The New Press, 1999).

Krauss, Rosalind, 'A Note on Photography and the Simulacral', in Carol Squiers (ed.), *Over-Exposed: Essays on Contemporary Photography* (New York: The New Press, 1999).

Krygier, Irit, *The Unreal Person: Portraiture in the Digital Age* (Huntington Beach, CA: Huntington Beach Art Center, 1998).

Mitchell, William J., *The Reconfigured Eye: Visual Truth in the Post-Photographic Era* (Cambridge, MA: MIT Press, 1994).

Ritchin, Fred, *In Our Own Image: The Coming Revolution in Photography: How Computer Technology Is Changing Our View of the World* (New York: Aperture, 1999).

Taylor, John, *Body Horror: Photojournalism, Catastrophe, and War* (New York: New York University Press, 1998).

Timeline
Museums and
Websites
List of Illustrations
Index

Timeline

1835	Talbot invents photogenic drawings, a process for producing contact prints on paper
1839	Invention of daguerreotype in France Samuel F. B. Morse brings daguerreotype process to the US
1841	Talbot patents his Talbotype (or 'calotype') process, the first negative–positive process in photography
1844	Mathew Brady opens the Daguerrian Miniature Gallery, the first of many galleries in New York and other major cities
1850	Brady publishes a collection of engravings based on photographs, *A Gallery of Illustrious Americans*
1851	Wet collodion process, which will replace daguerreotype, announced by Englishman Frederick Scott Archer
1857	Oscar Rejlander creates multiphoto compositions, based on allegorical themes, in England
1860	Brady creates flattering photograph of Abraham Lincoln, who is running for president—the first campaign photograph
1861	Oliver Wendell Holmes, physician and amateur photographer, creates a popular stereoscope viewer
1861–5	Brady and Alexander Gardner, along with many others, document the Civil War, sending cameramen to battle scenes
1866	Carleton Watkins creates photographs of Yosemite Valley for sale to tourists
1870s	Timothy O'Sullivan, William Henry Jackson, and others photograph the Western American landscape for the first time
1873	First photograph is printed using the half-tone method, the foundation for later printed photographs
1877	Eadweard Muybridge experiments with high-speed photo apparatus, working in Palo Alto, California, to capture frozen images of moving horses. Experiments continue at the University of Pennsylvania in the 1880s
1879	George Eastman invents a machine for coating photographic dry plates with emulsion, thus enabling mass production. Plates are commercially produced the following year
1880	Muybridge demonstrates zoopraxiscope in San Francisco, projecting photographic images in motion
1881	*New York Daily Graphic* prints first half-tone print, a scene of *Shantytown* by Stephen Horgan
1882	George Eastman devises a flexible gelatin film to support the emulsion on a paper backing, and a roll film holder. A machine is invented to produce the film
1882	Étienne-Jules Marey invents a camera-rifle capable of recording twelve successive photographs per second, the chronophotographic gun
1885	First transparent film negative invented, Eastman American Film
1887	Thomas Alva Edison and W. K. L. Dickson work on inventing a motion picture camera
1888	The Kodak camera put on the market, loaded with 100 exposures on a film roll at a price of $25. It is advertised with slogan, 'You press the button and we do the rest.' Exposed film and camera must be sent back to Eastman company in Rochester, NY
1889	Eastman company puts first commercial transparent roll film on market, making possible development of motion picture camera by Edison in 1891
1890	Jacob Riis's *How the Other Half Lives* published, with half-tone illustrations and drawings, contributing to the revision of tenement house laws
1892	The Linked Ring, a confederation of art photographers in England, is founded. Alfred Stieglitz elected a member in 1894
	Frederick Ives, a pioneer in half-tone printing processes, develops the first three-colour camera, the photochromoscope
1894	Edison's motion pictures studio in New Jersey produces the *Edison Kinetoscopic Record of a Sneeze, January 7, 1894*
	Lumière brothers invent the cinématographe in France, projecting moving images on to a screen. The Edison vitascope brings projection to the US a year later, in New York City
1895	Public cinema programmes begin, showing in Germany and France
	The Pocket Kodak camera introduced
	The Brownie, the first mass-market camera, is sold for $1
	F. Holland Day organizes The New School of American Photography exhibition for the Royal Photographic Society in London, featuring Gertrude Käsebier, Clarence White, Edward Steichen, and Alvin Langdon Coburn
1902	Alfred Stieglitz founds the Photo-Secession group in New York, an association of art photographers. He also begins editing and publishing *Camera Work*, a periodical devoted to photography and the arts
1903	American Edwin S. Porter's *The Great Train Robbery*, one of the first realistic film narratives, is shown
	Single-lens reflex camera introduced by American Graflex

1904 Stieglitz curates the Photo-Secessionists exhibition at the Corcoran Gallery in Washington, DC

1905 Stieglitz and Edward Steichen open, at 291 Fifth Avenue in New York City, the Little Galleries of the Photo-Secession (called '291'), which becomes a centre in the US for art photography and modern European art

Lewis Hine photographs immigrants in his *Ellis Island* series

1906–8 First commercially successful photographic colour process, Kinemacolor, invented by George Albert Smith and Charles Urban. Englishman Clare L. Finlay invents the successful additive colour process

1907 First colour autochromes, by Steichen, Stieglitz, and Frank Eugene, exhibited in the US at the Little Galleries of the Photo-Secession

1908–14 D. W. Griffith develops the foundations of motion picture technique, inventing the fade-out, close-up, soft focus, cross-cutting, iris dissolve

1910 Lewis Hine, working for the National Child Labor Committee, begins his *Child Labor* series

Seminal show, The International Exhibition of Photography, organized by Stieglitz and held at the Albright Gallery in Buffalo, New York

1912 Vest Pocket Camera introduced, also First Model Speed Graphic

1913 Alvin Langdon Coburn's abstract vortographs exhibited in London

1914 Prototype Leica, 35 mm still camera, developed

Clarence H. White School of Photography in New York City is founded—runs until 1942

First movie palace, the Strand (holding 3,300) opens in New York City. Nickelodeons start to become obsolete

1916 Stieglitz features work of the young Paul Strand in the last two issues of *Camera Work*

1917 End of the Photo-Secession group, Stieglitz's 291 Gallery, and *Camera Work*

1918 Christian Schad, in Switzerland, produces photo abstractions made without film, anticipating Man Ray and Moholy-Nagy

1919 Bauhaus founded in Weimar, Germany. Photography is central to curriculum

First tabloid and picture newspaper, the *New York Daily News*, begins publication. Tabloid newspapers, with photographs crowding small pages, emerge during 1920s as a major journalistic form

1920 Soviet film-maker Dziga Vertov founds *cinéma-verité* technique with his documentary newsreels. Vertov's *Man with a Movie Camera* produced

1920 Edward Steichen moves from art photography to fashion, becoming chief photographer for *Vogue* and *Vanity Fair*

Man Ray creates the rayogram, exposing objects placed on photographic paper to light

Photomontage works exhibited at first Berlin Dada exhibition

1922 Robert Flaherty's early documentary film, *Nanook of the North*, produced

1923 16 mm movie film for amateur use introduced by Kodak

Time magazine begins publication

1924 The 35 mm Leica camera (designed by German Ernst Leitz), small and easily handled, opens up news coverage and street photography

1925 RCA patents RCA Photophone, a sound-on-film process. The success of *The Jazz Singer* in 1927 would shift movie production from silent to sound

1927 Modern flashbulb, ignited by weak electric current, marketed by General Electric

1928 Erich Salomon photographs famous people in Berlin for illustrated press, attracting attention as the first 'candid photographs'

1929 *Film and Foto* exhibition in Stuttgart, Germany, features European and American modernists

Rolleiflex, 2¼″ twin-lens reflex camera, introduced in Germany, becomes very popular in the US

Berenice Abbott begins photographing New York City, emulating Atget. Her *Changing New York* project is supported by WPA Arts Project in 1935

Stock market crashes, precipitating the Great Depression of the 1930s

1930 *Fortune* magazine begins publication

Workers' Film and Photo League, producing propaganda for Workers' International Relief, started in New York. Later in the 1930s this becomes New York Film and Photo League, dedicated to showing the daily struggle of workers in still and moving images

1931 Harold Edgerton invents electronic flash to capture motion at high speeds

1932 Group f.64 founded by Ansel Adams, Imogen Cunningham, Willard Van Dyke, Edward Weston, and others; dedicated to sharp focus, straight photography. Their first exhibition is held in San Francisco's M. H. de Young Memorial Museum

Lewis Hine publishes *Men at Work*

1933 Franklin Delano Roosevelt initiates the New Deal programmes to deal with the Depression. Federal Arts projects founded in 1935

Henri Cartier-Bresson's first 35 mm exhibition in New York

1935 March of Time newsreel series, produced by *Time* magazine, commences in movie theatres, changing monthly

Roy Stryker brought to Washington by Rexford Tugwell to become chief of the Historical Section, the photography unit within the Resettlement Administration (later known as the Farm Security Administration). Stryker's first hires are Arthur Rothstein, Walker Evans, and Dorothea Lange. Stryker remains at the FSA until 1943

1936 Robert Capa photographs the Spanish Civil War, including *Death of a Loyalist Soldier*

Life magazine begins, with the first cover photo by Margaret Bourke-White

Walker Evans, borrowed from the FSA project, spends the summer in Alabama with James Agee, photographing tenant farmers; the results are published in 1941 as the photo-documentary book, *Let Us Now Praise Famous Men*

A segment of the New York Film and Photo League which had called itself Nykino in 1934, leaves to form Frontier Films

1937 Margaret Bourke-White and Erskine Caldwell publish the photo-documentary book, *You Have Seen Their Faces*, a study of Southern poverty

The Photo League, a socially committed New York photographic society, is formed out of the old New York Film and Photo League. It includes Aaron Siskind, Max Yavno, Walter Rosenblum, and others

Look magazine is founded by Gardner Cowles

Edward Weston is the first photographer to be awarded a Guggenheim Fellowship

Beaumont Newhall organizes the first exhibition of photography at the Museum of Modern Art. The catalogue, published as *Photography, 1839–1937*, becomes a major text, revised in later years as *The History of Photography*

1938 Walker Evans's first show at the Museum of Modern Art is the basis for his book, *American Photographs*

Archibald MacLeish uses FSA photos to illustrate *Land of the Free*

1939 Dorothea Lange and Paul S. Taylor publish their photo-documentary study of the Dust Bowl migration, *American Exodus*

Berenice Abbott publishes *Changing New York*

1940 Film adaptation of *The Grapes of Wrath* by John Ford, dealing with the Great Depression and the migration of Okies to California

Lewis Hine retrospective organized by Elizabeth McCausland at the Riverside Museum in New York

1941 Orson Welles's *Citizen Kane* produced, with innovative sound and flashback techniques

Eastman Kodak introduces Kodacolor negative film

James Agee and Walker Evans publish *Let Us Now Praise Famous Men*, the greatest photo-documentary of the period

1942 Office of War Information established, replacing the FSA, to coordinate wartime propaganda

1943 Roy Stryker, having left the FSA/OWI, becomes head of the Standard Oil Project, which continues in the FSA tradition of aiming to document American life. Several FSA photographers hired by Stryker

1946 Aaron Siskind photographs exhibited at the Museum of Modern Art

1947 House Un-American Activities Committee (HUAC) holds hearings of leftists in cultural spheres, branding them communists

Magnum Photos, a journalistic photo cooperative, is founded in New York by Robert Capa, 'Chim' (David Seymour), Henri Cartier-Bresson, George Rodger, and others

Polaroid-Land camera invented by Edwin H. Land. Produces a finished print in minutes

1948 35 mm Nikon camera introduced

1950 Nancy Newhall and Paul Strand collaborate on a photo book, *Time in New England*

1951 W. Eugene Smith's feature photo essay in *Life, Spanish Village*

Film and Photo League disbands after being listed as a 'subversive' organization by McCarthy

1952 Cartier-Bresson's book and exhibition (at the Louvre), *The Decisive Moment*

Minor White establishes the quarterly *Aperture*, dedicated to fine art photography

1953 *Life* magazine starts using colour

1955 Edward Steichen organizes The Family of Man exhibition at the Museum of Modern Art

Art in America publishes its first article on photography, by Beaumont Newhall

Roy DeCarava opens A Photographer's Gallery

1956 William Klein publishes his work in France, *Life Is Good and Good for You in New York: William Klein Trance Witness Revels*

1958 Lightweight 16 mm movie cameras and portable tape recorders introduced, leading to *cinéma-verité* in France and elsewhere

1959 Robert Frank's *The Americans* published in the US with preface by Jack Kerouac

Image Gallery in New York becomes first gallery devoted to photography

1962 Society for Photographic Education founded by Nathan Lyons

John Szarkowski appointed curator of photography at the Museum of Modern Art

1963 Beaumont Newhall goes to the Universitiy of New Mexico to head the photography programme

Kodak's Instamatic camera is marketed

1964 Szarkowski curates The Photographer's Eye at the Museum of Modern Art, educating the public on how to look at photos

1966 *Towards a New Social Landscape* (exhibition and book) is published by Nathan Lyons, including Bruce Davidson, Lee Friedlander, Garry Winogrand, Danny Lyon, and Duane Michals

Cornell Capa forms the International Fund for Concerned Photography, which later becomes the International Center of Photography

1967 Cornell Capa organizes the exhibition, The Concerned Photographer, featuring Dan Weiner, Werner Bischof, André Kertesz, Bruce Davidson, Larry Clark, Mary Ellen Mark, and others

New Documents exhibition is curated by Szarkowski at the Museum of Modern Art, featuring Diane Arbus, Lee Friedlander, and Garry Winogrand

Persistence of Vision exhibition, dealing with manipulated images, curated by Nathan Lyons at George Eastman House, shows work by Robert Heinecken, Ray Metzker, Jerry Uelsmann, and others

1968 Earth is photographed from the moon

Exposure, newsletter of the Society of Photographic Education, becomes a journal of photography

Walter Benjamin's *Illuminations* published in English, containing the classic 1936 essay, 'The Work of Art in the Age of Mechanical Reproduction'

1969 Richard Rudisill is appointed first photographic historian to teach at the University of New Mexico

Nathan Lyons leaves Eastman House to found the Visual Studies Workshop in Rochester, NY

1970 IMAX process introduced in Japan

Eliot Porter publishes *Appalachian Wilderness*

A. D. Coleman begins writing photography criticism for *The New York Times*

Jerry Uelsmann exhibition at Philadelphia Museum of Art

1971 *Tulsa*, a chronicle of drug culture in Oklahoma, is published by Larry Clark

1972 Huge crowds go to see the Diane Arbus exhibition at the Museum of Modern Art. The accompanying book becomes a bestseller

Princeton endows the first chair for the history of photography in its art history department. Peter C. Bunnell is appointed

Life magazine ceases publication

Afterimage, a periodical devoted to photography, film, and video, is founded by Nathan Lyons at the Visual Studies Workshop

1974 Estelle Jussim publishes *Visual Communication and the Graphic Arts*

1975 New Topographics exhibition, featuring photographs of man-altered landscapes, organized by William Jenkins at George Eastman House

Era of Exploration: The Rise of Landscape Photography in the American West (exhibition and book) is curated by Weston Naef and James Wood at the Metropollitan Museum of Art

Women of Photography: An Historical Survey, exhibition at San Francisco Museum of Art

1976 Steadicam, which stabilizes portable cameras, first used in filming *Rocky*

1977 *History of Photography* (quarterly journal) begins publication

Susan Sontag's *On Photography* examines the social and cultural context of photography

Pictures, curated by Douglas Crimp at New York Artists Space, introduces postmodern photography, in the work of Sherri Levine, Robert Longo, and others

Philadelphia Photo Review, later changed to *The Photo Review*, founded by Stephen Perloff. Features historical articles, reviews, and current notices on photography

1978 Duane Michals publishes *Homage to Cavafy*, one of the first openly gay books by a photographer

The Council of Latino Photographers/USA founded in Los Angeles to promote Latino photographers

1979 Fabricated to be Photographed, featuring photographs of constructions, curated by Van Deren Coke, at San Francisco Museum of Modern Art. Includes Les Krims, John Pfahl, Robert Cumming, and others

1980 Roland Barthes's influential *Camera Lucida* is published

Szarkowski's Mirrors and Windows: American Photography Since 1960 exhibition at the Museum of Modern Art

1981 IBM introduces the personal computer

1982 Cindy Sherman's photos are included in an exhibition at San Francisco Museum of Modern Art, Recent Color

1983 Jean Baudrillard's influential postmodern text, *Simulations* (with an essay on 'Hyperreality') is published

Image Scavengers exhibition, focusing on appropriated imagery, at the Institute of Contemporary Arts in Philadelphia

A Century of Black Photographers: 1840–1960, an exhibition, originates at Rhode Island School of Design

1984 J. Paul Getty Museum, with Weston J. Naef as curator, purchases several major photography collections

Second View: The Rephotographic Survey Project (Rick Dingus, Mark Klett, JoAnn Vergurg, and others) rephotographs well-known sites and images taken by Western landscape photographers

1985 Richard Avedon's *Great American West*

1986 Nan Goldin's *Ballad of Sexual Dependency* is published

Robert Mapplethorpe's *The Black Book* is published

1987 Cindy Sherman, exhibition with essays by Peter Schjeldahl and Lisa Philips, at the Whitney Museum of American Art

1988 Arnold Newman retrospective at New York Historical Society

Garry Winogrand retrospective at the Museum of Modern Art

Digital Photography: Captured Images, Volatile Memory, New Montage, one of first exhibitions on digital photography, at San Francisco Cameraworks

Stuart Ewen's *The All Consuming Image*, on photography and consumerism, published

1989 Friends of Photography in Carmel, California, re-established in San Francisco as Center for Friends of Photography

Alan Trachtenberg's *Reading American Photographs* exemplifies historical approach to photography

1990 Kodak announces Photo CD system

Harlem Photographs, 1932–1940/ Aaron Siskind is shown at the National Museum of American Art

Language of the Lens: Contemporary Native American Photographs, features ten Native American photographers, first of Native American exhibitions

1991 First consumer digital cameras introduced

Electronic imaging used in coverage of the Gulf War

1992 *Digital Photography*, by Mikkel Aaland and Rudolph Burger, on technical aspects, published

Sally Mann's *Immediate Family* is published

Viewfinder: Black Women Photographers, written by Jeanne Moutoussamy-Ashe

1993 Adobe Photoshop available for MS-DOS/Windows

1994 AP/Kodak NC2000 digital camera announced for photojournalists

Naomi Rosenblum, author of *A World History of Photography*, writes *A History of Women Photographers*

Digital Imaging Technology for Preservation is published, addressing preservation and access of digital images

1995 *Doubletake* magazine is founded at Duke Center for Documentary Studies, featuring photography and literature

1996 Advanced Photo System (APS) is introduced, using 24 mm format

1998 *Women's Camera Work: Self/Body/Other in American Visual Culture*, by Judith Fryer Davidov, affirms a counter-tradition to the traditional male narrative

2000 Deborah Willis publishes *Reflections in Black: A History of Black Photographers, 1840 to the Present*, surveying a tradition whose significance is being rediscovered

2001 David Hockney's *Secret Knowledge: Rediscovering the Lost Techniques of the Old Masters*, argues that painters have used optical instruments to achieve realistic illusions, even before photography was invented

Here Is New York: A Democracy of Photographs collects photographs from any contributors, relating to the 11 September 2001 World Trade Center disaster. Pictures are exhibited without distinction to professional or amateur status, and are offered for sale in storefront locations and on the internet (proceeds to charity)

Museum	Website

North America

California Museum of Photography
3824 Main Street
Riverside, CA 92501
Emphasis on new imaging media and society;
regional exhibitions

www.cmp.ucr.edu

Canadian Museum of Contemporary
Photography
1 Rideau Canal
PO Box 465, Station A
Ottawa, Ontario
Large collection of Canadian photography; most
exhibitions are Canadian

www.cmcp.gallery.ca

Center for Creative Photography
University of Arizona
Tucson, Arizona
Archive, museum, and research centre, with
extensive holdings in Ansel Adams, Weston,
Frederick Sommers. Major centre

www.creativephotography.org

George Eastman House
International Museum of Photography and Film
900 East Avenue
Rochester, NY 14607
Major collections in the history of photography;
large holdings in American photography

www.eastman.org/

Houston Center for Photography
1441 West Alabama
Houston, TX 77006-4103
Exhibits emerging to mid-career photographers,
from documentary to experimental

www.hcponline.org

International Center of Photography
1114 Avenue of the Americas @43rd Street
New York, NY 10036
The major exhibition venue for photography in
New York City; strong interest in documentary
and photojournalism. Extensive workshop and
education programme

www.icp.org

Light Factory Photographic Arts Center
809 West Hill St
Charlotte, NC 28232
Alternative contemporary visual art, new media,
educational programmes

www.lightfactory.org

Museum of Photographic Arts
1649 El Prado
San Diego, CA 92101
Holdings include full range of photography from
nineteenth century through present

www.mopa.org

Photo Antiquities Museum of Photographic
History
531 East Ohio St
Pittsburgh, PA 15212
Regional focus, emphasizing industrial and
working-class history of Western Pennsylvania

www.photoantiquities.org

Museum	Website
Southeast Museum of Photography Daytona Beach Community College Bldg 37, 1200 International Speedway Daytona Beach, FL 32114 *Strong in regional photography, tourism, anthropological photography*	www.smponline.org
UCR-California Museum of Photography 3824 Main Street Riverside, CA 92501	www.cmp.ucr.edu/photo/

Australia **Australian Centre of Photography**
 257 Oxford Street
 Paddington NSW 2021 www.acp.au.com/main.php

Denmark **National Museum of Photography**
 The Royal Library, Copenhagen www.kb.dk/kb/dept/nbo/kob/fot-mus_en/dafot.htm

England **Fox Talbot Museum**
 Lacock, Chippenham
 Wiltshire SN15 2LG www.r-cube.co.uk/fox-talbot/

National Museum of Photography, Film and Television
 Bradford, West Yorkshire BD1 1NQ www.nmsi.ac.uk/nmpft/

Royal Photographic Society
 The Octagon, Milsom Street
 Bath BA1 1DN www.rps.org//aboutus.html

India **Centre for Photography**
 National Centre for the Performing Arts
 D. Tata Road
 Nariman Point, Bombay 400021 www.charm.net/~nayak/cpa.html

Ireland **Gallery of Photography**
 Meeting House Square
 Temple Bar, Dublin 2 www.irish-photography.com/

Italy **Fratelli Alinari Museum of Photography**
 Largo Alinari, 15
 Florence www.alinari.i

Japan **Nara City Museum of Photography**
 600-1 Takabatakecho
 Nara 630-8301 www.dnp.co.jp/museum/nara/nara-e.html

Sweden **The Photomuseum in Osby**
 Osby www.fotomuseetiosby.nu/frameseng.html

Modern Museum and Photography Museum
 Stockholm www.modernamuseet.se

Virtual museums **American Museum of Photography** www.photographymuseum.com/

Canon Camera Museum
 Tokyo www.canon.com/camera-museum/

Collected Visions (Lorrie Novak) http://cvisions.nyu.edu/

Tokyo Metropolitan Museum of Photography www.tokyo-photo-museum.or.jp/eng/index.html

Ability: Photography History www.ability.org.uk/photography_history.html

American Photography: A Century of Images www.pbs.org/ktca/americanphotograph/
Site related to Public Broadcasting Service series (US), with materials organized thematically

A History of Photography from Beginnings to 1920s www.rleggat.com/photohistory
An international history, emphasizing individual photographers and broad themes

History of Photography **(journal) home page** www.tandf.co.uk/journals/tf/03087298.html

Jones Telecommunications and Multimedia Encyclopedia www.digitalcentury.com/encyclo/update/photo_hd.html
Strong on technical history of photography and film

Library of Congress, Prints and Photographs http://memory.loc.gov/ammem/amhome.html
Includes the massive FSA collection

Magnum Photos www.magnumphotos.com
News photo agency

Masters of Photography www.masters-of-photography.com
Major photographers, images, and resources

Media History Project www.mediahistory.umn.edu/photo.html
Links to useful articles and sources

National Museum of American Art, Smithsonian Institution http://nmaa-ryder.si.edu/collections/exhibits/helios/index.html

Open Here www.openhere.com/hac/photography/history
Animations of early motion photography

Sight: Fine Photography Online www.sightphoto.com

Syracuse University Library, Photography: History and Collections www.syr.edu/research/internet/photography/hist.html

Third View www.thirdview.asu.edu
Rephotography project

Urton's Art History www.urtonart.com/history/photography.html
A brief history of photography, including technical aspects

List of Illustrations

The publisher and author would like to thank the following individuals and institutions who have kindly given permission to reproduce the illustrations listed below.

platinum print. The Art Museum, Princeton University. Gift of John Emlem Bullock Estate/Bruce M. White. © 2002 Trustees of Princeton University, Princeton, NJ.

21. Anne Brigman, *The Dying Cedar*, c.1909. Toned silver print. Oakland Museum of California (A65.163.37). Gift of Mr and Mrs Willard M. Nott/copy print Iris Davis.

22. Alfred Stieglitz , *Equivalent: Music No. 1, Lake George, New York*, 1922. Gelatin silver print. Courtesy George Eastman House (GEH 8662), International Museum of Photography and Film, Rochester, NY.

23. Timothy O'Sullivan, *Desert Sand Hills near Sink of Carson* [Nevada], 1868. Albumen print. The J. Paul Getty Museum, Los Angeles, CA.

24. William Henry Jackson, *Rocks below Platte Cañon* [Colorado], 1870. Academy of Natural Sciences of Philadelphia, Ewell Sale Stewart Library, Philadelphia, PA.

25. Timothy O'Sullivan, *Crab's Claw Peak, Western Nevada*, 1869. US Geological Exploration of the 40th Parallel (King Survey), plate 100. US Geological Survey Library Denver, CO.

26. Rick Dingus, *Witches Rocks, Weber Valley, Utah*, 1978. © Rick Dingus for the Rephotographic Survey Project, 1978, plate 17. University of New Mexico Press.

27. Robbert Flick, *Near Live Oak 1, Joshua Tree National Monument, California*, 1981. Print made from 81 negatives. Courtesy Robbert Flick, Claremont, CA.

28. Lewis Baltz, *Prospector Village, Lot 85, Looking West, Park City, Utah*, 1980. V&A Picture Library, Victoria and Albert Museum/courtesy Lewis Baltz.

29. Terry Evans, *Smoky Hill Bombing Range Target, Tires, Kansas*, 1990. Gelatin silver print. National Museum of American Art (1992.7.2), Gift of the artist (COPR.1990), Smithsonian Institution, Washington, DC.

30. Richard Misrach, *Dead Animals #324 The Pit, Nevada*, 1987–9. Courtesy Robert Misrach, 1986.

31. George N. Barnard, *Fire in the Ames Mills, Oswego, NY, July 5, 1853*. Daguerreotype, sixth plate. Courtesy George Eastman House (GEH 5815), International Museum of Photography and Film, Rochester, NY.

32. Mathew Brady, *Dead Boy in the Road at Fredericksburg, May 3, 1863*. Stereoscopic photograph. Prints and Photographs Division (B81713175), Library of Congress, Washington, DC.

33. Anonymous. Frank Leslie's *Illustrated Newspaper* (18 June 1864). Library of Congress, Washington, DC.

34. Timothy O'Sullivan, *A Harvest of Death, Gettysburg, July 1863*. Albumen print. From *Gardner's Photographic Sketch Book of the War*, vol. 1 (1866), plate 36. Courtesy George Eastman House (GEH 9030), International Museum of Photography and Film, Rochester, NY.

35. Unidentified engraver, *The Harvest of Death—Gettysburg, July 4, 1863*. From *Harper's Weekly* (22 July 1865), p. 452. Wood engraving after albumen print by Timothy H. O'Sullivan. Courtesy Department of Rare Books and Special Collections, University of Rochester, NY.

36. Eadweard Muybridge, *Galloping Horse, Motion Study—Sallie Gardner, Owned by Leland Stanford, Running at a 1.40 Gait over the Palo Alto Track, June 19, 1878*. Collotype print. Courtesy George Eastman House (GEH 30560), International Museum of Photography and Film, Rochester, NY.

37. Jacob Riis, *Sabbath Eve in a Coal Cellar, Ludlow Street*, early 1890s. Jacob A. Riis Collection (#286; 90.13.4.291), © Museum of the City of New York.

38. Jacob Riis, *Street Arabs in Sleeping Quarters*, 1890. Jacob A. Riis Collection (#123; 90.13.4.126), © Museum of the City of New York.

39. Lewis Hine, *Making Human Junk*, c.1915. National Child Labor Committee Poster. Prints and Photographs Division (Z62046392), Library of Congress, Washington, DC.

40. Lewis Hine, *Playground, Boston*, c.1909. Prints and Photographs Division (Z62092351), Library of Congress, Washington, DC.

41. Lewis Hine, *Looking for Lost Baggage, Ellis Island*, 1905. Gelatin silver print. Courtesy George Eastman House (GEH 3982), International Museum for Photography and Film, Rochester, NY.

42. Frances Benjamin Johnston, *A Class in Dressmaking, Hampton Institute, Hampton, Virginia*, 1899. Prints and Photographs Division (Z6238151), Library of Congress, Washington, DC.

43. Arnold Genthe, *On the Ruins, Chinatown, San Francisco*, 6 April 1906. Prints and Photographs Division (G403-T-0003-A), Library of Congress, Washington, DC.

44. Charles S. Bradford, Jr, *Landscape*, 1890. Platinum print. Chester County Historical Society (#618), West Chester, PA.

45. Gertrude Käsebier, *Blessed Art Thou amongst Women*, 1899. Platinum print. George Eastman House (GEH 32824, 17904), International Museum of Photography and Film, Rochester, NY.

46. F. Holland Day, *Ebony and Ivory*, 1897.

Platinum print. The Metropolitan Museum of Art, Alfred Stieglitz Collection, 1933 (33.43.166), New York. All Rights Reserved.

47. Edward Steichen, *Rodin and 'The Thinker'*, 1902. Gum-bichromate print. George Eastman House (GEH 7618), International Mueum of Photography and Film, Rochester, NY. By permission of Joanna T. Steichen.

48. Alfred Stieglitz, *The Steerage*, 1907. Photogravure. Courtesy Whitney Museum of Art, New York.

49. Alfred Stieglitz, *Winter—Fifth Avenue, New York*, 1893. Carbon photograph. Alfred Stieglitz Collection (1949.3.94). Photograph © 2002 Board of Trustees, National Gallery of Art, Washington, DC.

50. Alfred Stieglitz, *Georgia O'Keeffe: A Portrait—Hands and Breasts*, 1919. Palladium print. Alfred Stieglitz Collection (1980.70.113). Photograph © 2002 Board of Trustees, National Gallery of Art, Washington DC.

51. Paul Strand, *Shadows. Twin Lakes, Connecticut*, 1915. © 1971 Aperture Foundation Inc., Millerton, NY/Paul Strand Archive.

52. Paul Strand, *Man, Five Points Square, New York*, 1916. © 1971 Aperture Foundation Inc., Millerton, NY/Paul Strand Archive.

53. Paul Strand, *Truckman's House, New York*, 1920. © 1971 Aperture Foundation Inc., Millerton, NY/Paul Strand Archive.

54. Clarence White, *Ring Toss*, 1899. Platinum print. Prints and Photographs Division (308877), Library of Congress, Washington, DC.

55. Alvin Langdon Coburn, *Vortograph No. 3*, 1917. Gelatin silver print. Courtesy George Eastman House (GEH 23952), International Museum of Photography and Film, Rochester, NY.

56. Paul Outerbridge, *H.O. Box*, 1922. Estate of Paul Outerbridge, Jr./© 2002 G. Ray Hawkins Gallery, Los Angeles, CA.

57. Man Ray, *Rayograph*, 1922. From *Champs délicieux* (Paris, 1922). © Man Ray Trust/ADAGP, Paris and DACS, London 2002/Telimage, Paris.

58. Edward Weston, *Peppers*, 1929. Gelatin silver print. © 1981 Center for Creative Photography, Arizona Board of Regents, University of Arizona, AZ.

59. Imogen Cunningham, *Amaryllis*, 1933. © 1970 The Imogen Cunningham Trust, Berkeley, CA. All Rights Reserved.

60. Minor White, *Sun and Rock*, 1948. George Eastman House (GEH 22172), International Museum of Photography and Film, Rochester, NY. Reproduced by courtesy the Minor White Archive, Princeton University,

© 1989 by the Trustees of Princeton University. NJ. All Rights Reserved.

61. Berenice Abbott, *Rockefeller Center with Collegiate Church of St. Nicholas in Foreground, 1936*. Federal Arts Project, Changing New York (49.282.71), © Museum of the City of New York.

62. Walter Rosenblum, *Girl on a Swing*, 1938. © Walter Rosenblum.

63. Aaron Siskind, from *The Most Crowded Block in the World* series, 1940. Gelatin silver print. George Eastman House (GEH 16028), International Museum of Photography and Film, Rochester, NY. © Aaron Siskind Foundation.

64. Walker Evans, *Allie Mae Burroughs, Hale County, Alabama*, 1936. The Metropolitan Museum of Art, Acquisition Benefit Fund, 2001 (2001.415) © Walker Evans Archive, The Metropolitan Museum of Art, NY.

65. Walker Evans, *Washstand with View onto Dining Area of Burroughs Home, Hale County, Alabama*, 1936. © Walker Evans Archive, The Metropolitan Museum of Art (1994.258.393), New York.

66. Arthur Rothstein, *Fleeing a Dust Storm, Cimarron County, Oklahoma*, 1936. Prints and Photographs Division (z6211491), Library of Congress, Washington, DC.

67. Dorothea Lange, *Migrant Mother, Nipomo, California*, 1936. Prints and Photographs Division (F349058C), Library of Congress, Washington, DC.

68. Title page, The Family of Man exhibition catalogue, 1955, with photograph by Wynn Bullock. © 1955 Museum of Modern Art, New York. The Wynn and Edna Bullock Trust.

69. W. Eugene Smith, *'Weary but watchful, Maude sits by as mother dozes'*, 1951. Gelatin silver print. © The Heirs of W. Eugene Smith. Center for Creative Photography, University of Arizona, Tucson. From *Life* magazine, xxxi/23 (3 December 1951).

70. Gordon Parks, *Ella Watson, US Government Charwoman*, 1942. Prints and Photographs Division (z62060024), Library of Congress, Washington, DC. © Gordon Parks 1942, courtesy Howard Greenberg Gallery, New York.

71. Robert Frank, *Elevator—Miami Beach*, 1955. © The Americans, Robert Frank, courtesy Pace/MacGill Gallery, New York.

72. Walker Evans, *Girl in Fulton Street, New York*, 1929. Gelatin silver print. The Metropolitan Museum of Art, Gift of Carol and Arthur Goldberg, 2000 (2000.656). © Walker Evans Archive, The Metropolitan Museum of Art, New York.

73. Weegee, 'Their First Murder, 9 October 1941', from *Naked City*, 1945. © Weegee/International Center of Photography/Getty Images.

74. William Klein, *Ynette, New York, 1955*. © William Klein/Courtesy Howard Greenberg Gallery, New York.

75. Garry Winogrand, *Hard-Hat Rally, New York*, 1969. © The Estate of Garry Winogrand/Courtesy Fraenkel Gallery, San Francisco, CA.

76. Lee Friedlander, *Albuquerque, New Mexico*, 1975. Courtesy Fraenkel Gallery, San Francisco, CA.

77. Diane Arbus, *A Jewish Giant at Home with His Parents in the Bronx, NY*, 1970. Gelatin silver print. © Estate of Diane Arbus, LLC 1971/Courtesy Robert Miller Gallery, New York.

78. Danny Lyon, *Atlanta*, 1963–4. © Danny Lyon/Magnum Photos.

79. Bruce Davidson, *Untitled*, 1970. © Bruce Davidson/Magnum Photos.

80. Helen M. Stummer, *Sharell Showing Easter Dress to Grandmother*, n.d. Courtesy Helen M. Stummer, Metuchen, NJ.

81. Jacob Holdt, *Untitled*, n.d. Courtesy Jacob Holdt, Copenhagen.

82. Camilo José Vergara, *The Work of Giants Moulders Away. Downtown Detroit*, 1991. Courtesy Camilo José Vergara, New York.

83. Sebastião Salgado, *Slaughterhouse, Sioux Falls, South Dakota, United States*, 1988. © Sebastião Salgado/Network/Amazonas.

84. Susan Meiselas, *Children Rescued from a House Destroyed by 1,000-pound Bomb Dropped in Managua. They Died Shortly After*, 1978–9. © Susan Meiselas/Magnum Photos.

85. James Nachtwey, *Somalia*, 1992. © James Nachtwey/Magnum Photos.

86. Anonymous, *Unidentified Mother with Dead Child*, between 1845 and 1855, Strong Museum, Rochester, NY.

87. Andres Serrano, *The Morgue (Pneumonia Death)*, 1992. Cibachrome, silicone, plexiglass, wood frame. Courtesy Paula Cooper Gallery, New York.

88. Anonymous, *The Story of the Kodak Album*, 1910s. Advertisement. Courtesy Eastman Kodak Company.

89. Carrie Mae Weems, *Dad and Son–Son*, from *Family Pictures and Stories*, 1978–84. Courtesy Carrie Mae Weems and PPOW Gallery, New York.

90. Richard Avedon, *Jacob Israel Avedon, Sarasota, Florida*, 1969–73. Courtesy Richard Avedon Studio, New York.

91. Emmet Gowin, *Edith and Rennie Booher, Danville, Virginia*, 1970. © Emmet Gowin/Courtesy Pace/MacGill Gallery, New York.

92. Sally Mann, *Easter Dress*, 1986. © Sally Mann/Courtesy Edwynn Houk Gallery, New York.

93. Jim Goldberg, 'We are a contemporary family . . .', from *Rich and Poor: Photographs by Jim Goldberg*. © Jim Goldberg/Courtesy Pace/MacGill Gallery, New York.

94. Howard Schatz, *Penny Rodriguez, 18, San Francisco, California*, 1993. From *Homeless: Portraits of Americans in Hard Times* (Chronicle Books, 1993). © Howard Schatz/Ornstein Studio, New York.

95. Charlene Williams, *Untitled*, 1990. Silver print. Jim Hubbard, *Shooting Back, A Photographic View of Life by Homeless Children* (San Francisco: Chronicle Books, 1991), © Shooting Back Inc./Venice Arts Mecca.

96. Nan Goldin, *Self-portrait Battered in Hotel, Berlin, 1984*. Courtesy Nan Goldin, Paris.

97. Francesca Woodman, *I could no longer play, I could not play by instinct, Providence, 1975–78*. Courtesy the Estate of Francesca Woodman, Betty and George Woodman.

98. Andy Warhol, *Self-portrait*, 1979. Instant colour print (Polaroid). © The Andy Warhol Foundation for the Visual Arts, Inc./Art Resource/Scala/ARS, NY and DACS, London 2003.

99. Sol LeWitt, unnumbered page from *Autobiography Sol LeWitt 1980* (New York: Multiples Inc.) © ARS, NY and DACS, London 2003.

100. Anonymous, *The Child's Dream*, 1880. Albumen print stereograph. George Eastman House (84:1453:1), International Museum of Photography and Film, Rochester, NY.

101. Alexander Black, '"Miss Jerry", The First Picture Play', from *Scribner's Magazine*, xviii/3 (September, 1895). Cornell University Library, Ithaca, NY.

102. William Mortensen, *L'Amour*, 1937. Bromoil transfer print. Center for Creative Photography (88.052.030), University of Arizona, Tucson.

103. Duane Michals, *This Photograph Is My Proof*, 1975. © Duane Michals/Courtesy Pace/MacGill Gallery, New York.

104. Joel-Peter Witkin, *Mother and Child*, 1979–82. Courtesy Fraenkel Gallery, San Francisco, CA.

105. Cindy Sherman, *Untitled Film Still #21*, 1978. Gelatin silver print. Collection Jane B. Holzer. Courtesy of the artist and Metro Pictures, New York.

106. Cindy Sherman, *Untitled, #216*, 1989. Courtesy the artist and Metro Pictures, New York.

107. Cindy Sherman, *Untitled, #264*, 1992. Courtesy the artist and Metro Pictures, New York.
108. Laurie Simmons, *The Music of Regret IV*, 1994. Courtesy Laurie Simmons, New York.
109. David Levinthal, *World of War*, 1995. Courtesy David Levinthal, New York.
110. Sandy Skoglund, *Walking on Eggshells*, 1997. © 1997 Sandy Skoglund, New York.
111. Gregory Crewdson, *Untitled*, 1994. C-print. Courtesy Gregory Crewdson/ Luhring Augustine Gallery, New York.
112. Jeff Wall, *Eviction Struggle*, 1988. Courtesy Jeff Wall, Vancouver.
113. Paul Outerbridge, *Ide Collar*, 1922. Estate of Paul Outerbridge, Jr. © 2002 G. Ray Hawkins Gallery, Los Angeles, CA.
114. Deborah Turbeville, *Krakow*, 1998. Courtesy Deborah Turbeville/Marek and Associates.
115. Eugene Robert Richee, *Carole Lombard*, 1935. Kobal Collection, London.
116. Anonymous, *Bonnie Parker, the Gun Moll of the 1930s*, n.d. Corbis UK.
117. Weegee, Untitled, from *Naked City*, 1945. [Charles Sodokoff and Arthur Webber Use Their Top Hats to Hide Their Faces, 27 January 1942] © Weegee/International Center of Photography, New York/Getty Images.
118. Martha Madigan, *Aestas*, 2000. Solar photogram. Courtesy Martha Madigan/ Michael Rosenfeld Gallery, New York.
119. David Hockney, *Sunday Morning, Mayflower Hotel New York, Nov. 28, 1982*. Photographic collage. Courtesy David Hockney, Los Angeles, CA.
120. Mike and Doug Starn, *Triple Christ*, 1986. Courtesy Leo Castelli Gallery/© ARS, NY and DACS, London 2003.
121. Robert Heinecken, *TV Newswomen*, 1986. Cibachrome prints. © Robert Heinecken/ courtesy Pace/MacGill Gallery, New York.
122. John Baldessari, *The Overlap Series: Street Scene (With Cosmic Event)*, 2000–1. Colour digital photographic print with acrylic on sintra board. Courtesy of John Baldessari/Marian Goodman Gallery, New York/Jon and Anne Abbott.
123. Richard Prince, *Untitled (Cowboy)*, 1980–4. Ektacolour print. Courtesy Richard Prince/Barbara Gladstone Gallery, New York.
124. Barbara Kruger, *Untitled* (Your Body Is a Battleground), 1989. Billboard, photographic silkscreen/vinyl. Collection of the Broad Art Foundation, Santa Monica, CA/courtesy Mary Boone Gallery, New York. © DACS 2003.
125. Pedro Meyer, *The Strolling Saint, Nochistlan, Oaxaca, 1991–92*. Courtesy Pedro Meyer, Los Angeles, CA.
126. Anonymous, *Tourist Guy*. Internet source, http://www.snopes2.com/rumors/crash.htm http://urbanlegends.about.com/library/ blphoto-wtc.htm
127. Anonymous, *The Burning Corpse of William Brown. September 28, 1919, Omaha, Nebraska*. Special Collections Department, Robert W. Woodruff Library, Emory University, Atlanta, GA.
128. Joe Rosenthal, *Iwo Jima—Old Glory Goes Up on Mt. Suribachi, February 23, 1945*. AP/Wide World Photos, New York.
129. Vik Muniz, *Memory Rendering of Tram Bang Child*, 1989. © Vik Muniz/VAGA, NY/DACS, London 2003.
130. Joel Meyerowitz, *North Tower and Woolworth Building*, 2001 © Joel Meyerowitz, New York.

The publisher and author apologize for any errors or omissions in the above list. If contacted they will be pleased to rectify these at the earliest opportunity.

Index